VISIONS 2023

ILLUSTRATORS BOOK

SUPERVISED BY pixiv

CONTENTS

● Each artist's work is presented on a two-page spread. On the left side, you will find the artist's social media accounts and contact information. Use the camera on your phone to read the QR code in the bottom left corner and directly access[1] the artist's pixiv page.[2]

[1] Please note that pixiv usernames and other social media accounts, URLs, and e-mail addresses of the artists in this book are subject to change without notice.
[2] pixiv is a social media platform for artists provided by pixiv, Inc.

3°C

sando

TWITTER n79oqc3Yja6JLOF

TOOLS SAI / Deco LW

PROFILE Creating original works that are immediately recognizable as my own. Currently experimenting with illustrations that employ a multitude of fresh, vibrant colors.

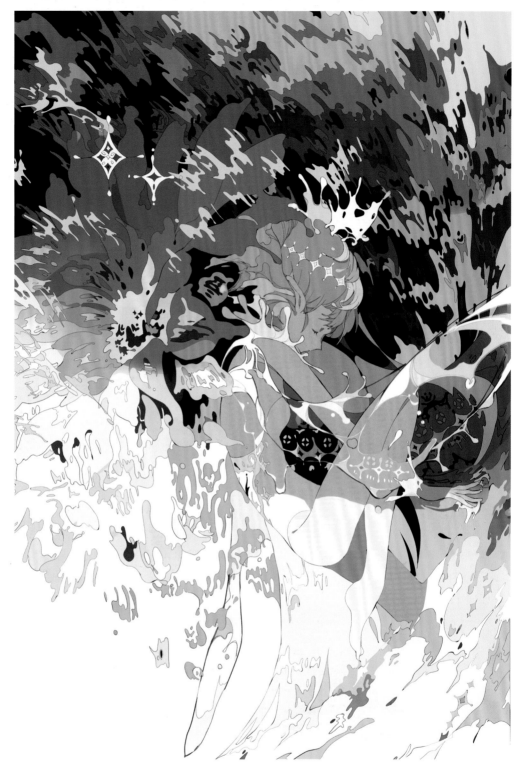

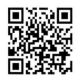
| 1 | 2 | 3 |

TITLE **1** Water's Edge **2** Black Swan **3** White Swan all original works created in 2022

60160 Golgo

TWITTER Xenophoss

TOOLS CLIP STUDIO PAINT / Wacom Intuos5 Touch

PROFILE Draws gentle pictures.

E-MAIL xenophoss@gmail.com

TITLE **1** haru (spring) **2** ハル (spring) **3** 春 (spring) **4** Monkeys all original works created in 2022

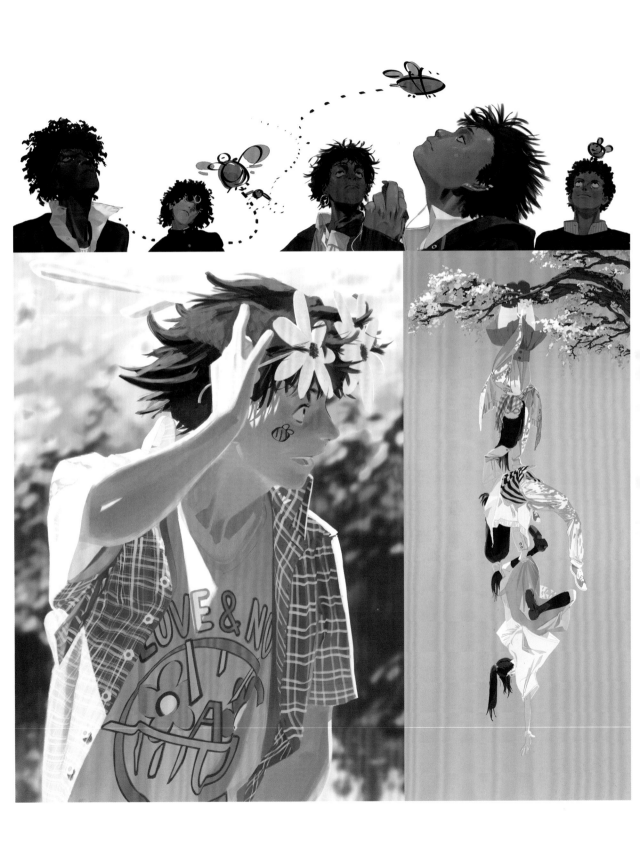

82PIGEON

TWITTER 666pigeon **E-MAIL** pigeon646464@gmail.com

TOOLS Photoshop CC 2018 / Wacom Cintiq 22HD

PROFILE Freelance illustrator from Korea. Aims to create works that combine typical manga styles with realism that people can enjoy viewing.

AT : ODDS

TITLE **1** Children of romanticists／2020 **2** At;odds／2021 **3** 20211202／2021 all original works

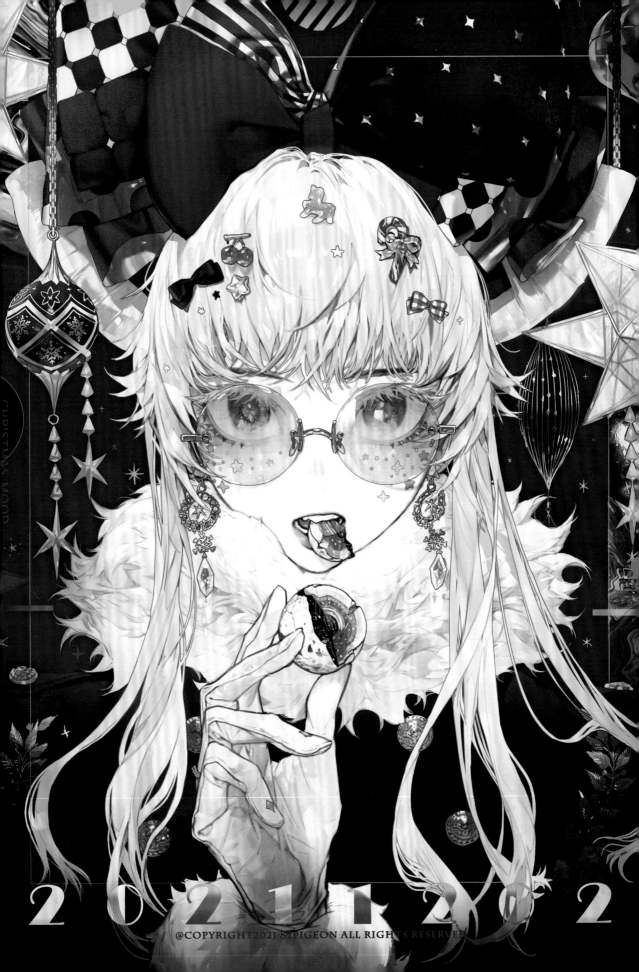

AF_KURO

TWITTER llcabR18 **E-MAIL** giulia.super1570@gmail.com

TOOLS CLIP STUDIO PAINT / Photoshop / Wacom Cintiq 22HD

PROFILE
Illustrator, character and mechanical designer, and toy designer with a style influenced by product design as well as sci-fi and car culture. Creator of the original *Motored Cyborg Runner* illustration series depicting street racers on internal combustion engines set against a dystopian backdrop.

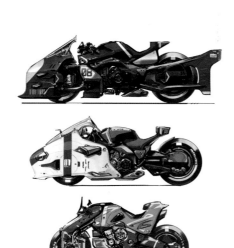

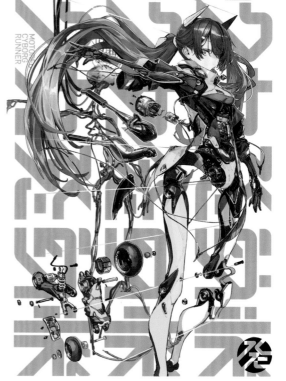

1		4
2	3	

TITLE 1 SHIBUYA_RUN / 2022 2 MOTORCYCLES / 2021 3 2Stroke_SPECIAL / 2021 4 POWERD_BY / 2021
all original works

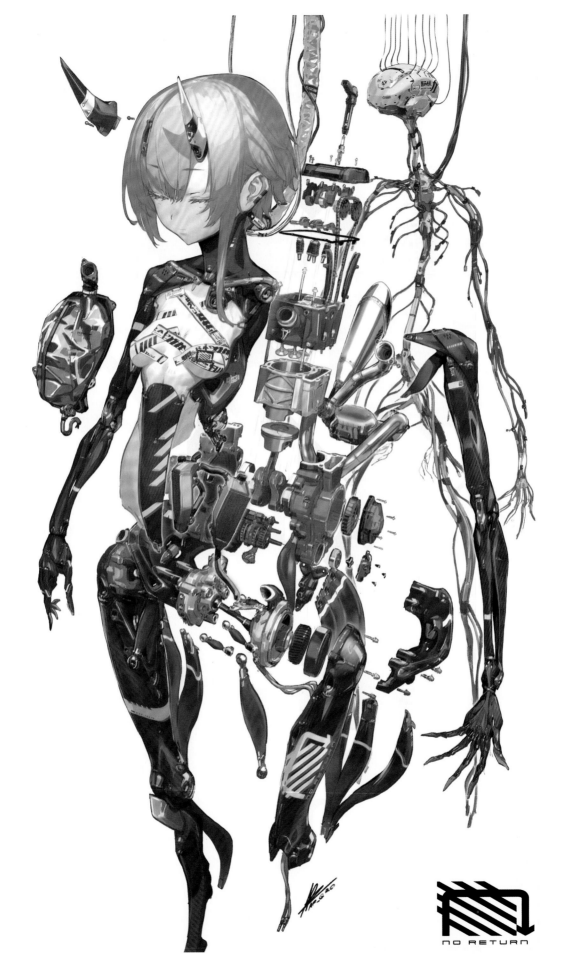

NO RETURN

Aiamiam 逢編いあむ

TWITTER iamuu_n **E-MAIL** iamuu.n28@gmail.com

TOOLS CLIP STUDIO PAINT / iPad Pro / Huion Kamvas Pro 16

PROFILE
Loves cute things and mysterious things. Mainly works as an illustrator doing character pieces, but also creates many original works of illustration, animation, video, and music.

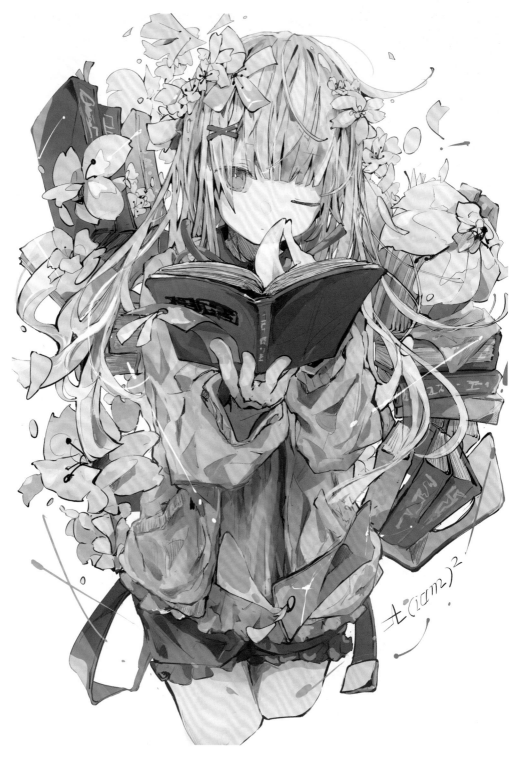

pixiv user ID : 35025269

TITLE **1** 211219／2021　**2** 220205／2022　**3** 220502／2022　all original works

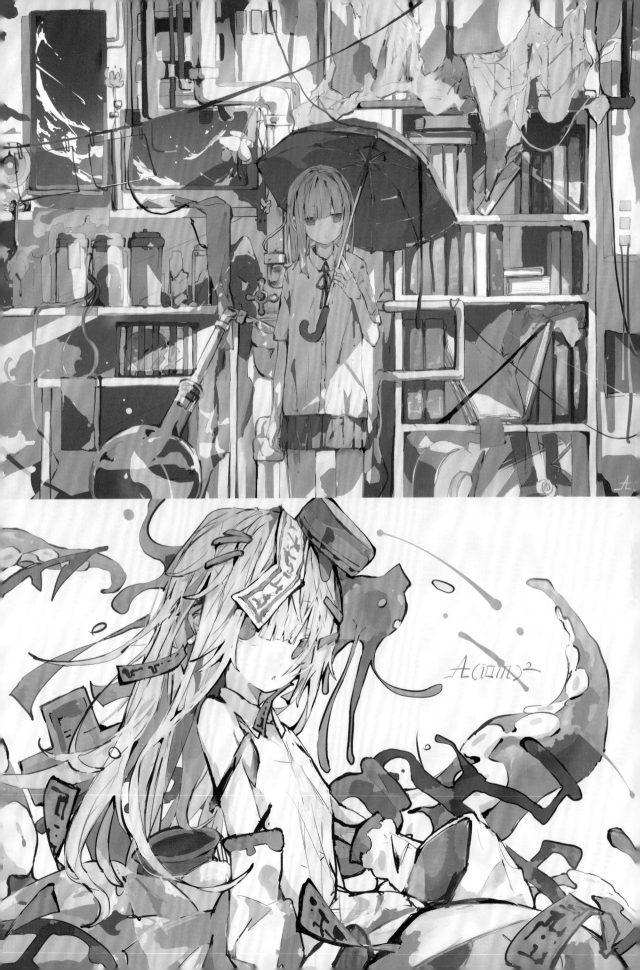

akaisashimi 赤井さしみ

TWITTER sas_akai **E-MAIL** akaisrf@gmail.com

TOOLS CLIP STUDIO PAINT / Wacom Cintiq Pro 24

PROFILE Draws laid-back art and manga. Recently published a short story collection called *Tasogare ni Maniaeba: akaisashimi Sakuhinshuu (When You Encounter It at Dusk: The Short Stories of akaisashimi)* through KADOKAWA.

TITLE 1 Fox / original / 2022 **2** Time to Eat / cover illustration of *Tasogare ni Maniaeba: akaisashimi Sakuhinshuu* (KADOKAWA) / 2021 **3** Flight / Original / 2022

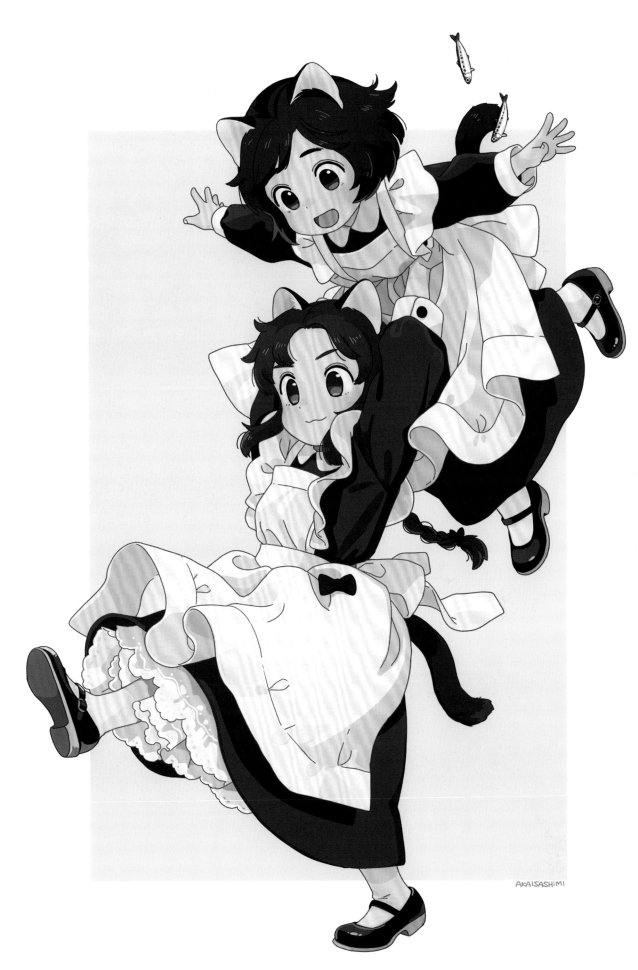

aki
あき

TWITTER Aki_a0623 E-MAIL aki0623.work@gmail.com

TOOLS Photoshop / Wacom Intuos Pro

PROFILE A freelance illustrator since 2021. Published the artbook *Yume no Iriguchi* (*Entrance to Dreams*) through Japan Publications, Inc. Values light and dark as well as coloration in art.

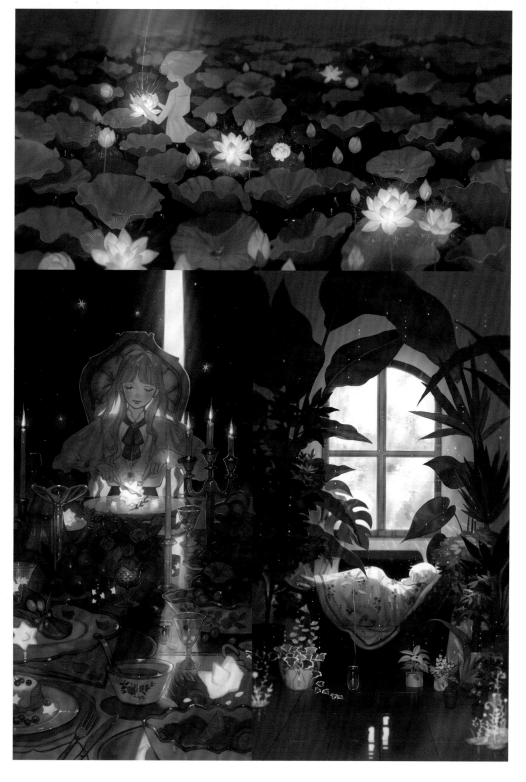

1		4	5	6
2	3		7	

TITLE **1** Lighting the Stars ⁄ 2022 **2** Dinner ⁄ 2022 **3** Photosynthesis ⁄ 2021 **4** I Had a Dream ⁄ 2021
5 Goodnight Moon ⁄ 2021 **6** Hazy Stars Falling ⁄ 2021 **7** Night of Falling Stars ⁄ 2022 all original works

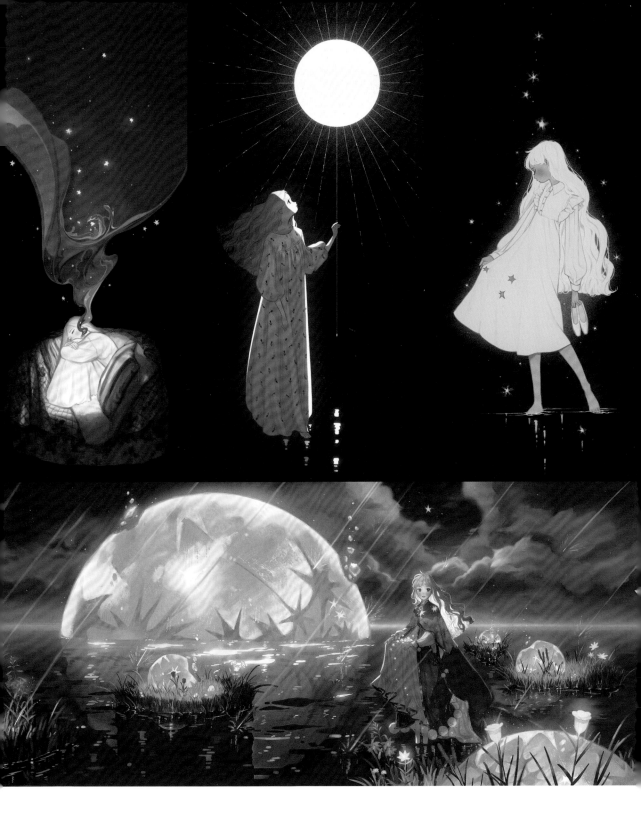

amebiyori 飴日和

TWITTER anbiyori **E-MAIL** totomoufu@gmail.com

TOOLS CLIP STUDIO PAINT EX / After Effects / Wacom Cintiq 16

PROFILE Born in 2001. From Nagano Prefecture. Draws scenes from everyday life.

TITLE 1 Watching a Movie / 2021 **2** Morning Cleaning / 2022 **3** Long Conversation / 2022 **4** Summer Break / 2022
all original works

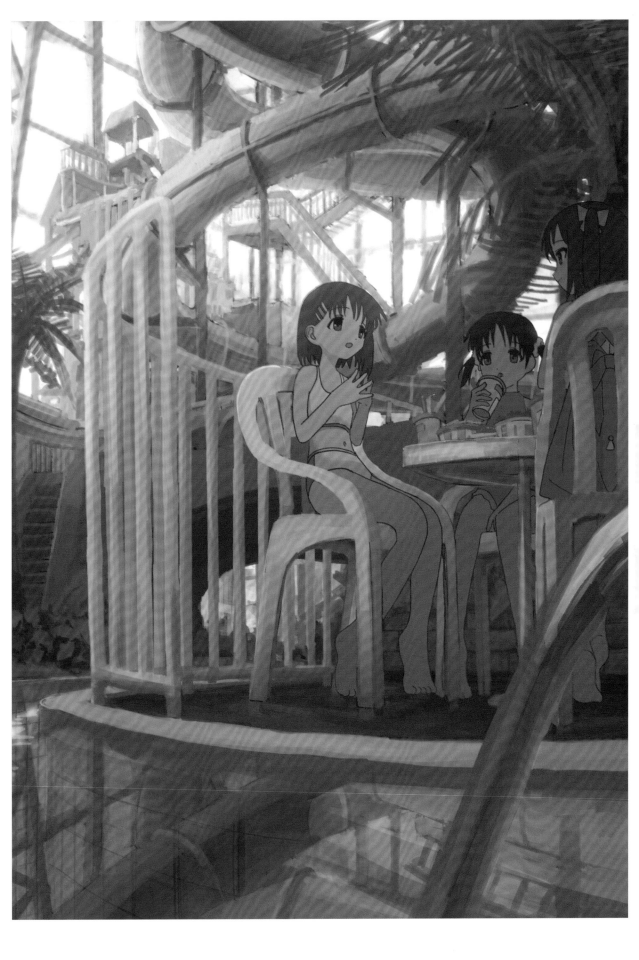

Amelicart ア・メリカ

TWITTER amelicart　**E-MAIL** amelicart@gmail.com

TOOLS Photoshop / Procreate / Wacom Intuos / iPad

PROFILE Major works include the loading screen for *Pikmin Bloom* (Niantic) and cover images for the magazine *Kenchiku Chishiki* (Architectural Knowledge) (X-Knowledge). Works in advertising, book illustration, and concept art for domestic and foreign clients.

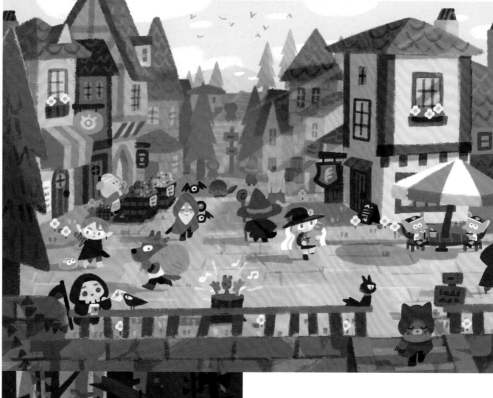

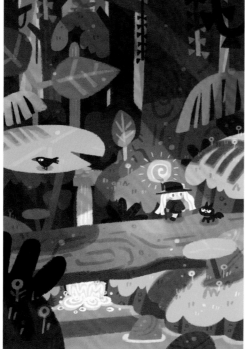

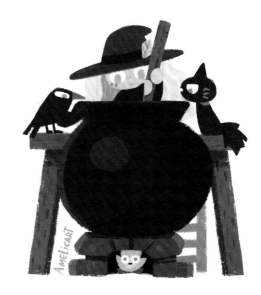

1	4
2 3	

TITLE　1 Shopping District / original / 2021　**2** One Day, In the Forest / original / 2021　**3** What Will I Make? / original / 2021　**4** *Kenchiku Chishiki* Cover Illustration / cover illustration for the April 2022 issue of *Kenchiku Chishiki* (X-Knowledge) / 2022

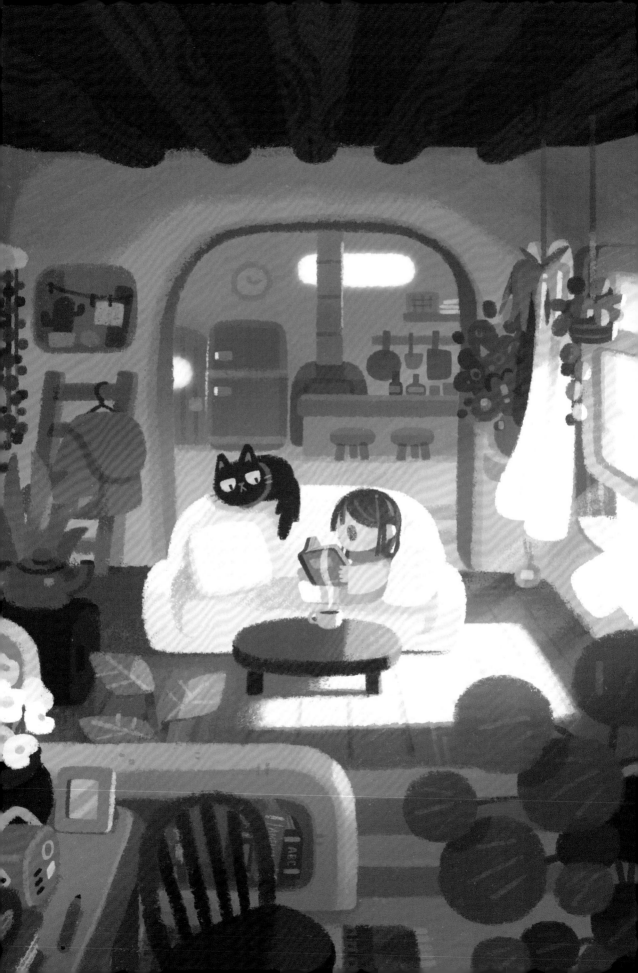

Andrei Riabovitchev

TWITTER Riabovitchev **E-MAIL** riabovitchev@gmail.com

TOOLS Photoshop / Huion

PROFILE Born in Apsheronsk in Southern Russia in 1968. Moved to Moscow to study engineering, then entered the animation industry. Worked on several projects while in the United Kingdom, including *Aladdin, Wrath of the Titans, X-Men: First Class, The Wolfman,* and *Harry Potter and the Deathly Hallows.* Now works as an artist.

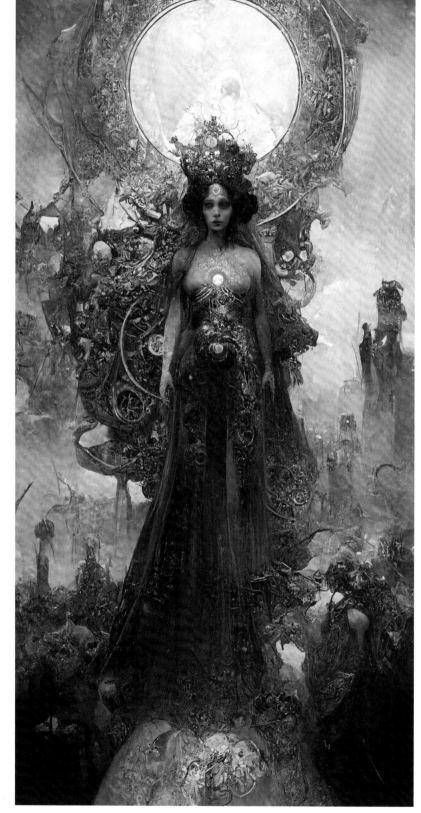

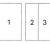

TITLE **1** Summer June **2** Goddess of Summer July **3** Goddess of Nature all original works created in 2022

Anhaoqwq

TWITTER anhaoqwq **E-MAIL** 221681147Ｓ@qq.com

TOOLS Photoshop 2019 / UGEE EX12

PROFILE I am a newcomer from Chongqing who began studying art from scratch two and a half years ago. I like mixing colors and drawing in black and white, but with limited time to draw, I don't have a true masterpiece yet. I'm very interested in outer space, probably because of the movie *Interstellar*. The first time I saw it, I cried a lot (;v;)...

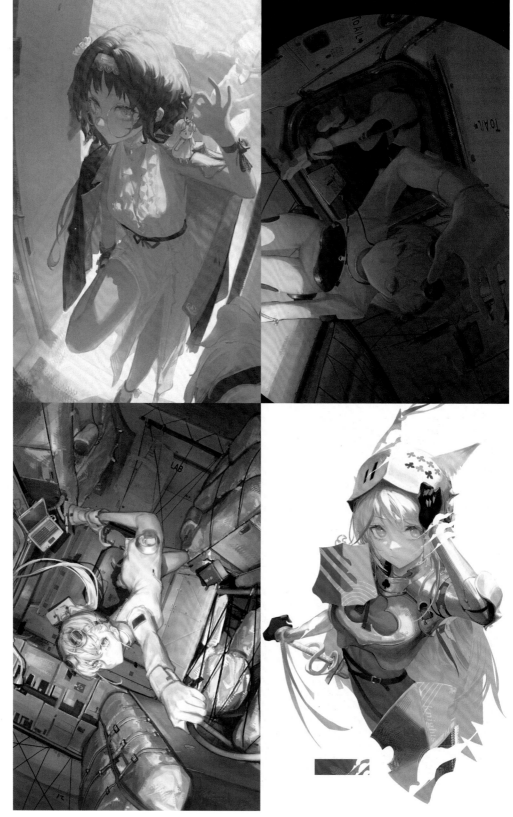

1	2	
3	4	5

TITLE 1 Visit / 2022 2 See You Tomorrow / 2021 3 Zero-G Maintenance / 2021 4 Knight / 2022
5 Leaving Port / 2022 all original works

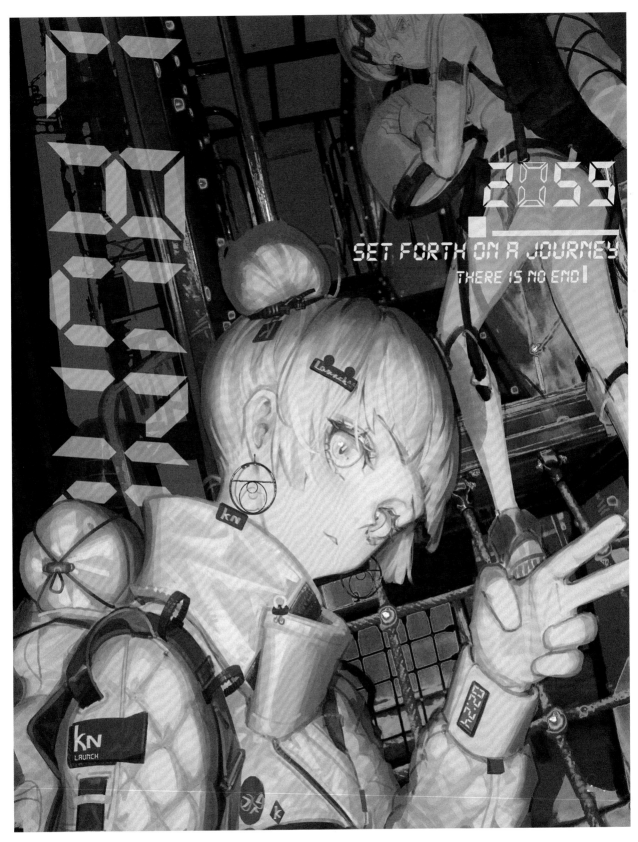

Antonio Reinhard

TWITTER WisesaAntonio **E-MAIL** antonio.reinhard@gmail.com

TOOLS Photoshop / Wacom Intuos

PROFILE An illustrator from Indonesia. Largely influenced by the surrounding lifestyle and culture, but mainly aims to capture vivid scenes, emotional stories, and moods in their works.

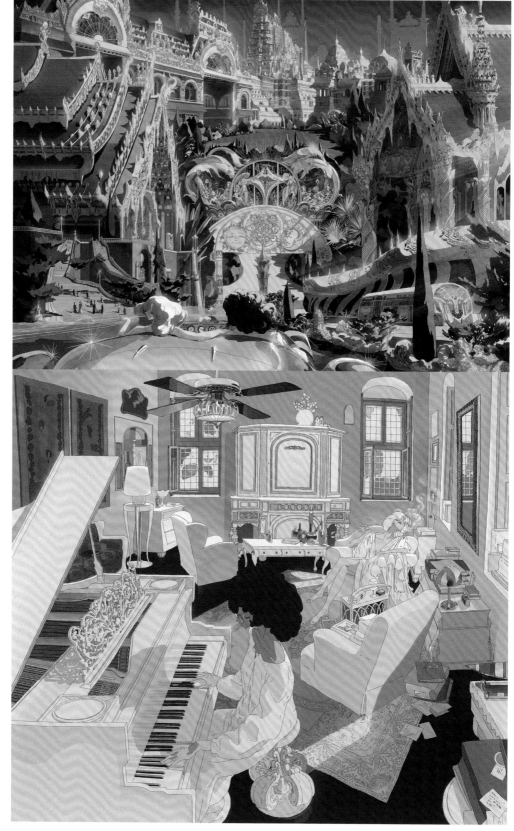

1	3
2	

TITLE **1** Nayandra / 2022 **2** Ondine / 2021 **3** Daughters / 2021 all original works

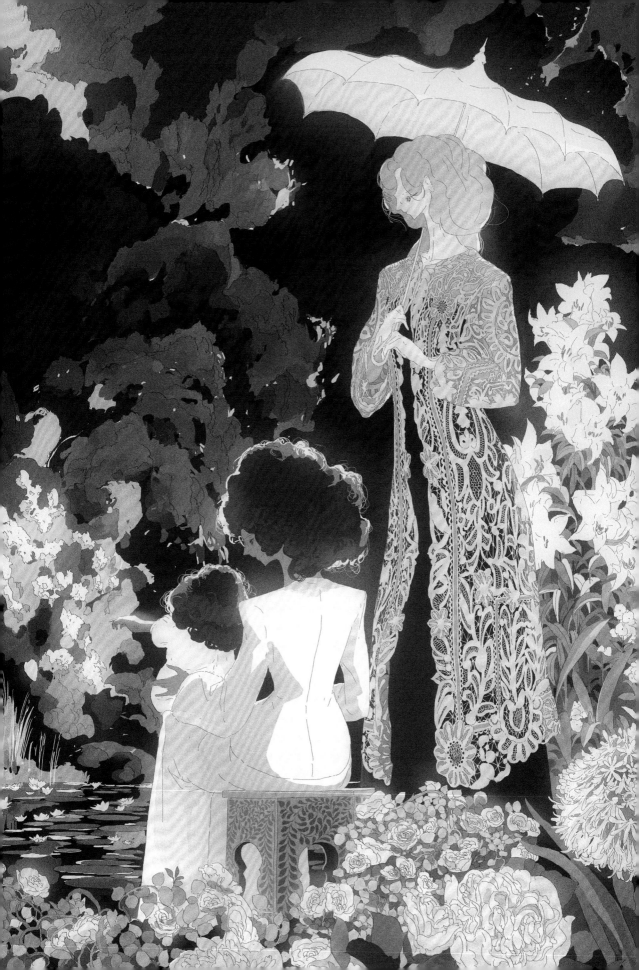

Asteroid あすてろid

TWITTER asteroid_ill **E-MAIL** asteroidbelt.mail@gmail.com

TOOLS Photoshop / Wacom Bamboo CTL-470

PROFILE A designer working for a video game studio.

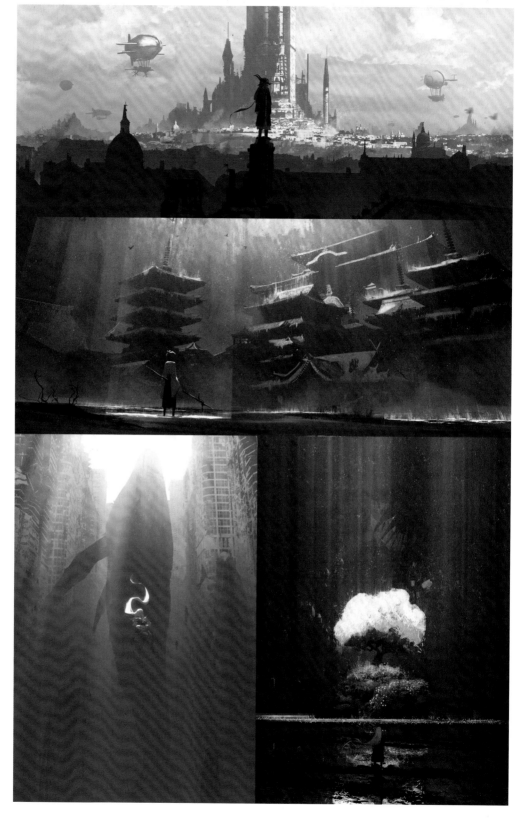

1	
2	5
3 4	

TITLE **1** Tower City **2** Sealed Capital **3** Voice of the Sea **4** Golden Autumn **5** Red Lights
all original works created in 2021

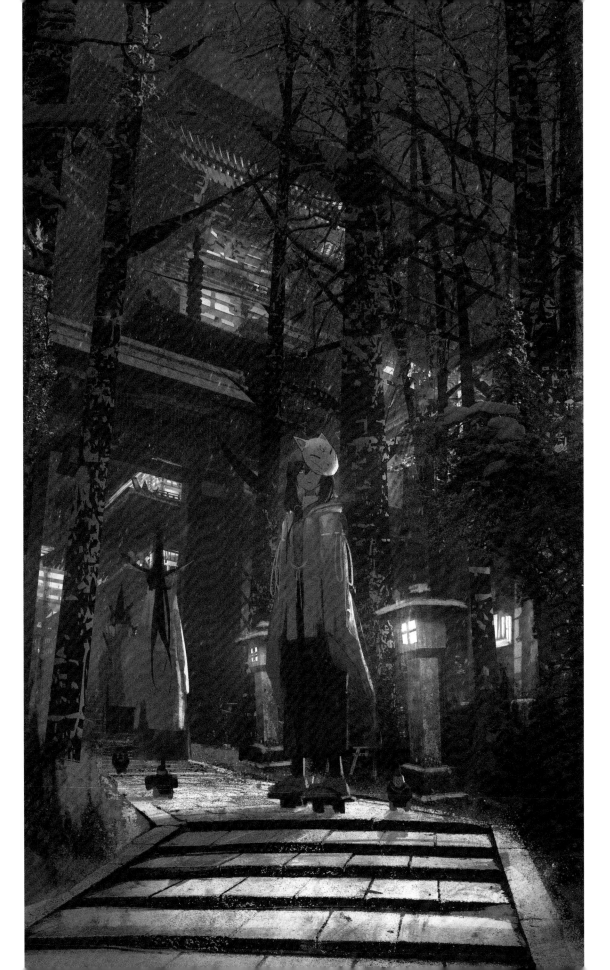

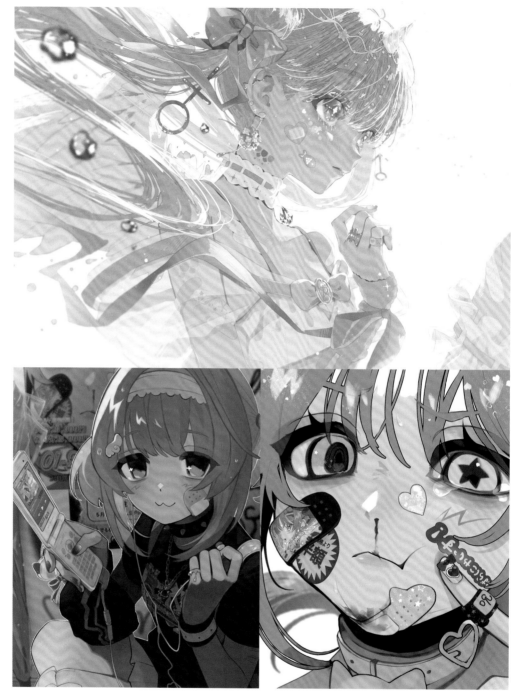

awashima ehu 淡嶋えふ

INSTAGRAM awashima.ehu URL https://ehu-rouge.wixsite.com/manta

TOOLS CLIP STUDIO PAINT / iPad

PROFILE Creating thought-provoking works through visuals and text. Loves Heisei subcultures.

1		4
2	3	

TITLE **1** Dream Shore／2021 **2** Waiting for a Friend to Go Out／2022 **3** Otaku-chan B Fighting to Live／2022 (*stickers:* half off at this store, Paranyaice!) **4** Just Like Her!／2022 (*clip:* Mel. Mel★ Meruchi) all original works

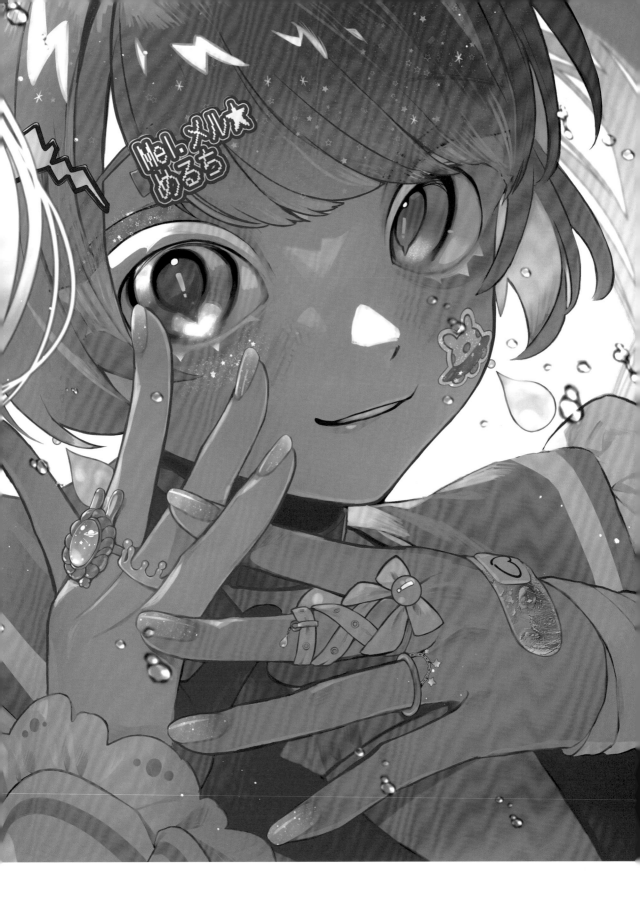

Bampshi

TWITTER bampshi **E-MAIL** bampohp@gmail.com

TOOLS Procreate / iPad Pro

PROFILE Specializes in digital illustration. Born and raised in London, England, and creates artwork inspired by local society. Interests include anime, video games, and drawing really cool women.

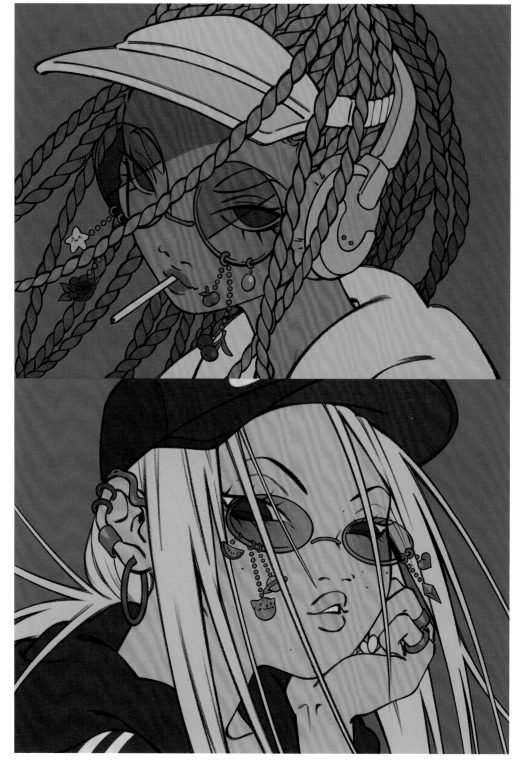

TITLE **1** GLASS01 **2** GLASS02 **3** 2X22 SUMMER all original works created in 2022

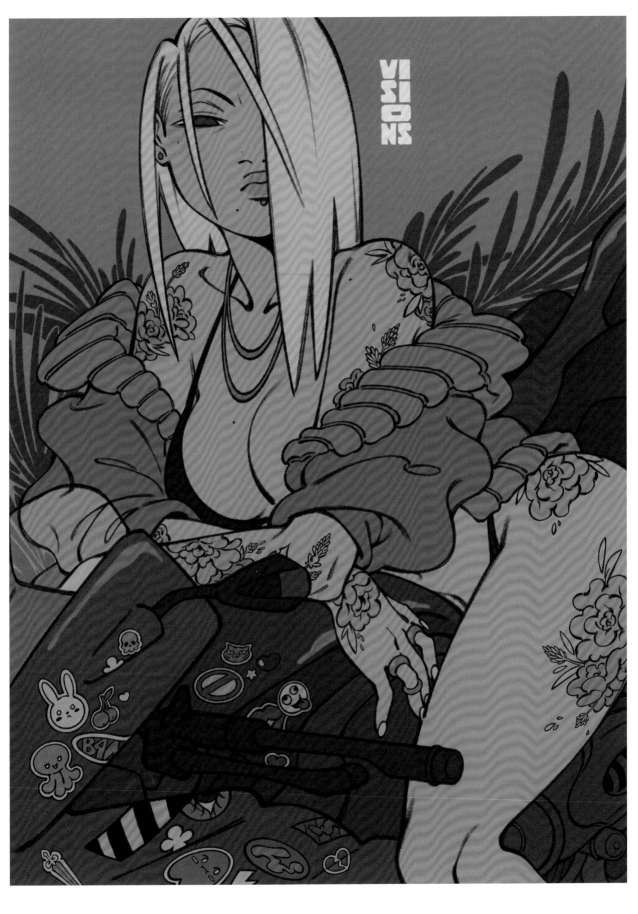

BBANG

우유빵／パン

TWITTER BBANG_1130

TOOLS CLIP STUDIO PAINT／Wacom CTL-480

PROFILE Steadily creates original characters. Pursues retro artwork. Also creates GIF animations.

1	3
2	4

TITLE **1** Zombie Maids／2022 **2** Older Teenager Kanna／2021 **3** Kimono and Parfait／2022 **4** Choose One, Renji!／2021 all original works

BM

TWITTER BM94199　E-MAIL　bouncepeople@naver.com

TOOLS Photoshop / Wacom Intuos Pro Medium (PTH-660)

PROFILE A freelance illustrator working in Korea. Jobs mainly include cover illustrations for web novels. Dream is to draw all kinds of things. Has come to enjoy illustrations in the style of famous works of art recently. Loves beautiful girls.

pixiv user ID : 83097243

1		3	4
2		5	6

TITLE　1 Winter breath／2021　**2** Eva／2022　**3** Misty lilac／2022　**4** Girl with a hairband／2022　**5** Afternoon day／2022　**6** Black／2021　all original works

pages　036 - 037　　VISIONS 2023　ILLUSTRATORS BOOK　supervised by pixiv

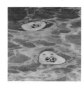

CHAKOTATA ちゃこたた

TWITTER akcotCOoOoOoO **E-MAIL** chakotata09@gmail.com

TOOLS Photoshop / Wacom Cintiq Pro

PROFILE A certain city and the boys and girls living in it. Creates illustrations that are like little cutouts of the world they live in. Favorite food is the crab cream croquettes from home.

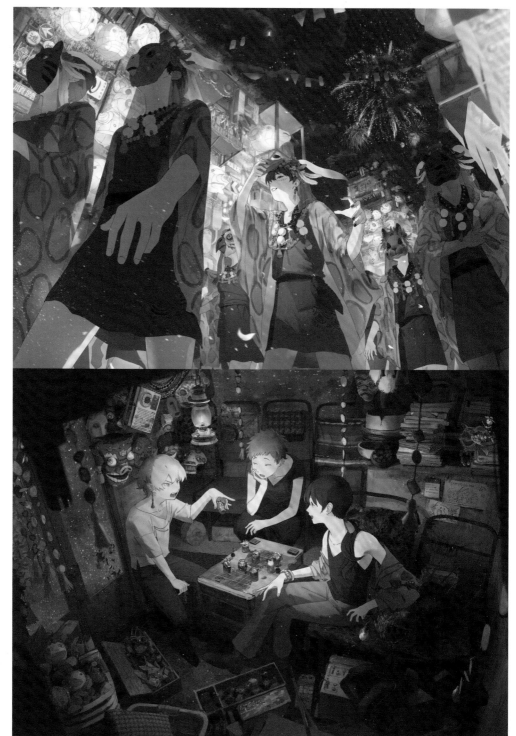

pixiv user ID : 77688754

1	3
2	

TITLE **1** Big Summer Parade / 2021 **2** A Secret Base to Pass the Rain / 2021 **3** Emergency Meeting! / 2022
all original works

pages 038 - 039 VISIONS 2023 ILLUSTRATORS BOOK supervised by pixiv

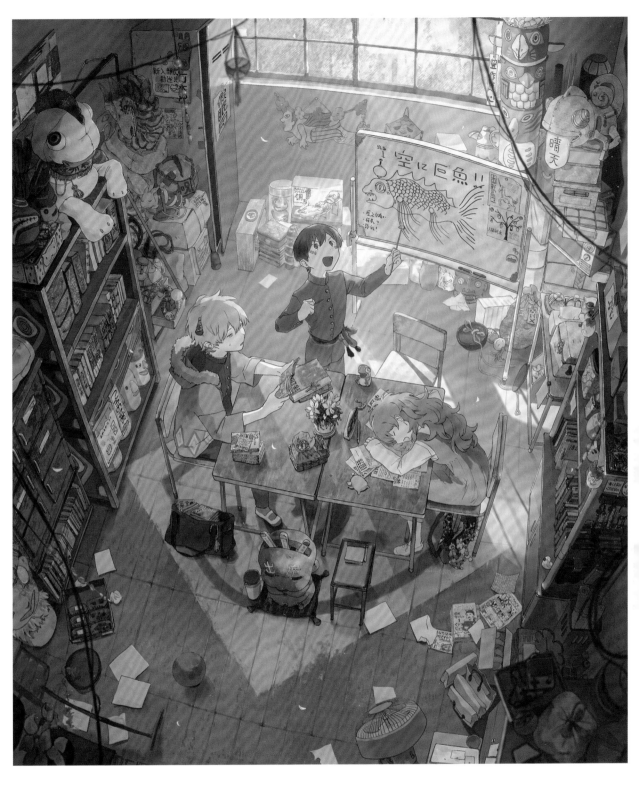

Cherico チェリチ

TWITTER chie_rico **URL** https://www.cherico-cerise.net/

TOOLS CLIP STUDIO PAINT / Wacom Intuos Pro

PROFILE Began serious work as a freelance illustrator in 2020 after retiring from a job at a video game company. Works include the music video illustrations for "Chururira Chururira Dadadada!" by Takeaki Wada, the music video illustrations for "Aitakute" by Ado, illustrations for Benesse's Shinkenzemi promo mailer, and the character designs for the voice creation software Chis-A.

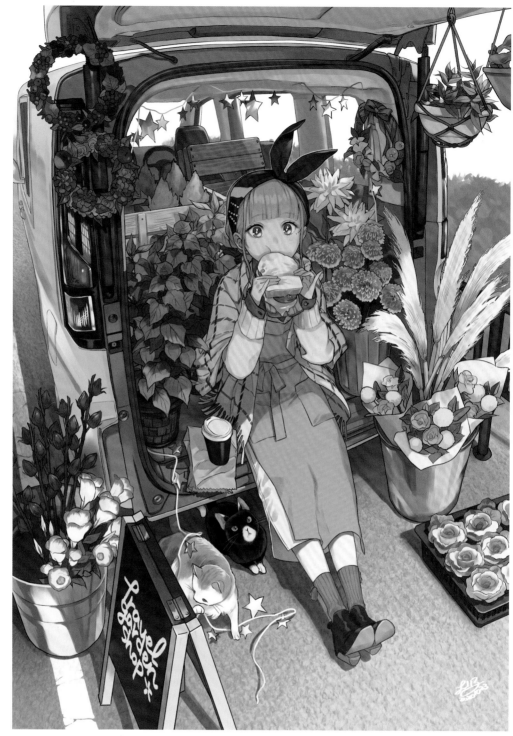

1	2	3
	4	5

TITLE **1** Breaktime／2020 **2** Budding／2022 **3** Spring Bouquet／2022 **4** Sailor Hood／2022 **5** Poolside Tart／2022 all original works

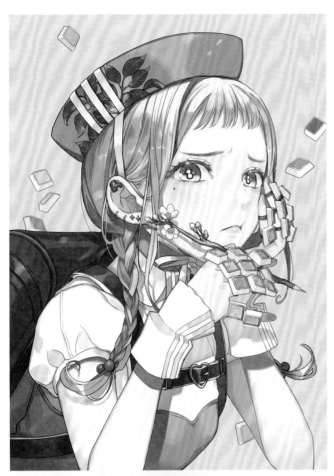

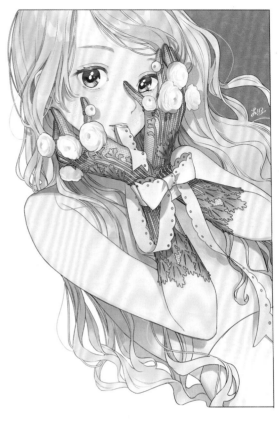

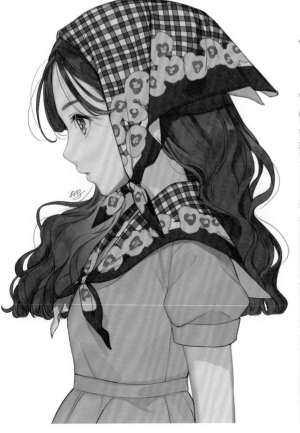

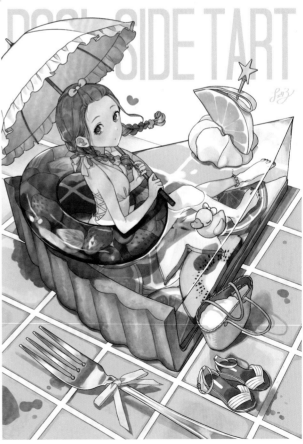

POOL SIDE TART

chooco

TWITTER chocoshi3 **URL** chooco3-illust.studio.site

TOOLS SAI / Photoshop / Wacom Intuos2

PROFILE
Guided by the principle of producing "a single piece of art to reach people's hearts" and centered around the color blue. Has worked on CD jackets, key visuals, music videos, logos, and banners, among other things. Committed to fantastical scenes and buildings.

TITLE **1** At the End of the World / 2021 **2** To a City of Sky / 2021 **3** Blue Horizon / 2021 **4** Whale Cloud / 2022
all original works

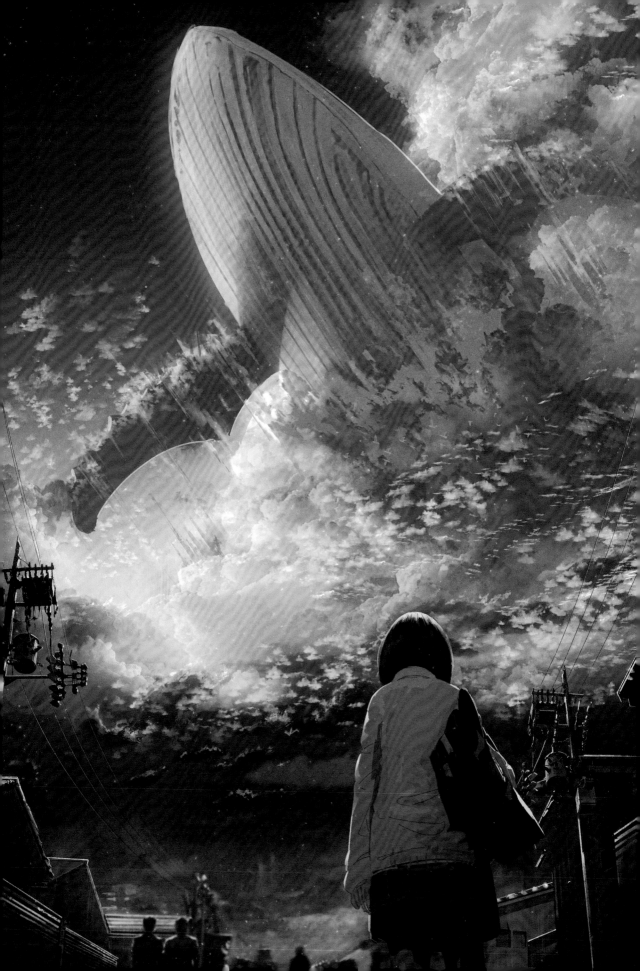

cotono

TWITTER cotono_cot **E-MAIL** cotonocot@gmail.com

TOOLS CLIP STUDIO PAINT / iPad / One by Wacom

PROFILE Creating digital illustrations that pack the screen with things they think are cute. Currently working to expand their range of original pieces to include worlds that let the characters shine the best. Likes hair buns and cool colors.

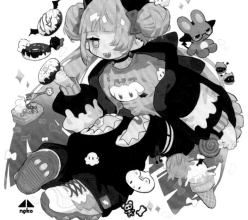

1		4
2	3	5
		6

TITLE 1 game room／2021 **2** Bad Girl／2022 **3** I Love Sweets!／2021 **4** Milky Way／2019 **5** Wind-Up Jiangshi (*note:* a hopping vampire from Chinese folklore)／2021 **6** paints／2021 all original works

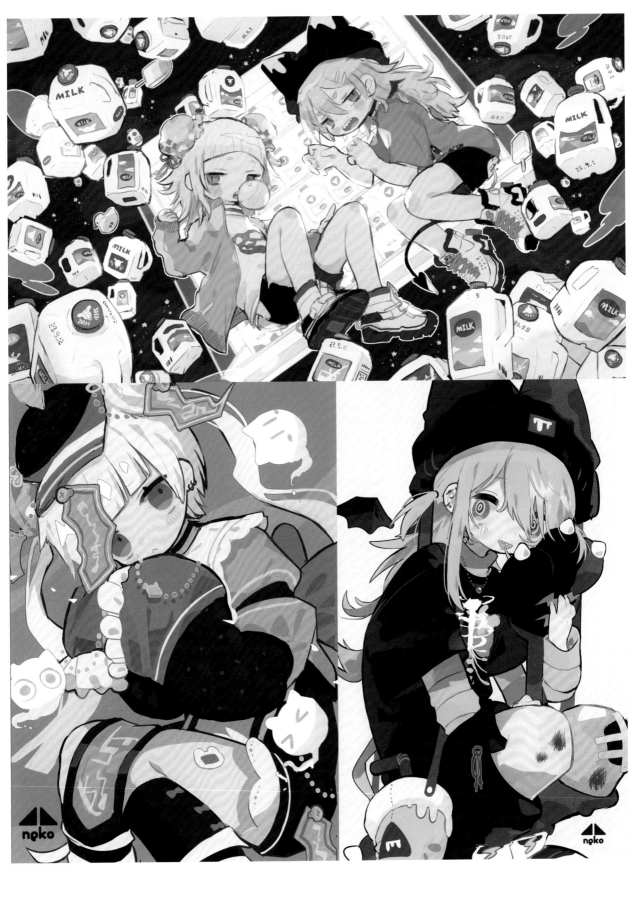

Demizu Posuka 出水ぽすか

TWITTER DemizuPosuka E-MAIL posukanosigoto@gmail.com

TOOLS Photoshop / CLIP STUDIO PAINT / Wacom Cintiq / iPad

PROFILE Demizu Posuka, illustrator and manga artist. Illustrated Weekly Shonen Jump's The Promised Neverland, and drew cover illustrations and similar pieces for Monthly CoroCoro Comic and other books before that. Recently started drawing with an iPad. Wants to try their hand at different styles.

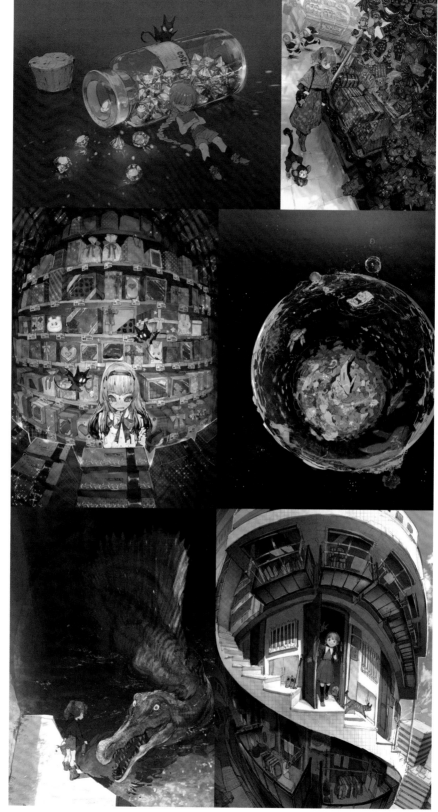

1	2	7
3	4	
5	6	8

TITLE 1 Relaxant / 2022 2 Advent Streets / 2021 3 Can't Choose at the Chocolatier / 2022 4 Planet of Only Water / 2021 5 Here, Here / 2022 6 I'm heading out~ / 2022 7 Nothin' Better Than Pizza! / 2021 8 We Have the Blessing of the Dinosaurs / 2022 all original works

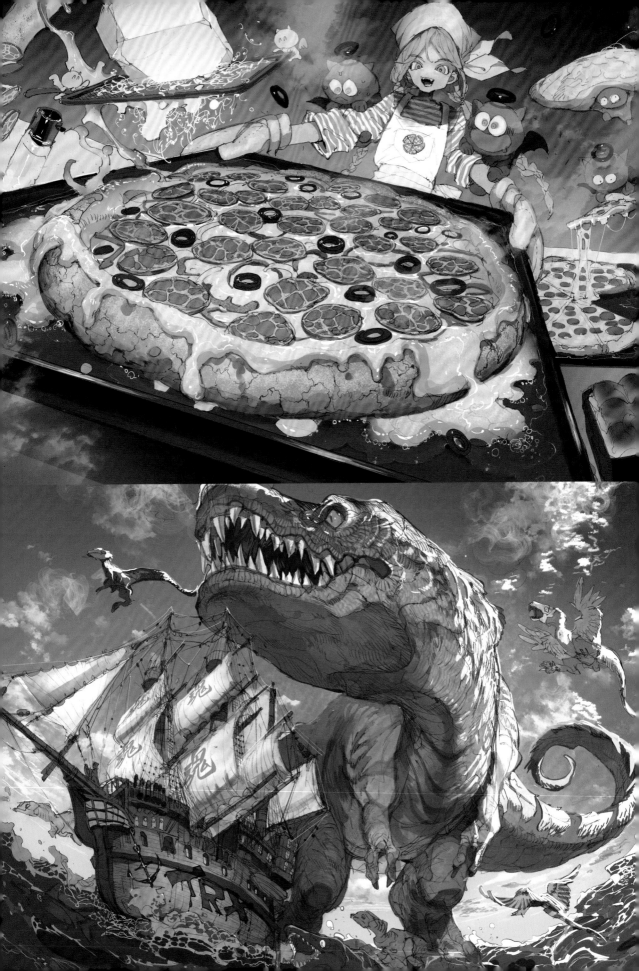

DENN でん

TWITTER naluse_flow E-MAIL mewstraight@yahoo.co.jp
TOOLS Procreate / iPad
PROFILE Born in 2001. Currently in the oil painting program at Tokyo University of the Arts. Creates works focusing on worlds and stories that capture an entire movie in a single illustration.

1	3
2	4

TITLE 1 Not Yet! / 2021 2 I Hope You Get Better Soon / 2021 3 Do You Like It? / 2022 4 Don't Blame Me If Bread is All You End Up Eating! / 2021 all original works

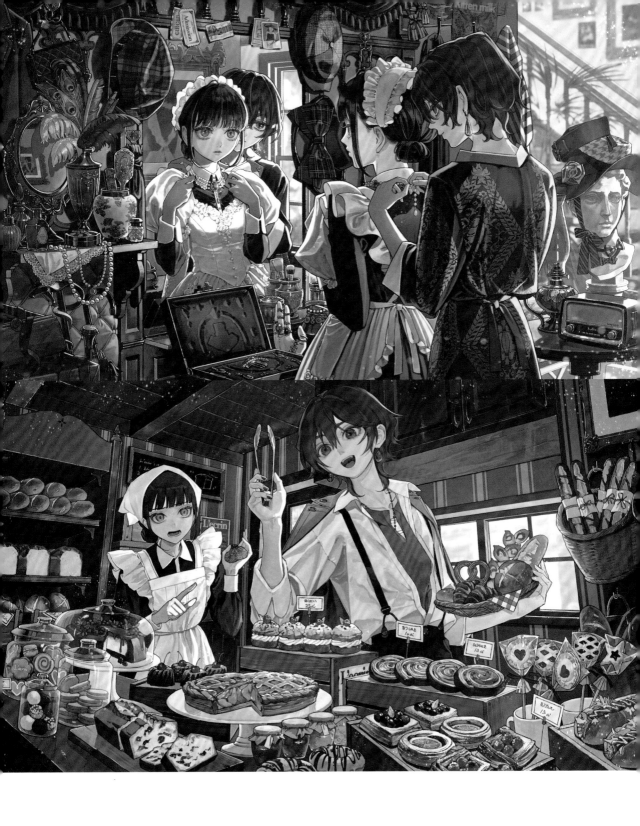

Devin Elle Kurtz

TWITTER DevinElleKurtz **URL** https://www.devinellekurtz.com/

TOOLS Photoshop CC / Wacom Cintiq Pro 24

PROFILE Likes drawing fantasy artwork that imparts a sense of mystery, making you feel like when you were a kid and there was magic in everything.

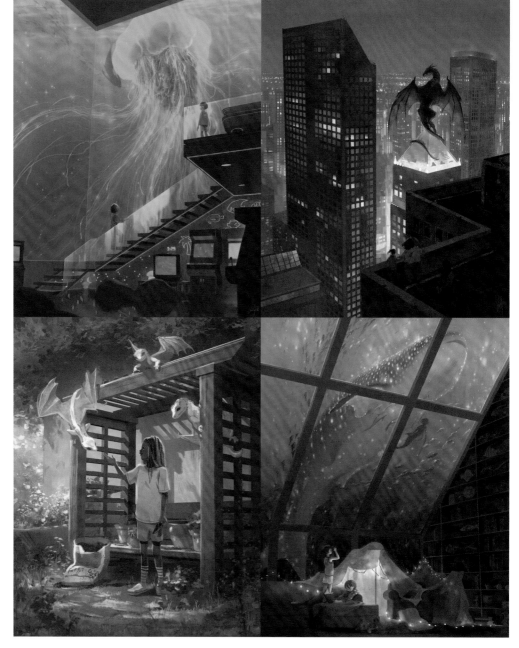

1	2	5
3	4	6

TITLE **1** Jellyfish Arcade / 2020 **2** The Local Dragon / 2021 **3** The Garden Dragons / 2021 **4** The Research Outpost / 2021 **5** The Observatory / 2021 **6** Hallway / 2020 all original works

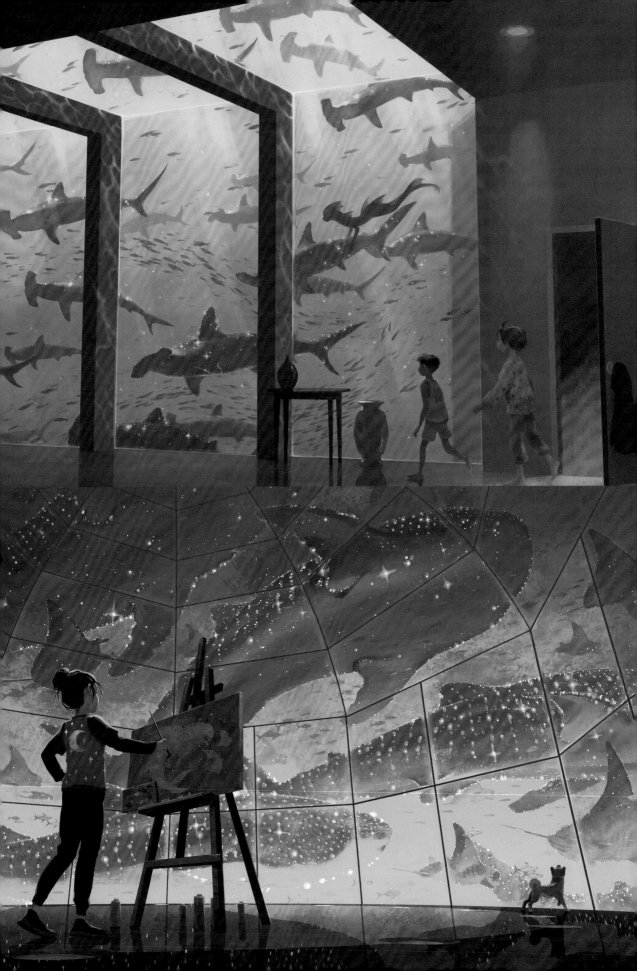

DSmile DSマイル

TWITTER DSmile9 **E-MAIL** mkt.dsmile@gmail.com

TOOLS SAI / CLIP STUDIO PAINT / Wacom Intuos Pro

PROFILE From Korea. Works on character designs, etc., for books and social network games. Has published an artbook, *Dear Smile*, and a how-to book, *Let's Make ★ Character: CG Illustration Techniques Vol. 10* (BNN).

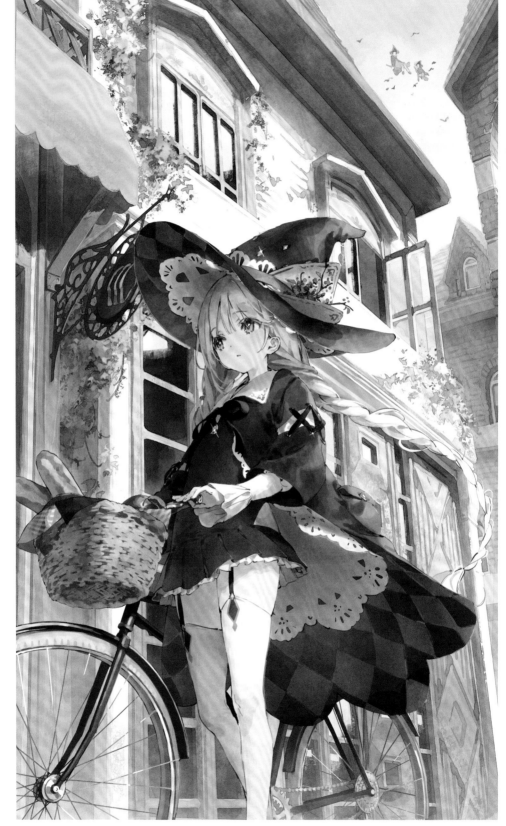

1	2	
	3	4

TITLE **1** Town Where Witches Live／original／2021 **2** I Guess I Grew Wings／original／2020 **3** Dear Smile／cover illustration of *Dear Smile: DSmile Illustration Book* (BNN)／2022 **4** Taiwan Girl／9-Tensha／2022

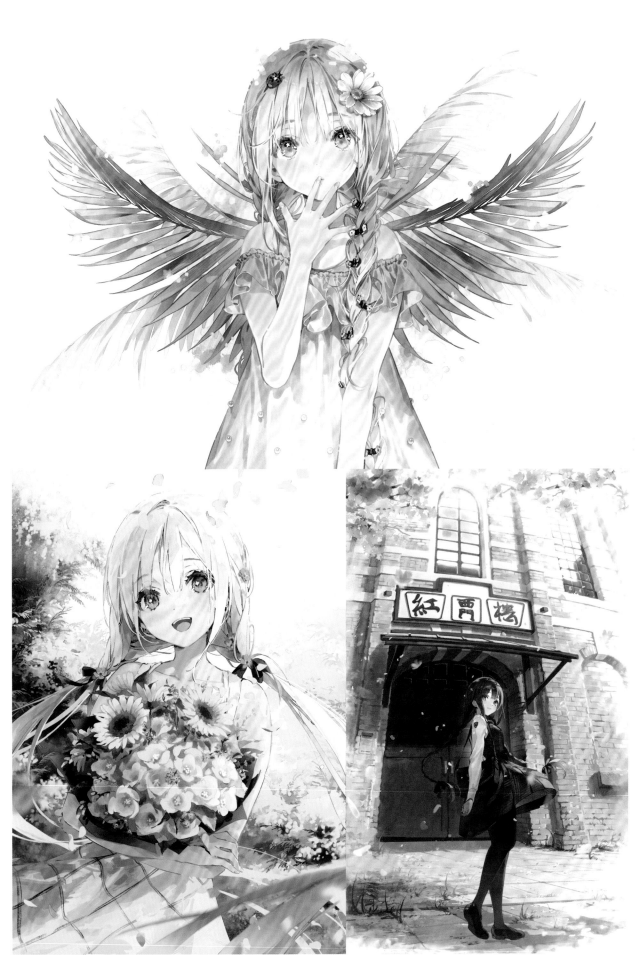

edoya inu8 江戸屋犬八

TWITTER neko_cer E-MAIL i_n_u_8@yahoo.co.jp
TOOLS SAI2 / CLIP STUDIO PAINT / Wacom Intuos
PROFILE Strong point: enthusiasm.

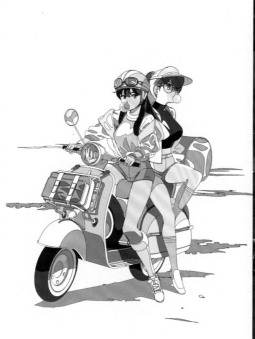

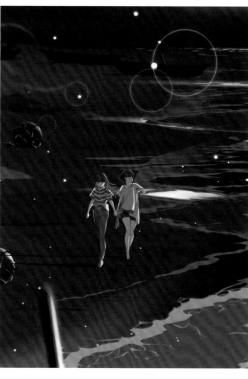

TITLE 1 0001 / pixiv Comic 10th anniversary illustration **2** 0005 / original **3** 0008 / original **4** 0006 / original
all created in 2022

ELIOLI

TWITTER EliOLiart **URL** https://www.elioliart.net/

TOOLS Photoshop CS6 / Procreate / Wacom / XP-Pen Tablet

PROFILE Our names are Elena and Olivia Ceballos, and we're twin sisters who love to draw. We love creating scenes that express all kinds of interesting moods, colors, emotions, and situations. We hope you will feel something special from our art.

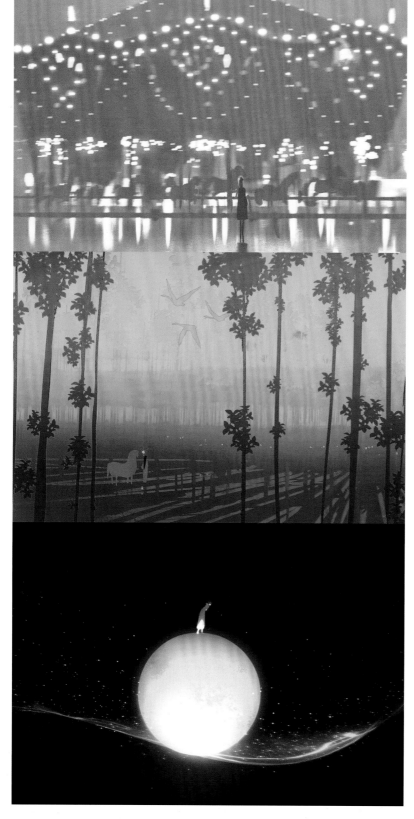

1		
2	4	5
3	6	7

TITLE **1** Carousel / 2022 **2** Lantern In the Night / 2021 **3** Yellow Moon / 2022 **4** Let's Go / 2019 **5** Nothing More Nothing Less / 2021 **6** LookThrough / 2021 **7** Over Looking the Marsh / 2021 all original works

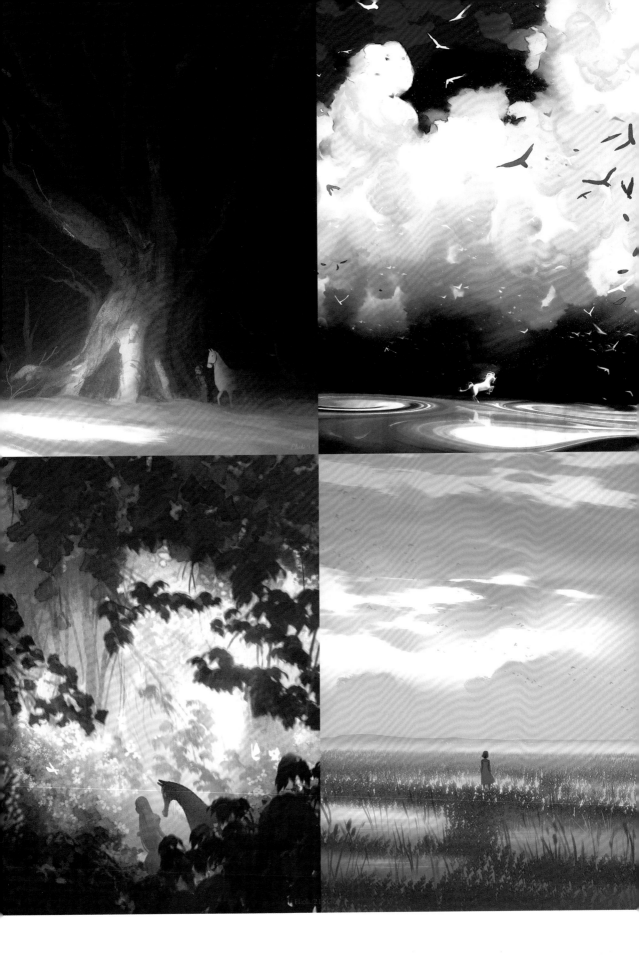

fuzichoco 藤ちょこ

TWITTER　fuzichoco　**E-MAIL**　fuzichoko@yahoo.co.jp

TOOLS　CLIP STUDIO PAINT PRO / openCanvas7 / Wacom Cintiq 24HD / Wacom Intuos5

PROFILE　Illustrator from Chiba Prefecture now living in Saitama Prefecture. Works include the main visual for Magical Mirai 2020 and character designs for Lize Helesta and Amairo Kitsunegasaki: Two artbooks, *Fuzichoco Artbook: The World of Gokusai Girl* (BNN), and *Saigenkyou* (Genkosha) are on sale now.

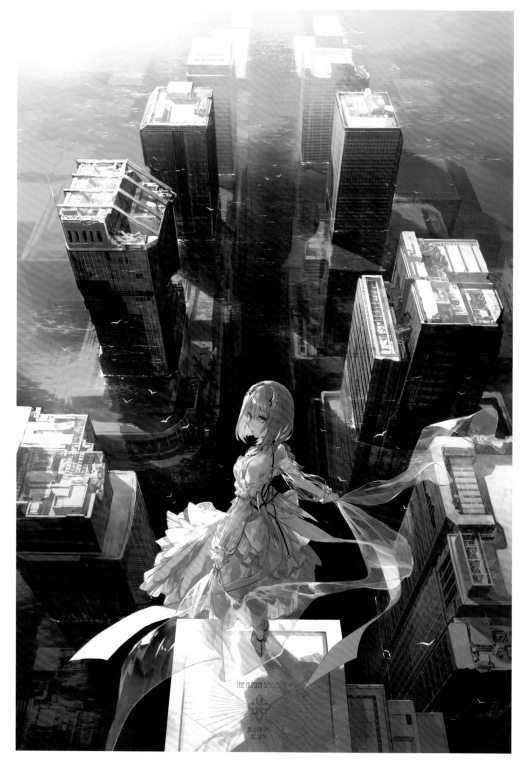

TITLE　**1** Drowned City／2022　**2** Tasty Breakfast／2021　**3** Daydream／2021　**4** Sky Egg／2021　all original works

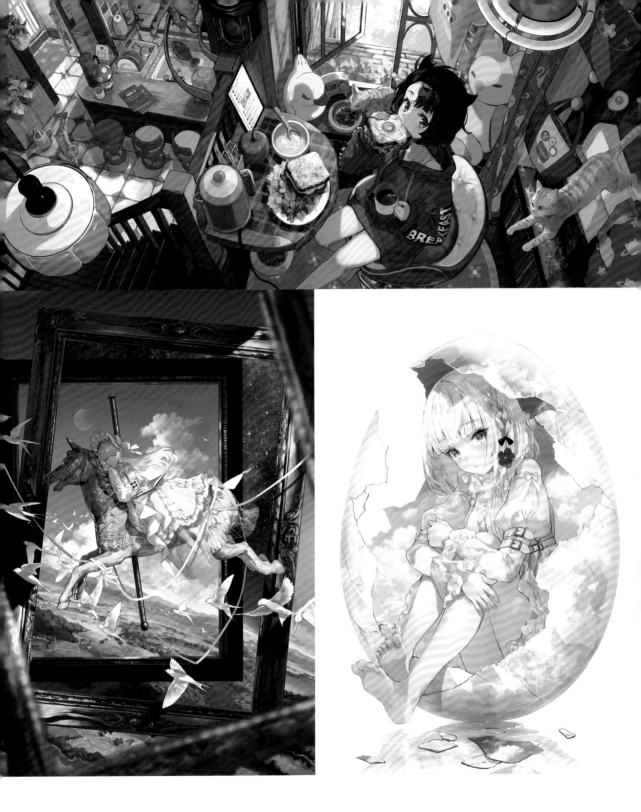

gensuke ゲン助

TWITTER genskc
TOOLS SAI / CLIP STUDIO PAINT / Wacom Intuos
PROFILE Lives in Niigata Prefecture. Mainly draws backgrounds. Wants to draw art that gives you a real feeling of the air and sounds depicted in it.

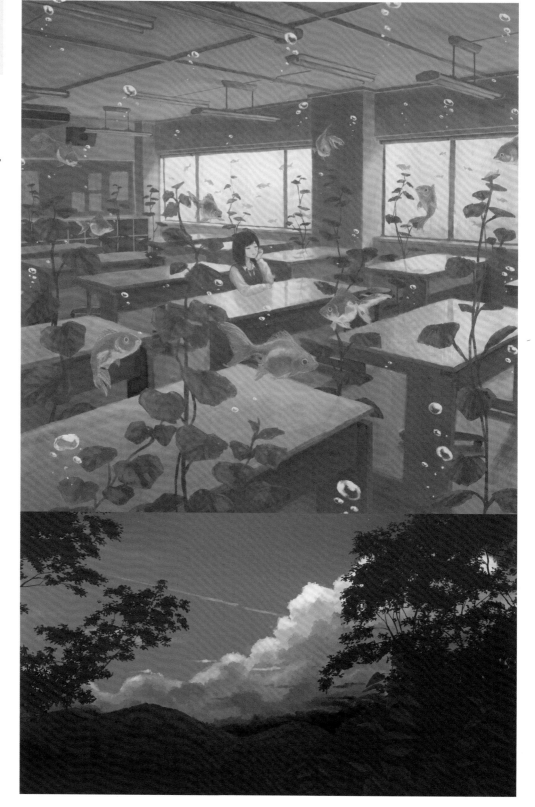

1	3	
2	4	5

TITLE 1 Breath / 2021 **2** Should Go Home Soon / 2020 **3** Snowlit Night / 2022 **4** Ribbit Ribbit Ribbit / 2022 **5** Finite Wings / 2022 all original works

 VISIONS 2023 ILLUSTRATORS BOOK supervised by pixiv

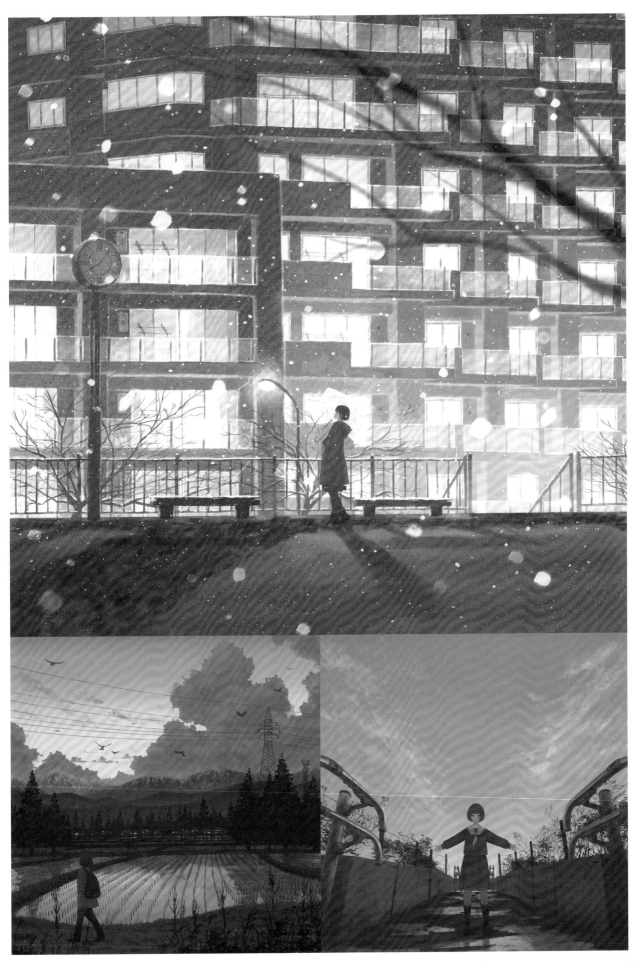

GODTAIL

INSTAGRAM godtail777 **E-MAIL** godtail777@gmail.com

TOOLS CLIP STUDIO PAINT / Wacom

PROFILE
Representative director of GODTAIL Corporation. Creates illustrations, character designs, manga, and movies. Works are many and include the concept art for *Lincoln* (TBS), *Zakuri TV* provided by au, Nissin Chicken Ramen's Akuma no Butter Corn promotion, the PV anime for *The City in the Deep Sea* by Yumi Matsutoya, and design work for *Pokémon Brilliant Diamond* and *Pokémon Shining Pearl*. Others are listed on the website.

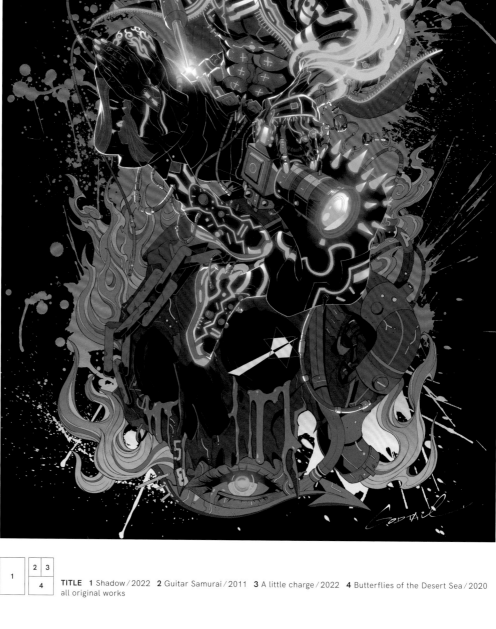

1	2	3
	4	

TITLE **1** Shadow／2022 **2** Guitar Samurai／2011 **3** A little charge／2022 **4** Butterflies of the Desert Sea／2020
all original works

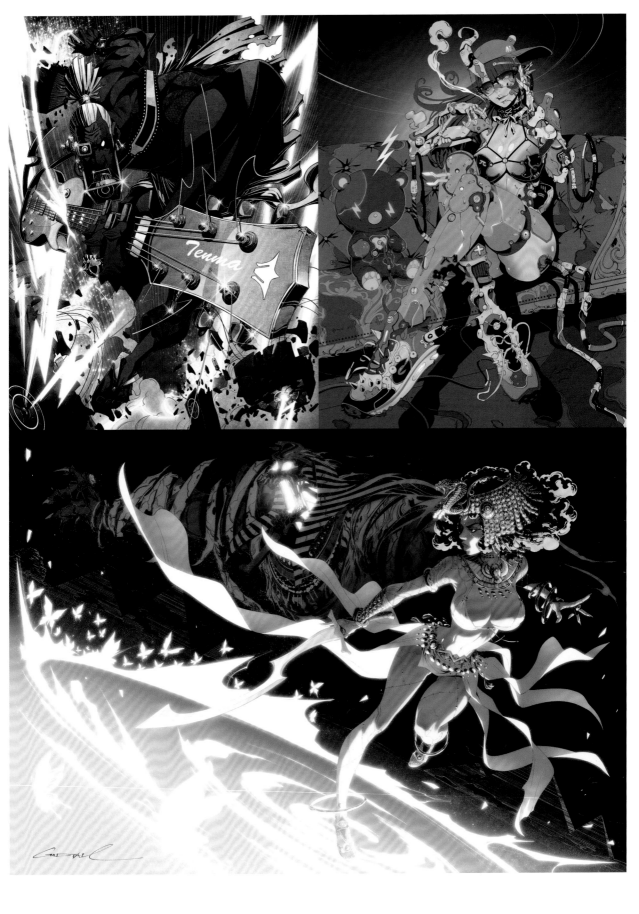

Gong_Gong 꿍꿍

TWITTER / INSTAGRAM O————O———O————O E-MAIL gong-gong.00kr@gmail.com

TOOLS iPad / Procreate

PROFILE Creates original works mainly themed around summer. Captures the feel of analog media through digital means.

TITLE 1 Derailed **2** Walk on the Night Sea **3** Worries Big and Small **4** Heat all original works created in 2021

Gurin.

INSTAGRAM guringurin28
TOOLS Procreate / CLIP STUDIO PAINT / MediBang Paint / iPad Pro
PROFILE
E-MAIL guurin.28@gmail.com

Illustrator living in Kanagawa Prefecture, born in 1996. Works on key visuals, music video illustrations, merchandise designs, and more.

1	2	5
3	4	

TITLE 1 Ghostly Girl (Peach) / 2022 **2** Ghostly Girl (Azure) / 2022 **3** Where's the Mint Chocolate Chip!? / 2021 **4** TEL / 2021 **5** Watching TV / 2022 all original works

hamunezuko はむねずこ

TWITTER nezukonezu32 **E-MAIL** hamunezuko@gmail.com

TOOLS ibisPaint X / iPad Pro

PROFILE Likes girls with a touch of darkness.

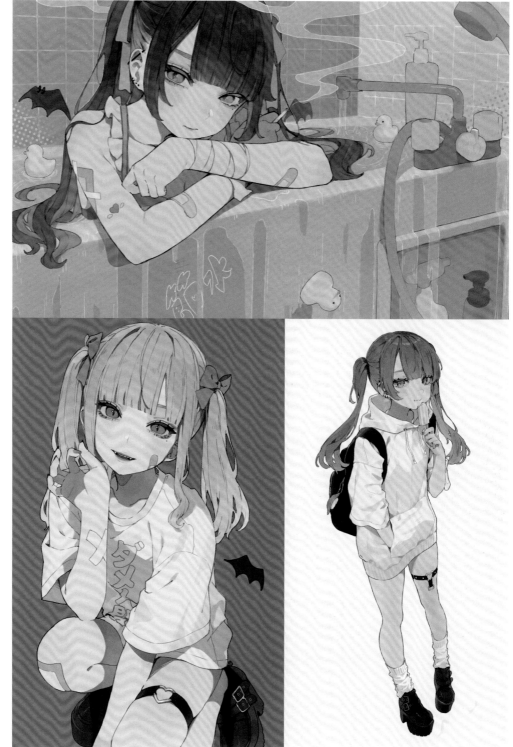

TITLE 1 I'm Tired (*tub:* save water) / 2022 **2** Meow (*shirt:* failure) / 2022 **3** Good Ice Pop / 2022 **4** How Far Will I Go Today? (*signs:* Emergency Button / In case of emergency press and hold the button above until you hear a buzz. After using, immediately contact the number below. Using this button outside of emergency situations will result in a fine.) / 2021 all original works

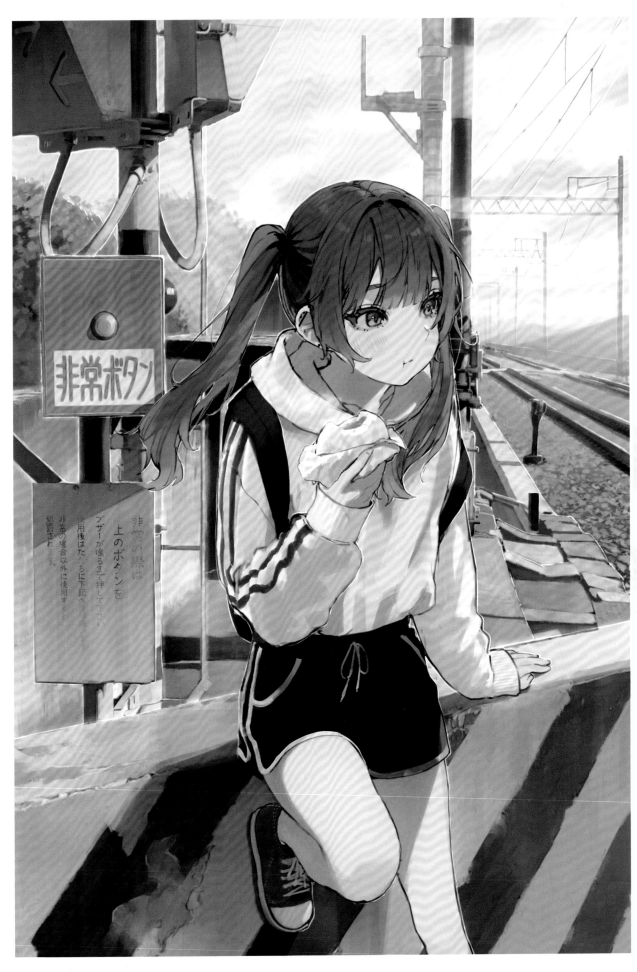

Happi_115

TWITTER happi_115 **E-MAIL** happi11555@gmail.com

TOOLS Procreate / Photoshop / iPad Pro

PROFILE Chinese illustrator and designer born in 2000, now living in Australia. Loves rabbits and cute retro stuff. Goal is to brighten people's days with fun, unique designs that make you feel nostalgic and playful. Creates surreal art based on items fondly remembered from the past and dreams.

1	3	
2	4	5

TITLE **1** Bubble Dart **2** Lonely Dream **3** Sky **4** Candyball Exe **5** Escape the halls
all original works created in 2022

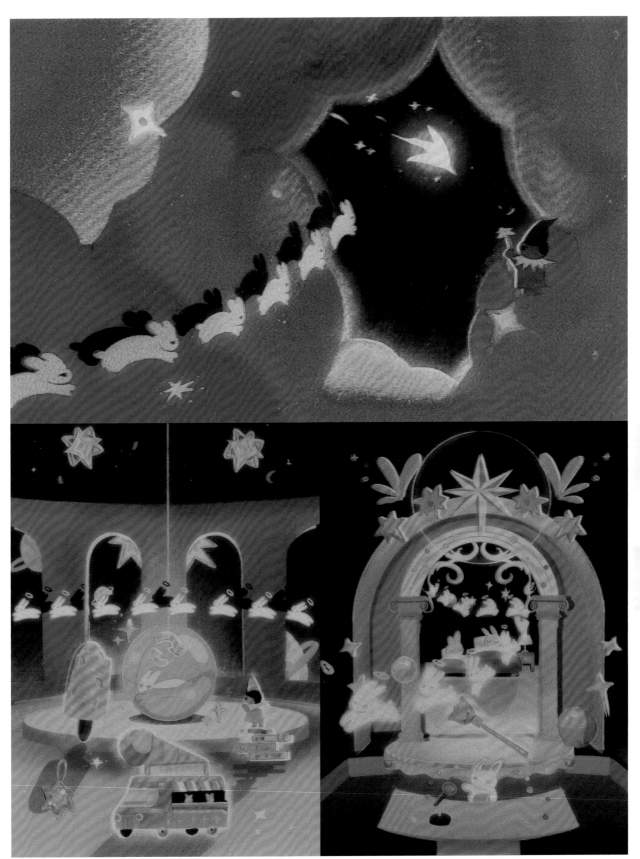

houtei9

河底9

TWITTER hotelblender **E-MAIL** hotei7739@gmail.com

TOOLS Photoshop / Blender / Zbrush / Wacom Cintiq 16 / iPad Pro

PROFILE Born in 2003 in Hyogo Prefecture, now lives in Tokyo. Goes for a feeling of "creation" in visuals when making illustrations. Has always liked drawing, and now produces art using 3DCG and simulations to express what drawing alone can't accomplish.

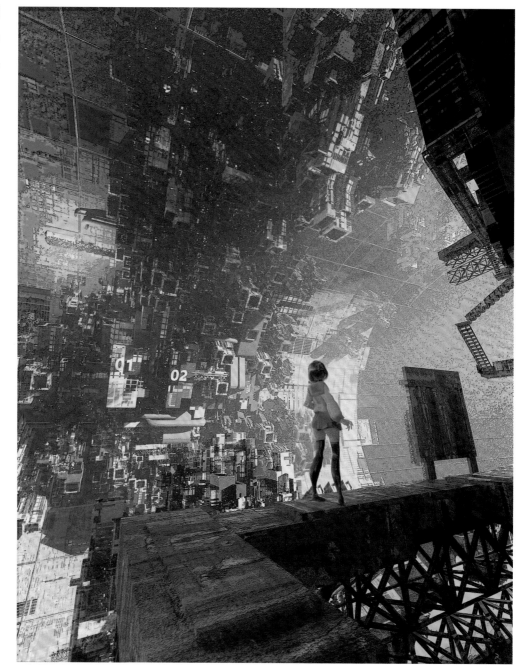

TITLE **1** Those Who Live Here Don't Know of the Land or the Sea **2** Invitation
all original works created in 2022

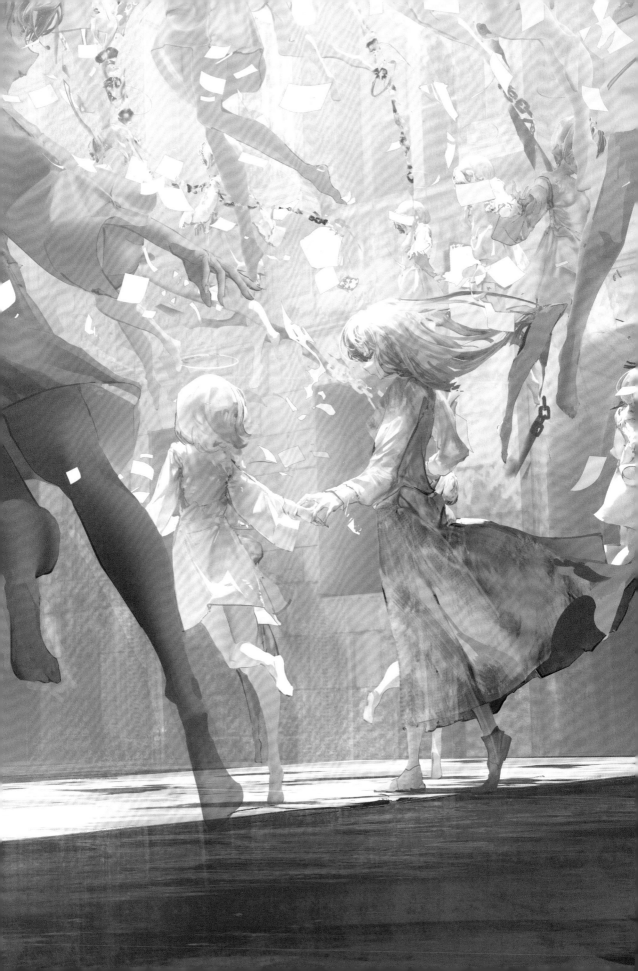

HYOGONOSUKE ヒョーゴノスケ

TWITTER hyogonosuke **E-MAIL** hyo_gonosuke@hotmail.com
TOOLS Photoshop / Wacom Intuos
PROFILE Illustrator from Hiroshima Prefecture, now living in Tokyo. Working on picture books. Has provided cover images and insert illustrations for several works, including the Japanese editions of the *Scream Street* book series (Kaiseisha) and the *Code Busters Club* series (KADOKAWA). Currently publishing a series of picture books based on Japanese folk tales (Mynavi Publishing).

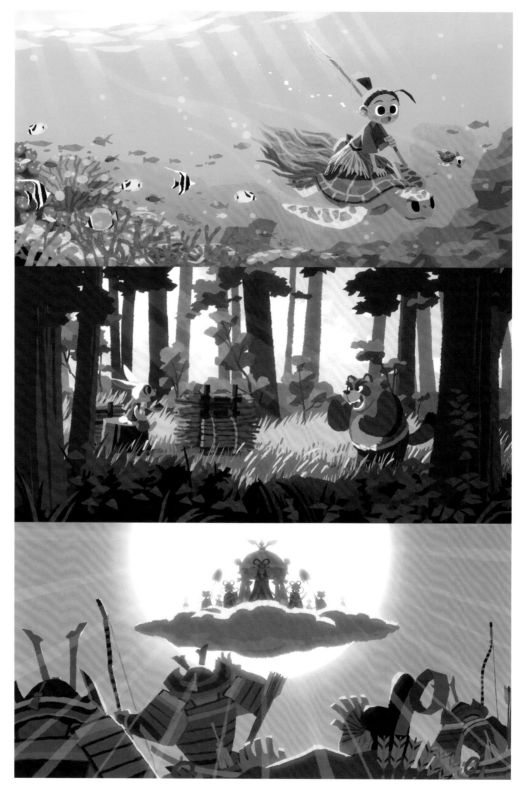

pixiv user ID : 75814

1	4
2	5
3	6

TITLE **1** From the picture book *Urashima Tarou* / Mynavi Publishing / 2022 **2** From the picture book *Kachi-kachi Yama* / Mynavi Publishing / 2022 **3** From the picture book *Kaguya-hime* / Mynavi Publishing / 2021 **4** From the picture book *Momotarou* / Mynavi Publishing / 2021 **5** From the picture book *Momotarou* / Mynavi Publishing / 2021 **6** From the picture book *Kachi-kachi Yama* / Mynavi Publishing / 2022

ico 衣湖

TWITTER Aoiro_no_ame_

E-MAIL ico.aoirono.ame@gmail.com

TOOLS ibisPaint X / iPad

PROFILE
Digital artist. Specializes in both Eastern and Western fantasy, portraying feelings of sorrow. Likes dignified girls and lights in darkness.

1	2	
3		4

TITLE **1** Empty / 2022 **2** Reincarnation / 2022 **3** Flower Seller / 2021 **4** Child of Heaven / 2021
all original works

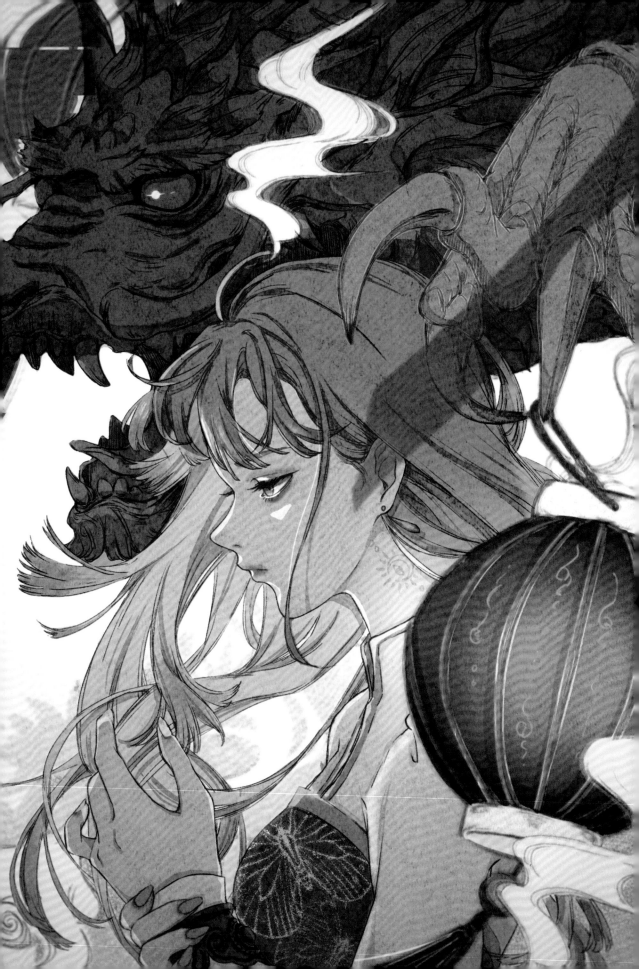

INPLICK

INSTAGRAM inplick **E-MAIL** inplick@naver.com

TOOLS CLIP STUDIO PAINT / Wacom Bamboo CTL-470

PROFILE Hello. I'm INPLICK, an illustrator. I mainly draw boy characters. My major works include the character designs and main poster for the animation *Link Click*.

| 1 | 2 |

TITLE 1 JELLYFISH / 2021 **2** LEO / 2022 all original works

ISHIDA UMI

TWITTER uminonaka0x0

TOOLS CLIP STUDIO PAINT / Wacom

PROFILE I like the sea.

TITLE **1** Humpty Dumpty **2** Squish. **3** Harvest **4** Friend **5** New Pet all original works created in 2022

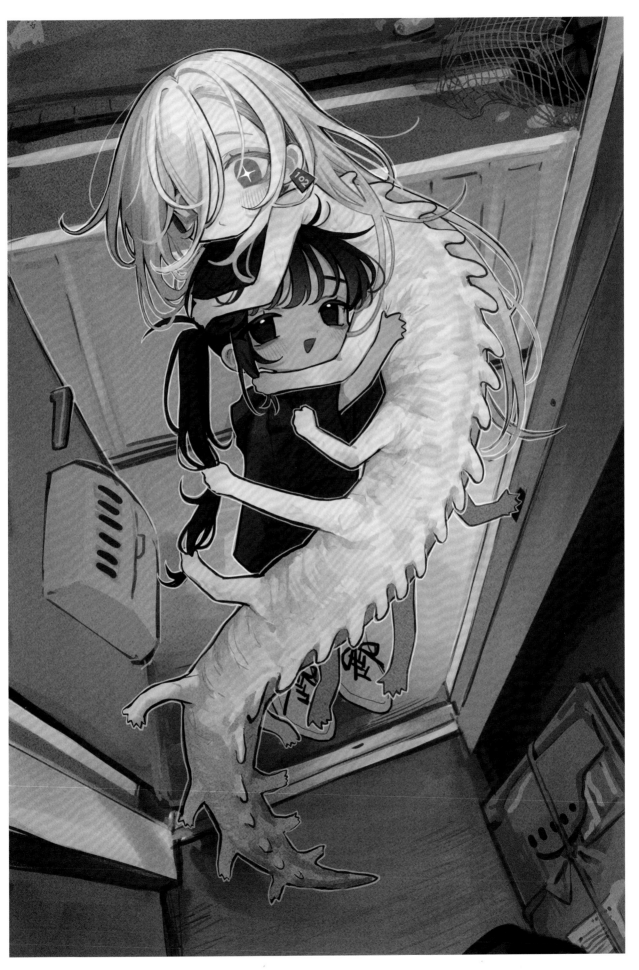

Itai 痛

TWITTER Alphaitai **E-MAIL** alphaitai@qq.com

TOOLS CLIP STUDIO PAINT / Wacom One

PROFILE Martian who likes fantasy illustrations and wants to build original worlds through art.

TITLE **1** Shelter／2020 **2** Sage／2021 **3** Quartz／2021 **4** Witch's Room／2022 **5** Systina／2021 **6** Naraku／2021 all original works

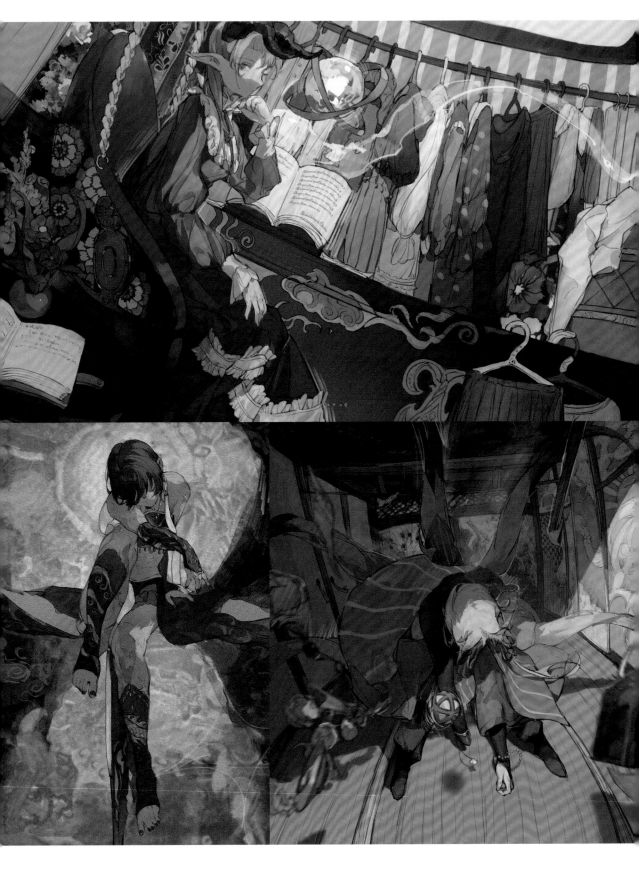

itami あたみ

TWITTER itami_gomi **E-MAIL** gomiartbox@gmail.com

TOOLS CLIP STUDIO PAINT / XP-Pen Deco mini7W

PROFILE Likes objects and backgrounds and cats.

1	3
	4
2	5

TITLE **1** Su...Summer / 2022 **2** Hot Summer Day (*signs: (blue)* to summer / *(purple)* endless festival / *(yellow)* careful of summer colds) / 2021 **3** Motif / 2021 **4** Nap / 2021 **5** Deserted Station (*signs:* reality) / 2021 all original works

JAZ 渣子

TWITTER jaaaaz_____
TOOLS Photoshop / Blender / Wacom Intuos4
PROFILE Likes salmon, religion, and soft vinyl toys!

E-MAIL jajako52@gmail.com

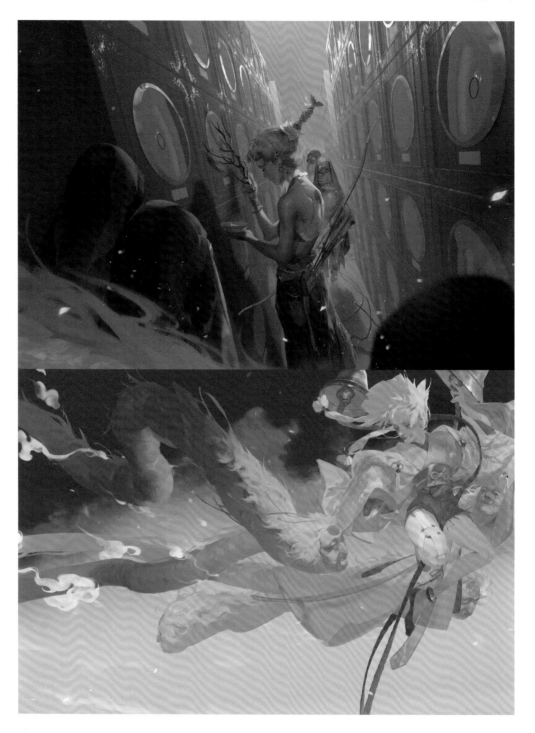

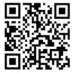

1	3	4
2	5	6

TITLE 1 Buried / 2022　2 Link these days / 2020　3 I was blind and then took poison / 2021　4 Scorching sun / 2020　5 Said goodbye in my dream / 2021　6 Claim your life / 2021　all original works

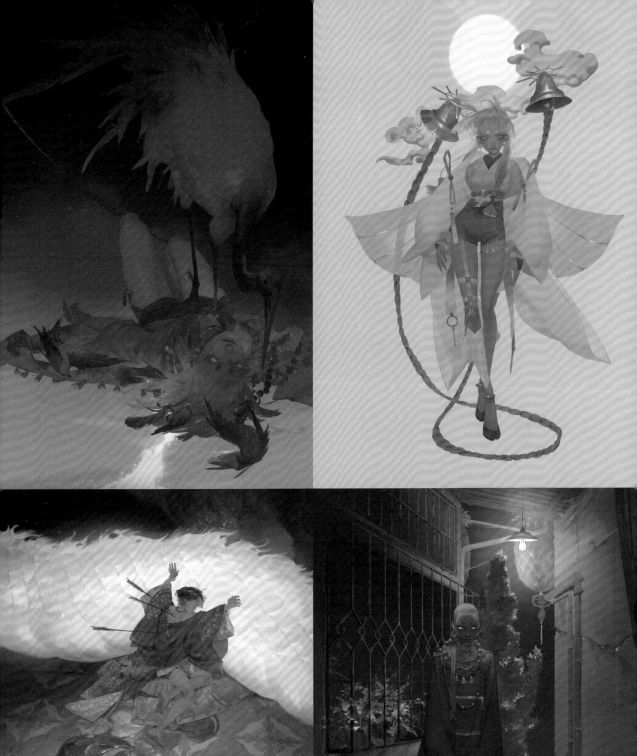
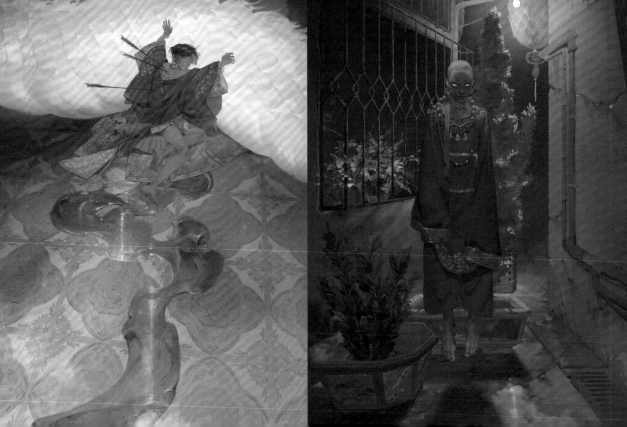

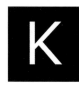

JINKEI 神麗

TWITTER jinkei_bunny **URL** www.jinkei-bunny.com

TOOLS CLIP STUDIO PAINT / Wacom MobileStudio Pro

PROFILE Freelance illustrator. Works include *How to Draw a Man with Glasses* (Genkosha et al) and the design of Amamiya Kei from the VTuber agency Nekonote.

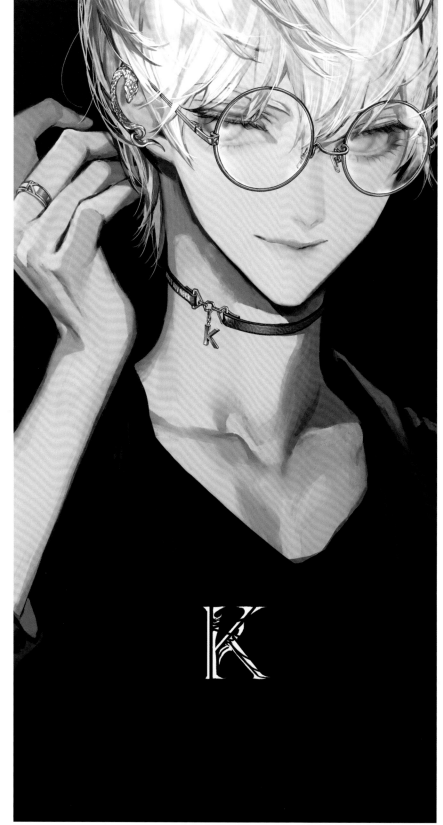

| 1 | 2 |
| | 3 |

TITLE 1 K **2** M **3** what'up? all original works created in 2022

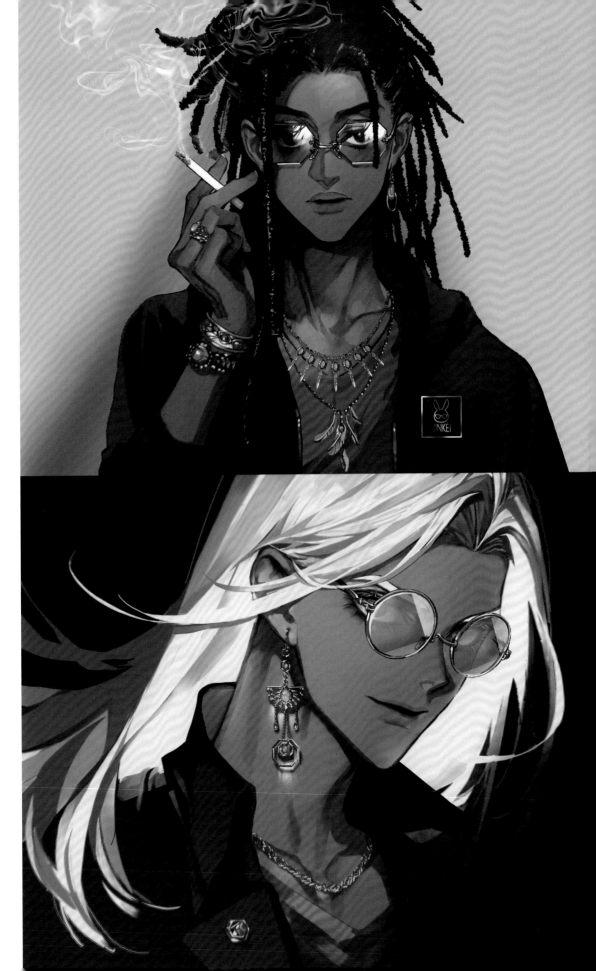

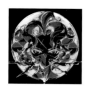

JNTHED ジェイエスティーヘッド

TWITTER JNTHED **URL** https://jnthed.fanbox.cc/

TOOLS Photoshop / Bamboo CTH670

PROFILE Promoter of #姫械帝国 (Empire of the Augmentia). Worked on mechanical designs for the TV anime Mobile Suit Gundam: The Witch From Mercury, mechanical designs for the TV anime Urusei Yatsura, and production design for Netflix's Spriggan.

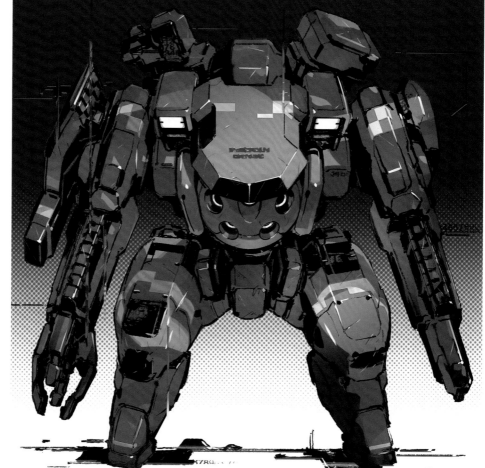

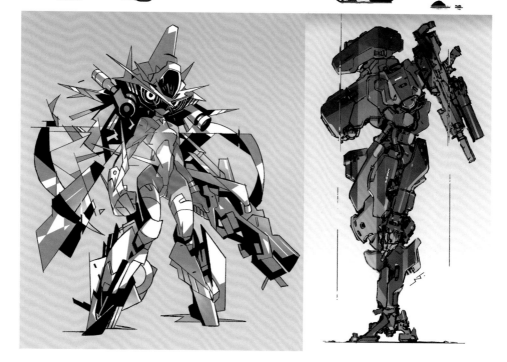

1		4	
2	3	5	6

TITLE 1 ADGBLACK / 2021 **2** ARMDROID Φ ABDIEL / 2022 **3** RIDEARMOR / 2022 **4** TORUS SPINDLE / 2021 **5** COWARMOR / 2021 **6** TRAFFIC LIGHTS / 2022 all original works

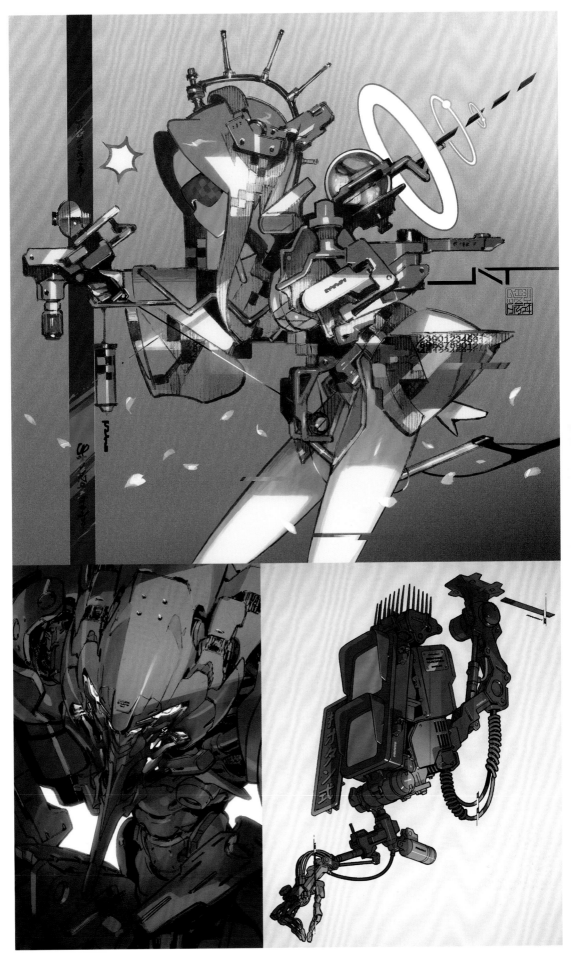

kaihara 恢原

TWITTER　Obscure_102sW　E-MAIL　sanguai86@gmail.com

TOOLS　Procreate / Photoshop / Oil Color / iPad

PROFILE　Born in 2000. Uses art to record originally-created children going on trips.

1	2
	3

TITLE　1 composition / 2021-2022　**2** Area of light / 2021-2022　**3** fetal sleep / 2022

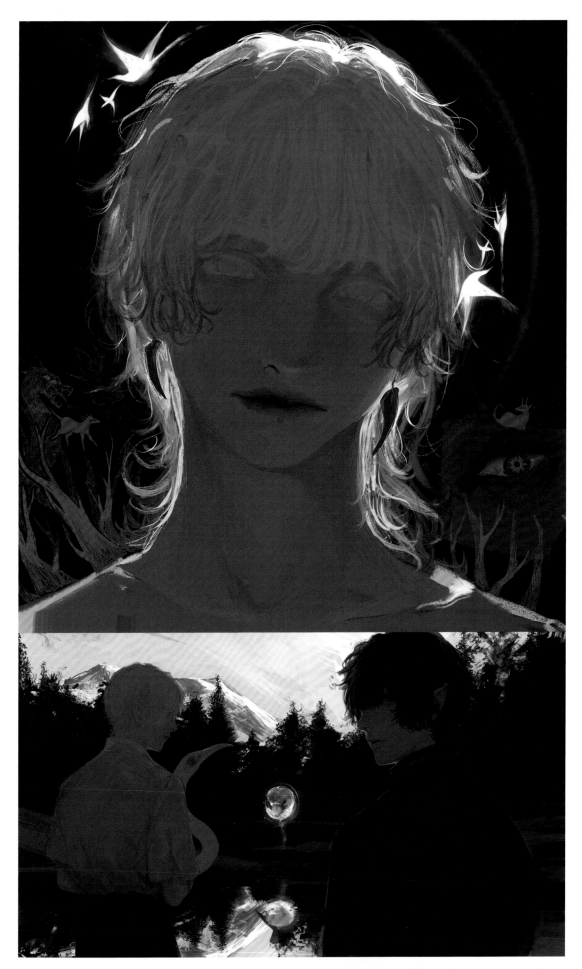

kamomira かもみら

TWITTER hc_feee **E-MAIL** kamomiland@gmail.com

TOOLS Procreate / iPad

PROFILE Born in 2001. From Hiroshima, lives in Hiroshima. Draws using both analog and digital methods.

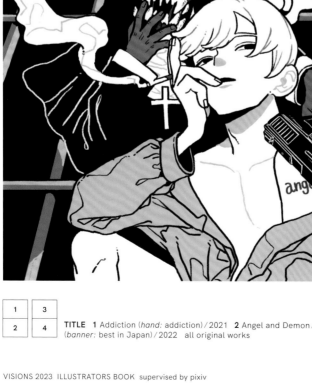

1	3
2	4

TITLE **1** Addiction (*hand:* addiction) / 2021 **2** Angel and Demon / 2021 **3** Watermelon / 2021 **4** Momotaro (*banner:* best in Japan) / 2022 all original works

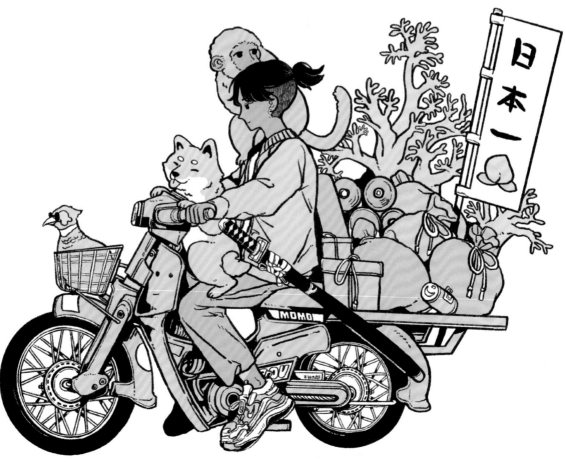

Kanekoshake かねこ鮭

TWITTER kanekoshake **E-MAIL** kanekoshake@yahoo.co.jp

TOOLS Procreate / dip pen / iPad Pro

PROFILE Illustrator from Hyogo Prefecture. Draws cute, comic-style characters and somewhat mysterious worlds. Loves video games.

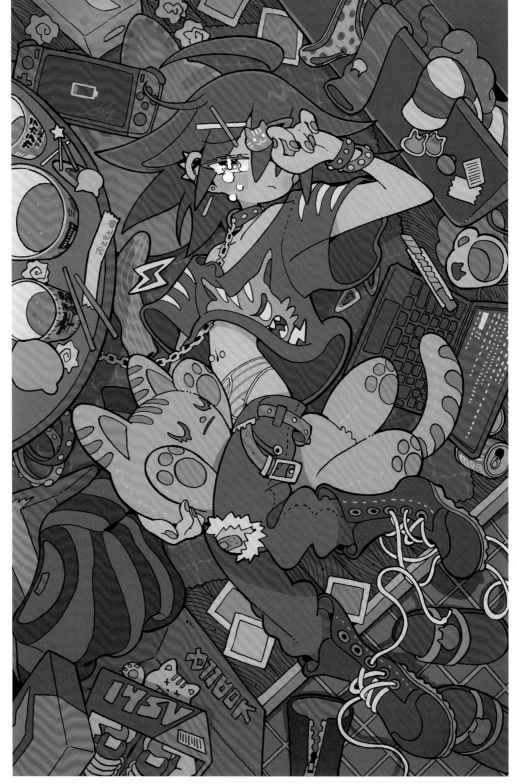

1	2	
	3	4

TITLE 1 Got Dumped (*packaging:* cup noodles / super spicy, super tasty / chopsticks) / 2021 **2** Where's the Train? (*signs:* (right) No smoking! (left) emergency button, train to — via —) / 2021 **3** I Want to Go to the Zoo A (*hat:* cat, *patch:* bear, *thermos:* cat, Rawr!) / 2022 **4** I Want to Go to the Zoo B / 2022 all original works

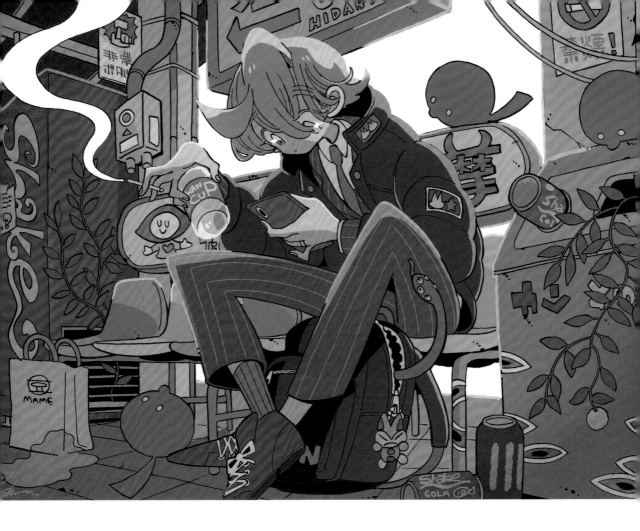

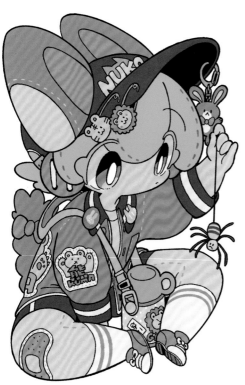

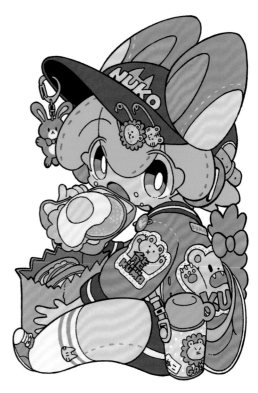

Kaneni

TWITTER WindOrche **E-MAIL** w.kaneni@gmail.com

TOOLS CLIP STUDIO PAINT / Wacom Cintiq

PROFILE From Hokkaido. Likes things with colors that pop and nostalgic feelings.

TITLE **1** Personal Space / 2022 **2** untitled / 2021 **3** Spring / 2022 **4** Shrine Maiden of the Sun / 2020
all original works

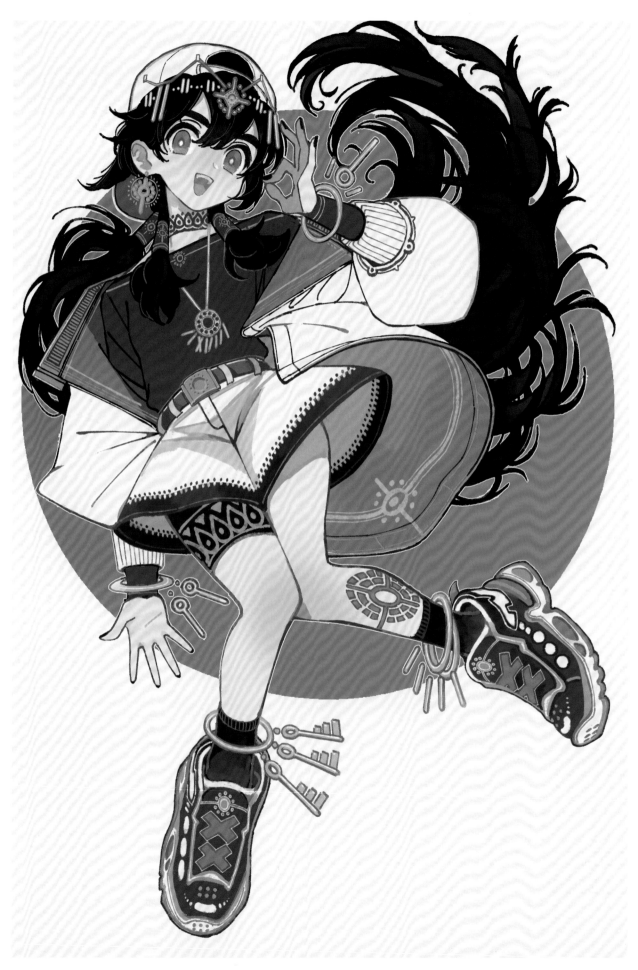

Kariya かりや

TWITTER KRY_aia **E-MAIL** kryaia0922@gmail.com

TOOLS Procreate / iPad Pro

PROFILE Animator and occasional illustrator. Worked on the title lettering and some animation for the NHK serial TV novel *Natsuzora* (*Summer Sky*). Worked on the character design, main visual, and illustrations for a Häagen-Dazs animated commercial. Working on PR poster illustrations for Kitakyushu's emigration promotion as well as illustrations for Shikoku Bank.

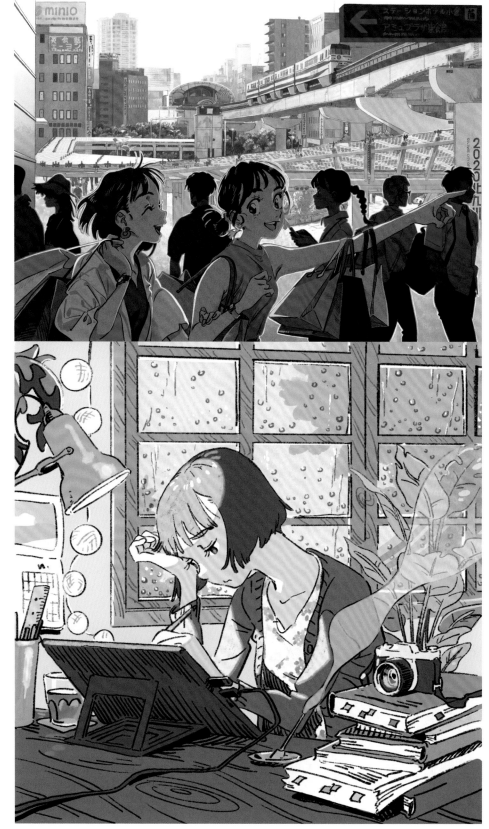

1	3
2	

TITLE 1 Kokura Station / Kitakyushu Emigration promotional PR poster illustration (*signs:* (left) Station Hotel Kokura, Amusement Plaza East Building (right) 2020 Kitakyushu) / 2021 **2** Migraine / original / 2022 **3** Working / QLEA Co. Ltd. recruitment advertisement poster illustration / 2022

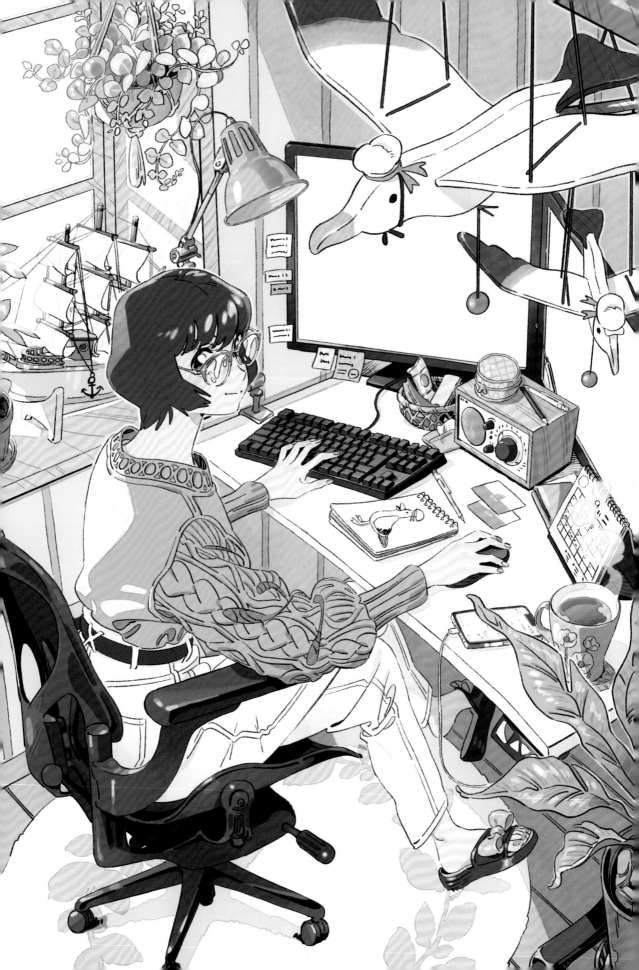

kawasemi 革蝉

TWITTER aozukikawasemi

TOOLS CLIP STUDIO PAINT / Procreate / iPad Pro / drawing tablet

E-MAIL aozukikawasemi@gmail.com

PROFILE Freelance illustrator, character designer, and animator. Worked on the music videos for "Seigi" by ZUTOMAYO as well as "FUTURE EVE" by sasakure.UK (feat. Hatsune Miku).

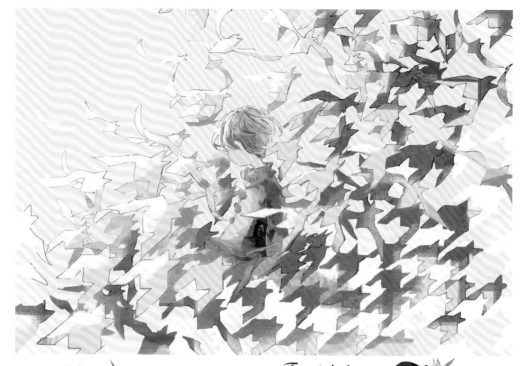

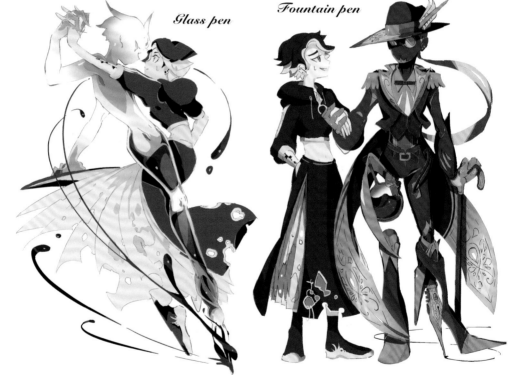

Glass pen

Fountain pen

1	3	4
2		5

TITLE 1 Field of a Thousand Checkered Birds (*note:* in Japanese, the word for the houndstooth pattern is chidori, which literally means thousand birds) / original / 2019 **2** Glass Pen and Ballpoint Pen / original / 2021 **3** People and the Rainy Season / original / 2021 **4** Hydrangeas / original / 2021 **5** Kafuka / song illustration for sasakure.UK / 2021

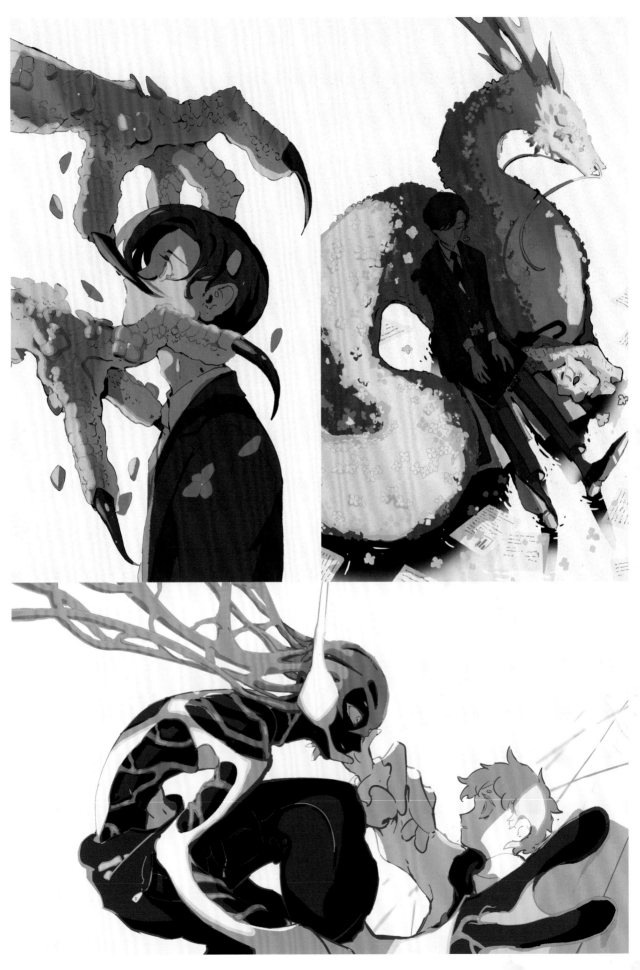

Kayuka かゆか

TWITTER 17_s_kyk **E-MAIL** 17.s.kyk@gmail.com

TOOLS CLIP STUDIO PAINT EX / iPad Pro

PROFILE Started working after the release of "Shikabanese" by jon-YAKITORY feat. Ado (2020). Major works include the character design, jacket illustration, and music video illustrations for Ado's "Odo" (2021) as well as the cover illustration for *Bad Boys Illustration* (PIE International). Mainly produces Vocaloid music video illustrations. Gets told a lot that said illustrations have a lot of impact.

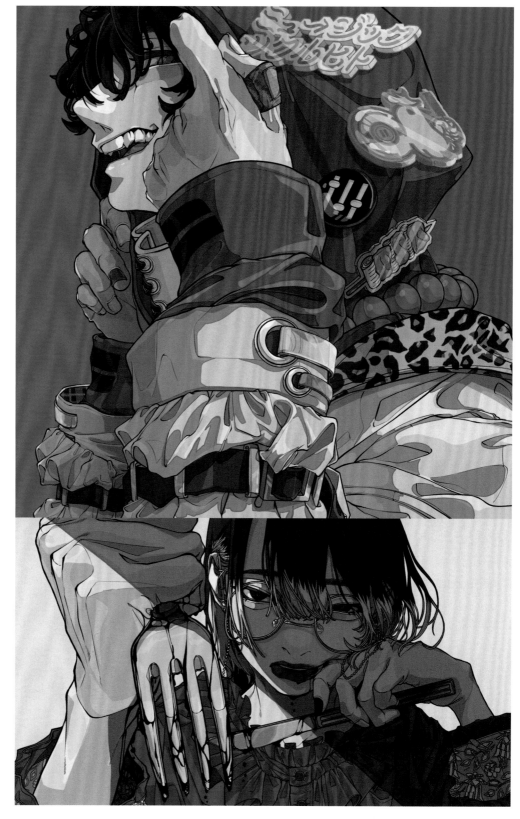

1	3
	4
2	5

TITLE **1** Profile Illustration / jon-YAKITORY / 2021 **2** Music video and cover illustration for "Eat" by jon-YAKITORY feat. Ado / jon-YAKITORY / 2020 **3** Jacket illustration for Ado's "Odo x Odo (Bon-Odo Remix)" / Universal Music / 2021 **4** Music video and cover illustration for "ONI" by jon-YAKITORY + Hatsune Miku / 2021 **5** Music video and cover illustration for "ONI" by jon-YAKITORY feat. Shiyui / Assistance: Sony Music Labels, Inc. / 2021

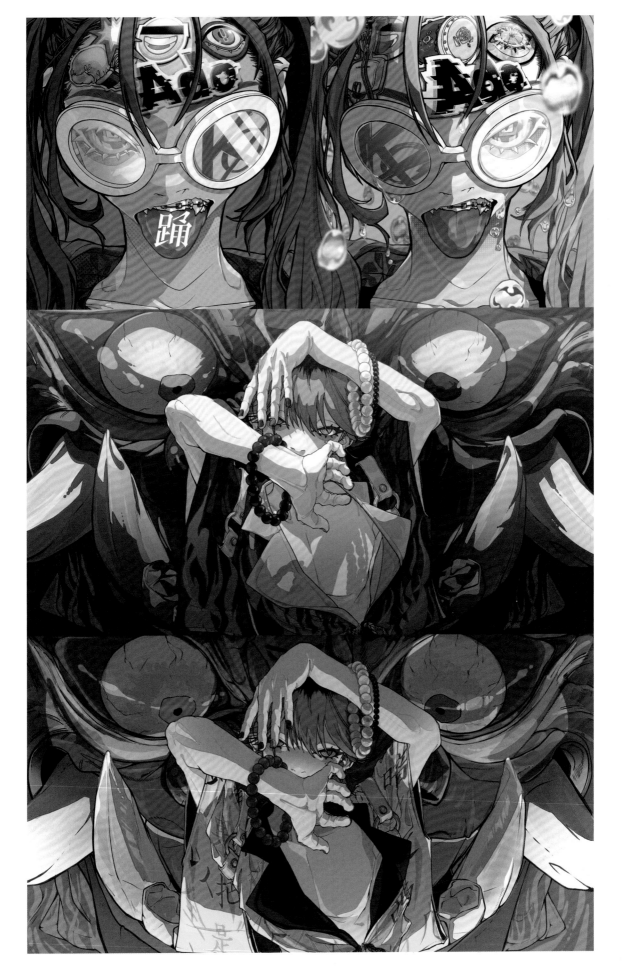

Keiko 慧子

TWITTER um7/mr1　**E-MAIL** kkokeiko2@gmail.com

TOOLS SAI2 / CLIP STUDIO PAINT / Huion

PROFILE Works on book covers and illustrations for videos and advertisements. Currently creating original works featuring women who are attentive down to their fingernails.

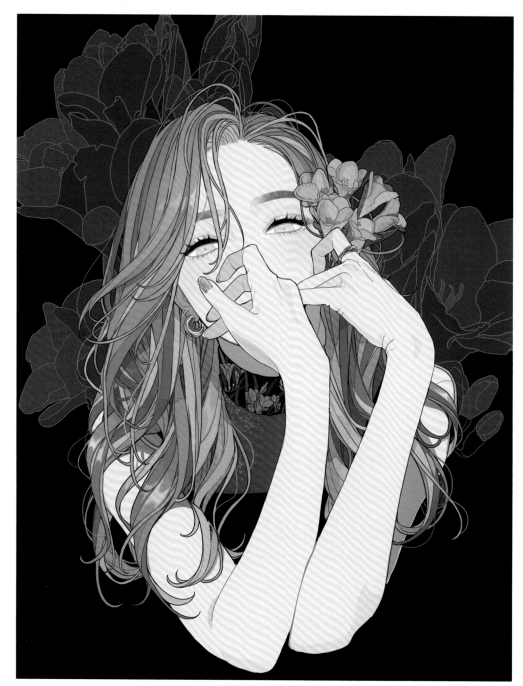

TITLE 1 Freesia **2** Sunflower　all original works created in 2022

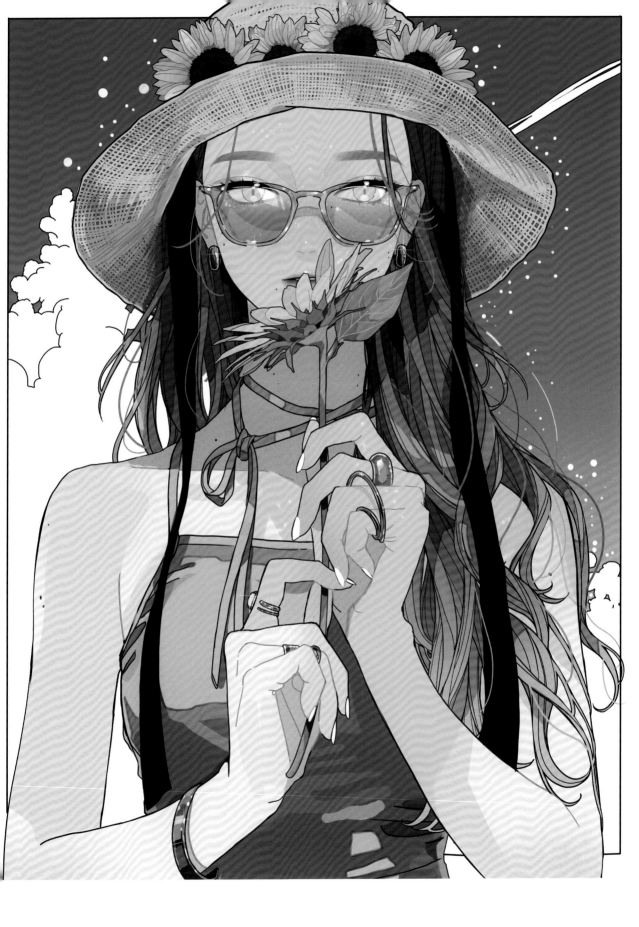

Kenharu けんはる

TWITTER harukenharu **E-MAIL** harukenharu223@gmail.com

TOOLS CLIP STUDIO PAINT / Wacom Intuos

PROFILE Born in 1999. Currently studying at Musashino Art University. Creates original works intended to tell stories.

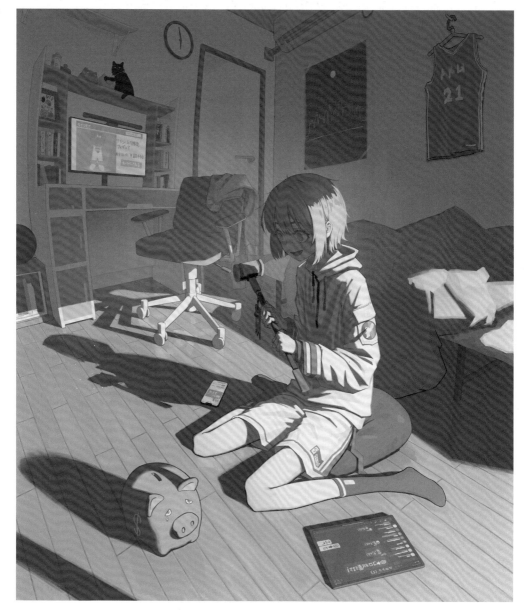

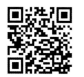

1	2
	3

TITLE **1** Had to betray a good friend to buy limited merch (*screen:* signed limited-edition figure / retail price ¥88,440) **2** Dreaming (*desk:* die / stay away from school / Get lost! / fatso / die / Beat it, tubby! *chair:* Dear fatso, You're so grooooss! You literal piece of shit! *locker:* Die.) **3** Washing blood with blood all original works created in 2022

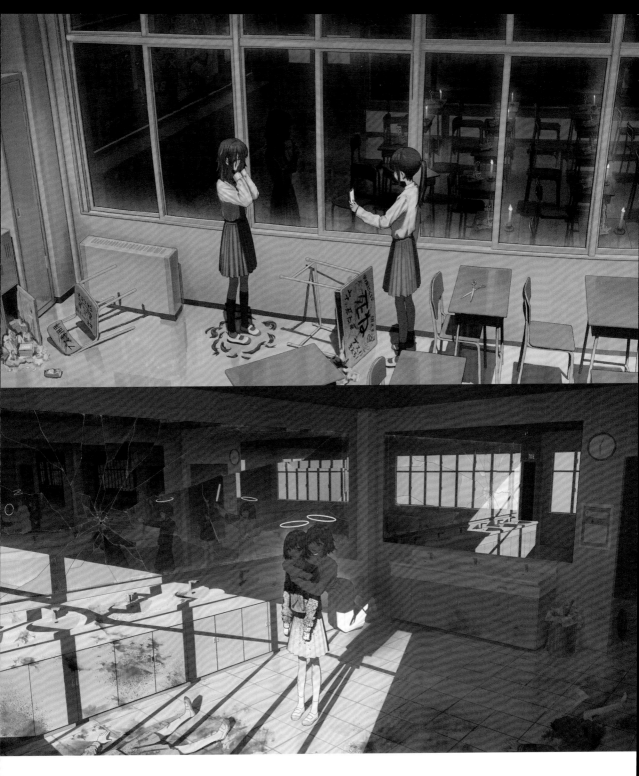

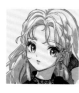

Kisumi Rei 木澄玲生

TWITTER kisumirei41 **E-MAIL** ksmrei1206@gmail.com

TOOLS CLIP STUDIO PAINT / Wacom Intuos Pro

PROFILE Born in 1998. From Kagoshima Prefecture. Illustrator and designer. Likes clothing designed for special occasions and magic. Worked on the cover song video illustrations for KAMITSUBAKI STUDIO's KAF feat. KAFU and the jacket illustration for DEN-ON-BU's "Eat Sleep Dance (feat. Moe Shop)."

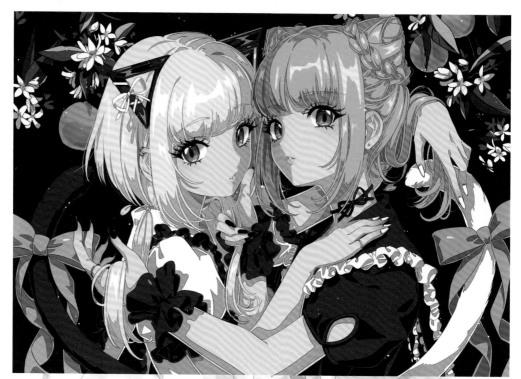

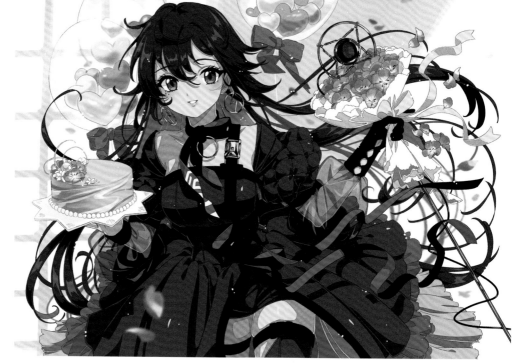

TITLE **1** "Cat Loving" cover by KAF feat. KAFU / KAMITSUBAKI STUDIO / 2022 **2** 1st Anniversary Congratulations / KAMITSUBAKI STUDIO / 2021 **3** Wired Over Wireless / original / 2020

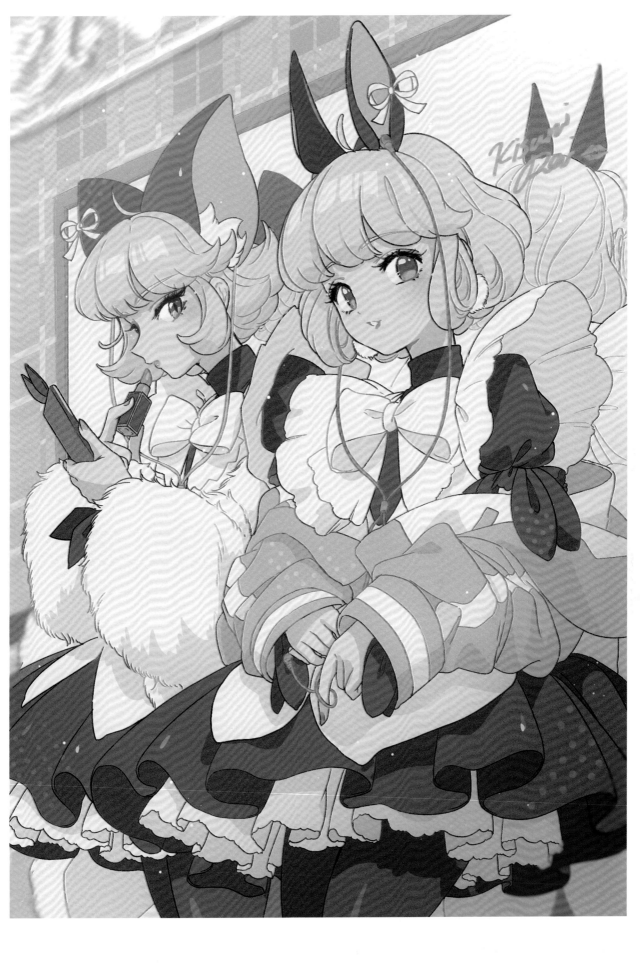

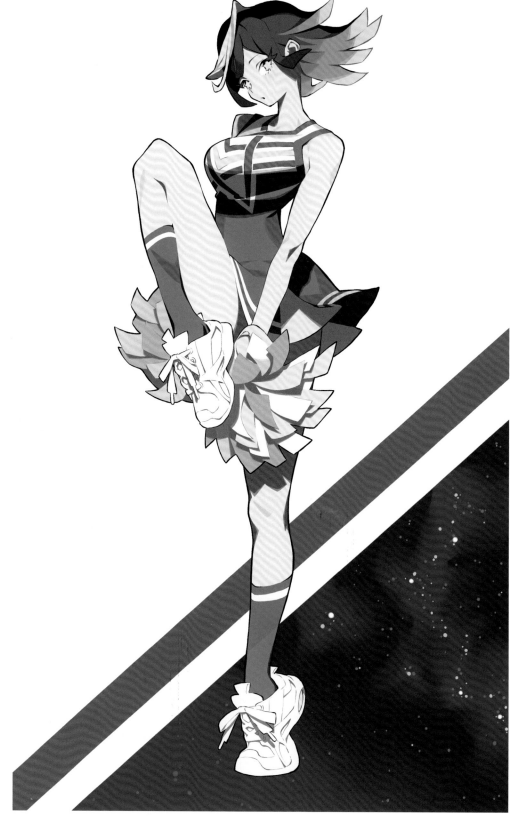

Kokonotsumbai 九つ違い

TWITTER kokonotsumbai　**E-MAIL** kyusokuhoko@gmail.com

TOOLS CLIP STUDIO PAINT / Wacom One

PROFILE Tries to draw simple yet unique characters every day.

1	2	
	3	4

TITLE　1 Star / 2022　**2** Tiger / 2022　**3** ??? / 2022　**4** Spider / 2021　all original works

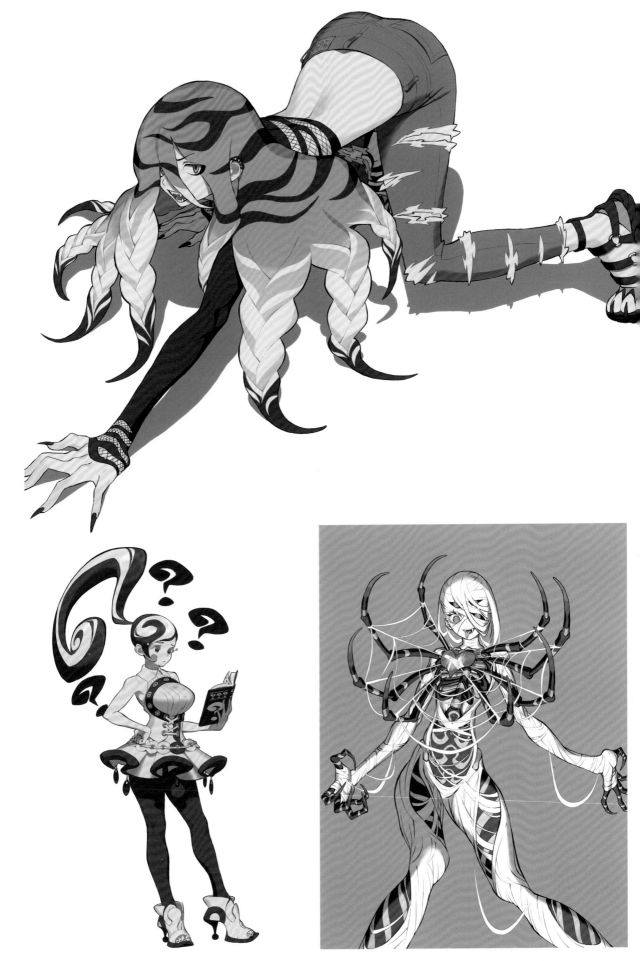

kuji

TWITTER ngc7027

E-MAIL kujishift9@gmail.com

TOOLS Blender / CLIP STUDIO PAINT / Wacom Intuos

PROFILE Has been creating 3D avatars since 2019.

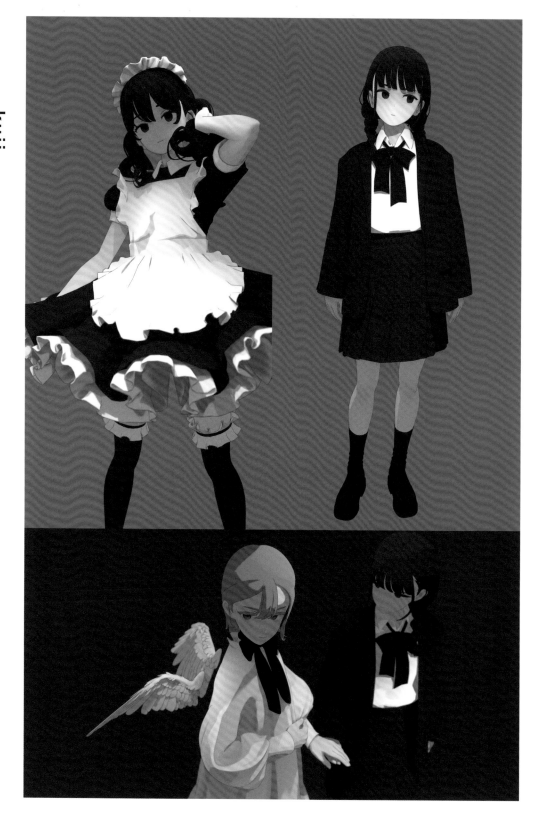

1	2	
3		4

TITLE 1-4 Grus all original works created in 2022

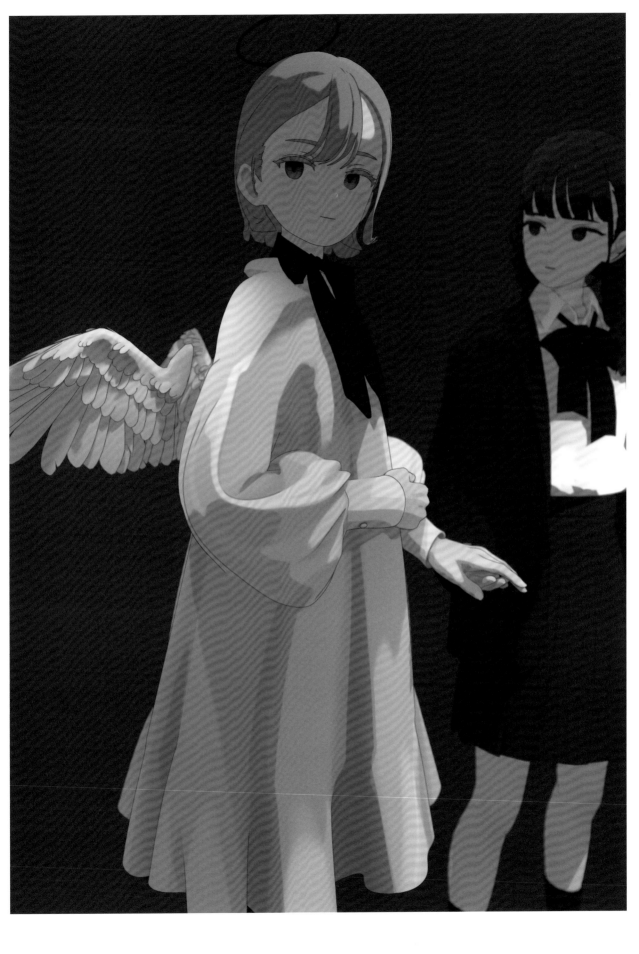

KUMAZOU <まぞう>

TWITTER kmz_sasshi **E-MAIL** kumazousasshi@gmail.com

TOOLS CLIP STUDIO PAINT / Wacom Cintiq 13HD

PROFILE Active mainly on Twitter and Instagram drawing snapshots of lazy, everyday life. Utilizes color ink and a judicious use of lines and surfaces in composition to create book covers, artist merchandise illustrations, manga, and corporate PR illustrations.

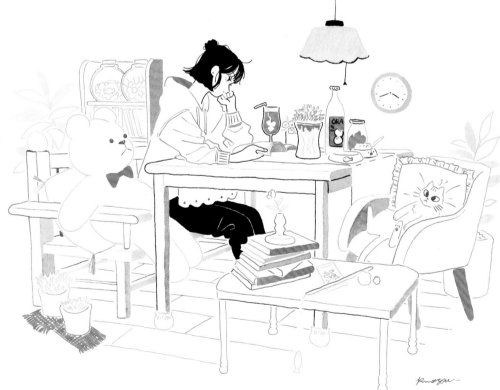

1	3	4
2	5	6

TITLE **1** Ribbon / 2022 **2** Tea Party / 2020 **3** Monolids / 2021 **4** Uneventful Morning / 2020 **5** Kitchen / 2022 **6** Wolf Cut / 2020 all original works

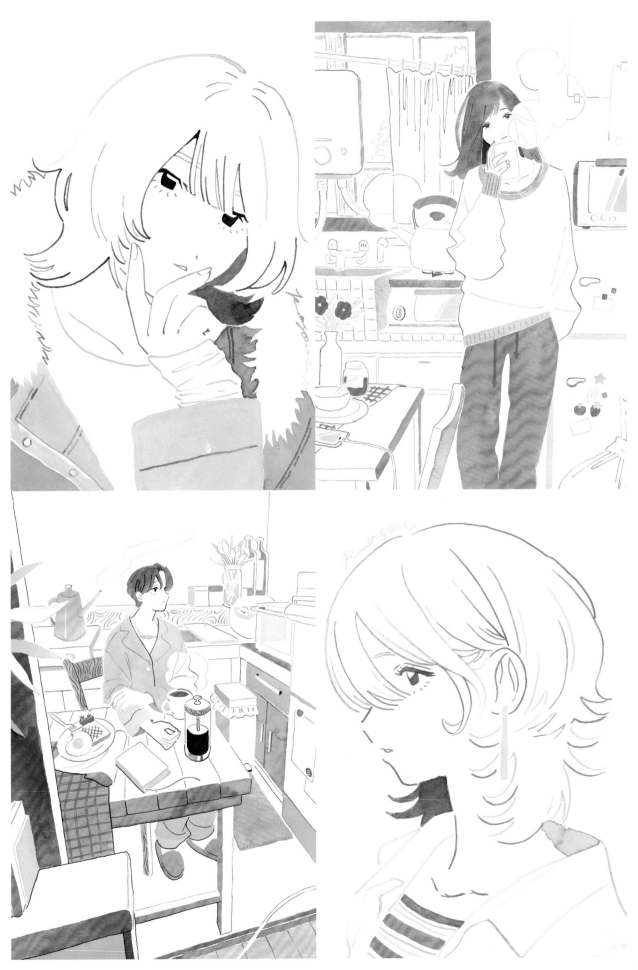

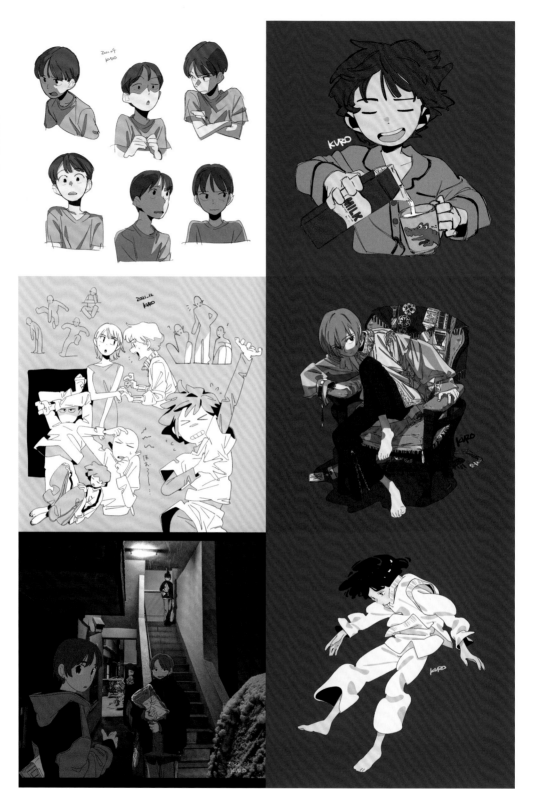

KURO

TWITTER K_u__R_o

TOOLS CLIP STUDIO PAINT / Wacom

PROFILE Animator and illustrator. Worked on character designs for *Pokémon: Hisuian Snow*, direction for *The Orbital Children*, and prop designs for *Pompo: The Cinephile*.

1	2	
3	4	7
5	6	

TITLE 1-7 untitled (*3 caption:* Hunngh…) all original works created in 2020-2022

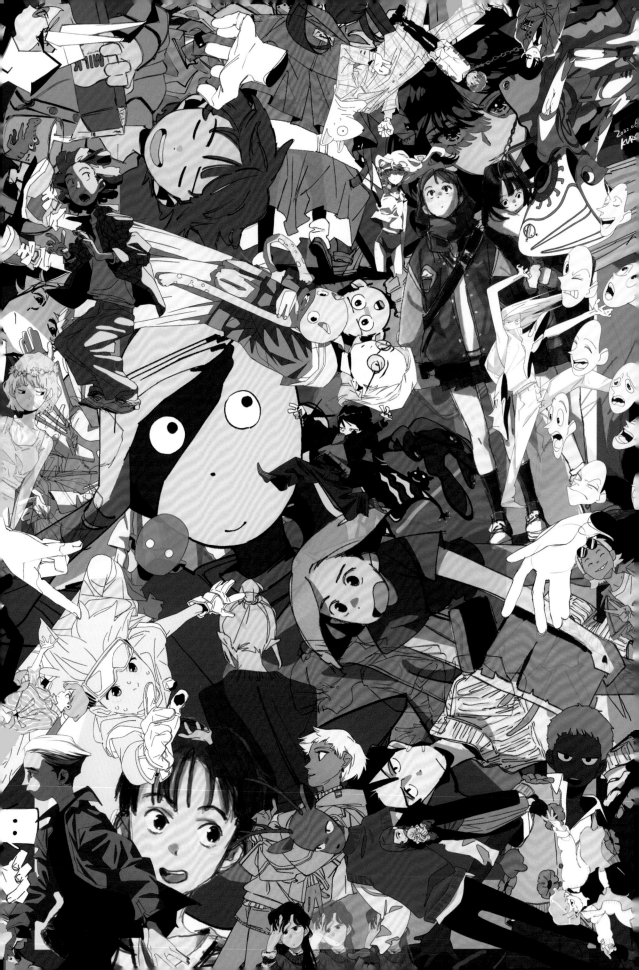

Kuroda Eri 黒田エリ

TWITTER kuroeri422
TOOLS CLIP STUDIO PAINT / Wacom Cintiq Pro
PROFILE Illustrator from Yamagata Prefecture living in Tokyo. Works center around themes of perpetual time, and common motifs include angels and androids.

E-MAIL kurohal422@gmail.com

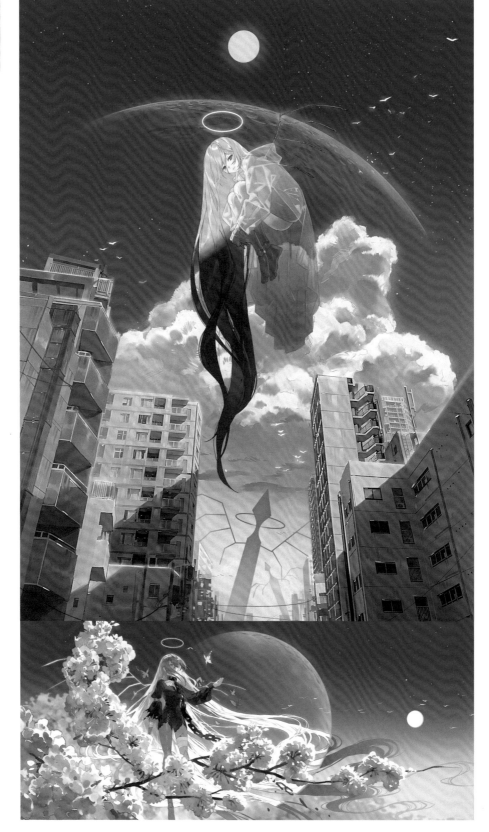

TITLE **1** Daydreaming / 2021 **2** Fleeting dream / 2022 **3** Inorganic / 2021 **4** In the light / 2021 **5** Summer ghost / 2022 all original works

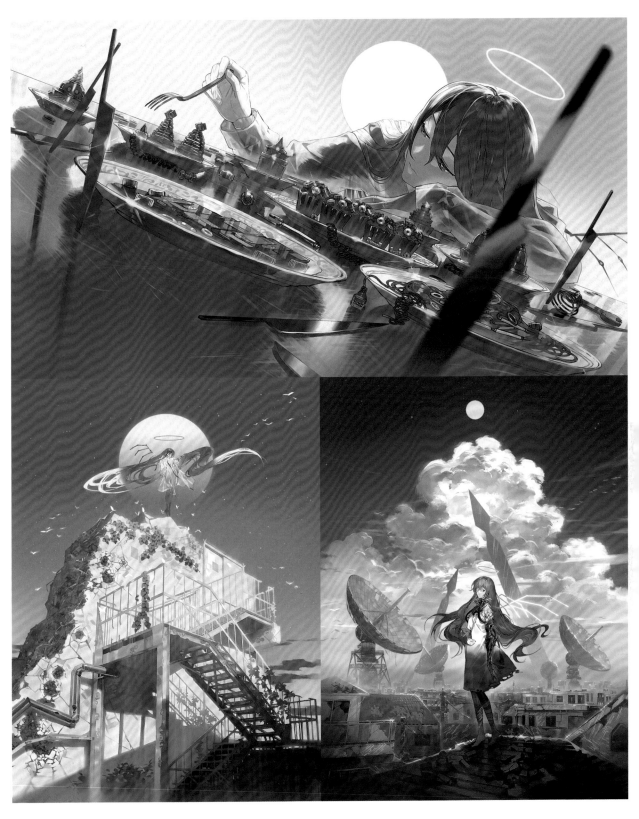

kuroume くろうめ

TWITTER kuroume_1024 **E-MAIL** 1024kuroume@gmail.com

TOOLS CLIP STUDIO PAINT / Wacom Cintiq

PROFILE Draws for fun.

1	2		7	8
3	4		9	10
5	6			

TITLE 1–10 untitled all original works created in 2021

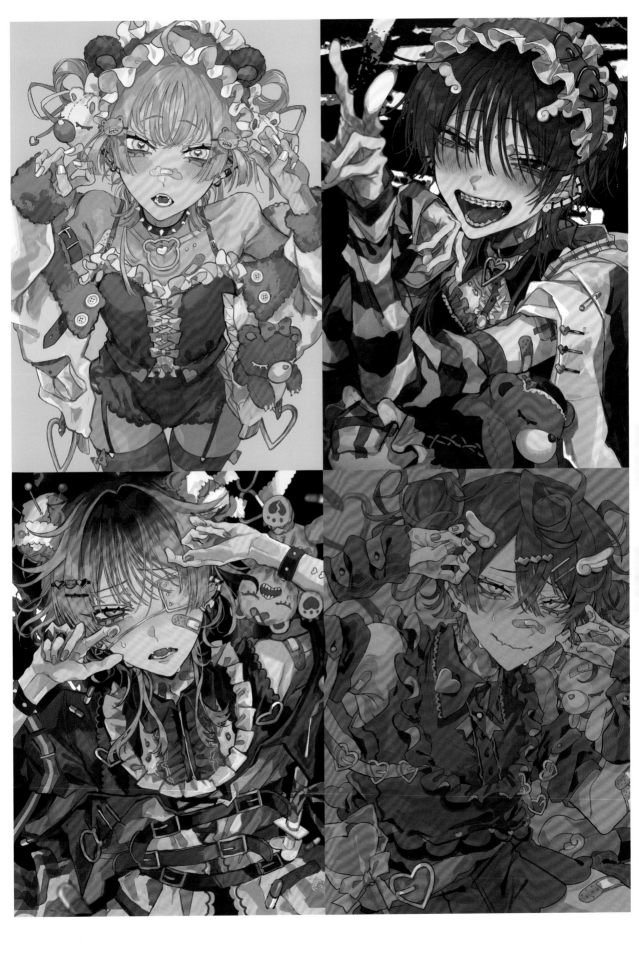

Kyuba Melo 炎場メロ

TWITTER 9baMelo **E-MAIL** 9bamelo@gmail.com

TOOLS Photoshop / Wacom Cintiq Pro 16

PROFILE Illustrator. Likes melons.

TITLE 1 illustration for release commemoration tribute project for *Kaizin*, Eve's third album / 2022 **2** illustration to celebrate *Utawarerumono: Lost Flag* / AQUAPLUS / 2021 **3** collaboration illustration for "Atashi ga Shindemo" by Koresawa / King Records / 2020 **4** contribution illustration for the *Bakemonogatari* manga (by Nisioisin, manga by Oh! great) / Kodansha / 2021 ©Nisioisin/Kodansha

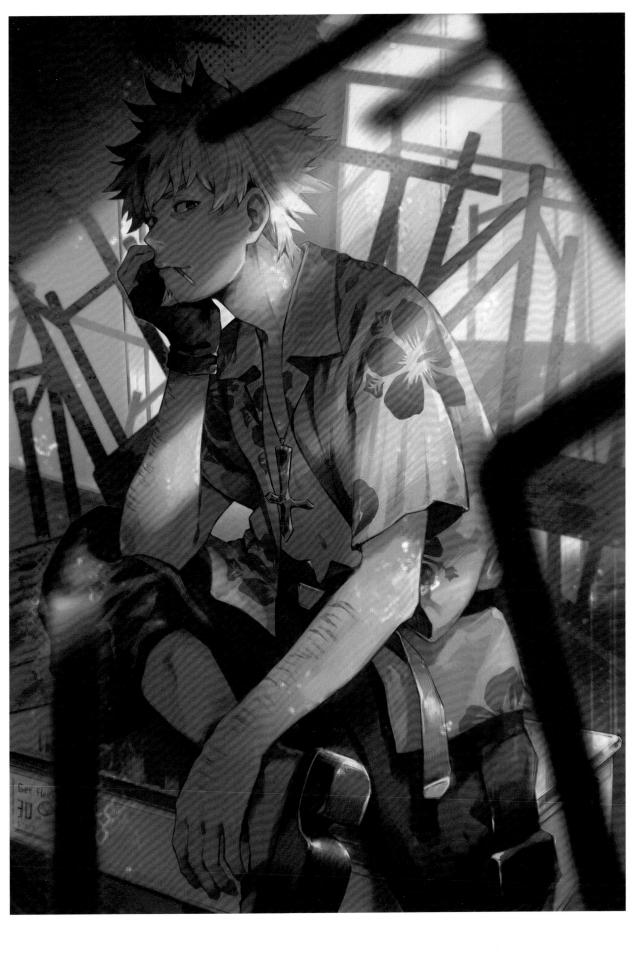

lillinc

TWITTER myss7777 **E-MAIL** kxk7713@gmail.com

TOOLS Procreate / Artstudio / iPad

PROFILE Chinese. Born in 2000. Likes Victorian-era maids and wheelchairs.

1	
2	3

TITLE **1** An Amusement Park Nobody Knows / 2022 **2** Mirror / 2022 **3** Shipwreck / 2021 all original works

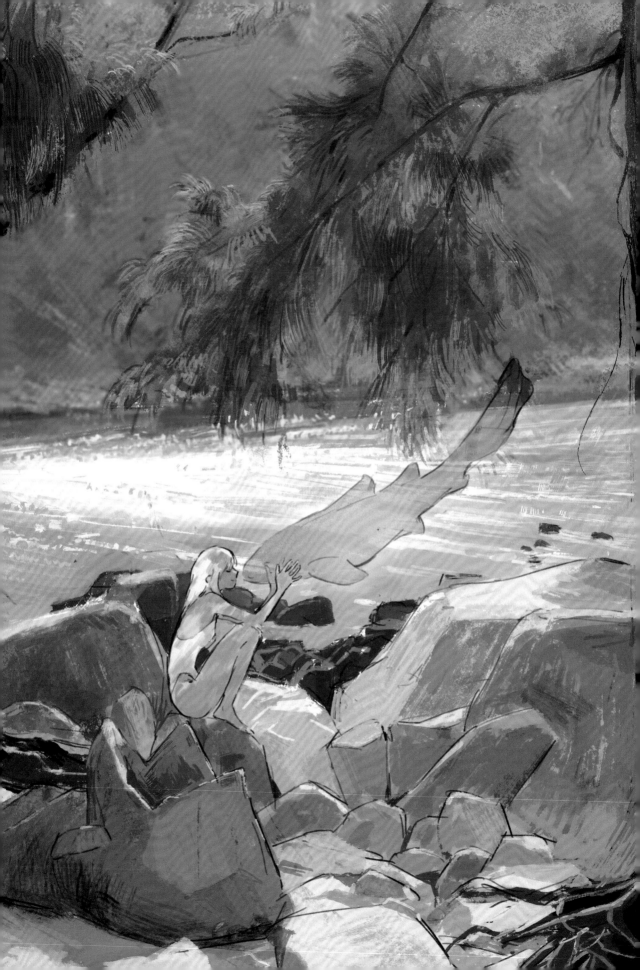

Liqi 立旗

TWITTER Lirseven

TOOLS SAI2 / Photoshop / Wacom Cintiq Pro

PROFILE Freelance illustrator and game art designer. Majored in visual communication design in college, now studying design in grad school. Good at capturing atmosphere in their works.

pixiv user ID : 14165905

TITLE 1 Researcher / original / 2022 **2** Leaping With Excitement / original / 2022 **3** Lost Ship / illustration for the song "Stardust Minus" / 2021

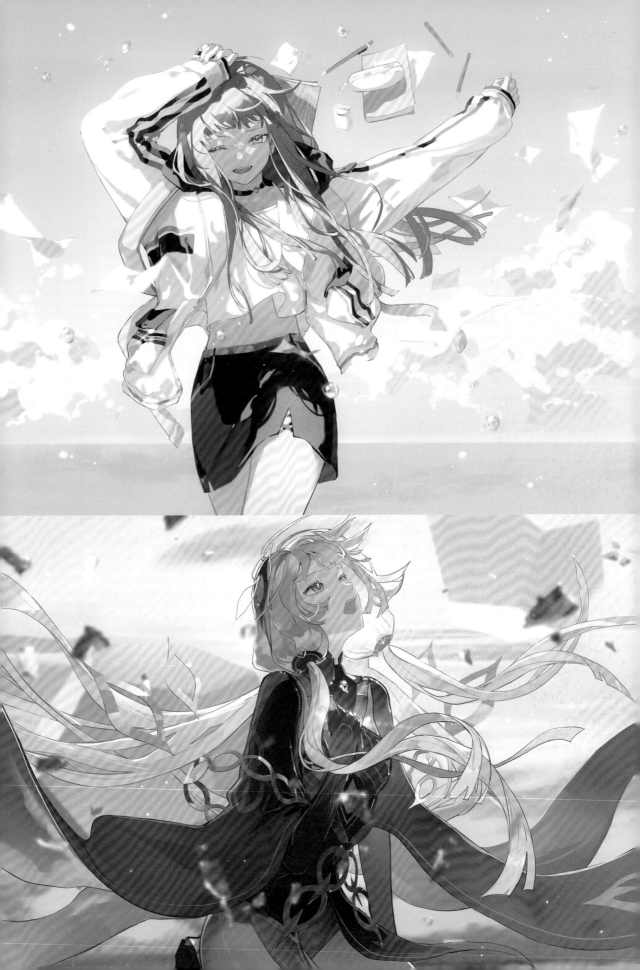

LOWRISE

TWITTER L0WR15E **E-MAIL** l0wr15egm@gmail.com

TOOLS Photoshop / CLIP STUDIO PAINT / Wacom Intuos Pro Small

PROFILE From Kansai, originally a produce store employee. Works on many cover illustrations and music-related illustrations.

1	2
	3

TITLE 1 202116 **2** 202114 **3** 202112 all original works created in 2021

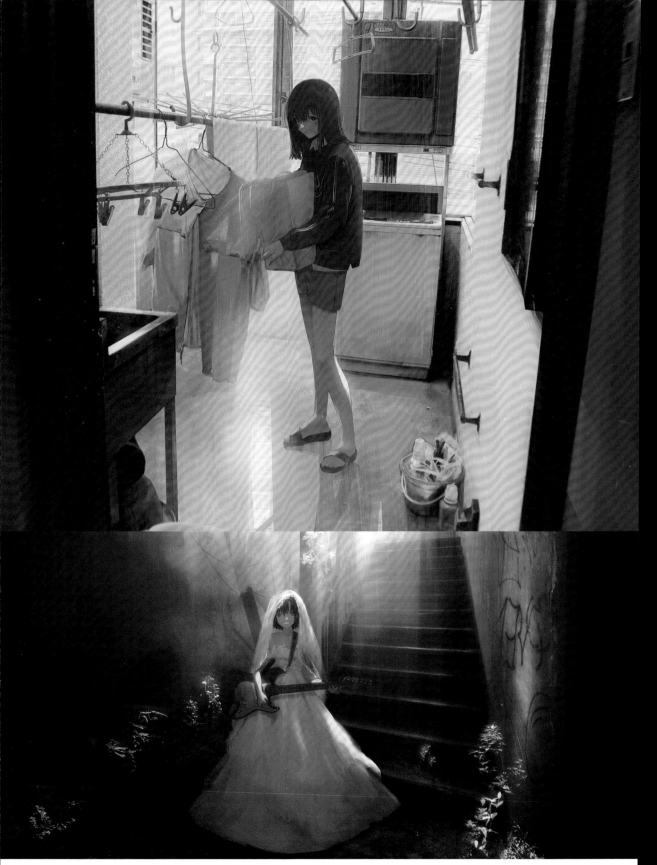

lvl374

TWITTER lvl374

TOOLS Aseprite / Processing / iPad

PROFILE A dreaming machine.

1	2	3
	4	5
	6	7

TITLE 1-7 untitled all original works created in 2021~2022

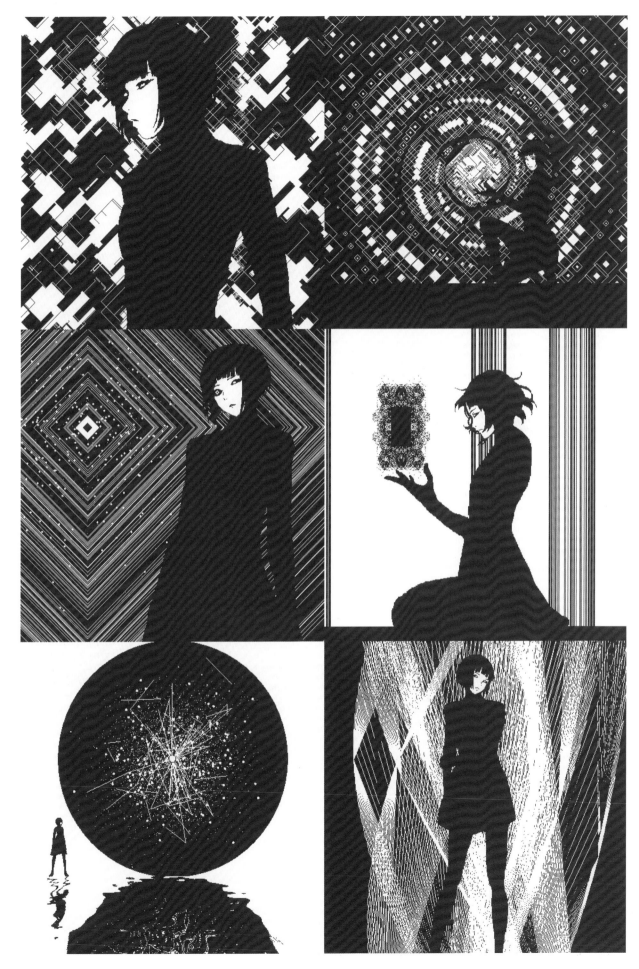

Magotsuki まごつき

TWITTER haruno_168 **E-MAIL** ruined_alice@hotmail.co.jp
TOOLS CLIP STUDIO PAINT EX / Wacom Cintiq Pro 16
PROFILE Designer for the movie production team Hurray! Works on concept art, character designs, and other visuals for the team.

1		5
2	3 4	6

TITLE 1 STRIKE / original / 2022 **2** red / original / 2021 **3** yellow / original / 2021 **4** cyan / original / 2021
5 Spring Storm / Drawing with Wacom 124 / 2021 **6** Rain Damage / original / 2022

SEVENTHRUN

Makai no Jumin 魔界の住民

TWITTER makai3 **E-MAIL** makainojumin@gmail.com

TOOLS Photoshop / SAI2 / CLIP STUDIO PAINT / Blender / Wacom Cintiq Pro 24

PROFILE Company illustrator. Mainly works on original pieces and within the video game industry.

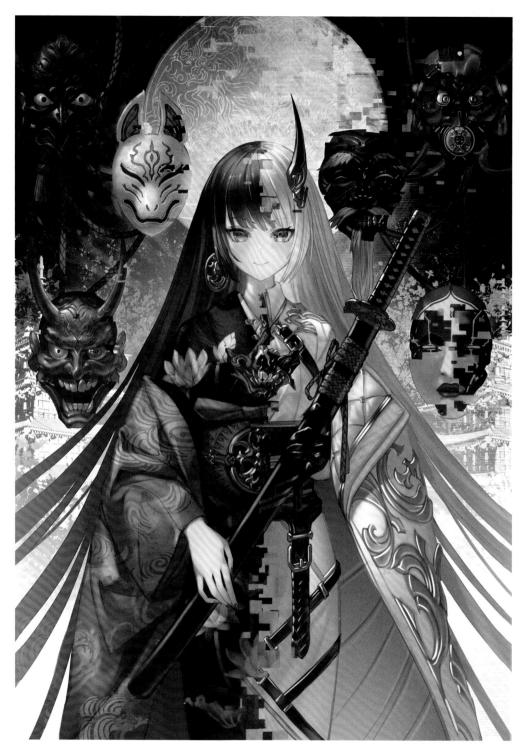

1	2	3
	4	5

TITLE **1** Oumagatoki (*note:* literally "the hour of meeting evil spirits," referring to the time after sunset but before darkness falls) **2** Susanoo (*note:* Japanese god of the sea, storms, and fields; famously slayed a giant serpent) **3** Amaterasu (*note:* Japanese goddess of the sun) **4** Kensei (*note:* an honorary title for a swordsman, literally "sword saint") **5** Tsukuyomi (*note:* Japanese god of the moon) all original works created in 2021

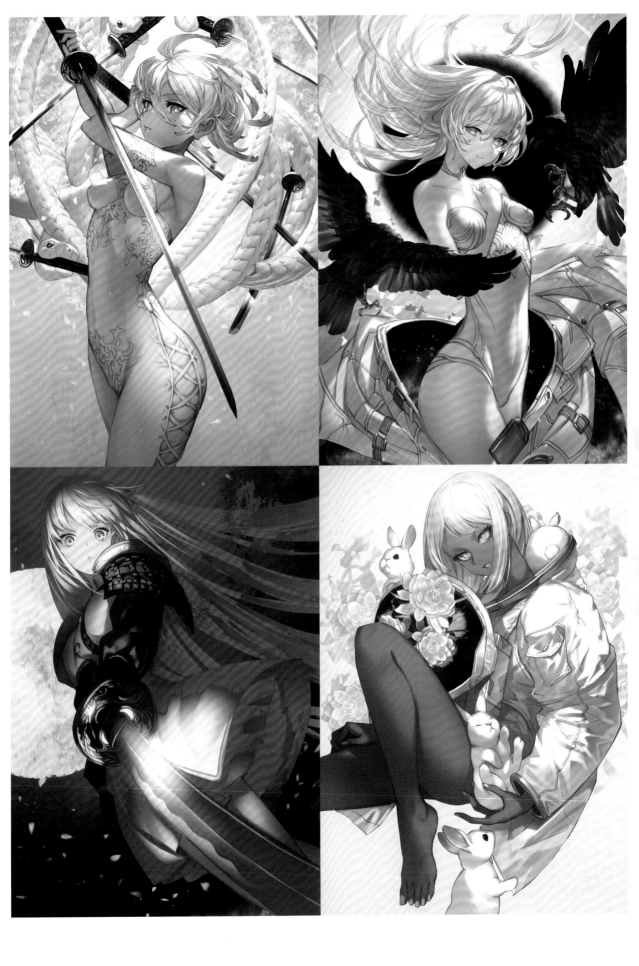

Makura Tami まくらたみ

TWITTER tami_yagi **E-MAIL** ruins.tower@gmail.com

TOOLS Photoshop / CLIP STUDIO PAINT / Wacom Cintiq 16

PROFILE Illustrator from Kanagawa Prefecture. Likes youkai. Mostly draws somehow strange, daydream-like scenarios and people living alongside ghosts and spirits.

1	2
	3

TITLE 1 Alice in the Library / 2021 **2** Tiger / 2021 **3** Cat Shrine / 2022 all original works

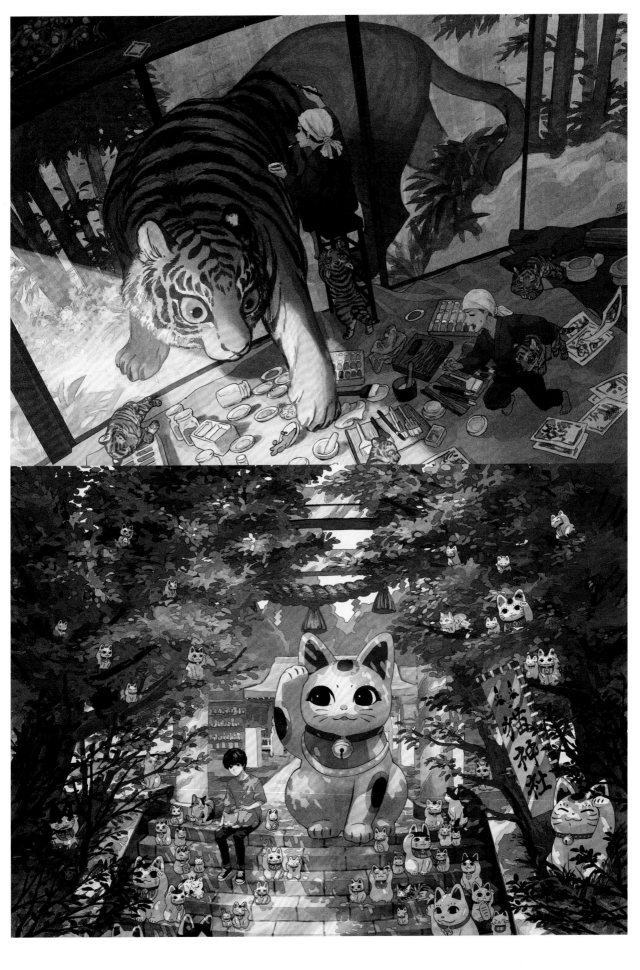

mashu

TWITTER mu_mashu **E-MAIL** mumashu12@gmail.com

TOOLS CLIP STUDIO PAINT / Photoshop / iPad

PROFILE Works include collaboration illustrations for *Love Fantasy: The Language of Flowers ~The Fairies of Wonderland~* (MDN Corporation) and others. Also insert illustrations, among other things. Draws from a romantic worldview to transform everyday things from everyday life.

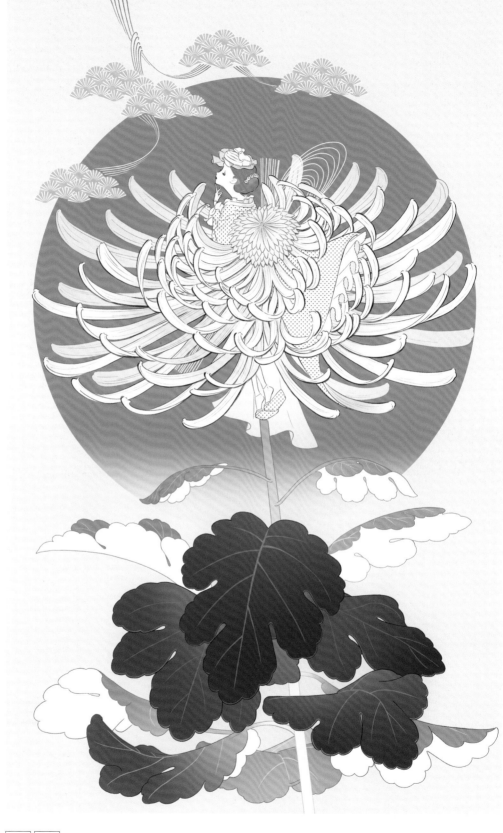

1	2
	3 / 4 / 5

TITLE **1** moment -Winter Chrysanthemum-／2021 **2** Flowers Thinking of Spring／2022 **3** The Frog Prince／2022 **4** Dreaming of the Day Flowers Bloom -Rose-／2021 **5** Dreaming of the Day Flowers Bloom -Chrysanthemum-／2021 all original works

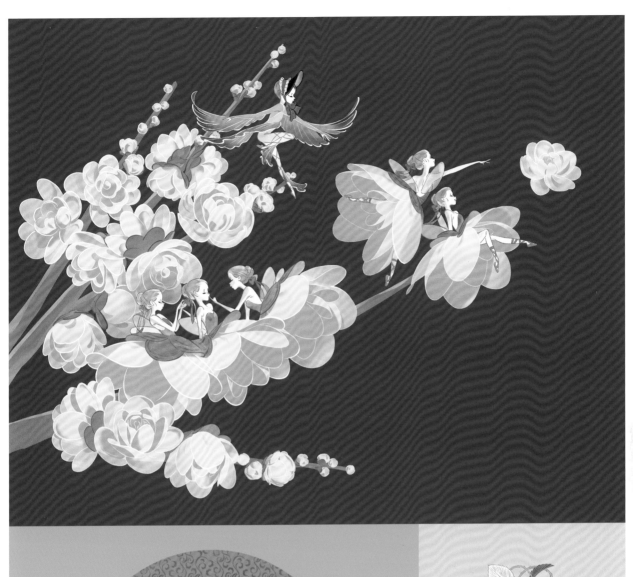

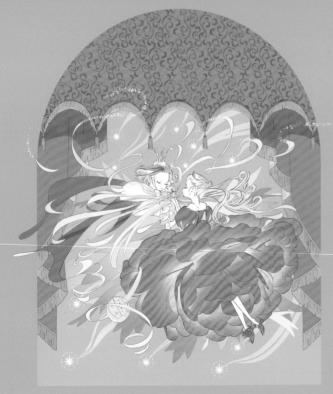

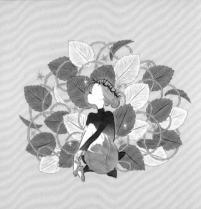

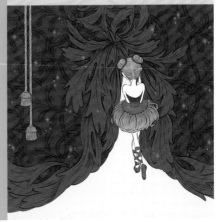

Matcha

TWITTER matchach **E-MAIL** matchachmat@gmail.com

TOOLS CLIP STUDIO PAINT / Wacom Intuos Pro

PROFILE Illustrator from China who graduated from the Central Academy of Fine Arts. Likes drawing pretty backgrounds and beautiful people.

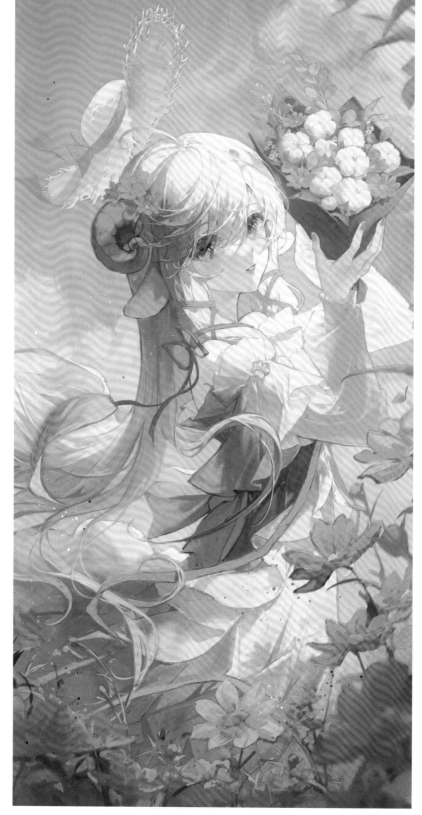

1	2	3
	4	

TITLE **1** Flowers' Peak / 2022 **2** Sunflower Mia / 2021 **3** Bride / 2021 **4** Spring and the Dessert Witch / 2020 all original works

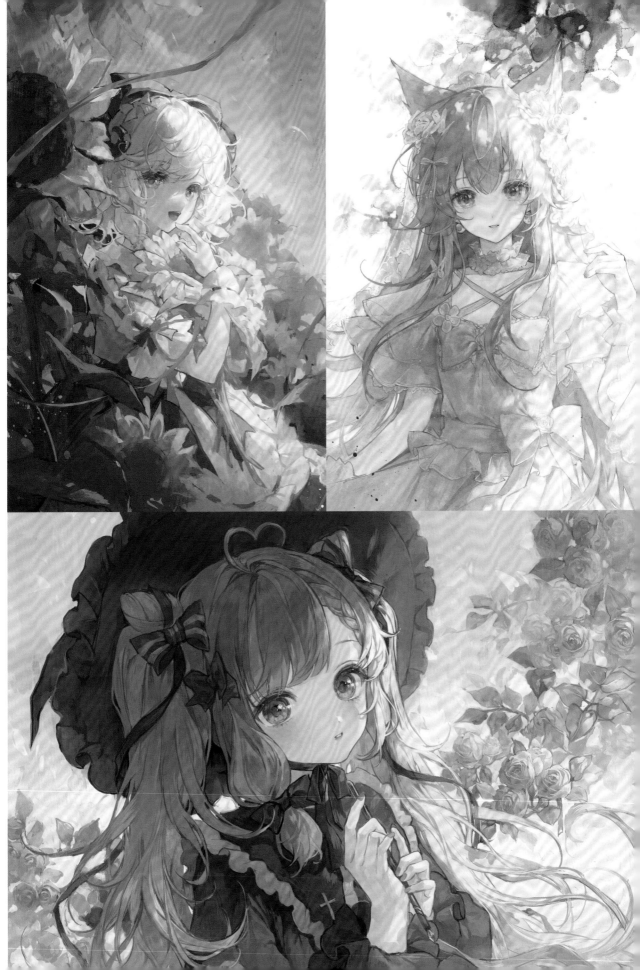

Memenchi めめんち

TWITTER nmememen
E-MAIL nmememen@gmail.com
TOOLS CLIP STUDIO PAINT / iPad
PROFILE Lives in Hiroshima Prefecture. Works mainly feature mysterious and somewhat sexy girls. Specializes in compositions utilizing specific color motifs. Works include the character designs for A.I. Voice's Unoka.

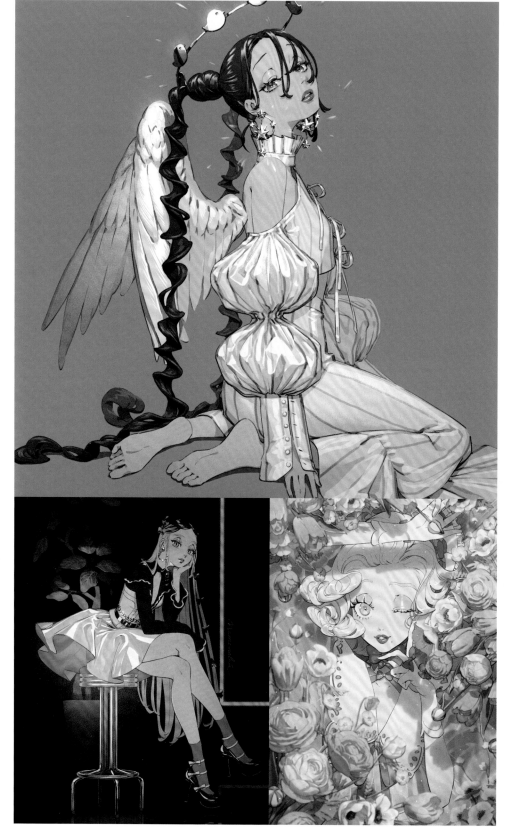

TITLE **1** dreaming／2021 **2** Neon Skirt／2021 **3** bloom／2022 **4** Snake Maid／2020 all original works

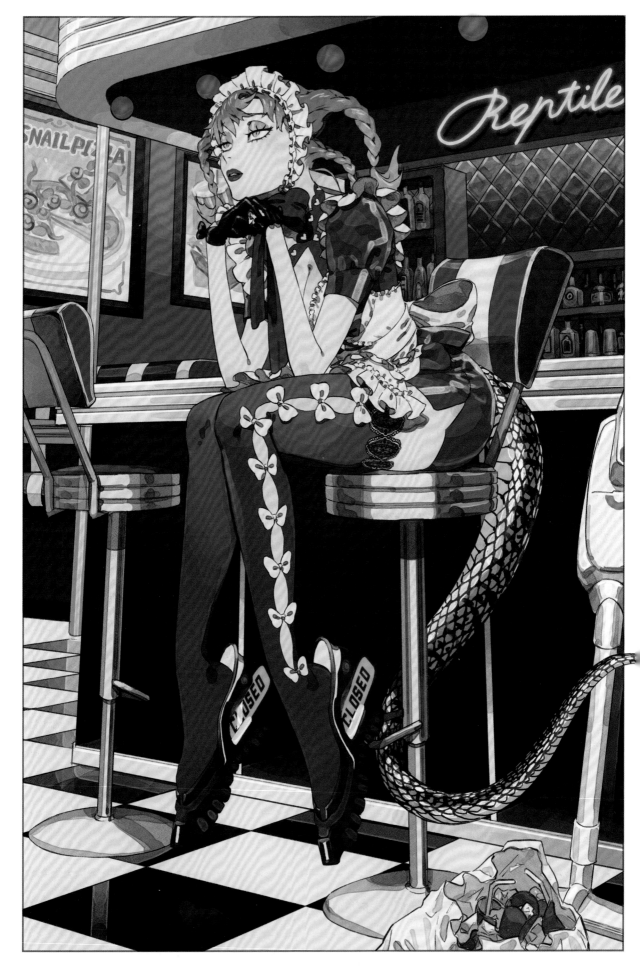

michellekuku

TWITTER thebigmeeshy **E-MAIL** michelleku12@gmail.com

TOOLS acrylic paints

PROFILE Artist and animator searching for the link between mind and body. Born in Canada to Hong Kongese immigrants. Graduated with a BA in graphic design from Central Saint Martins. Now practices art and creates animations. Has done work for Cartoon Network, Blinkink, FX, and others.

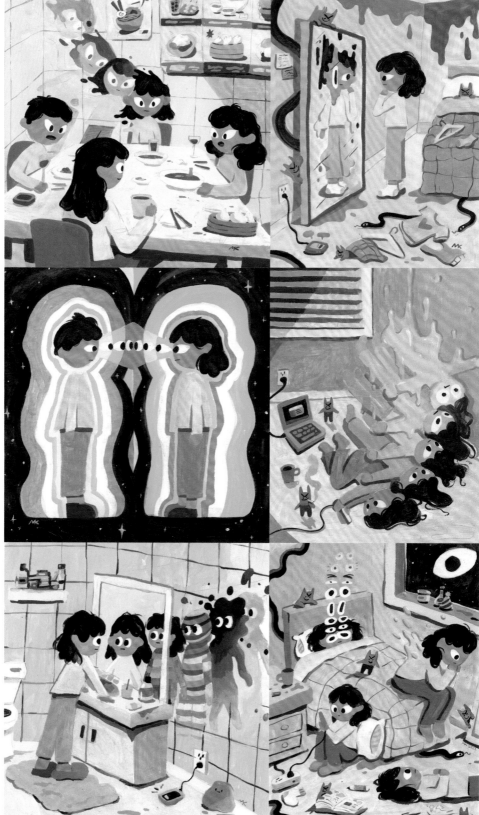

1	2	
3	4	7
5	6	

TITLE 1 Mind Body Series: Depersonalization／2022 **2** Mind Body Series: Body Dysmorphia／2022 **3** Mind Body Series: Projection／2022 **4** Mind Body Series: Dissociation／2022 **5** Mind Body Series: New Me／2021 **6** Mind Body Series: Insomnia／2022 **7** Mind Body Series: The Parts at Work／2022 all original works

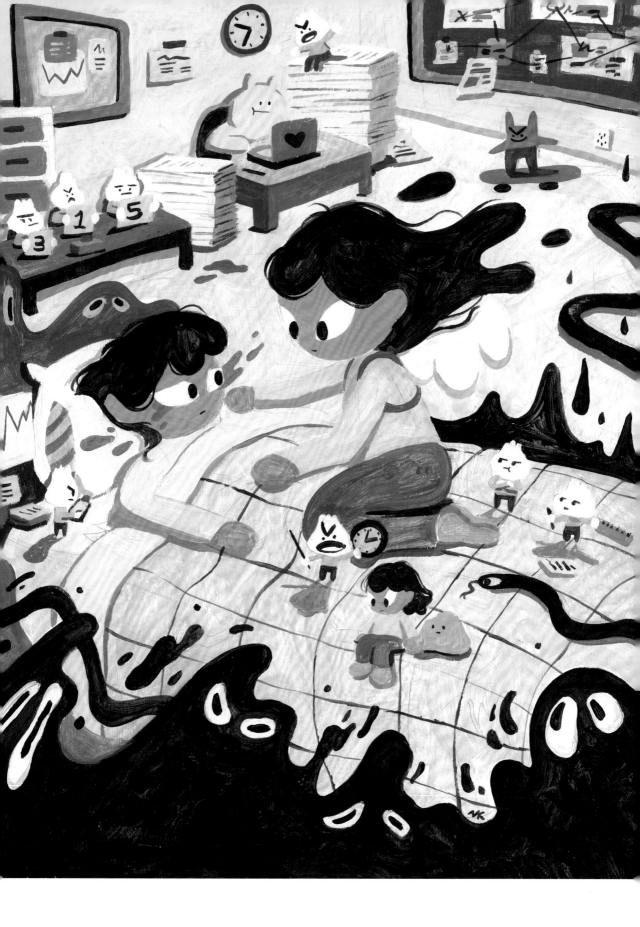

Mika Pikazo

TWITTER MikaPikaZo **E-MAIL** mikapikaworkz@gmail.com

TOOLS CLIP STUDIO PAINT / Photoshop / Wacom Intuos4

PROFILE Specializes in designing charming characters using a sense for vivid colors. Works include the character design, live art direction, and apparel design for VTubers Hakos Baelz and Kaguya Luna, the main visual for Hatsune Miku's Magical Mirai 2018, costume design for *Project Sekai*, and character design for DEN-ON-BU and *Fate/Grand Order*.

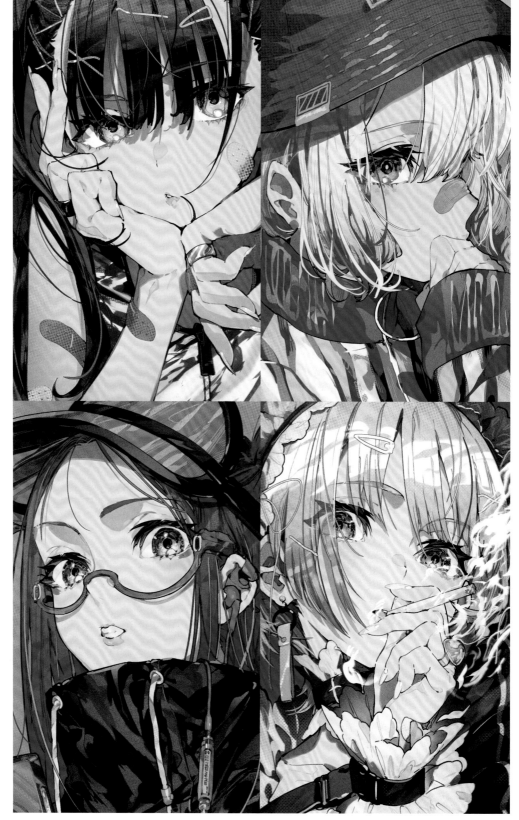

1	2	5
3	4	6

TITLE 1 blue1 / 2022 **2** blue2 / 2022 **3** blue3 / 2022 **4** blue4 / 2022 **5** FUN / 2021 **6** LAUGH / 2021
all original works

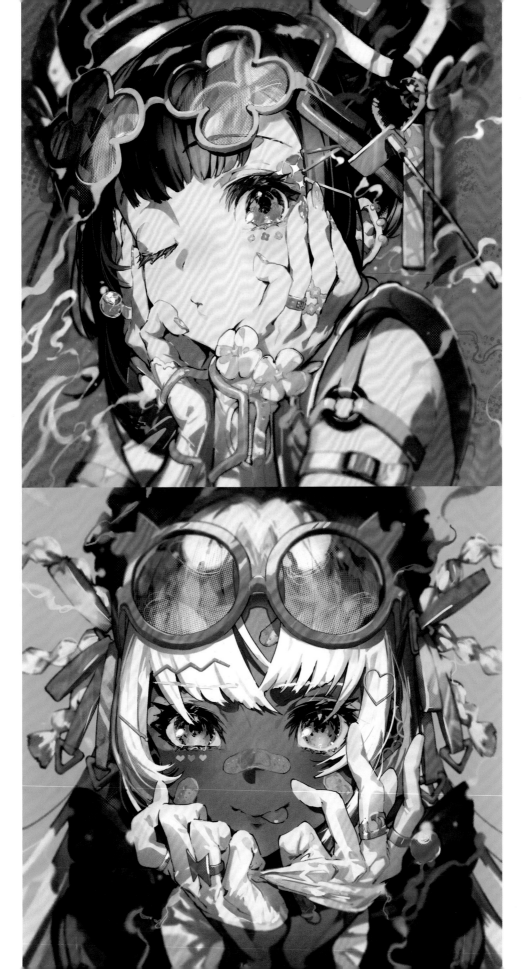

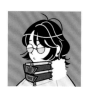

Mikio みきお

TWITTER mikitail
E-MAIL mikitail27@gmail.com
TOOLS Photoshop / Procreate / iPad / Wacom Cintiq 22
PROFILE Mainly works on book cover illustrations and anime character and prop designs while living a shrewd, calculating life. Used to exclusively draw younger women, but recently feels their depictions of middle-aged men are better.

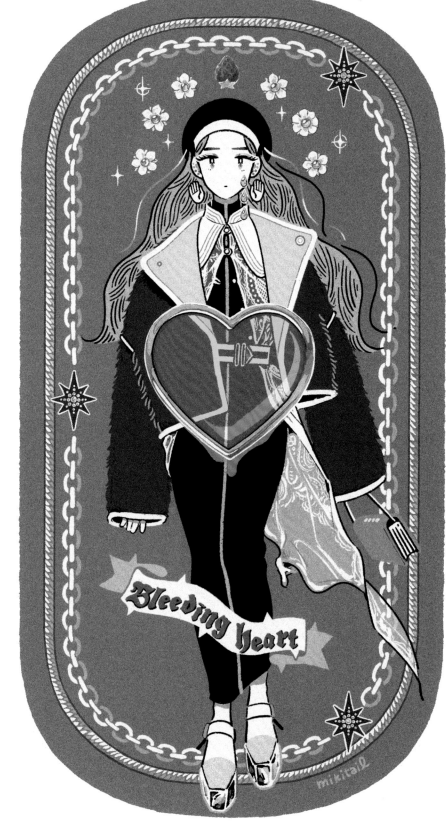

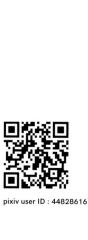

TITLE **1** Bleeding heart／2022 **2** View／2022 **3** boa／2019 **4** raglan sleeve／2019 **5** salvation／2019
all original works

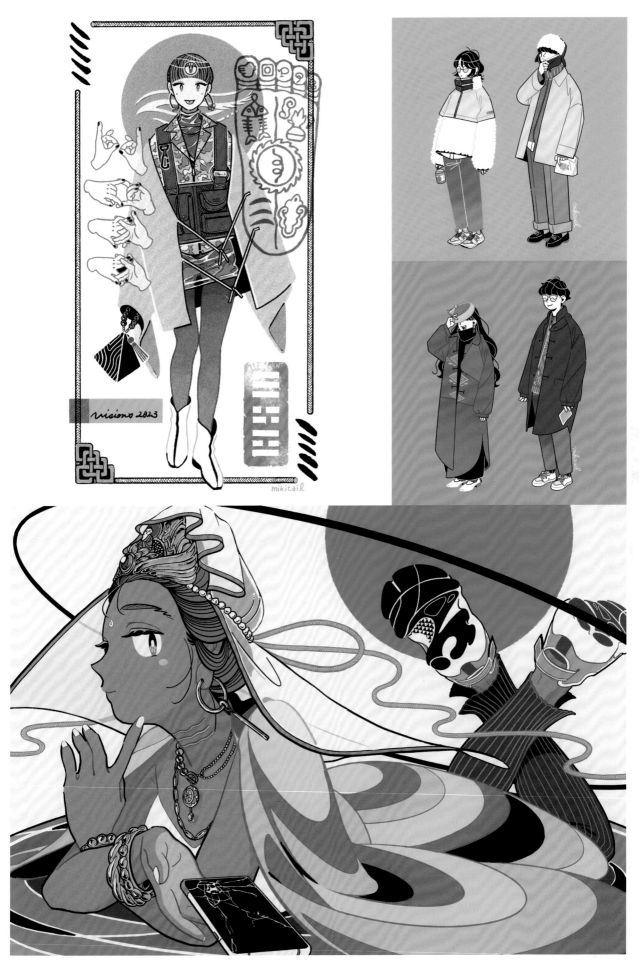

Miwano Rag 美和野らぐ

TWITTER rag_ragko **URL** https://potofu.me/miwanorag

TOOLS CLIP STUDIO EX / Wacom Cintiq Pro 24HD / Wacom Intuos M

PROFILE Born in Saga Prefecture, now lives in Tokyo. Likes reptiles, Japanese sake, and horror games. Published first artbook, *Drown in Water and Dream* (*Mizu ni Oborete Yume wo Miru*), in March 2022 through KADOKAWA.

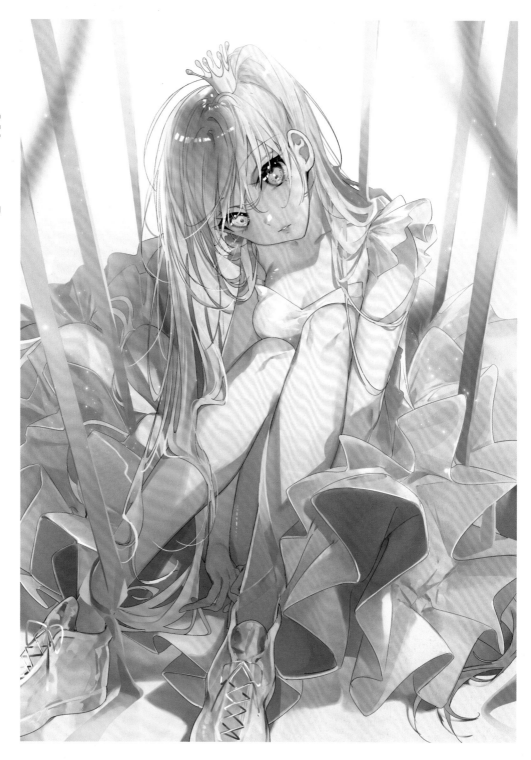

1	2	3
	4	5

TITLE **1** Girl of Glass / original / 2022 **2** Rain or Shine / original / 2021 **3** I Waited Forever, You Know / original / 2021 **4** Eldest Daughter, Temptation: "Welcome" / original / 2021 **5** Cover illustration of *Drown in Water and Dream* (KADOKAWA) / 2022

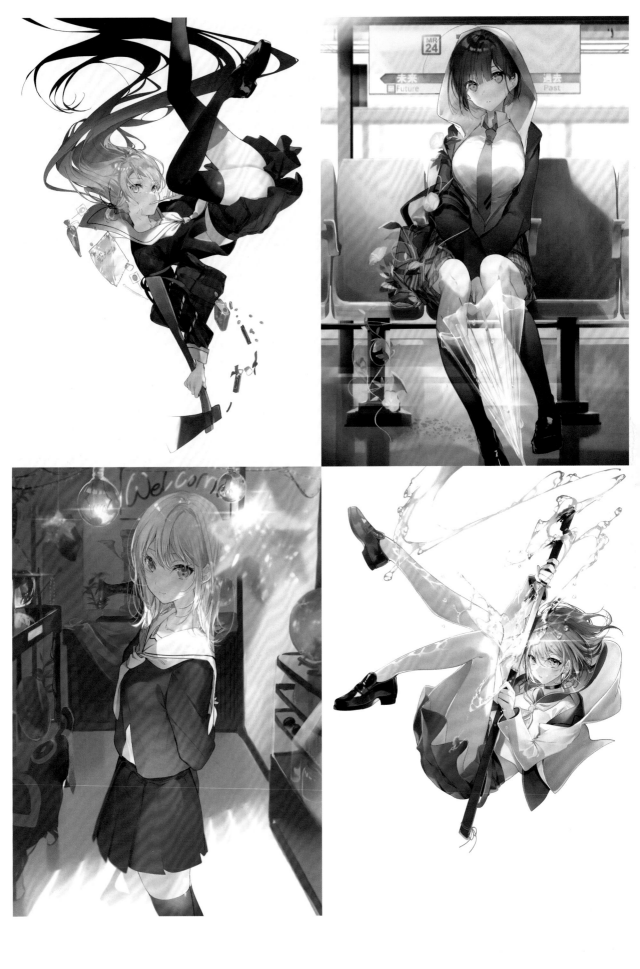

mna

TWITTER MaIIIMa　**E-MAIL** m.lovesong.m@gmail.com

TOOLS CLIP STUDIO PAINT / Wacom

PROFILE Draws pretty girls while obsessing over expressing beautiful colors.

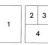

TITLE **1** Petals **2** Braid **3** Winter Sea **4** Past　all original works created in 2021

Mochipanko

TWITTER mochipanko **URL** https://mochipanko.com/

TOOLS Procreate / iPad

PROFILE Born in 1997. Freelance illustrator based in Germany. Tattoo artist. Has a history working with Steam and Bandai Namco, among other clients. Likes horror and large plants, but always worries about their pet cat eating those plants.

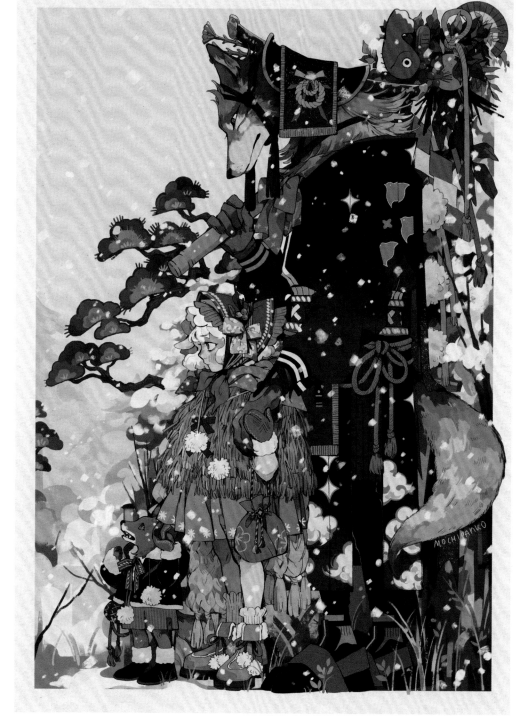

1	2	
	3	4

TITLE **1** From snow to harvest / 2021 **2** Masks / 2020 **3** Pool Party / 2019 **4** Rainy Windchime / 2021
all original works

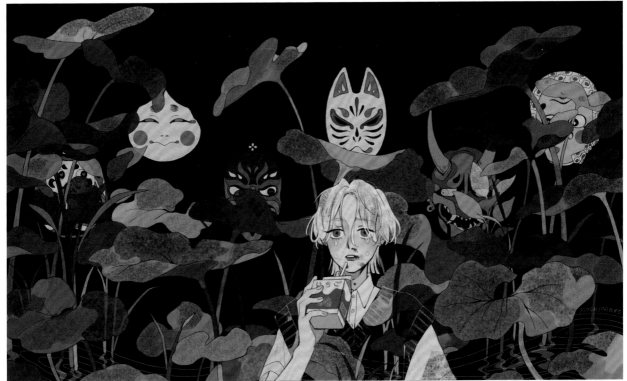

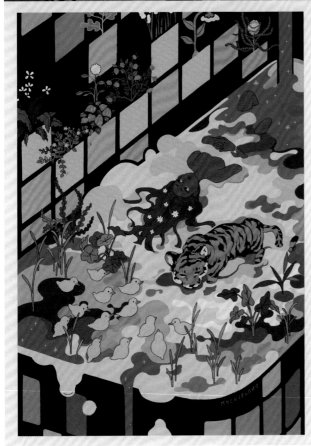

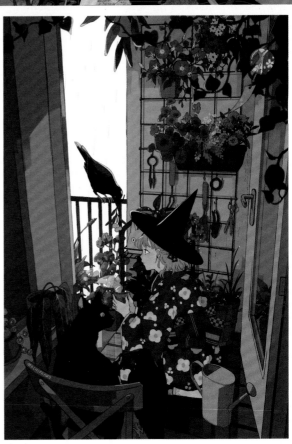

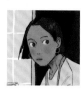

mohtz

TWITTER _mohtz **E-MAIL** stephaniesonhj@gmail.com

TOOLS Photoshop / Wacom Intuos Pro

PROFILE Stephanie, active under the pen name "mohtz," is a digital illustrator who creates works themed around a wide array of different topics and art styles.

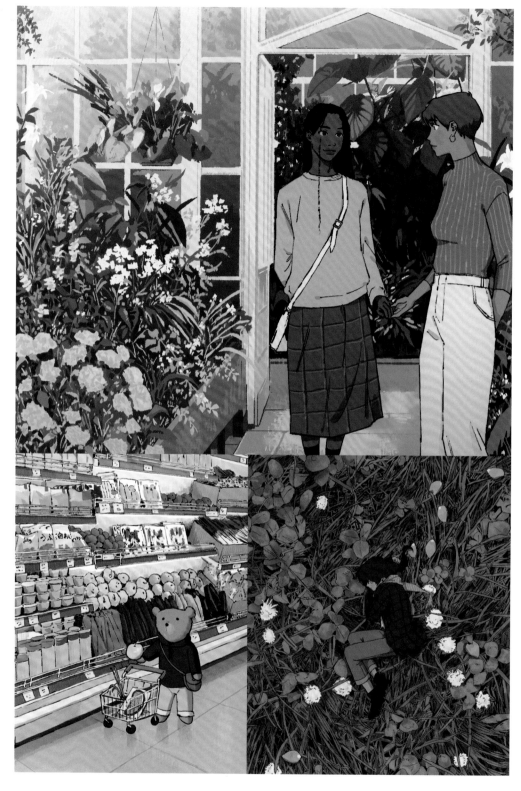

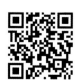

1		4	5
2	3	6	7

TITLE **1** abloom / 2022 **2** little guy grocery shopping / 2022 **3** to be small / 2022 **4** like the girls / 2020 **5** nyx / 2018 **6** renaissance part 2 / 2021 **7** renaissance part 1 / 2021 all original works

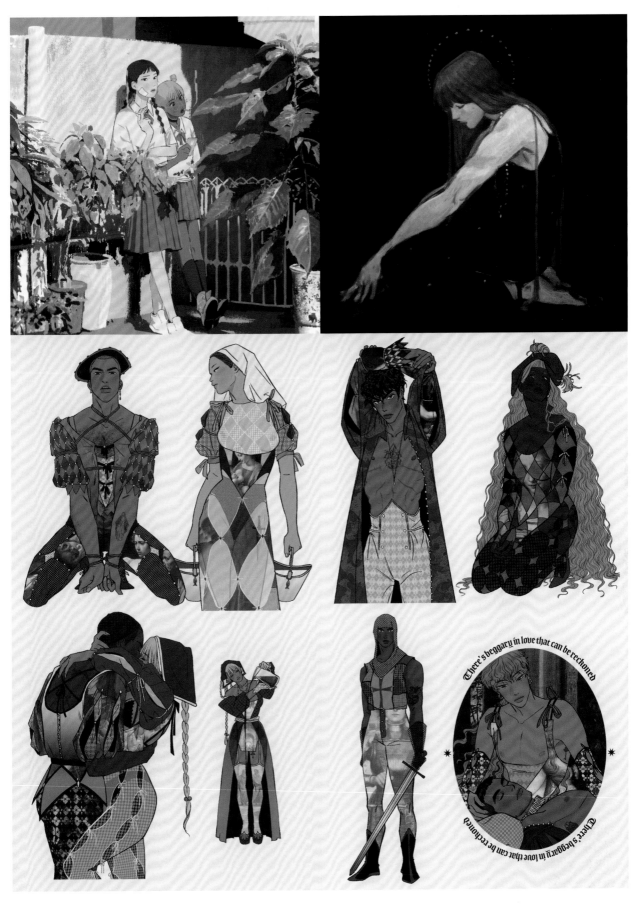

There's beggary in love that can be reckoned

mocha

TWITTER mocha708 **URL** https://mocha708.wixsite.com/mocha708

TOOLS Photoshop / Wacom Cintiq 27QHD

PROFILE Illustrator mainly specializing in backgrounds and scenery. Aims to create art that will immediately pull viewers into its world. Enjoys backgrounds that straddle the line between reality and fantasy. mocha's many works include *BACKGROUND ARTWORKS* and *Empathy* (Wani Books), *Learn Pro Techniques from Scratch: Backgrounds (Kamiwaza Sakuga Series)* (KADOKAWA), and the jacket illustration for "Hoshikage no Yell" by GReeeeN (Universal Music).

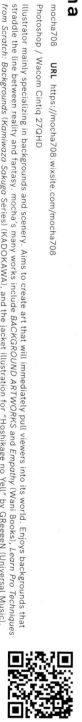

1	2
	3

TITLE **1** Stars Fill the Harbor / 2019 **2** Vestiges / 2021 **3** Four Views / 2020 all original works

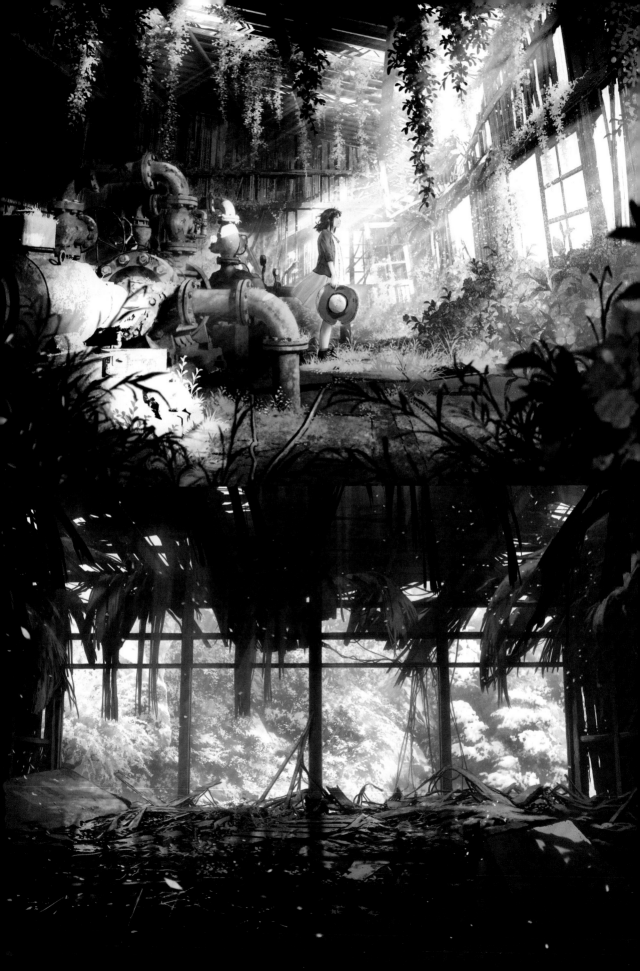

MONQ

TWITTER m_OnQ **E-MAIL** full0.vinyl@gmail.com

TOOLS CLIP STUDIO PAINT PRO / Wacom Cintiq Pro 24

PROFILE Works as an illustrator in their free time. Specialty is clothing design. Major works include the new outfit design and main visual for Mirai Akari and the campaign illustrations for Team Estonia at the 2020 Tokyo Olympics.

TITLE **1** BOY (*lanyand, shoes, straps:* lion dance / *jacket:* blessing / *skateboard:* Far East / *backpack:* Sanskrit) / 2020 **2** VINYL CAFE / 2019 **3** Santaclaus.mob / 2016 all original works

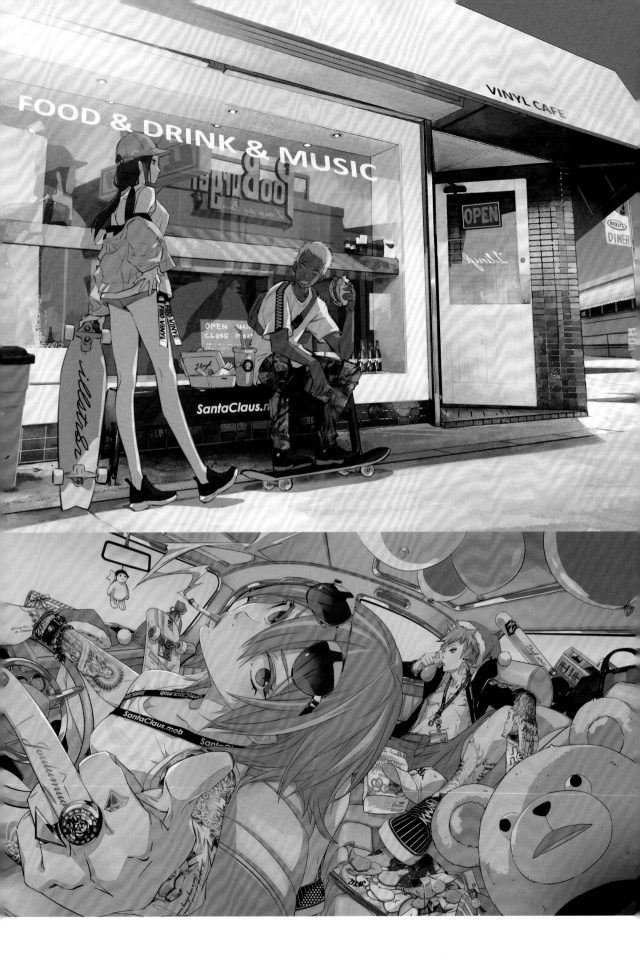

Morichika もりちか

TWITTER marutar

TOOLS Photoshop / CLIP STUDIO PAINT / Wacom Intuos4 / iPad Pro

E-MAIL marutar@marutar.com

PROFILE
Aside from illustration work, also draws manga. Recent manga works include *Oh, Our General Myao* (Coamix). Began creating a lot of pieces featuring girls with dogs after adopting a dog.

1		3	4
		5	6
2		7	

TITLE **1** Fixing Hair／2021 **2** Breathing in a Dog Makes You Happy／2021 **3** I Love Ramen／2021 **4** I Love Ramen ＿ Smile／2021 **5** Girls and Dogs Are the Best／2021 **6** Dog That Lets Me Hug It without Running Away／2022 **7** Hello, Little Cat／2018 all original works

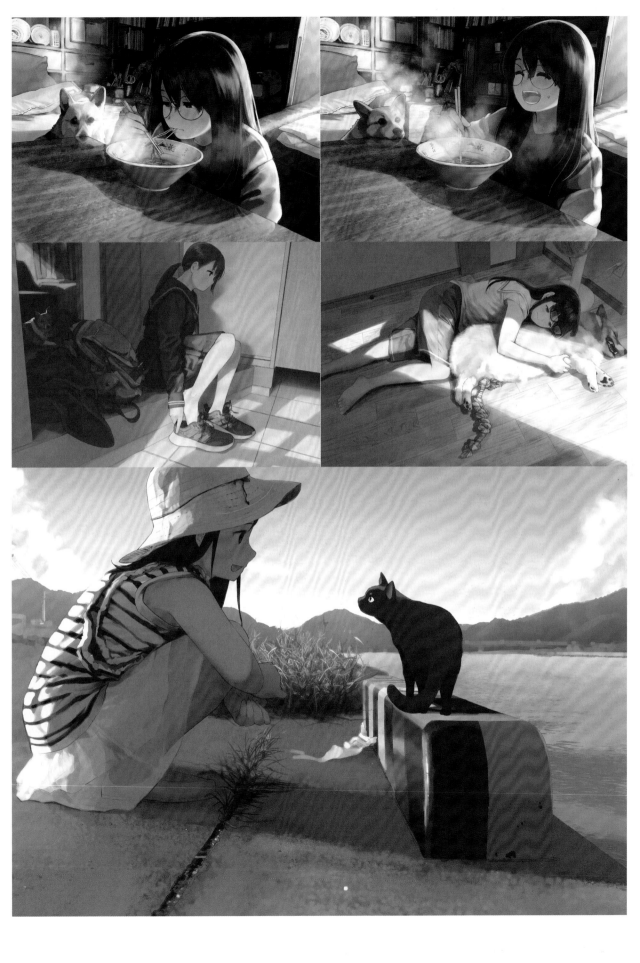

murakaruki 杓カルキ

TWITTER murakaruki **E-MAIL** mura7342403@gmail.com

TOOLS CLIP STUDIO PAINT / Wacom

PROFILE Illustrator and manga artist. Likes the color blue, bones, silver accessories, and video games. Author of *Learn Painting Techniques with 7 Color-themed Illustrations* (Hobby Japan) and artist of the currently in-serialization *A Blossom in the Snow Stands as a War God*. Cover illustrations include those for *Bride of Demise* and *This Unbound World's "Normal" Is Difficult* (both KADOKAWA), and has illustrated for works such as *Code Geass: Genesic Re;CODE*.

1		4	5
2	3		6

TITLE 1 SUMMER / 2021 **2** CIGARETTE / 2021 **3** Happy Valentine / 2022 **4** Abnormal Sexual Love / 2022 **5** HAPPY / 2022 **6** CIGAR KISS / 2021 all original works

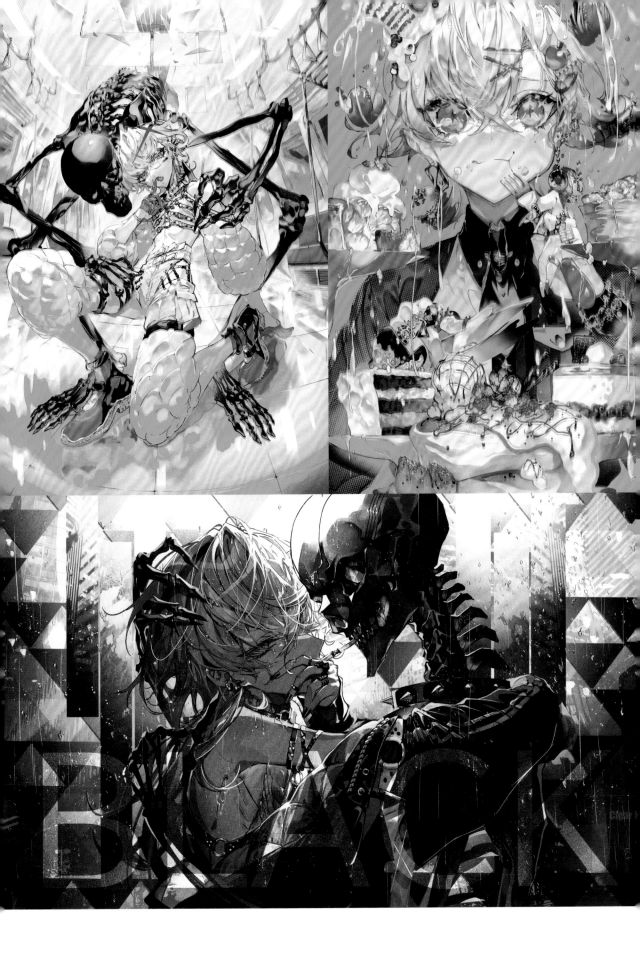

NaBaBa

TWITTER NaBaBa

TOOLS Photoshop / Wacom Intuos Pro

PROFILE Working mainly in the video game industry on character illustrations using neon colors. Worked on concept art for *Xenoblade Chronicles 2* (Monolith Soft) and teaches an illustration course at Kyoto University of the Arts.

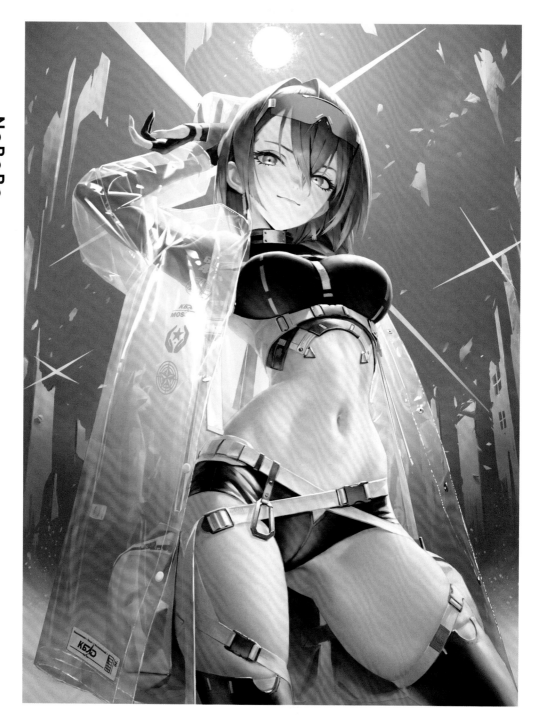

1	2	3
	4	5

TITLE **1** Debris / 2020 **2** Lilith 2 / 2021 **3** The SHARD / 2021 **4** Madness Returns / 2022 **5** Security / 2021
all original works

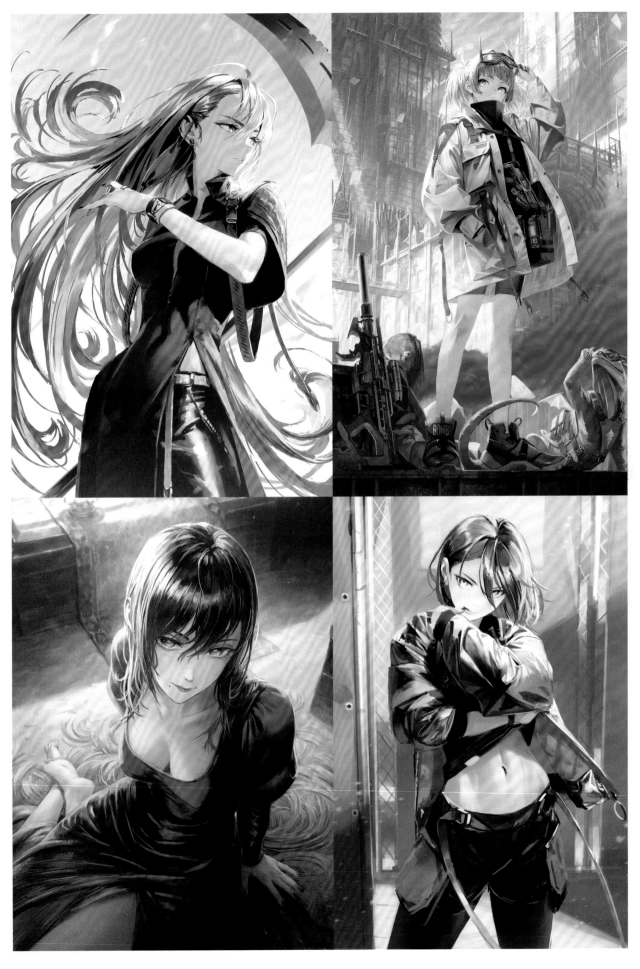

nagabe なが

TWITTER mucknagabe **E-MAIL** ketupaowlblakistoni@gmail.com

TOOLS Procreate / iPad Pro

PROFILE Born in 1993. Mainly depicts nonhumans and creatures. Published works include *The Girl from the Other Side* (Mag Garden), *Love on the Other Side: A Nagabe Short Story Collection* (Ichijinsha), and *Monotone Blue* (Libre).

TITLE **1** Fox **2** Κέρβερος (*translation:* Cerberus) **3** *caw **4** flower **5** Thin **6** sheer **7** Prayer **8** area
all original works created in 2022

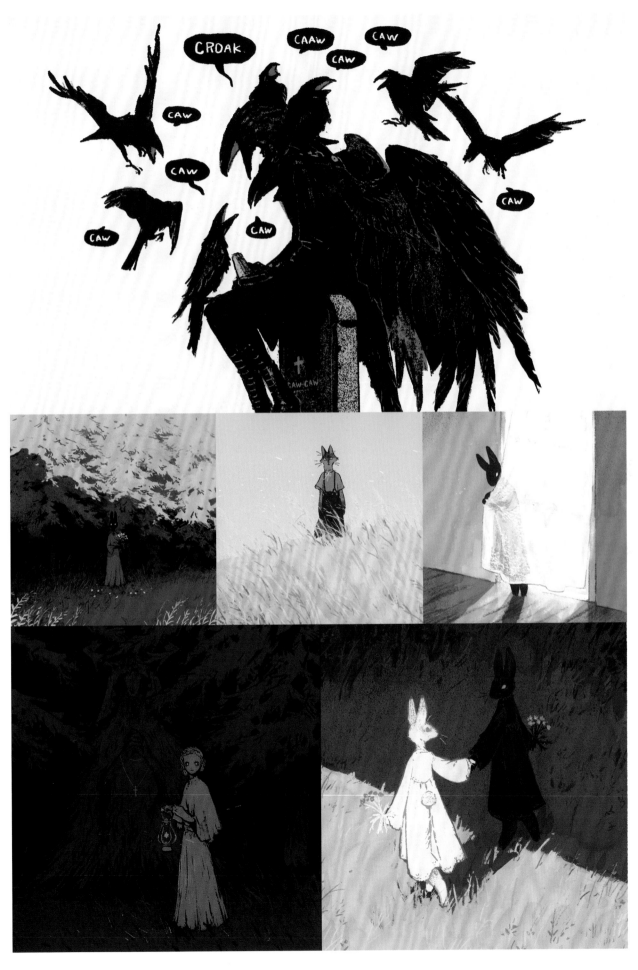

najuco

TWITTER Naju0517 **E-MAIL** najuco7105@gmail.com

TOOLS SAI / Photoshop / CLIP STUDIO PAINT / Wacom Cintiq 13HD

PROFILE Illustrator born in Akita Prefecture, now living in Tokyo. Mainly works on visuals for advertisements, song artwork, and illustrations and designs for apparel. The theme of their work is "slow, cute, and lazy."

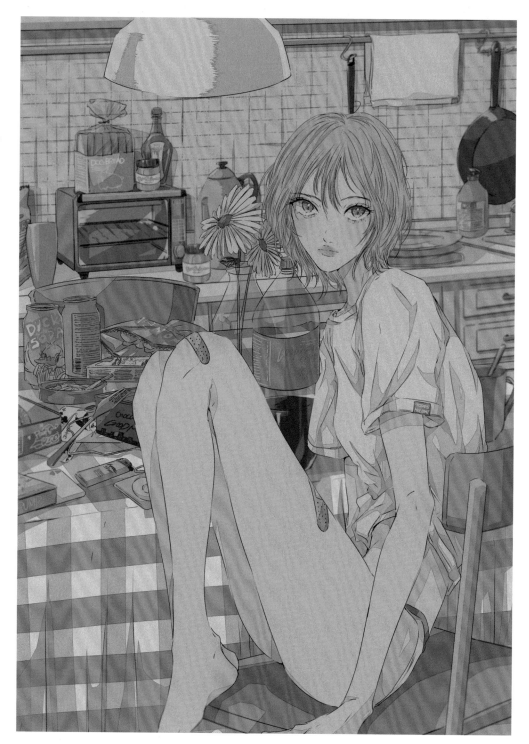

1		
	2	3
	4	5

TITLE **1** mustard **2** coolcoolcool **3** skateboardstore **4** Heaven **5** kungfuchan all original works created in 2022

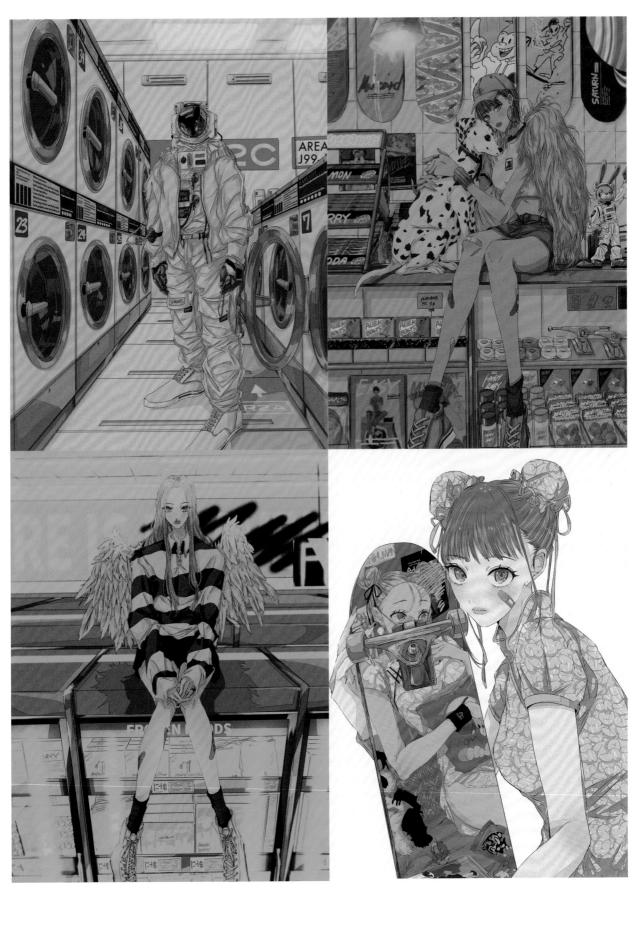

Naomi VanDoren

TWITTER NaomiVanDoren **URL** https://naomivandoren.com/

TOOLS Photoshop / Wacom Cintiq

PROFILE Artist and author from Northern California.

1		4	5
2	3		6

TITLE **1** A Good Read / 2020 **2** City in the Clouds / 2022 **3** Dragon Beach / 2022 **4** MerMay / 2020 **5** School of Magic / 2022 **6** Starbright / 2021 all original works

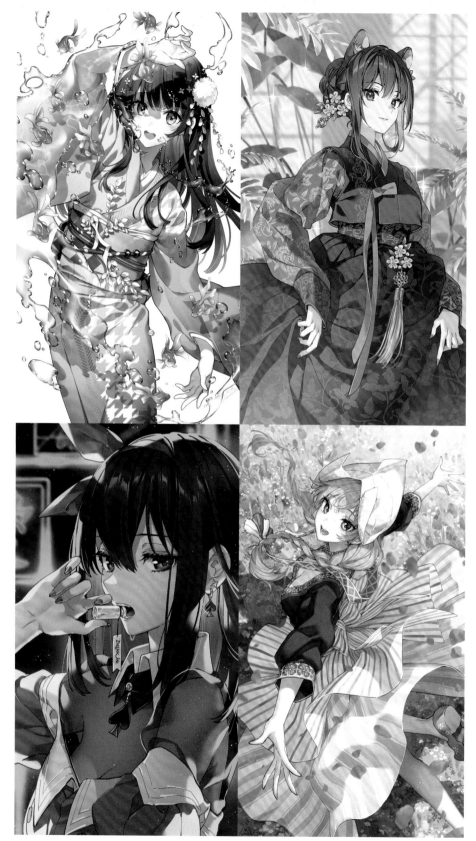

Nardack

TWITTER Nardack
E-MAIL nardack43@gmail.com
TOOLS CLIP STUDIO PAINT EX / Wacom Cintiq 27QHD
PROFILE Illustrator who loves *Sailor Moon* and magical girls. Likes to draw girls smiling brightly and shiny objects.

1	2	5
3	4	

TITLE **1** Goldfish／2021 **2** untitled／2022 **3** Drink Me／2022 **4** Girl from the Netherlands／2022 **5** HAPPY NEW YEAR 2022／2022 all original works

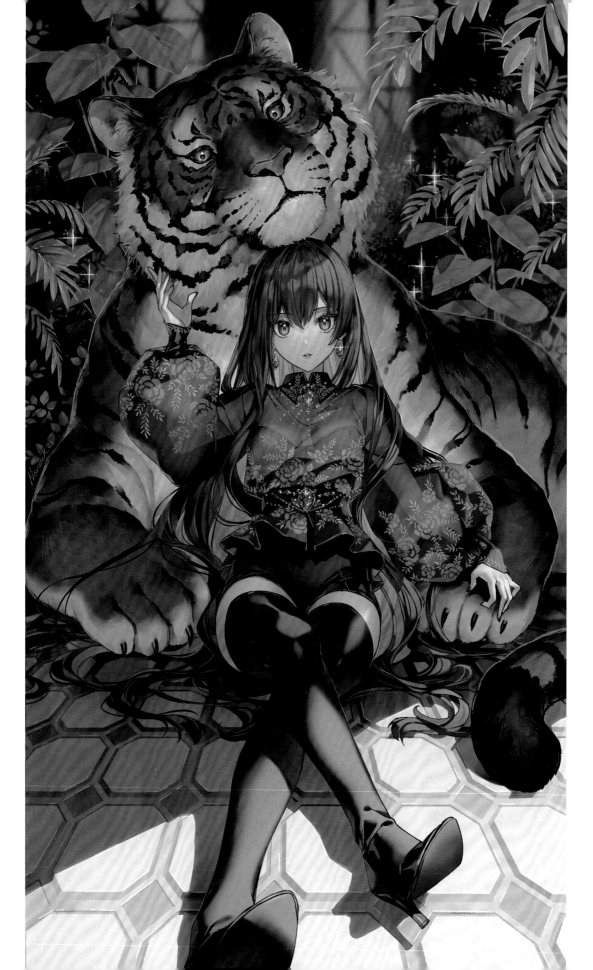

narume なるめ

TWITTER narumeNKR **E-MAIL** narumemei@gmail.com

TOOLS CLIP STUDIO PAINT / Photoshop / Wacom Cintiq 22

PROFILE Born in 1992. From north Hokkaido, now lives in the Kanto area. Illustrator and manga artist. Raised on BBS (bulletin board system) drawing sites. Major works include the manga ILY. (3 volumes / Houbunsha COMIC FUZ).

TITLE 1 With Your Voice **2** From the Ultramarine **3** Orutana **4** Swaying all original works created in 2022

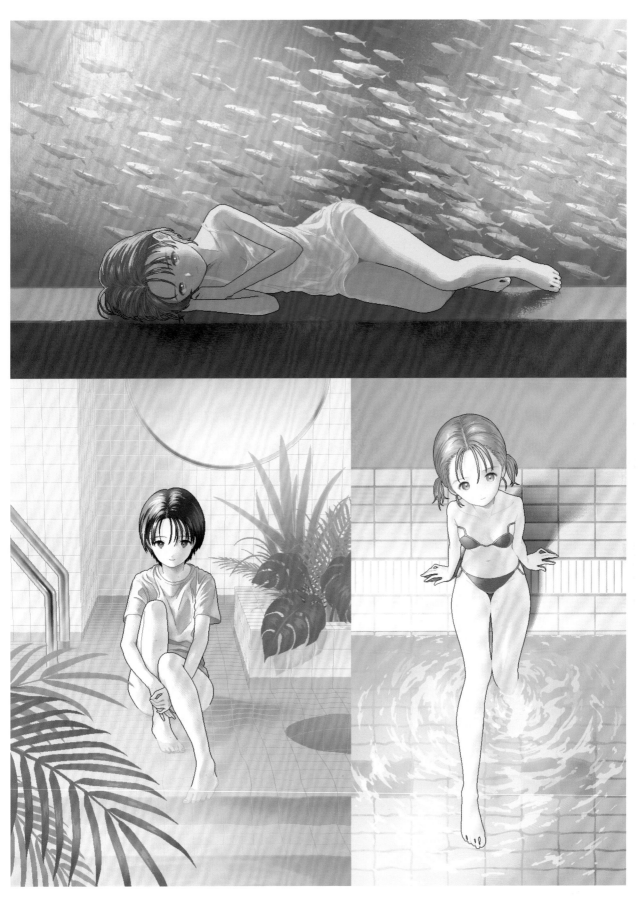

NATSUME LEMON 夏目レモン

TWITTER remon101121 **URL** remon101121.wixsite.com/mysite

TOOLS Photoshop / Wacom Cintiq

PROFILE Published *NATSUME LEMON Artbook -CITRON-* through Tokuma Shoten. Serializing a "making-of" segment using a variety of art materials in *Small S*. Did the cover illustrations for the *Koukyuu no Kenshi Nyokan* (*The Lady Coroner of the Inner Palace*) series (KADOKAWA). Also works on character illustrations for social network games. Creates works using both analog and digital techniques.

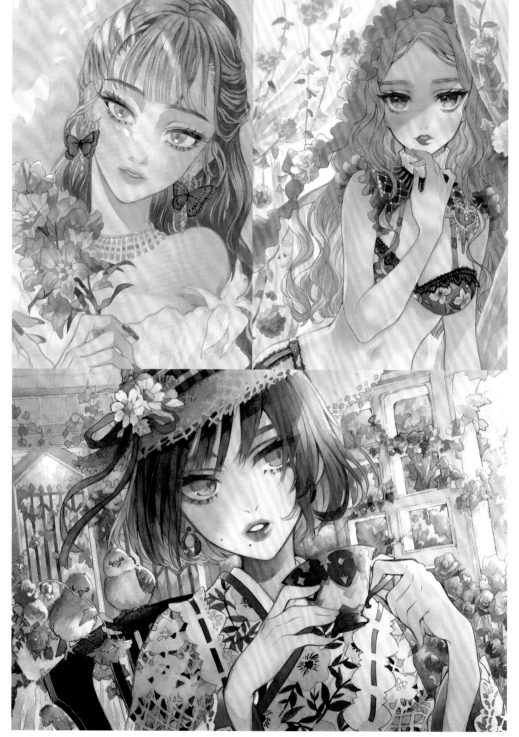

TITLE **1** lavender / 2022 **2** citron / 2020 **3** A Moment's Bliss / 2019 **4** lilac / 2022 all original works

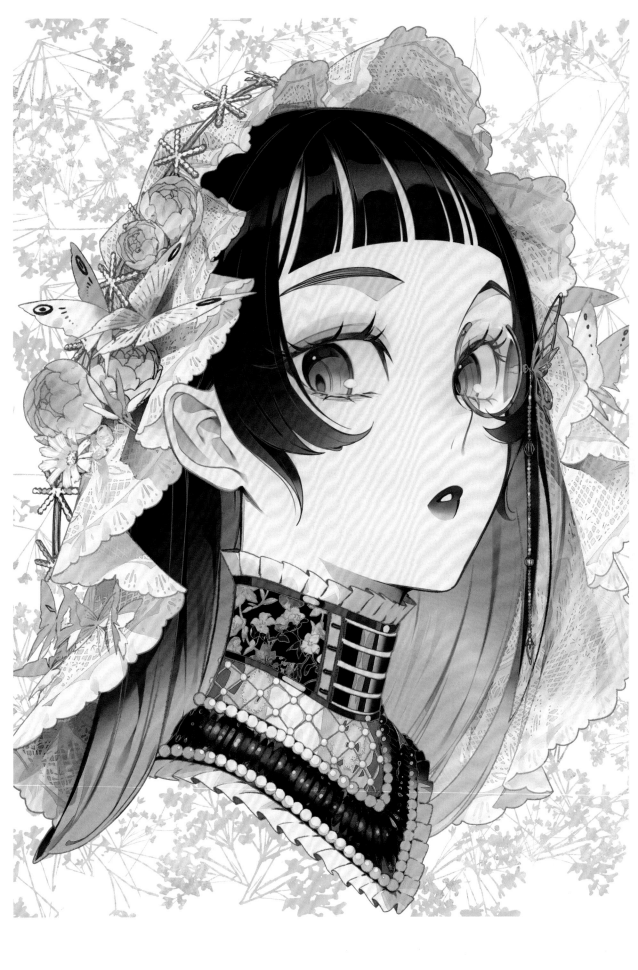

NAY

TWITTER Nay_Akane **E-MAIL** nayakane707@gmail.com

TOOLS Procreate / iPad

PROFILE Born in China. Specializes in fusing designs and creativity into art. Wants to express themselves more freely.

1	2	3
	4	5

TITLE **1** Pines and Cranes / 2022 **2** Moth / 2021 **3** Tiger Hunt / 2022 **4** AKANE / 2021 **5** Chess x Maid / 2022
all original works

謹賀新年 2022

Neg

TWITTER 101Neg **E-MAIL** negsan101@gmail.com

TOOLS Procreate / iPad

PROFILE
Developed an interest in art following college graduation. Gave up on further studies and started down the path of art. Likes to create illustrations that tell an entire story in a single image.

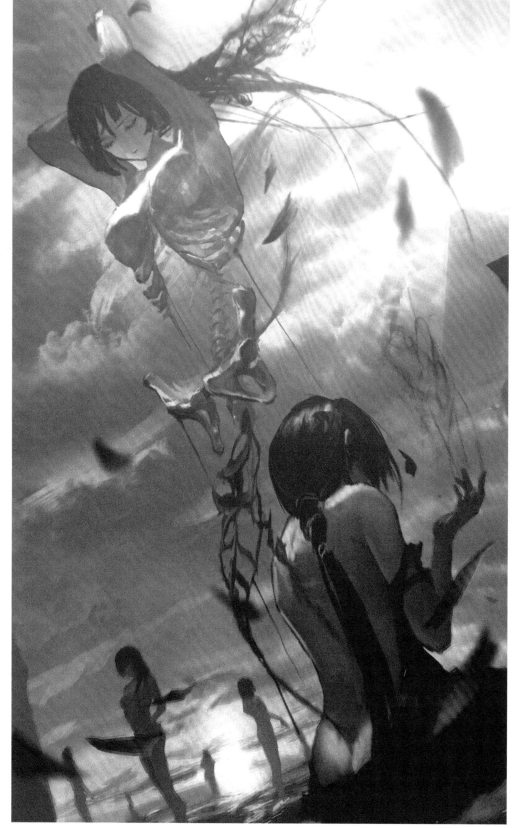

1	2	3
	4	5

TITLE **1** A Curse Where I Simply Keep Multiplying / 2021 **2** Stop / 2021 **3** Dream / 2022 **4** The Last Flower / 2022 **5** Hole / 2022 all original works

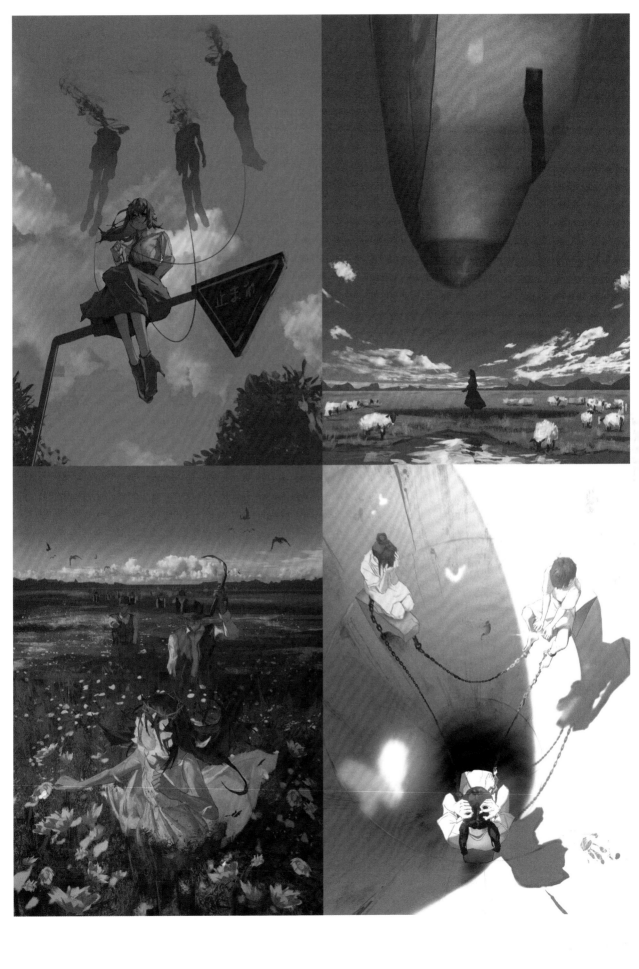

NEKOYAMA IORI 猫山依梨

TWITTER nekoyama_iori_

TOOLS CLIP STUDIO PAINT / Blender / iPad / Huion Kamvas Pro 16 Plus (4K)

E-MAIL nekoyamaaaaa@gmail.com

PROFILE Started working as a freelance illustrator in 2021. Likes doing illustrations of cute girls and accessories.

1	3
2	

TITLE **1** Hourglasses / 2022 **2** Red Heart (*note:* the title is an idiom; the phrase "red heart" indicates a love that is sincere and true) / 2021 **3** Nemophila / 2022

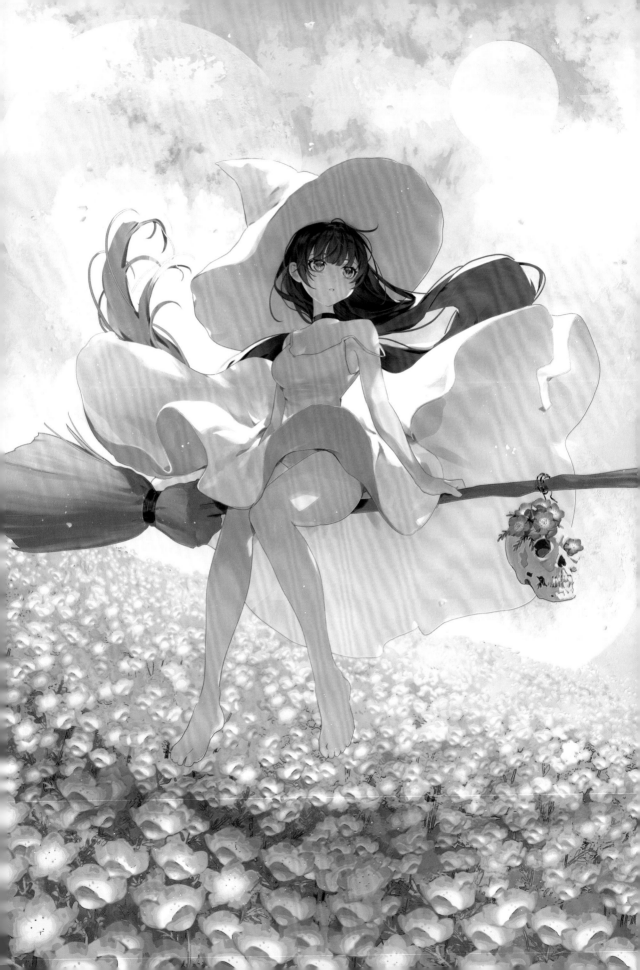

Nia

TWITTER
x_x02_

TOOLS
CLIP STUDIO PAINT / Huion

E-MAIL nia0521xx@gmail.com

PROFILE
Born in 2002. Specializes in characters who have an air of melancholy and compositions reflecting dark atmospheres or quiet insanity. Has an interest in fashion and frequently draws characters wearing what they would like to wear themselves.

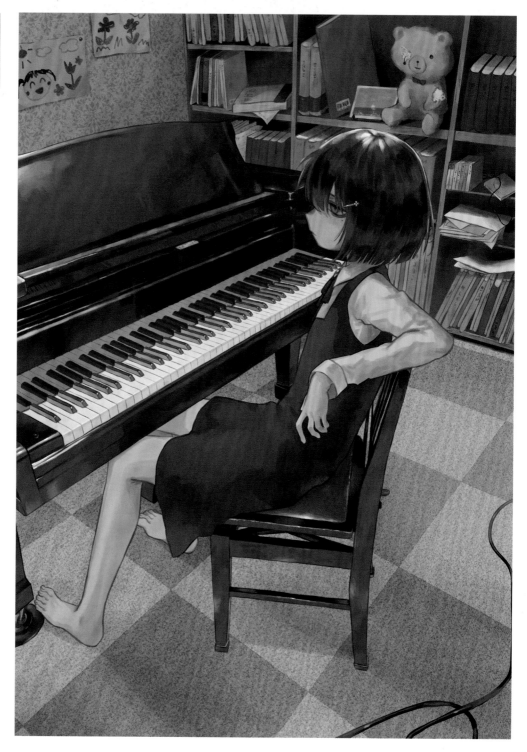

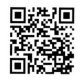

| 1 | 2 | 3 |
| | 4 | 5 |

TITLE 1 Boredom / 2022 2 119 (*note:* the Japanese emergency number) / 2021 3 void / 2022 4 Room / 2020 5 Salvation / 2022 all original works

niko4696

TWITTER niko_4696　　**E-MAIL** nikolaifletcher@gmail.com

TOOLS CLIP STUDIO PAINT EX / Blender / After Effects / Huion Kamvas 22 Plus

PROFILE Illustrator and concept artist from Canada. Also a 3D modeler and animator. Lived in Osaka for about three years.

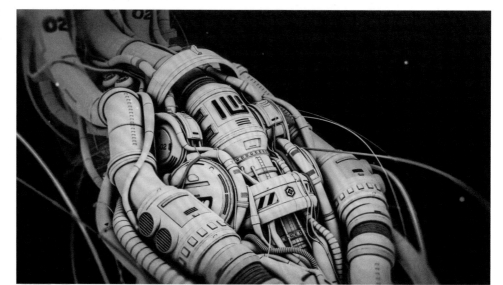

TITLE　1 biomechanica／2022　**2** REMNANT／2022　**3** Apparitions／2021　**4** BABEL-1／2020　all original works

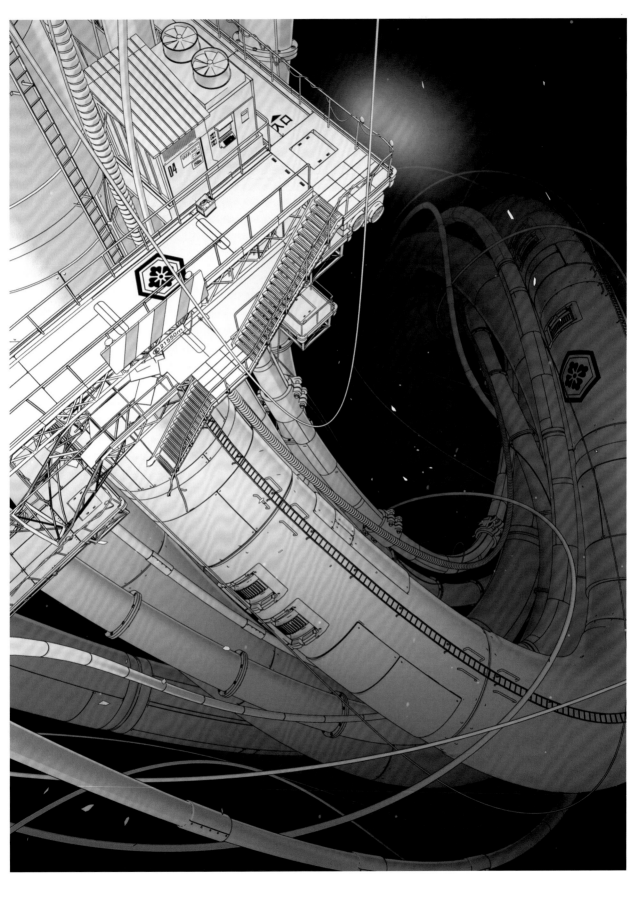

niL

TWITTER NiliiliiN25　**E-MAIL** fjui.521@gmail.com

TOOLS CLIP STUDIO PAINT / iPad

PROFILE Creates illustrations and animations while working as a beautician. Likes drawing eyes and hair.

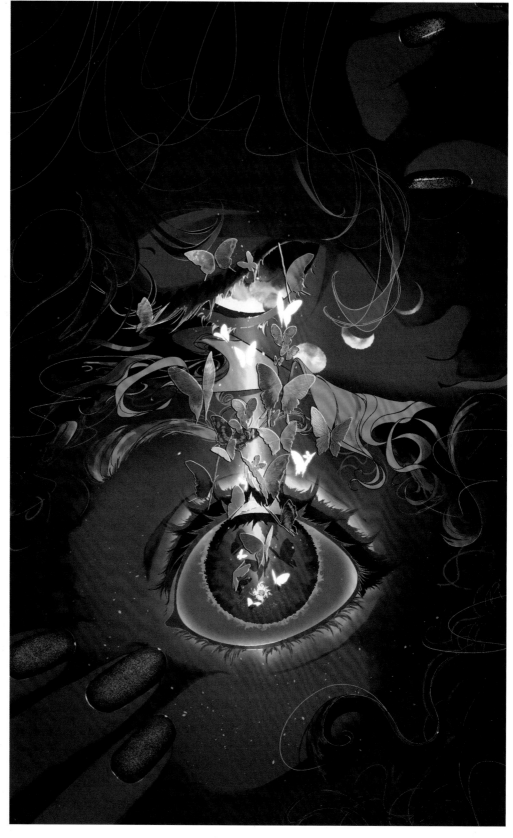

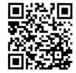

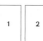

TITLE　1 Sun and Moon / 2022　**2** Shion, ver.2 / 2022　all original works

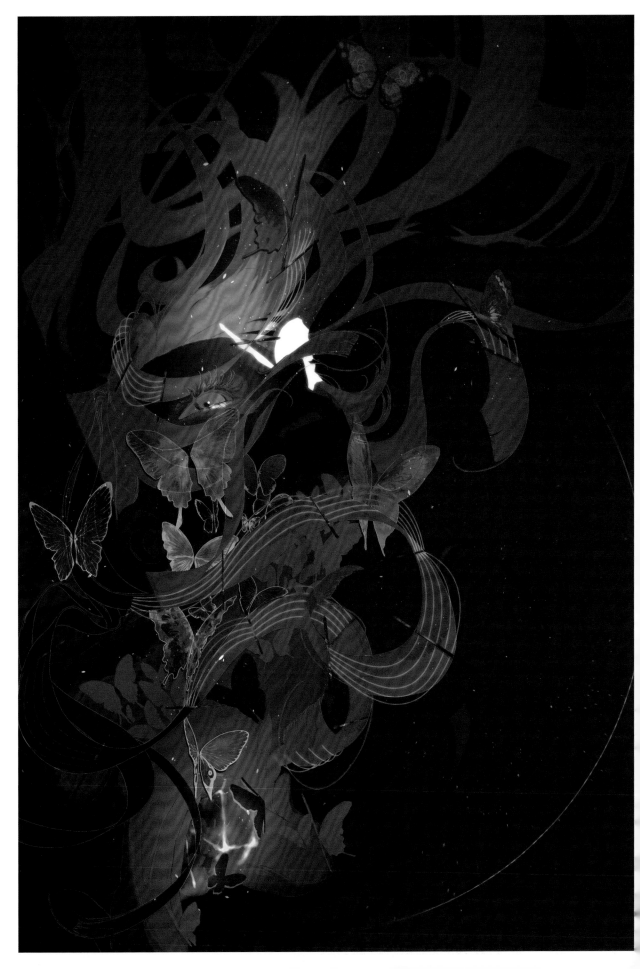

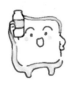

Nitanda Cona 二反田こな

TWITTER nitanda_cona **URL** https://nitandacona.work/

TOOLS CLIP STUDIO PAINT EX / Photoshop 2022 / Wacom Cintiq 16

PROFILE Works include music video illustrations for *Project Sekai: Colorful Stage! feat. Hatsune Miku* (SEGA / Colorful Palette) and the key visual for DMM Connect Chat (DMM). Moved to freelance work in winter 2021 after jobs at an anime studio and a video game developer. Expanding works into animation as well.

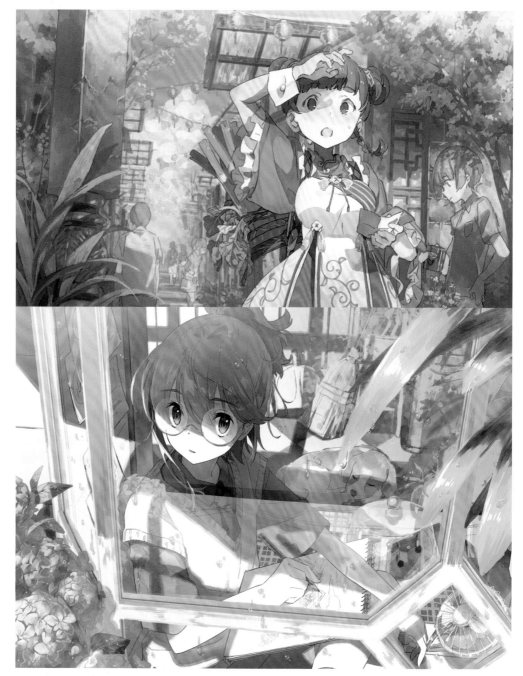

1	3	
2	4	5

TITLE **1** China Girl / 2018 **2** After the Rain / 2022 **3** Blue Santa Girl / 2021 **4** Snack Time / 2022 **5** Sleepy Senpai (*carton:* strawberry milk) / 2021 all original works

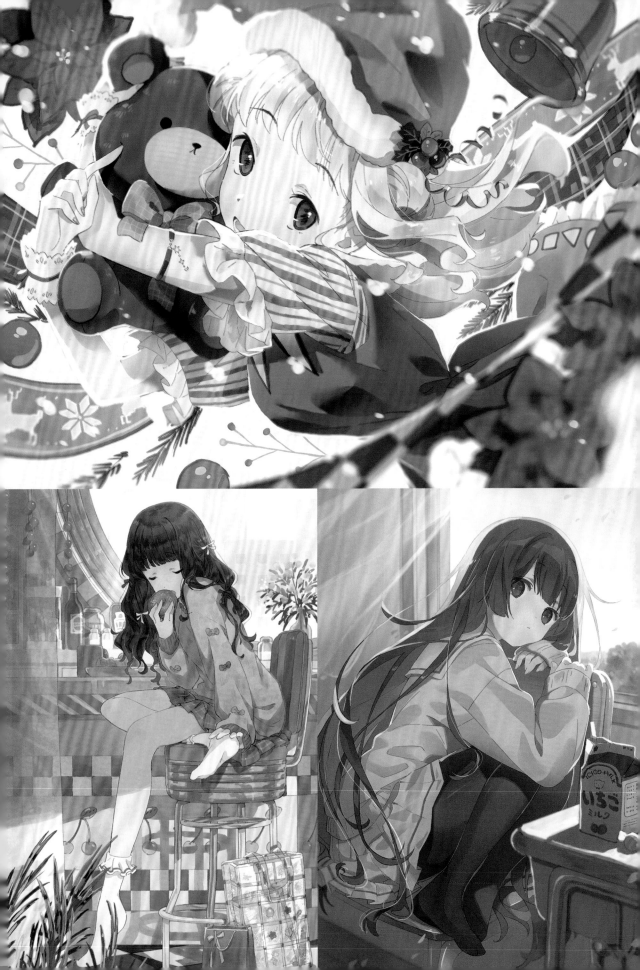

Niwa Haruki 庭春樹

TWITTER niwa_uxx **URL** https://potofu.me/niwa

TOOLS CLIP STUDIO PAINT / Wacom Cintiq Pro 24

PROFILE Manga artist and illustrator. Made their debut as a manga artist with an original one-shot. Illustrates mainly for novel covers, video games, and music videos.

1	3
2	

TITLE 1 SUMMER / 2021 **2** Swing Swing / 2020 **3** In the Garden / 2020 all original works

noco.

TWITTER itatyoko0031 **E-MAIL** nocotyo003@gmail.com
TOOLS CLIP STUDIO PAINT PRO / iPad
PROFILE Lives in Fukuoka Prefecture. Began creating original works that adopt a retro aesthetic and the theme "cute" with a single drop of poison" in 2020. Developing works that allow for multiple interpretations.

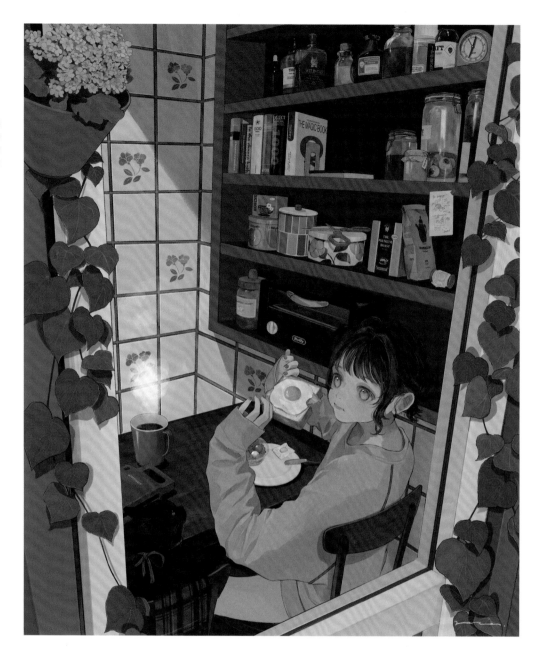

TITLE **1** Witch's Breakfast / 2022 **2** Consume Shortly After Opening (*sticker:* new product, *label:* *garbled* / price: ¥585 (with tax: ¥650) / please refrigerate) / 2022 **3** Beauty On a Deadline / 2022 **4** Laundry (Choice) (*note:* the original title is a pun; "sentaku" can mean either "laundry" or "choice") (*shop sign:* 24-hour service / Coin Laundry 13 THIRTEEN / easy washing and drying / open year-round / •antibacterial •anti-mites •high-temperature disinfecting, *top left sign:* To Our Patrons: To Improve Your Life / Please Choose ONLY ONE. / You cannot go back! 1-You may choose only once. The killed [redacted] will not come back to life. 2-The chosen one will choose next. 3-You may not refuse to choose. 4-Please live a life without regrets.) / 2022 all original works

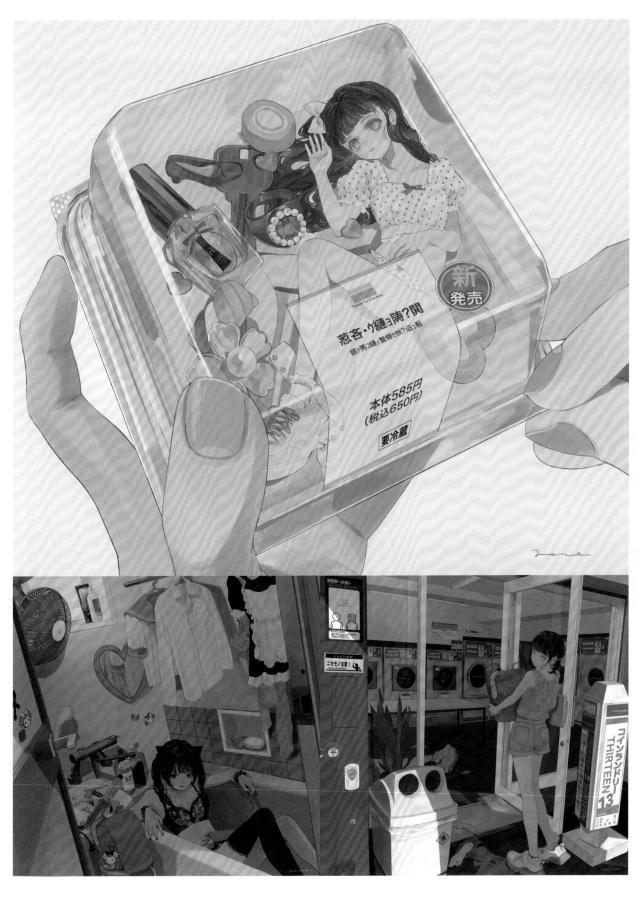

Nocopyright Girl ノーコピーライトガール

INSTAGRAM harunonioikaze **E-MAIL** nocopyrights2687@gmail.com

TOOLS Photoshop / Wacom Intuos Pro

PROFILE Nocopyright Girl is a free illustration gallery. The illustrator's name is Haru. Recent work includes a relatively high number of illustrations for music videos. Thinks the fine line between reality and fantasy is really interesting.

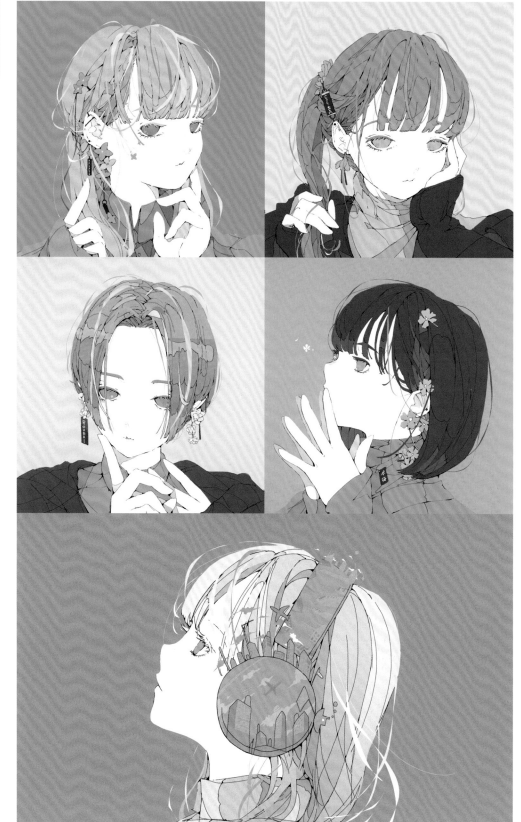

TITLE **1** Half-Up Half-Down Kalanchoe. / 2021 **2** Cyclamen Ponytail. / 2022 **3** Wintersweet Center Part. / 2022 **4** Winter Sakura Bob. / 2021 **5** Imaginary City Music. / 2022 **6** A Drawing Of A Stray Cat, For All Things Must Pass. (EKAKI: painter / ESHI: artist / WASSHOI: a rallying cheer / FREE NORA: free stray, *cat's back:* stray, *cat's fan:* spring) / 2022 all original works

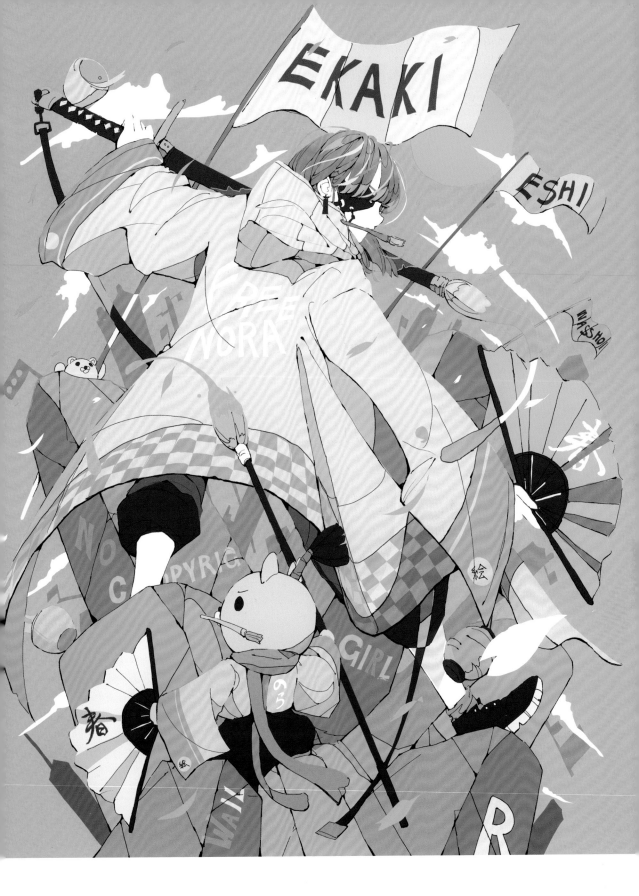

noInH ハInH

TWITTER 131_nngo **E-MAIL** noinh620@gmail.com

TOOLS CLIP STUDIO PAINT / Huion Kamvas

PROFILE Creates faintly scary pictures.

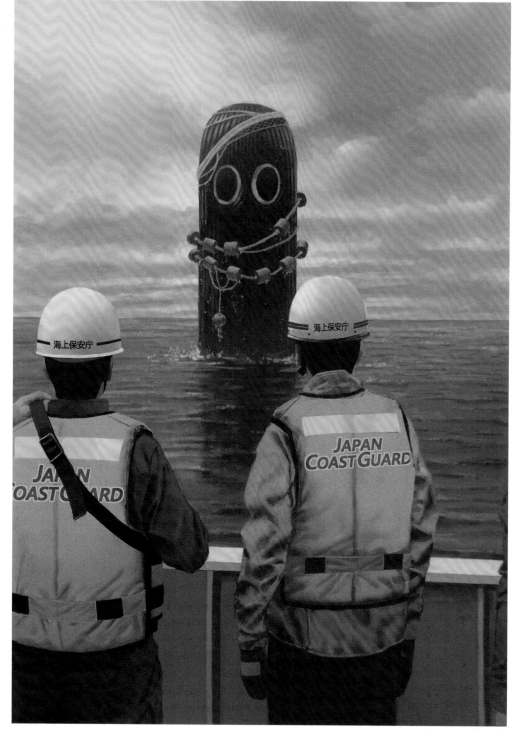

TITLE **1** Ghost **2** Discharge (*yellow sign:* Coin Operated Lockers) **3** Housing Development **4** Encounter (*red sign:* Aisle 5) all original works created in 2022

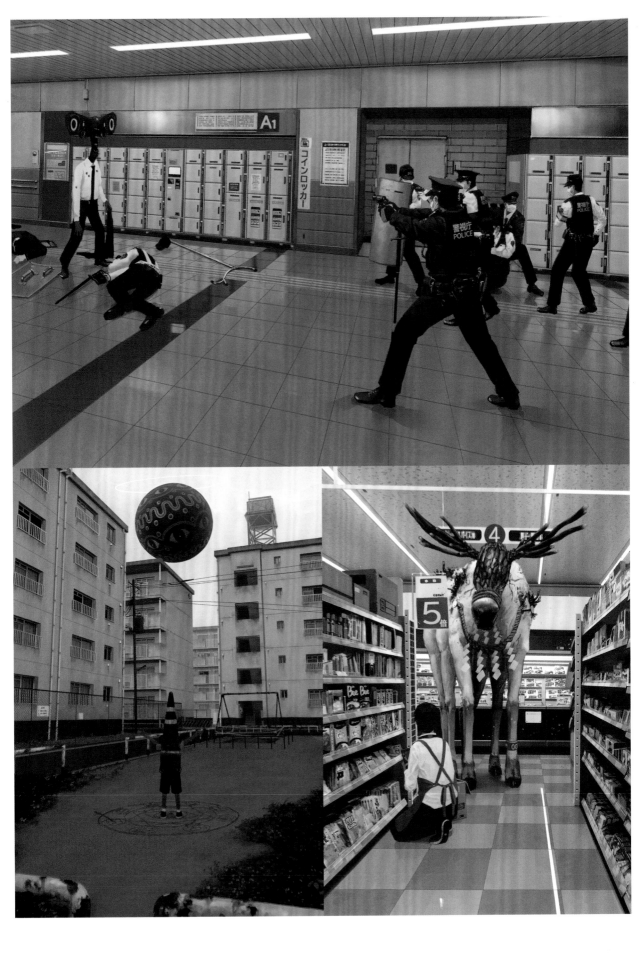

NUNOKISO 布基礎

TWITTER NUNOKISO
TOOLS Procreate / iPad Pro
PROFILE Working hard to get better at drawing. Thank you for your support.

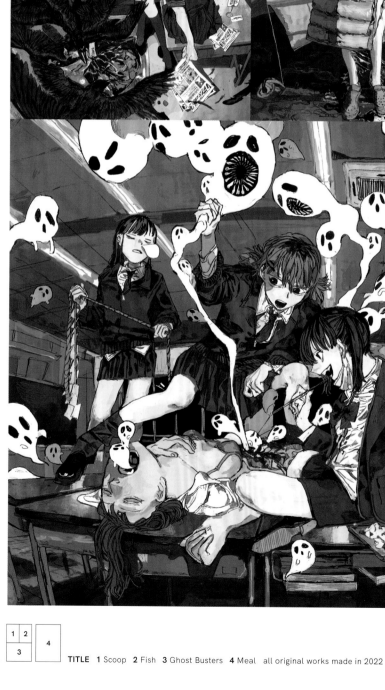

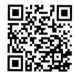

1	2	
3		4

TITLE **1** Scoop **2** Fish **3** Ghost Busters **4** Meal all original works made in 2022

pixiv user ID : 18721112

Nurikabe 塗壁

TWITTER nurikabenuri

TOOLS Photoshop / Wacom Intuos Pro Large

PROFILE Illustrator. Mainly develops original works with giant creature motifs. Focuses on illustrations for card games and social network games, but also works in a wide variety of genres like character design and background art for animation.

1	3	
2	4	5

TITLE **1** Tiger / 2022 **2** Bonsoceros (*note:* a pun; "rhino" is "*sai*" in Japanese, so the bon*sai* here includes a rhino) / 2021 **3** Turtle Terminal / 2020 **4** Brocade Dragon / 2021 **5** Braking / 2020 all original works

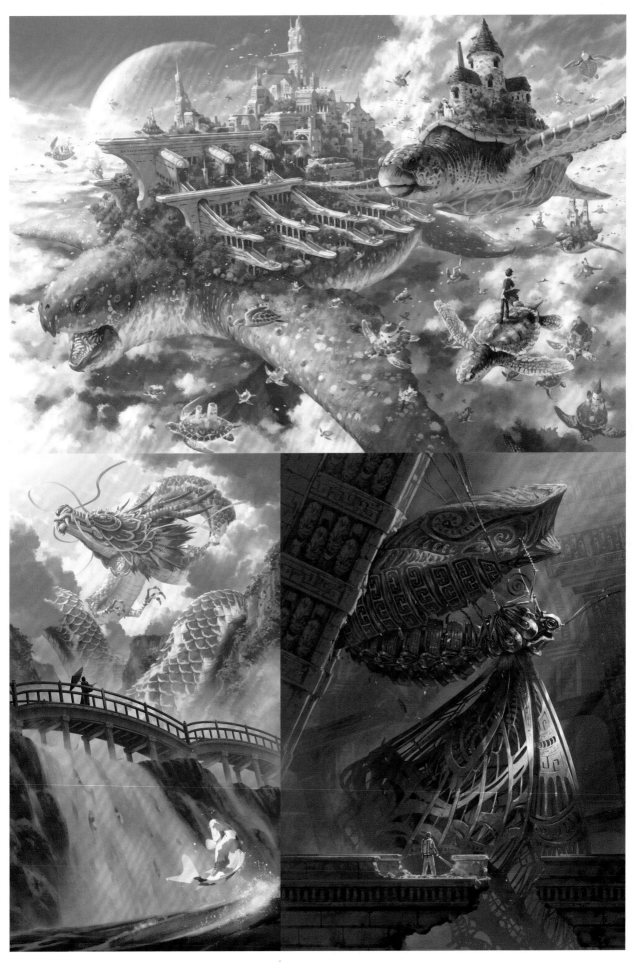

Nyan

TWITTER Nyan_2020_

TOOLS CLIP STUDIO PAINT / Wacom Intuos

E-MAIL nyan2020k@gmail.com

PROFILE Raised in Peking, graduated from college in Chicago, now building a career in Tokyo. A mainly digital artist creating illustrations, animations, and manga. Currently trying their hand at new methods of expression, and aiming to deliver new works to the world in the near future.

1	4
2	5
3	6

TITLE **1** Intact / 2020 **2** Mask / 2022 **3** PetriDish / 2021 **4** Seagull / 2020 **5** Comfort Zone / 2020 **6** Wings / 2020 all original works

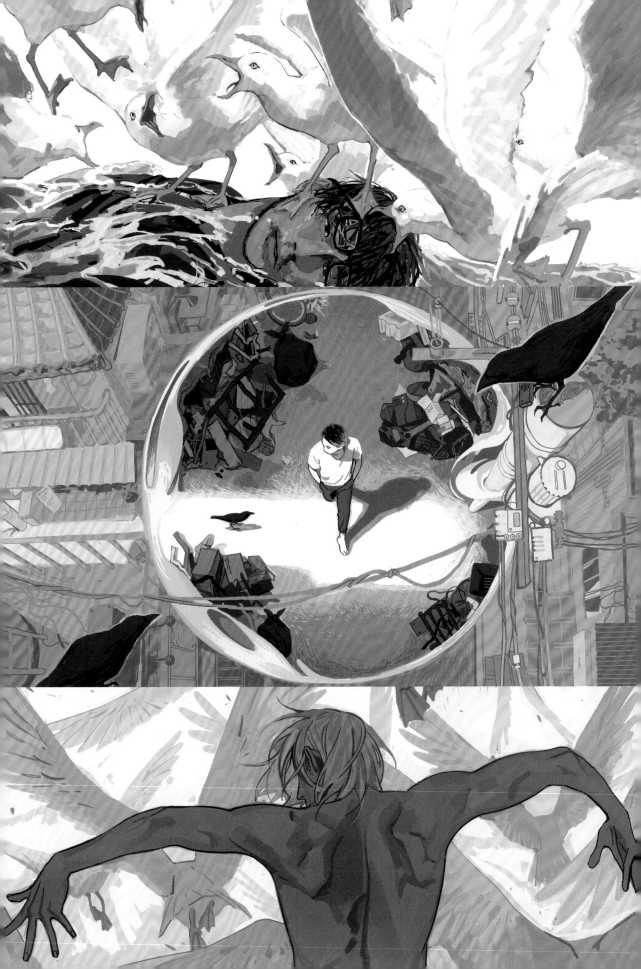

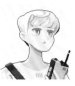

ONIONLABS

TWITTER instant_onion **E-MAIL** nelsonwuart@gmail.com

TOOLS Photoshop / Artisul D16

PROFILE Toronto-based pixel artist and illustrator. Currently working in the video game and entertainment industry. Takes inspiration for many works from experiences traveling across Asia and aims to reflect that experience through elements in their work such as urban architecture and food design.

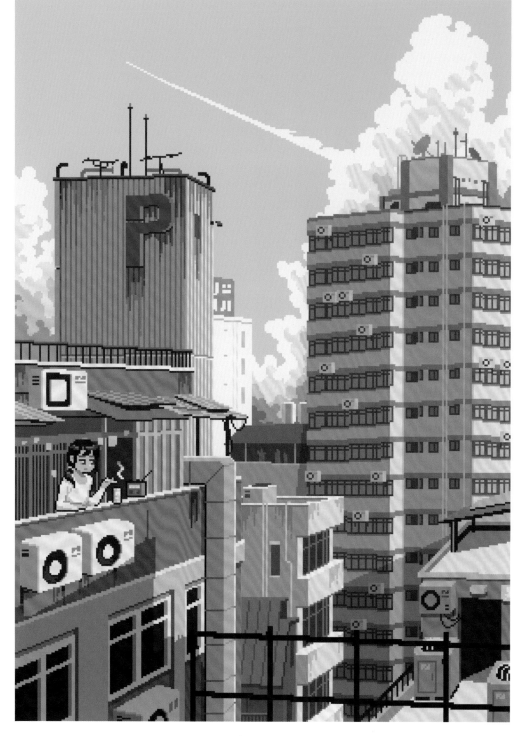

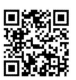

1	2
	3
	4

TITLE **1** Easier Days / 2021 **2** MT FUJI / 2021 **3** March Onwards (*green sign:* waku waku! (*excited*) / ume beer, *white sign:* (no U-turn) from here) / 2022 **4** Departing / 2021 all original works

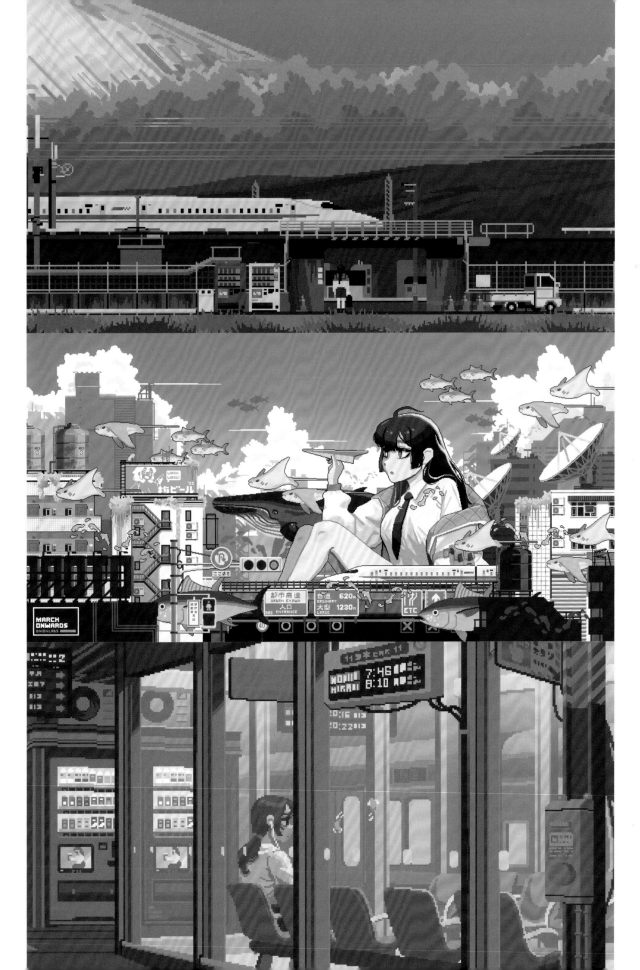

orie

TWITTER orie_h **E-MAIL** i8artwork@yahoo.co.jp
TOOLS CLIP STUDIO PAINT / One by Wacom
PROFILE Has developed character designs, book covers, music video illustrations, and designs for merchandise. Their artbook *ILLUSTRATION MAKING & VISUAL BOOK orie* was released through Shoeisha.

TITLE 1 What Makes Me Sad Is That You Know How Flowers End／2021 **2** Close to Tears／2022 **3** Witch／2022
4 Life Is Full Of Feelings, Isn't It?／2022 **5** hydrangea／2022 all original works

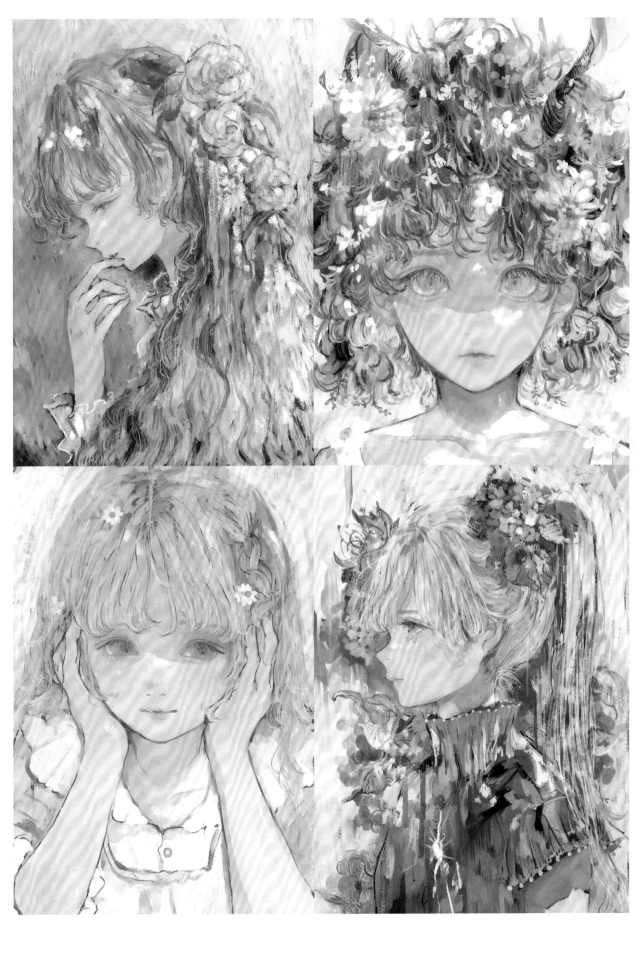

Otiakan おちあ缶

TWITTER tyawantyawan356 **E-MAIL** nekonekonekonekotarako@gmail.com

TOOLS drawing chats / MagicalDraw / GAOMON M106K

PROFILE Lives in Hyogo Prefecture. Mainly creates original works in drawing chatrooms. Likes nonhuman creatures more than humans.

1	2
	3

TITLE **1** Blacksteel Skeleton Type 2 **2** Blacksteel Skeleton Angel Type ? **3** Blacksteel Skeleton Legion
all original works created in 2021

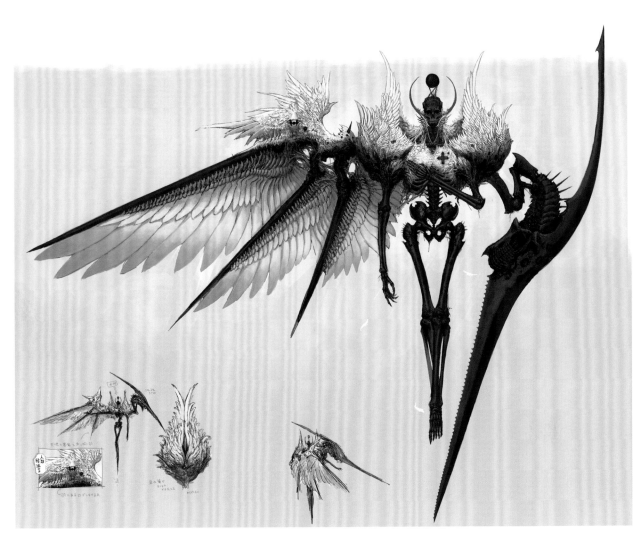

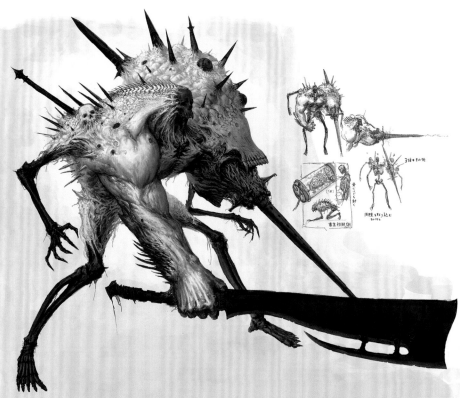

Ozaki Domino 尾崎ドミノ

TWITTER ozadomi **URL** https://ozakidomino.studio.site/

TOOLS Photoshop CC / CLIP STUDIO PAINT / Wacom Cintiq Pro

PROFILE Worked on the artwork and character designs for *Evil Prince and the Puppet*. Also works on light novel cover illustrations and apparel design. Aims to create illustrations that tell stories.

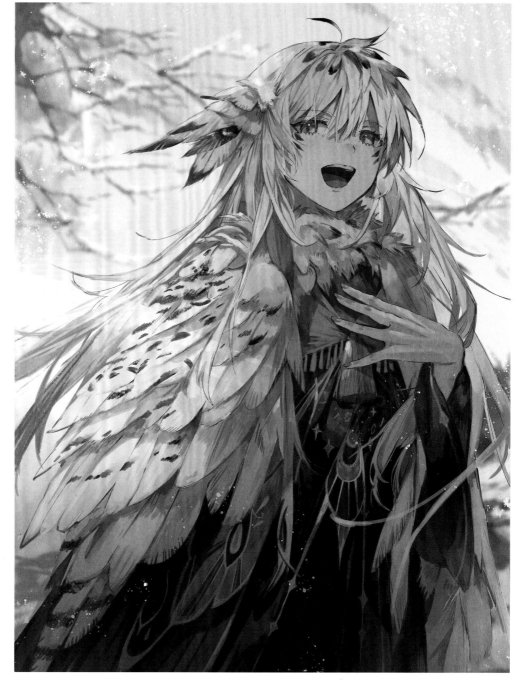

| 1 | 2 | 3 |
| | 4 | 5 |

TITLE **1** Snowy Owl's Song / 2022 **2** I Wanted To Become a Butterfly / 2021 **3** The Night Before Christmas / 2021 **4** Kakizome (*note:* calligraphy of auspicious words drawn first thing in the new year to bring about prosperity) / 2021 **5** Dreaming Bird / 2022 all original works

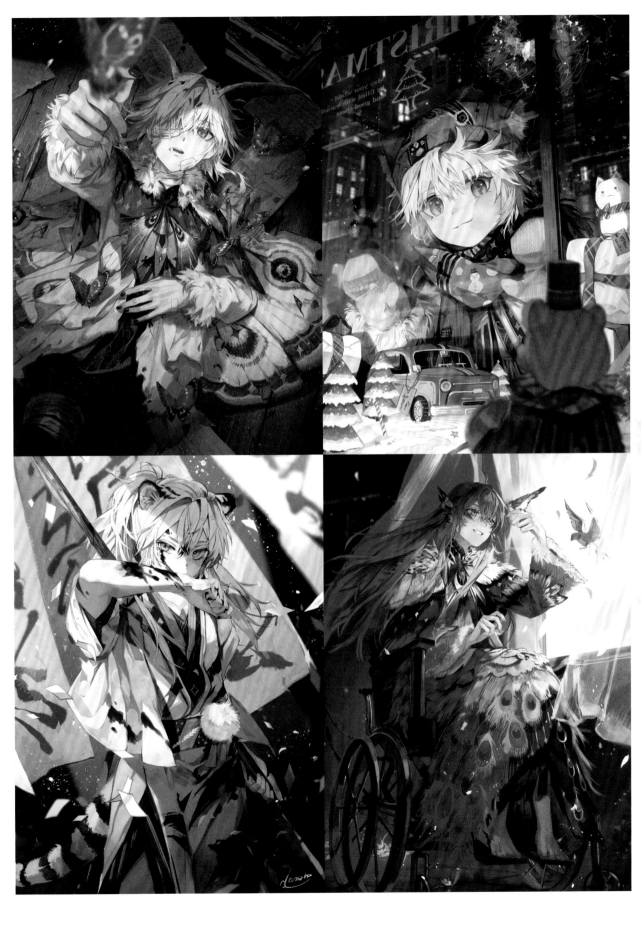

PALOW.

TWITTER PALOW_ **E-MAIL** palownakamura@gmail.com

TOOLS Photoshop / Wacom Intuos Pro

PROFILE Character designer and illustrator. Major works include Bug Mecha Girls, the character designs for the VSingers KAF and RIM, and the character designs for HAL College of Technology & Design's 2016 TV spot.

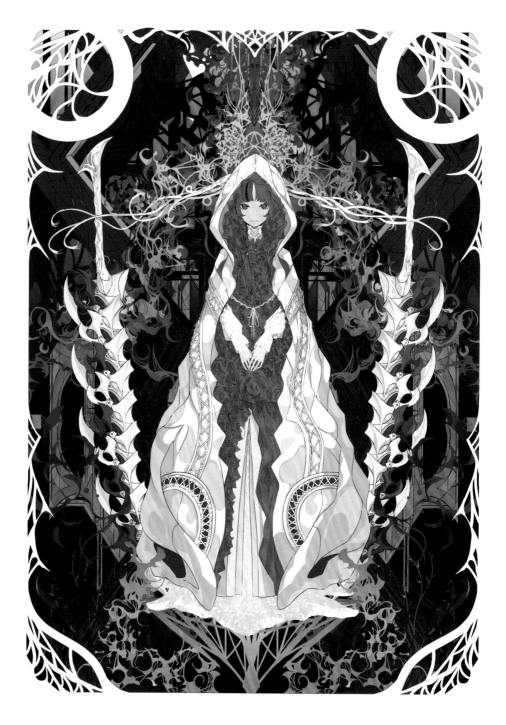

1	2

TITLE **1** Experimental 02 **2** Experimental 01 all original works created in 2022

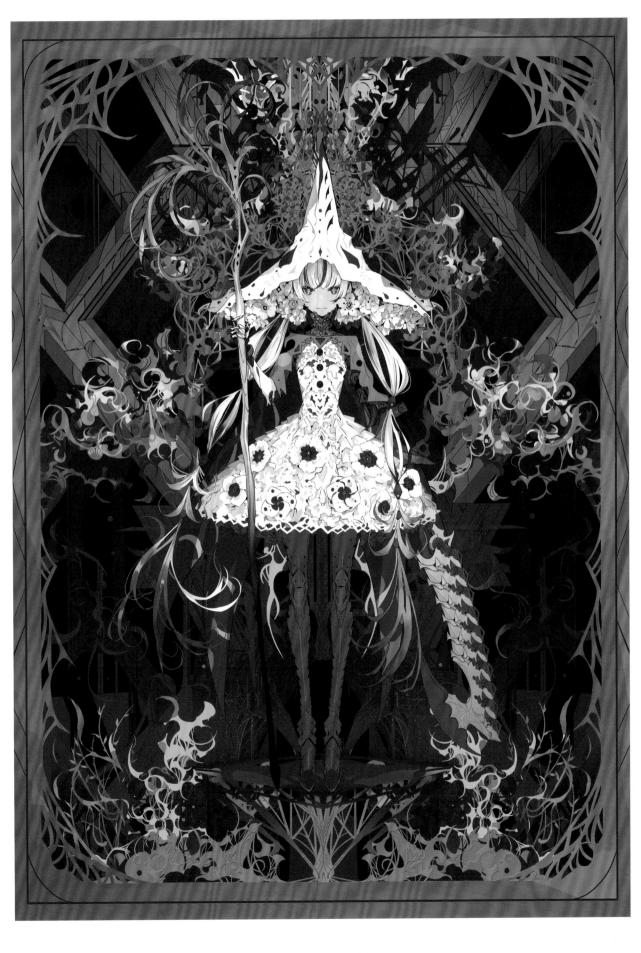

paperlarva

URL https://paperlarva.com/

TOOLS Procreate / iPad Pro

PROFILE A unit linked by love of fate and art. Their works are both love letters and explorations of the surreal.

E-MAIL paperlarvashop@gmail.com

TITLE **1** Cut Here **2** Paper Larva **3** Sink or Swim **4** Sweet Dreams **5** (Un)living Room all original works created in 2021

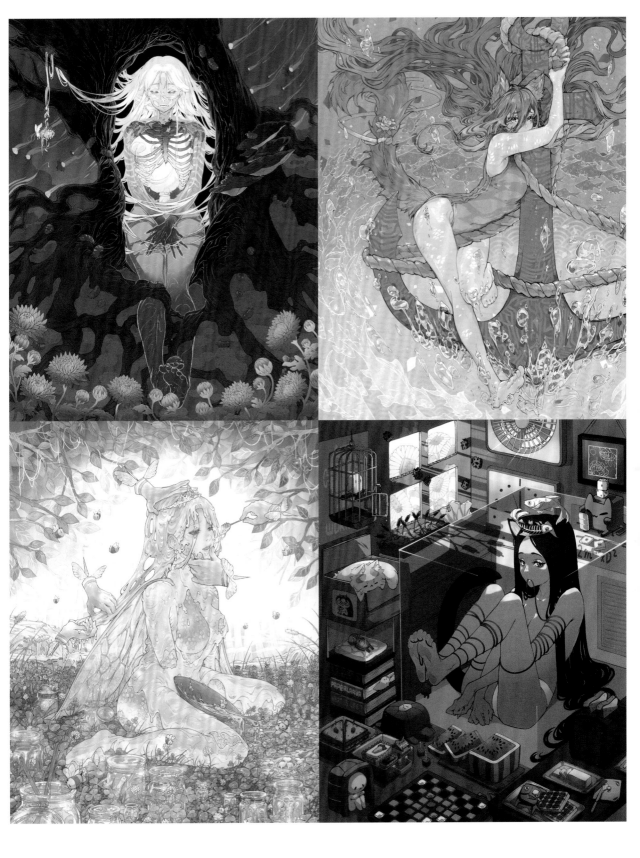

pikaole

TWITTER pikaole **URL** pikaole.com
TOOLS Photoshop CC / Wacom Intuos4
PROFILE Creating various animal-related pieces (illustrations, GIF stickers, etc.) featuring creatures like freshwater fish, marine life, birds, and insects. Creates said works so that more people come to love all these creatures.

1		3	4
		5	6
2		7	8

TITLE **1** Cephalopod / 2020 **2** Shark Day / 2020 **3** Wild pigeon / 2021 **4** Baby polypterus / 2021 **5** Sea Slug Jelly Beans / 2021 **6** Betta / 2022 **7** Bats / 2020 **8** The year of the big cat cubs / 2022 all original works

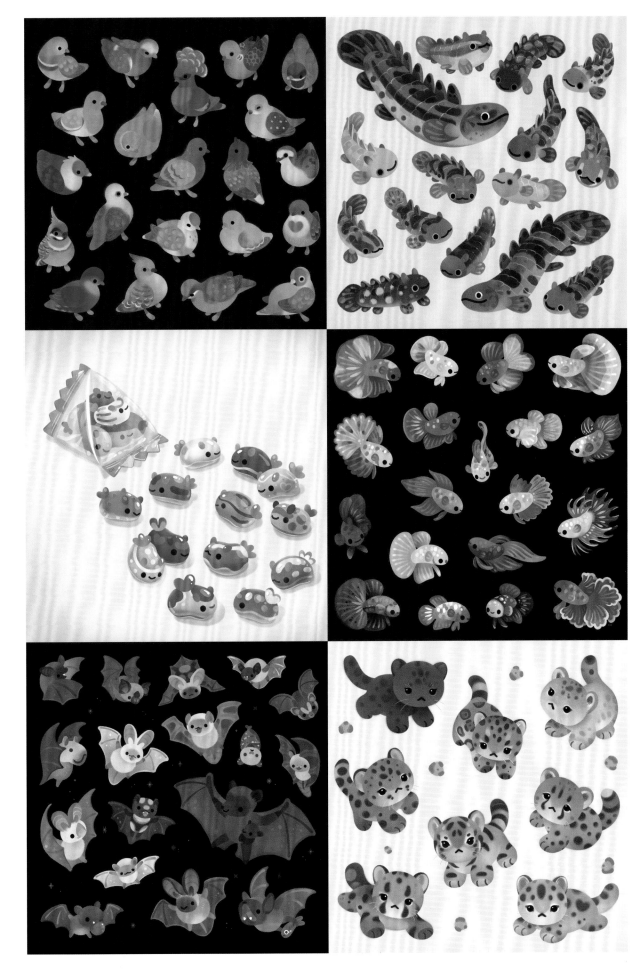

PONKO

TWITTER PONKO517 **E-MAIL** PONKO.0517o@gmail.com

TOOLS CLIP STUDIO PAINT / iPad

PROFILE Born in 1998, lives in Kansai. Draws what they think is sparkly and cute using vivid, colorful expression. Started over as a freelance illustrator in 2022, now expanding the range of their work.

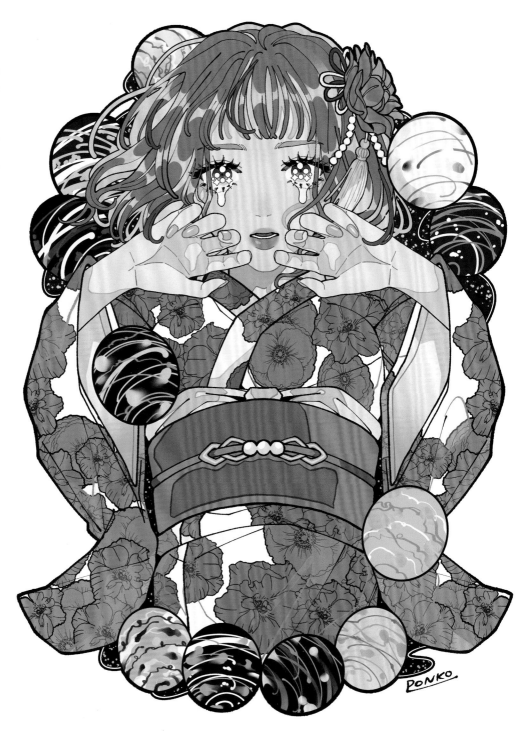

TITLE 1 Before My Emotions Completely Wither **2** Ramen ILY **3** spring **4** Kawaii New Face **5** I Just Wanted To Be Born a Bunny all original works created in 2022

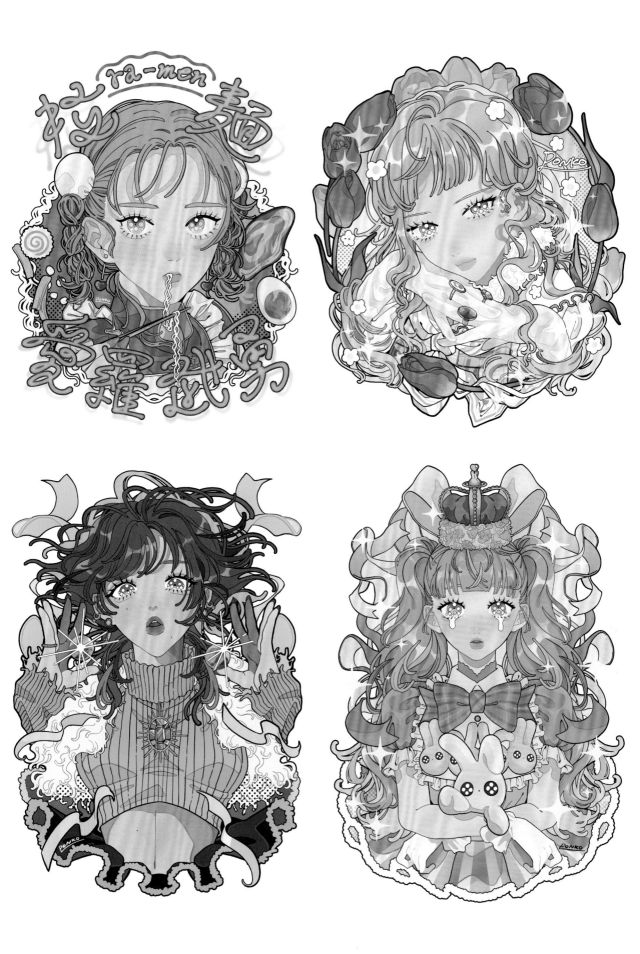

potg

TWITTER potg333 **E-MAIL** potgworkz333@gmail.com

TOOLS CLIP STUDIO PAINT EX / Wacom Cintiq 16

PROFILE Draws girls and backgrounds. Especially loves sunlight filtering through the leaves, white dresses, and long hair!

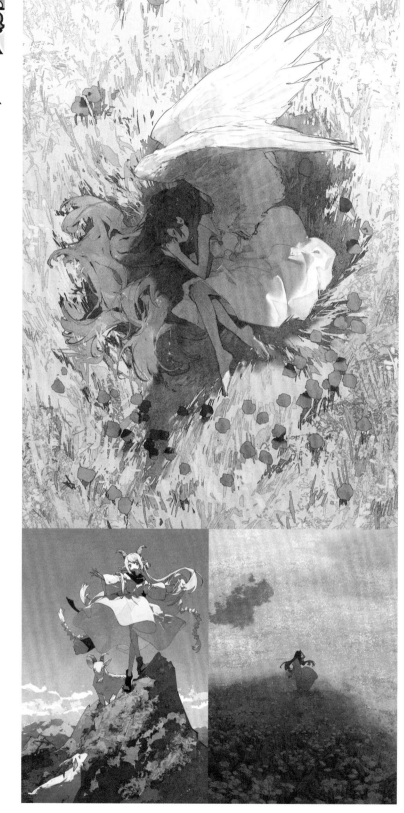

		4	5	6
1		7	8	9
2	3	10	11	12

TITLE **1** Shade / 2021 **2** I Always Thought "Koyagi" Was Pronounced "Koyari" (*note: "koyagi"* means "young goat," *"koyari"* means small spear) / 2021 **3** Descending / 2022 **4** In the Sea Forest / 2021 **5** Flowers / 2021 **6** Wall of Flowers / 2021 **7** Roof of Flowers / 2021 **8** Staircase / 2022 **9** The Sakura Have Bloomed! / 2022 **10** Fallen Leaves / 2021 **11** Mermaid's Song / 2022 **12** Sunset and the Witch / 2021 all original works

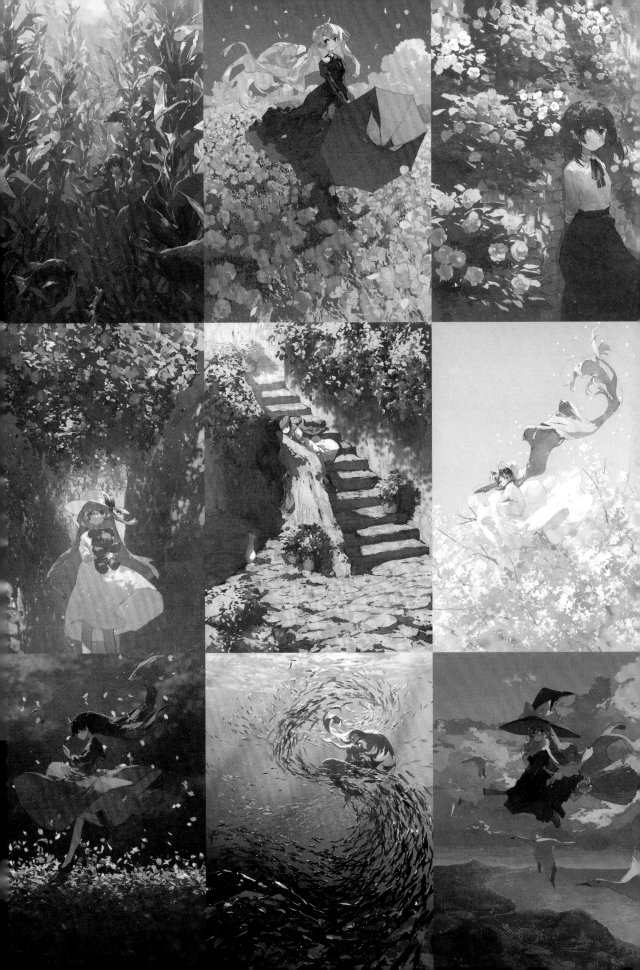

Puré フレー

TWITTER komemerda **E-MAIL** komemerdas@gmail.com

TOOLS CLIP STUDIO PAINT / iPad Pro

PROFILE

Hello. I am Puré from Portugal. Right now, my obsession is drawing European folk clothing and goats. My hobby is embroidery, and I think I reflect that in my art. Thank you so much for taking the time to view my works.

1	3
2	

TITLE **1** cats／2020 **2** goats／2022 **3** Original／2022 all original works

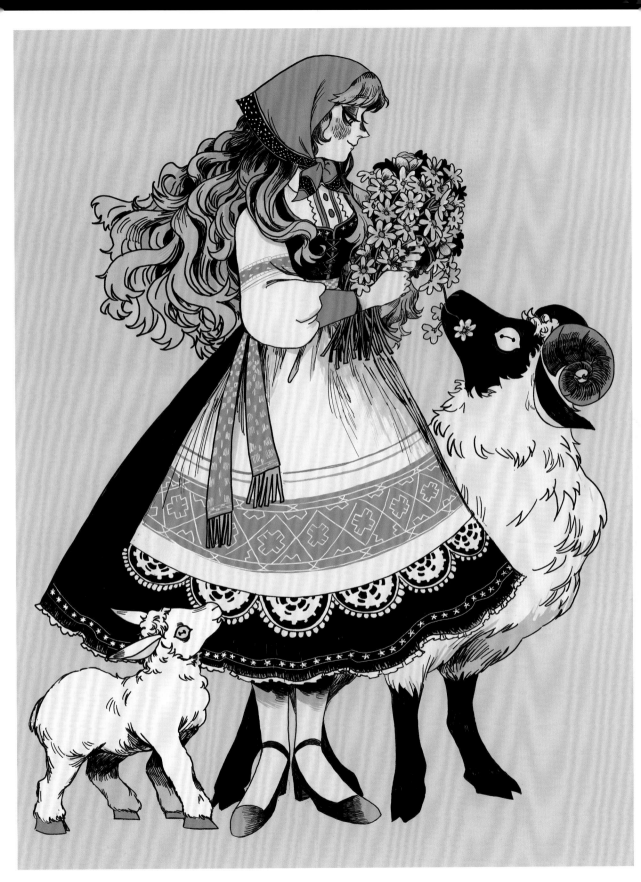

Quuni 九酱子

TWITTER MontblanC_9_ **E-MAIL** montblanc9@163.com

TOOLS Photoshop / Wacom Cintiq Pro 24

PROFILE A cat-loving illustrator living in Shanghai. Likes rendering textures and is always battling to improve the quality of their art. Mainly works on character designs and key art, including those for *Banner of the Maid* and *Echoes of Vision*.

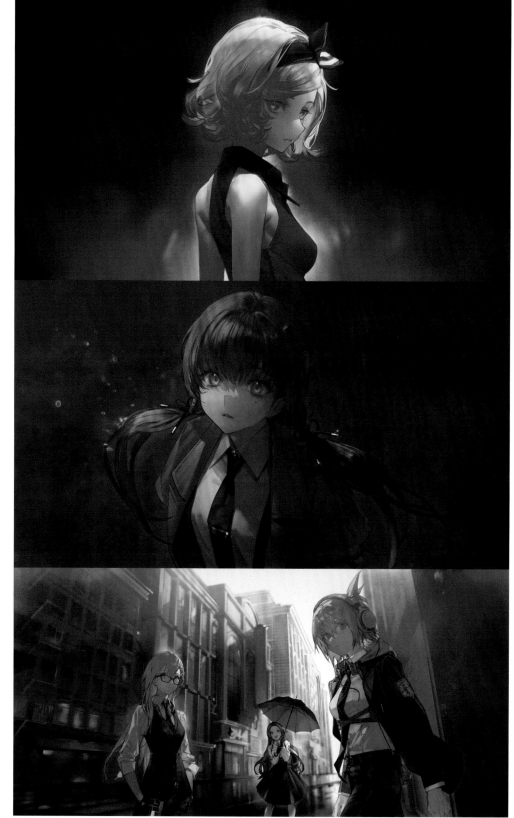

TITLE 1 Gracey / *Echoes of Vision* promo video illustration ① / 2022 **2** Ring / *Echoes of Vision* promo video illustration ② / 2022 **3** street / *Echoes of Vision* advertisement illustration / 2021 **4** Gracey / *Echoes of Vision* Gracey Forva / 2021 **5** Ring / *Echoes of Vision* Ring Rand / 2021

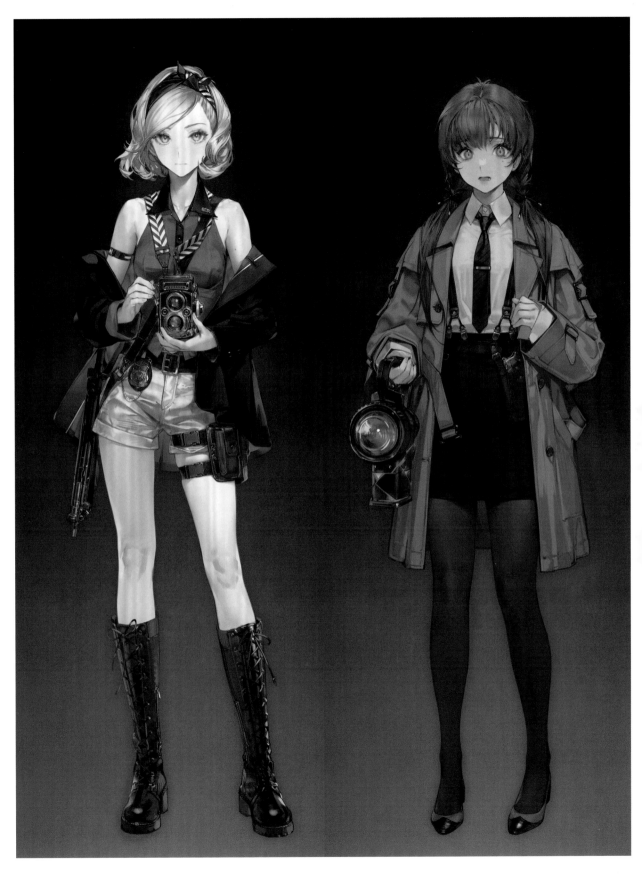

rab

TWITTER ququiqing **E-MAIL** 958586340@qq.com

TOOLS SAI / Wacom CTL-671

PROFILE Born in China in 1999. Currently at university. Likes drawing using brightly-colored surfaces and interesting compositions. Trying to find ways to impart powerful emotions through illustration.

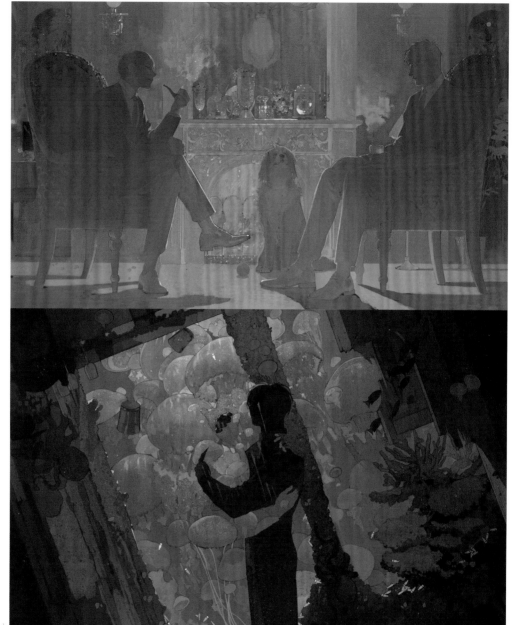

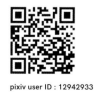

1	3	4
2	5	

TITLE **1** A snowy night / 2021 **2** Deep Sea / 2020 **3** New Year / 2021 **4** Flood / 2020 **5** Ball / 2021
all original works

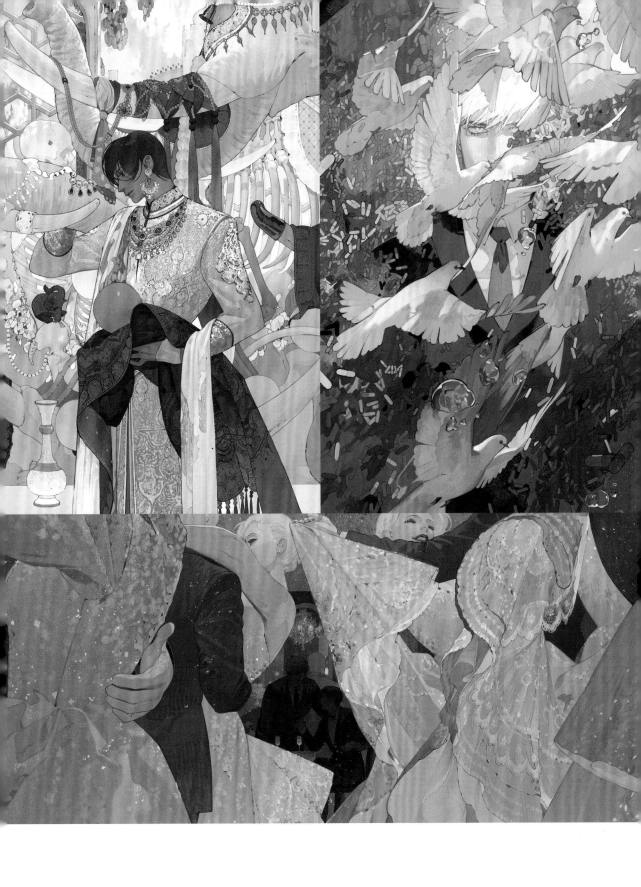

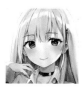

ran9u らんぐ

TWITTER ran9u **E-MAIL** ran9us@gmail.com

TOOLS CLIP STUDIO PAINT / Photoshop / Wacom Intuos Pro Medium (PTH-660) / Wacom Cintiq 13HD

PROFILE Lives overseas. Posts original illustrations of girls in everyday life and romantic comedy situations.

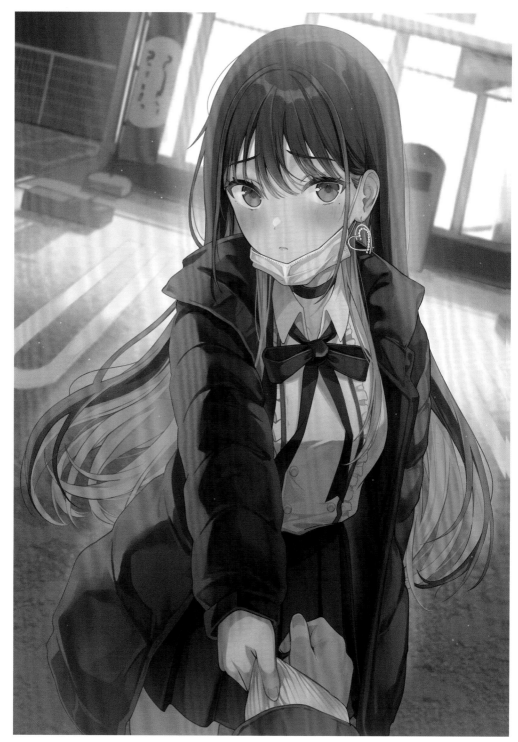

1		
	2	3
	4	5

TITLE **1** …Are you free for Christmas? / 2021 **2** Usagyaru-chan, Now Living On Her Own / 2021 **3** Morning Glories / 2022 **4** You're late. How many times does this make it? / 2021 **5** Sorry for the wait… / 2021 all original works

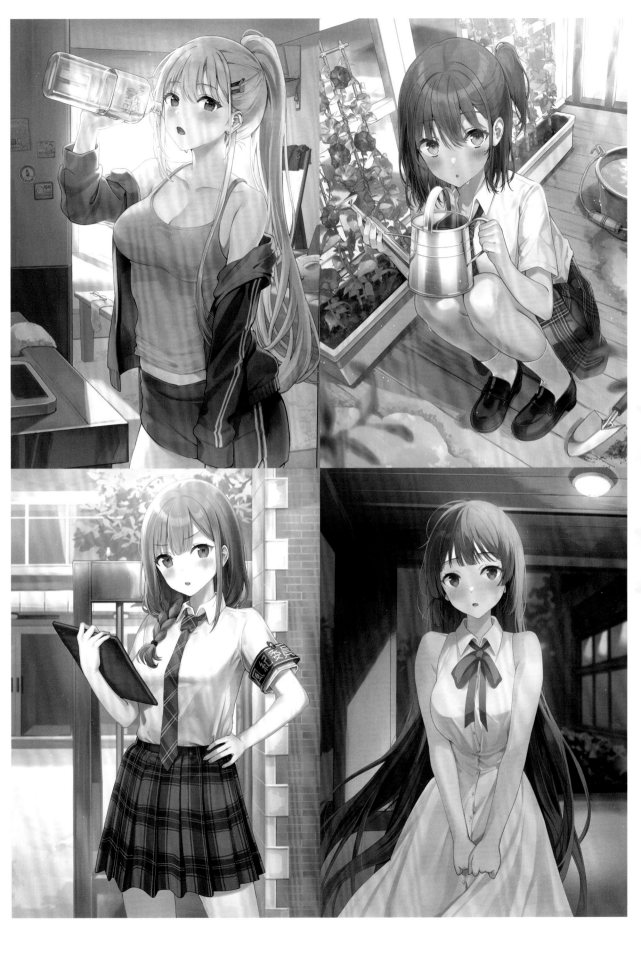

R.E.C

TWITTER R_E_C_fictiond **E-MAIL** artism0722@yahoo.co.jp

TOOLS CLIP STUDIO PAINT / Wacom Intuos Pro Medium (PTH-660)

PROFILE Designer. Born in 1992. Joined Square Enix after working as a manager for a hostess bar. Has worked on many projects, including game illustrations for the *Final Fantasy* series, acting as a special judge for CGWORLD's *WHO'S NEXT*, designing for restaurants, and creating insert illustrations. Published *How to Draw Backgrounds That Get You Work: A Game Designer Takes You From Getting Down the Basics to Getting Hired* (Shoeisha).

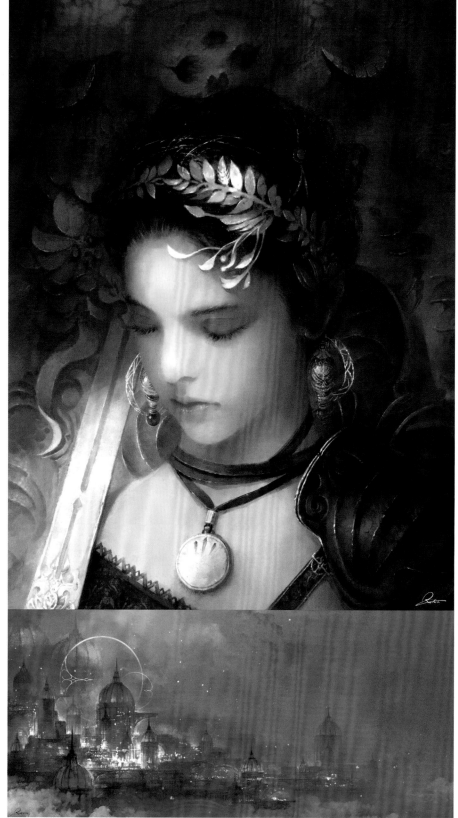

pixiv user ID : 9309530

	1		3	4
	2			5

TITLE **1** Silence / 2018 **2** Fantasy Kabuki-cho (*note:* a district in Tokyo known for its adult entertainment) / 2019 **3** Chang'e -Taiyin Xingjun- (*note:* in Chinese mythology, Chang'e is a moon spirit, appearing often alongside Taiyin Xingjun, goddess of the moon) / 2018 **4** Fleeting Things We Forget As We Grow Older / 2021 **5** Crystallized Tower of Fantasy / 2022 all original works

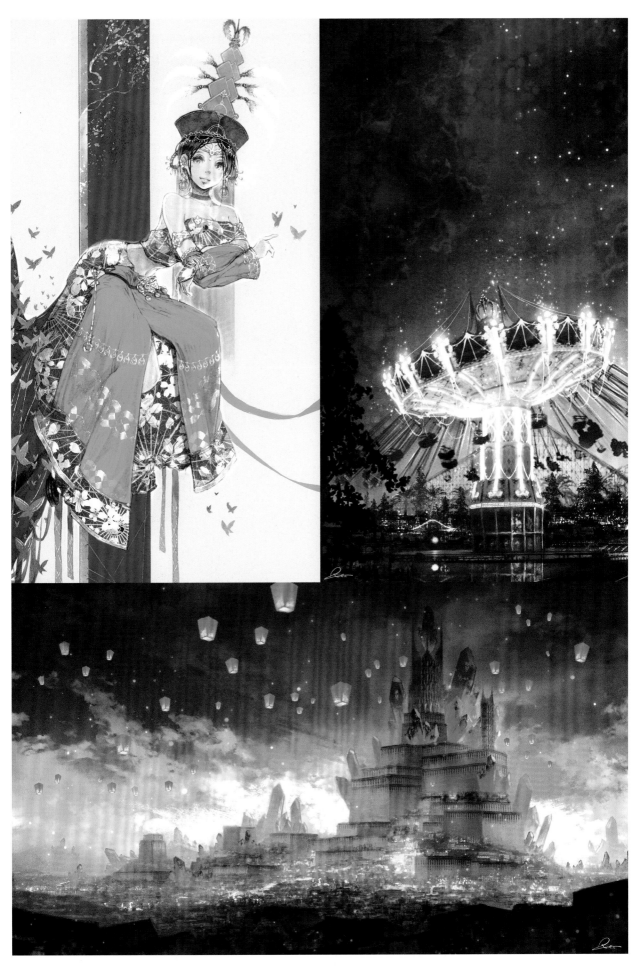

Rella

TWITTER Rellakinoko

TOOLS SAI / Photoshop / Wacom Intuos M

PROFILE Illustrator and designer. Specializes in delicate colors and unique expression of luminescence. Highly praised for character designs and has worked on many figure design projects as well. Individual projects include uploading many Hatsune Miku song illustrations to various social media sites.

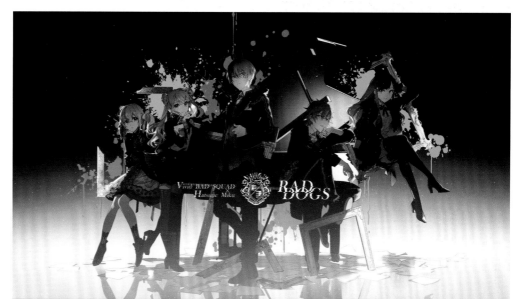

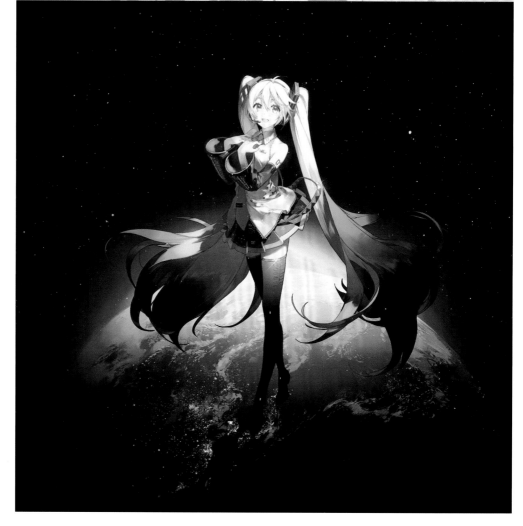

1	3	4
2	5	

TITLE **1** "RAD DOGS" / SEGA, Colorful Palette, Crypton Future Media / 2021 **2** Ihatov (*note: a fictional utopia imagined by author and poet Kenji Miyazawa that shares many features with Iwate Prefecture, where he was born*) / Crypton Future Media / 2021 **3** Gramophone / Crypton Future Media / 2020 **4** In The Mirror / Crypton Future Media / 2022 **5** Hatsune Miku Symphony 2022 / Crypton Future Media / 2022

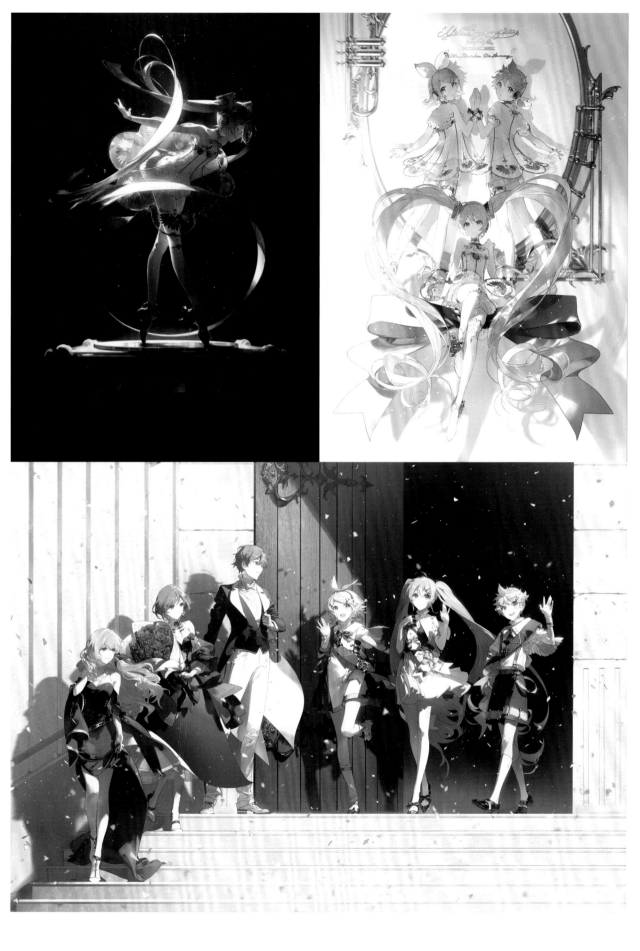

Reza Afshar

TWITTER rezaafshar **URL** https://www.artstation.com/rezaafshar

TOOLS Photoshop / Procreate / Wacom Intuos Pro / IPad Pro

PROFILE Concept artist and illustrator.

TITLE **1** Archadium **2** Circelleus **3** Ucronium **4** Mirage all original works created in 2022

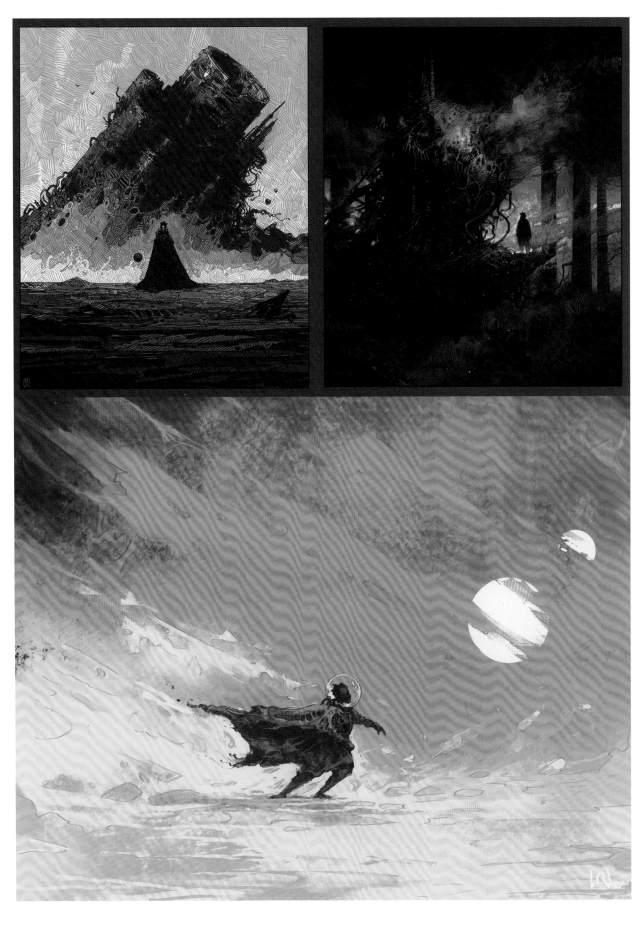

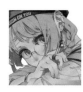

RITAO りたお

TUMBLR https://ritaokamo.tumblr.com/ **E-MAIL** ritao.info@gmail.com

TOOLS CLIP STUDIO PAINT / Artisul SP1603

PROFILE Focuses on color pallettes and motif-based charm. Major works include the Twitter illustration for ZONe Energy's official ambassador Zonko and the music video illustrations for "streamline shape mayday" by KAF x KAFU (KAMITSUBAKI STUDIO).

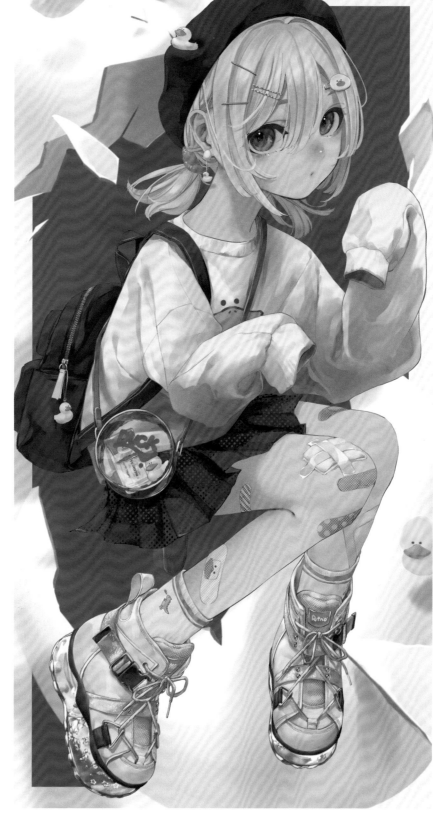

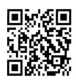

pixiv user ID : 49640022

1	
	2 3
	4 5

TITLE 1 DUCK / 2021 **2** Cigarette / 2021 **3** untitled / 2022 **4** untitled / 2021 **5** untitled / 2021
all original works

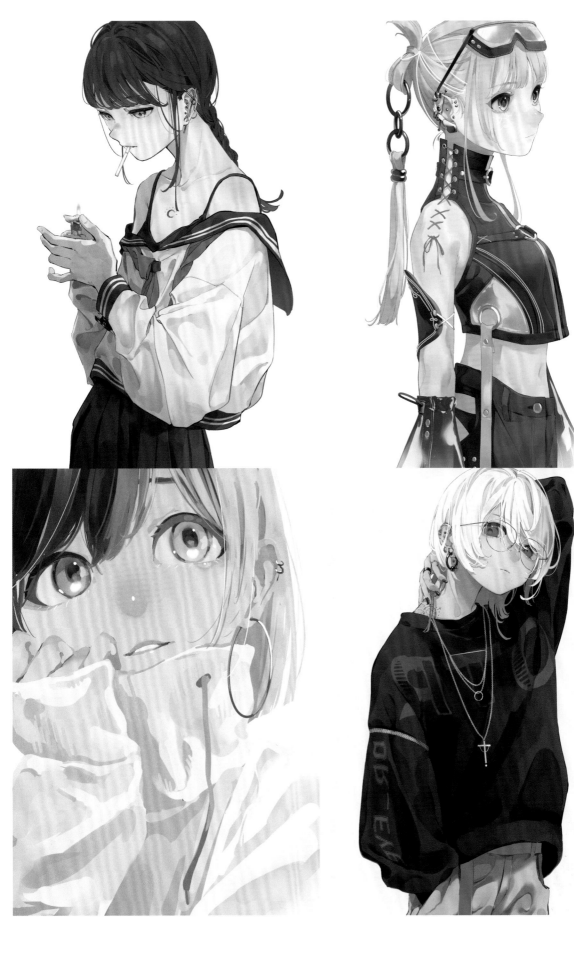

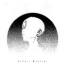

Rolua ろるあ

TWITTER Rolua_n **E-MAIL** rolua.noa.0001@gmail.com

TOOLS Photoshop / CLIP STUDIO PAINT / Wacom Cintiq Pro 24 / iPad

PROFILE Illustrator living in Tokyo. Active mainly on social media. Works include the music video illustrations for "CH4NGE ft. KAFU" (Giga), the jacket illustration for PR!SM, the 1st album of Nijisanji's ▽▲TR!NITY▲▽, and the cover illustration for Comic Yuri Hime (Ichijinsha) for the year 2020.

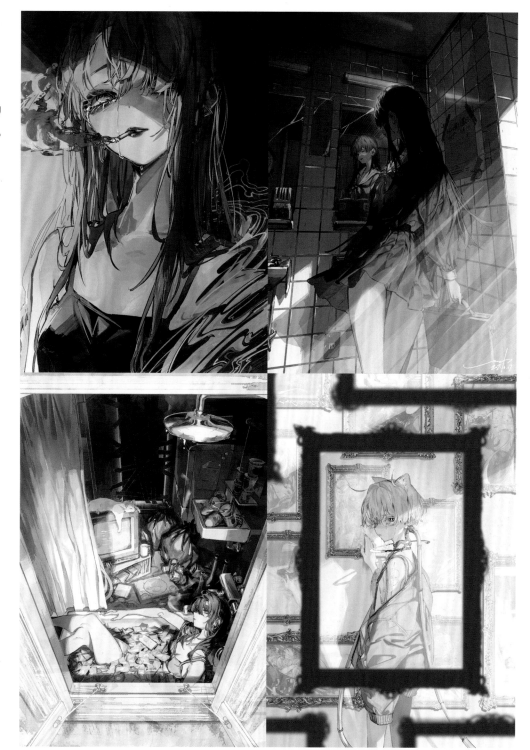

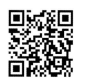
1	2	
3	4	5

TITLE **1** Fall / original / 2022 **2** A New Me / original / 2021 **3** Thirst _ Greed / original / 2022 **4** The Root Cause / original / 2022 **5** Thirst _ Friendship / Main visual for private exhibit "Thirst" / 2022

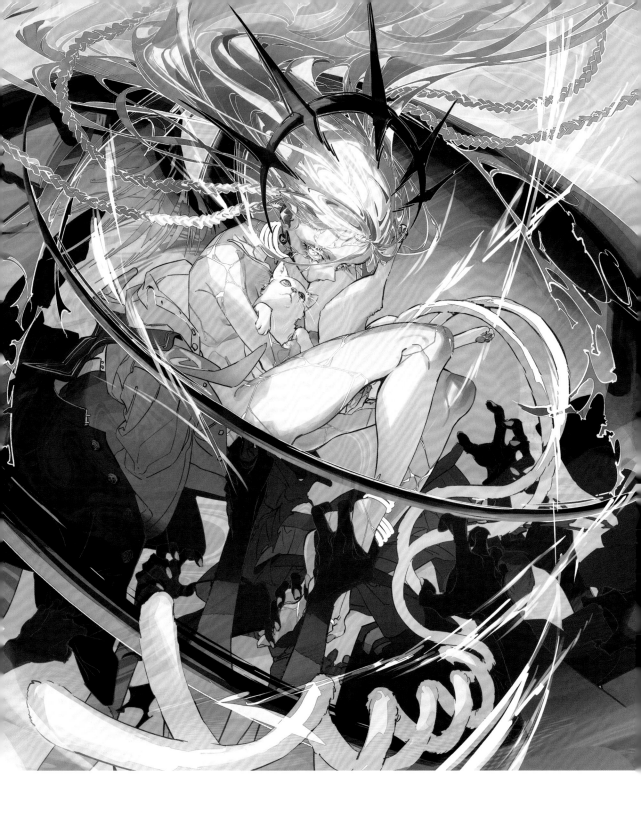

Ryota-H

TWITTER Ryota_H **URL** http://rakugakijikan.ninja-web.net/

TOOLS CLIP STUDIO PAINT EX / Wacom Cintiq Pro 16

PROFILE Worked as an animator and manga artist, now an illustrator. Mainly focuses on character designs and key visuals. Major works include character designs and illustrations for *Alchemy Stars*, *Fate/Grand Order*, and *Onmyoji*.

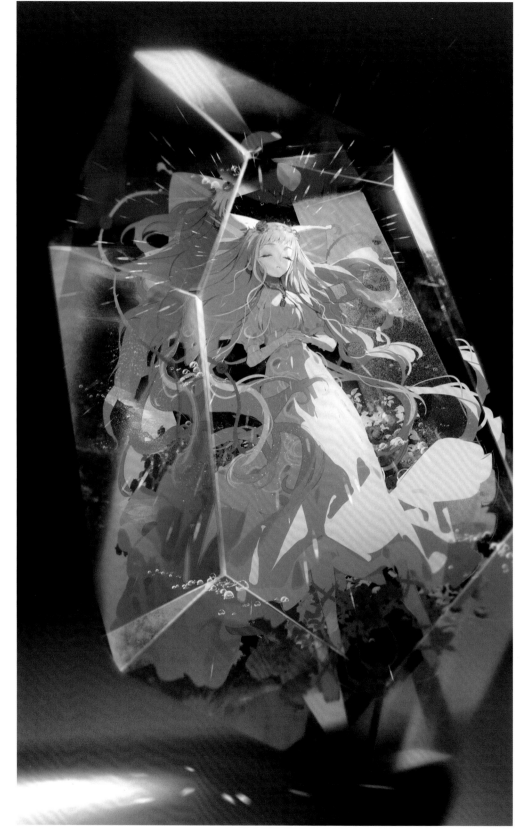

1	2

TITLE 1 Briar Rose in crystal / 2022 **2** First Trip of the Year (*gate labels:* congrats on so many visitors / blessings, *cat sign:* new year's greetings, *face sign:* good fortune and happiness will come to those who smile) / 2021 all original works

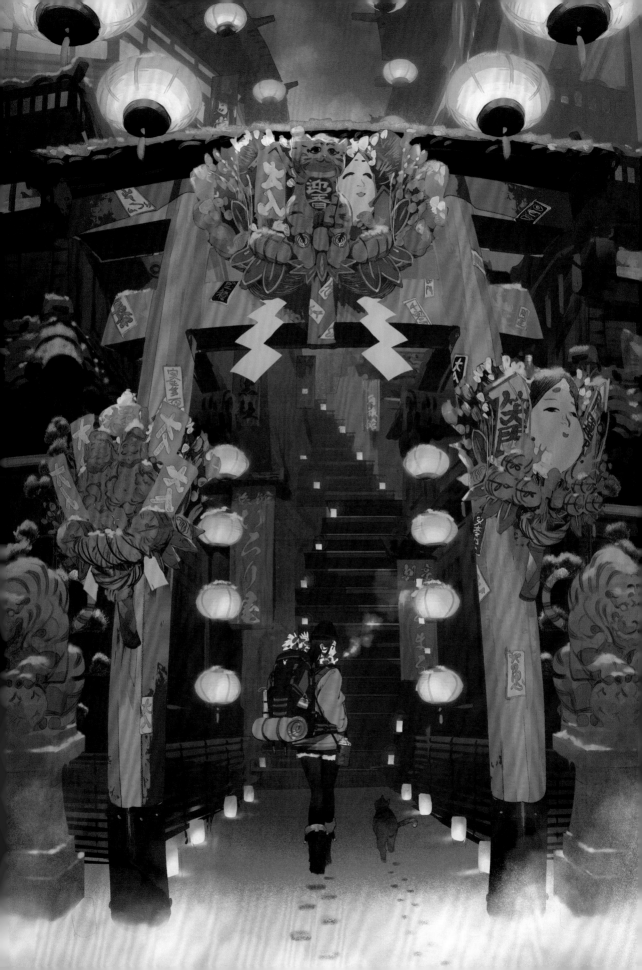

sakusyani さくしゃに

TWITTER sakusya2honda E-MAIL sakusya2.official@gmail.com

TOOLS CLIP STUDIO PAINT / iPad Pro

PROFILE "Sakusha" (Artist) "ni" (2). I first used my pen name in elementary school; precious feelings went into the name. My major is Asian History.

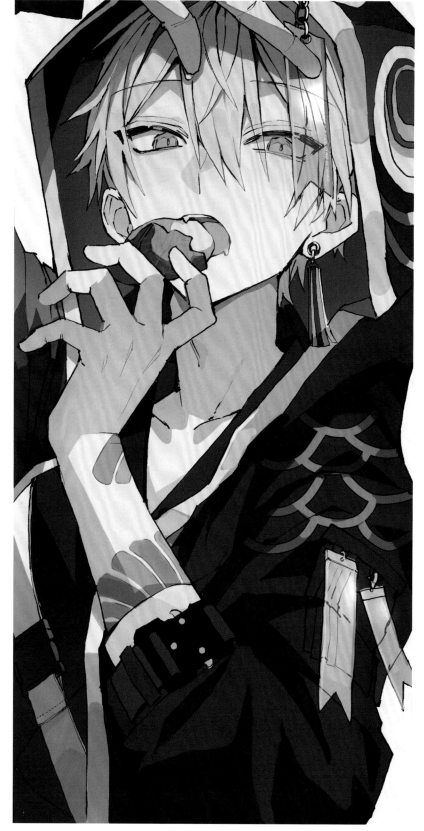

| 1 | 2 | 3 |
| | 4 | 5 |

TITLE 1 Children's Day 2022 (*note:* a Japanese holiday celebrated on May 5 during which carp-shaped banners are traditionally flown) **2** Jiangshi Man (*note:* a hopping vampire from Chinese folklore) **3** Arcade Man **4** Man Battling Pollen (*caption:* pollen warning / *papers:* prescription, oral medication, for external use) **5** Man Not For Sale
all original works created in 2022

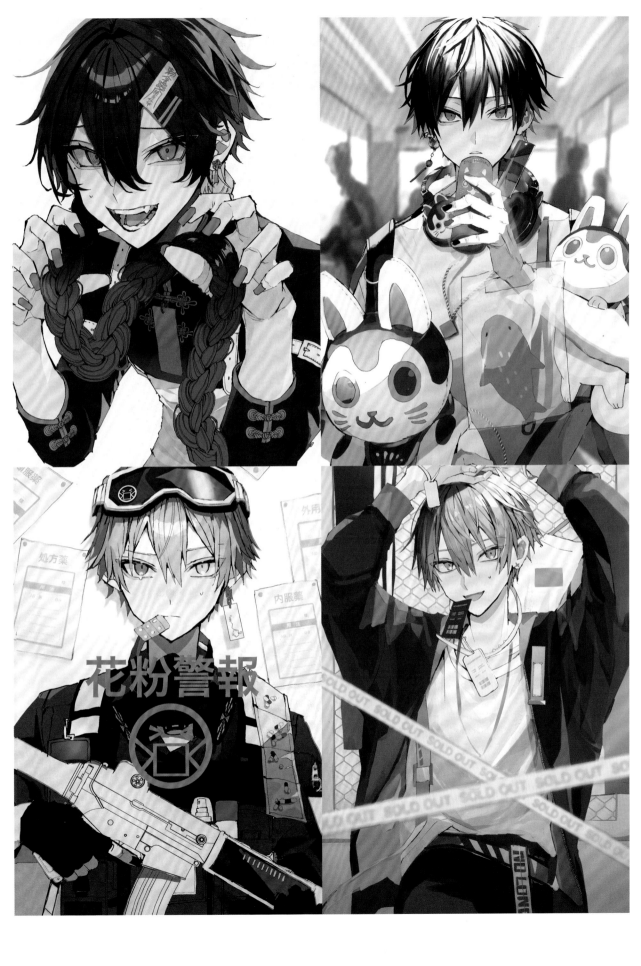

SANSA

TWITTER sansa0u0 **E-MAIL** sansakim02@gmail.com

TOOLS CLIP STUDIO PAINT / iPad / XP-Pen tabet

PROFILE Born in 2002. Born in Korea, but now studying illustration in the US. Began working as an illustrator in 2019 and has recently been drawing cover illustrations and insert art for children's books.

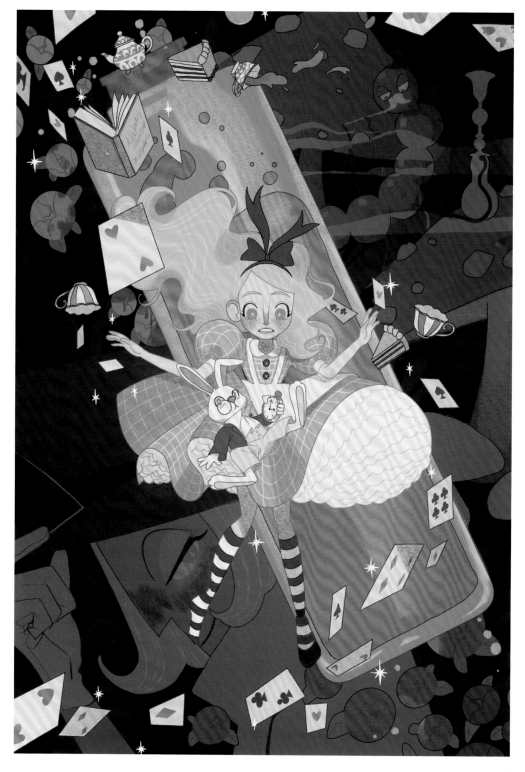

TITLE **1** Alice in Wonderland / 2020 **2** The flower girl / 2021 **3** Cinderella / 2020 **4** Gi-saeng / 2022
all original works

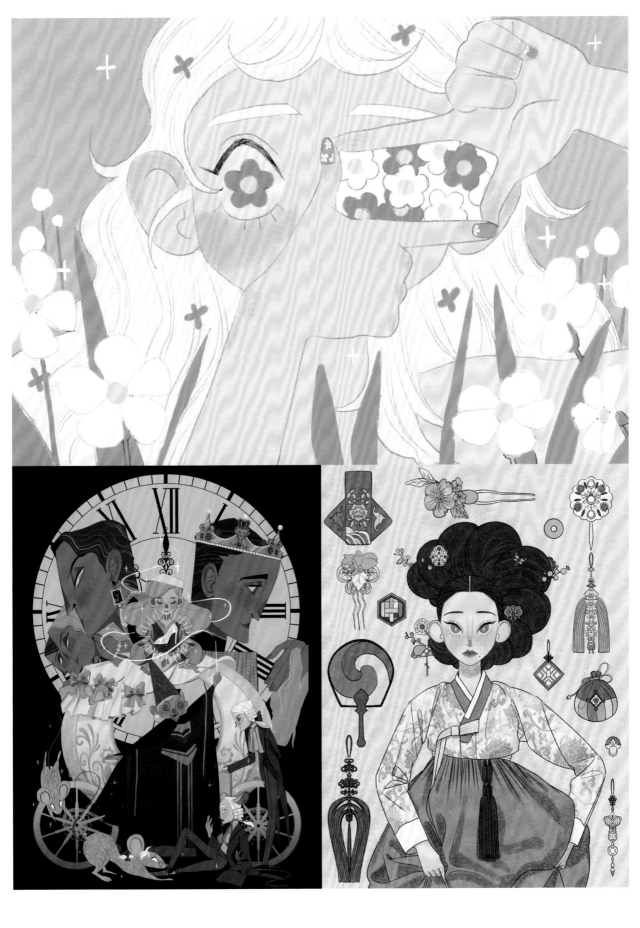

Sasumo Jiro さすも次郎

TWITTER j-sasum **E-MAIL** hakoirie@gmail.com

TOOLS Photoshop / Wacom Intuos Pro

PROFILE Creating original works that endeavor to capture the atmosphere, light, and story of a single moment into one piece. Aside from personal projects, also works as an illustrator for the Pokémon Trading Card Game, among others.

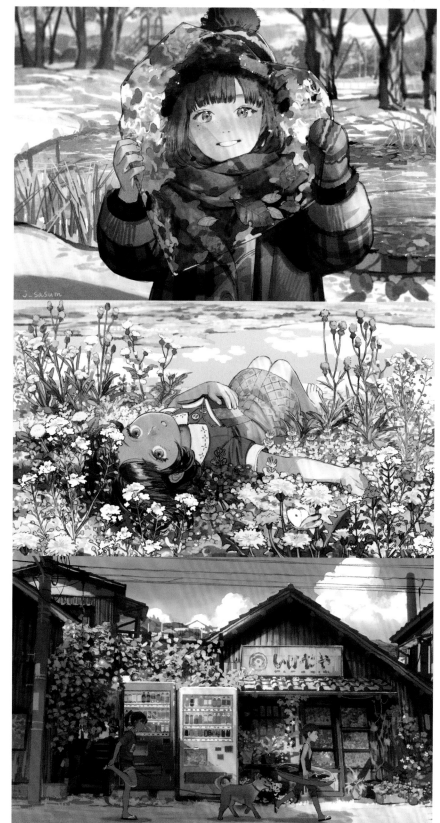

pixiv user ID : 326389

1	4
2	5
3	6

TITLE **1** The Shine of Winter / 2020 **2** The Density of Spring / 2020 **3** The Shade of Summer / 2020 **4** Confining the Light / 2021 **5** Forest of Rabbits / 2020 **6** Children's Day (*note:* a Japanese holiday celebrated on May 5 during which carp-shaped banners are traditionally flown) / 2020 all original works

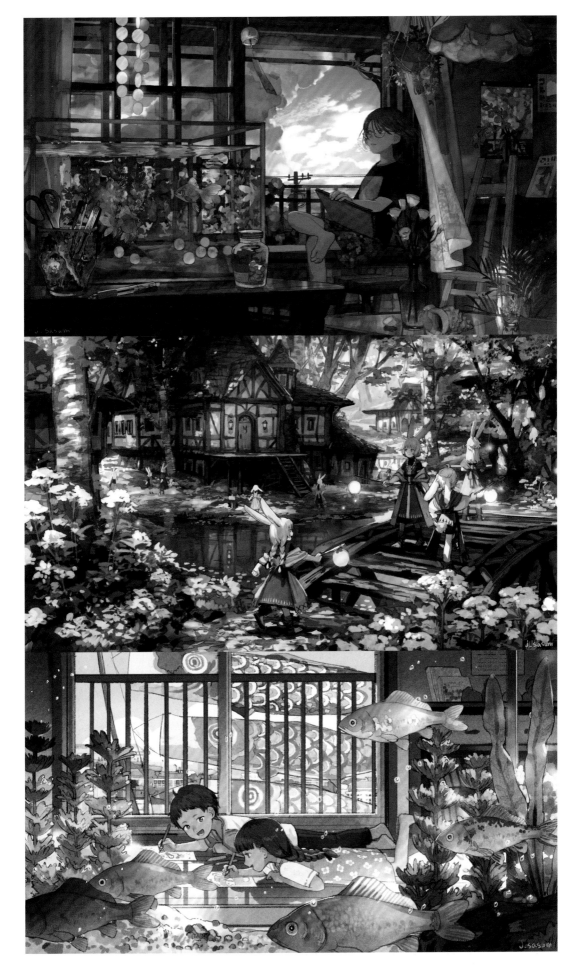

satsuki

INSTAGRAM s_i_t_t **E-MAIL** satsuki.illustration@gmail.com

TOOLS Photoshop / Procreate / iPad

PROFILE An illustrator living in Tokyo. Frequently draws pictures of people, dogs, and food.

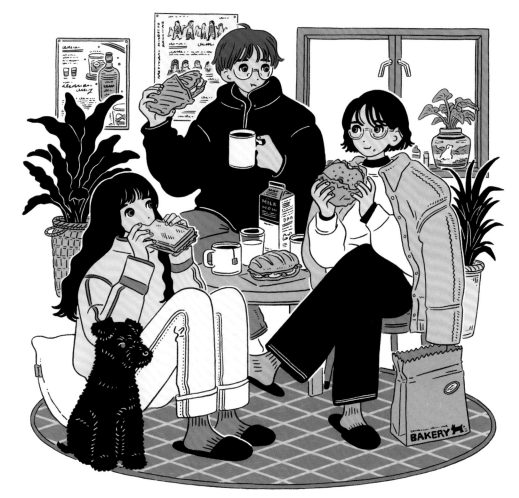

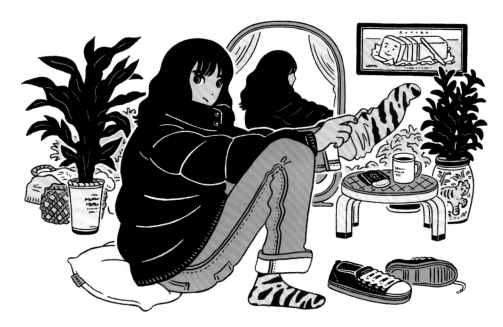

1	3
2	4

TITLE 1 breakfast 2 Tiger 3 moving 4 shopping all original works created in 2022

shiraho しらほ

TWITTER shiraho65 **E-MAIL** shiraho.0506@gmail.com

TOOLS CLIP STUDIO PAINT PRO / Wacom Intuos

PROFILE Works as a designer at a web-related company during the week, but illustrates as a hobby and as a job in their free time. Specializes in designing soft, cute characters and Western clothing. Thank you.

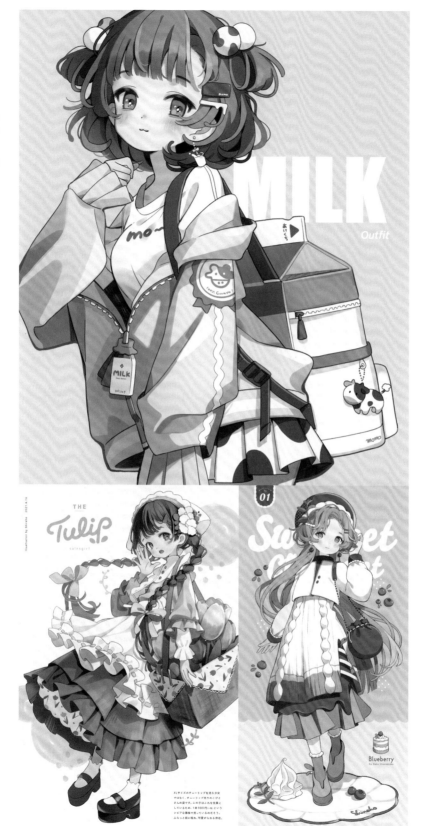

TITLE 1 Milk-flavored Outfit / 2021 **2** The Little Tulip Seller / 2021 **3** Blueberry Rare Cheesecake Outfit (*note:* a no-bake cheesecake) / 2022 **4** Flower Sisters / 2021 all original works

Flower
Tie/Braid

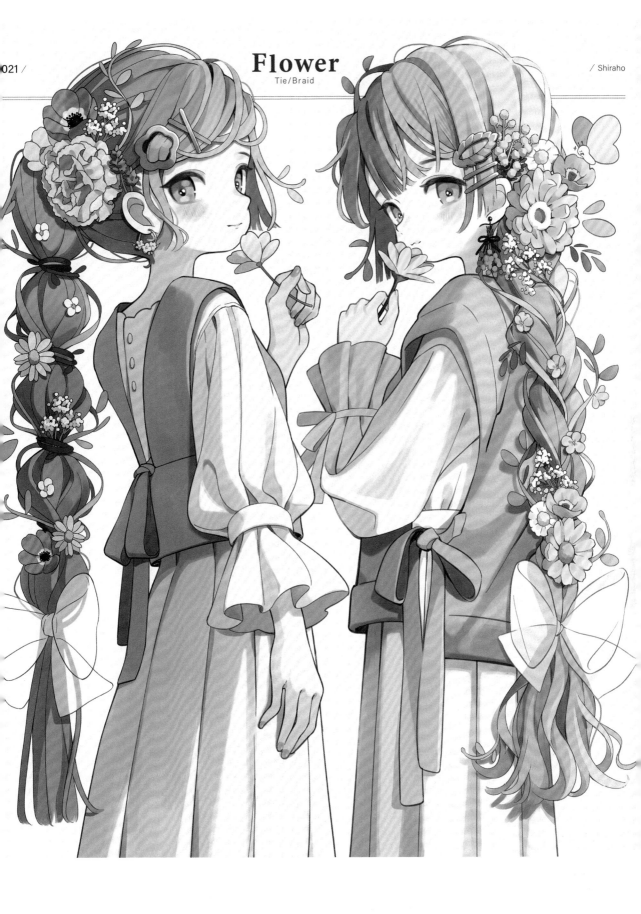

Sho 笙

INSTAGRAM _syouko_

TOOLS SAI2 / Photoshop / CLIP STUDIO PAINT / Wacom Cintiq 22HD

PROFILE Born on November 9, 2001. Illustrator from New Zealand, now living in Tokyo. Main theme of original works is people's delicate emotions. Enjoys putting feelings in concrete form.

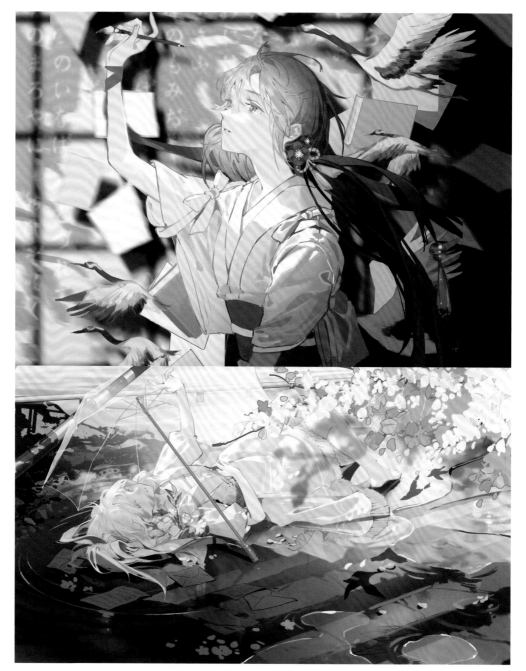

1	3
2	

TITLE **1** Chihayaburu / 2020 **2** Composition / 2021 **3** OWL / 2021 all original works

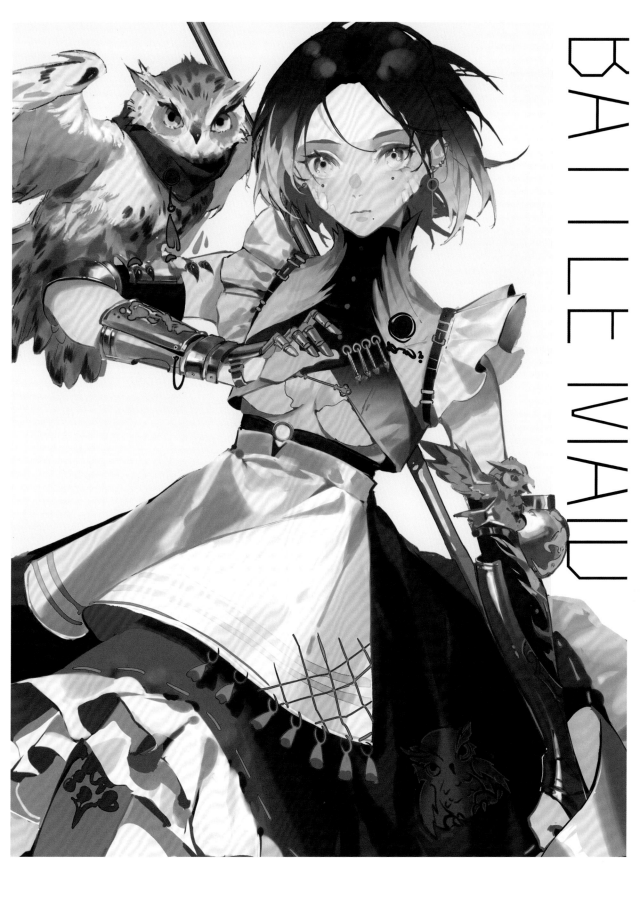

SHUEI HUEI 沐彗小

TWITTER whuijun_ **E-MAIL** w.huijun1128@gmail.com

TOOLS watercolors / POSTER COLOR

PROFILE Taiwanese.

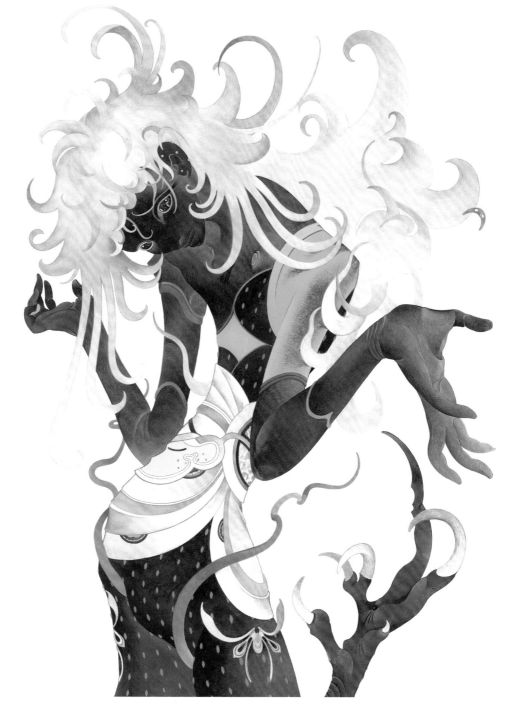

TITLE 1 Bean Goose **2** Net **3** Zuofu **4** Youyi **5** Wild Goose all original works created in 2021

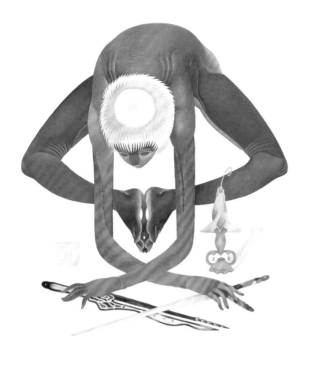
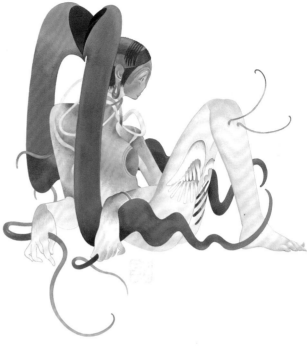
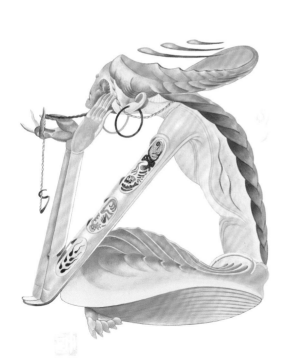
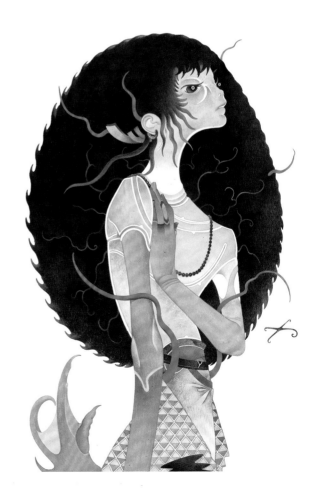

Somehira Katsu 染平かつ

TWITTER Katsu0073

TOOLS Photoshop / CLIP STUDIO PAINT / Wacom Cintiq Pro 24

E-MAIL katsu.h0703@gmail.com

PROFILE Born in 1993. Lives in Kanazawa, Ishikawa. Worked on cover illustrations for *Harta* (KADOKAWA) from issue 85 on. Has also created illustrations for video games and posters. Specializes in depicting scenes that make you feel stories and worlds.

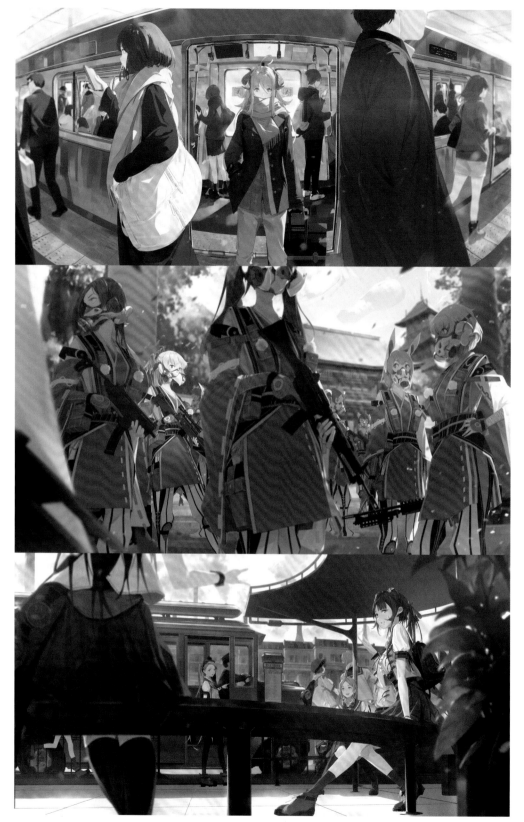

1	
2	4
3	

TITLE **1** Welcome To Another World **2** Zodiac Household Troops **3** At a Bus Stop of Billowing Steam **4** The hangar all original works created in 2020

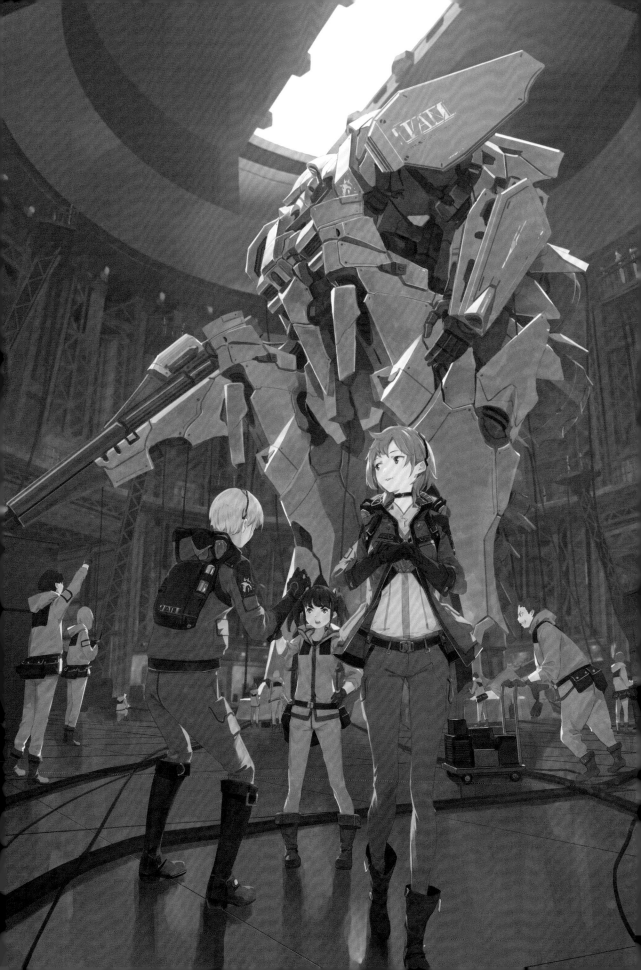

soOno そおの

TWITTER soOno2020 **E-MAIL** soono2022@gmail.com **URL** soono.weebly.com

TOOLS Procreate / Photoshop / CLIP STUDIO PAINT / iPad Pro

PROFILE Art director for a large game company. Working broadly as a 2D illustration artist doing concept art, key visuals, and character design.

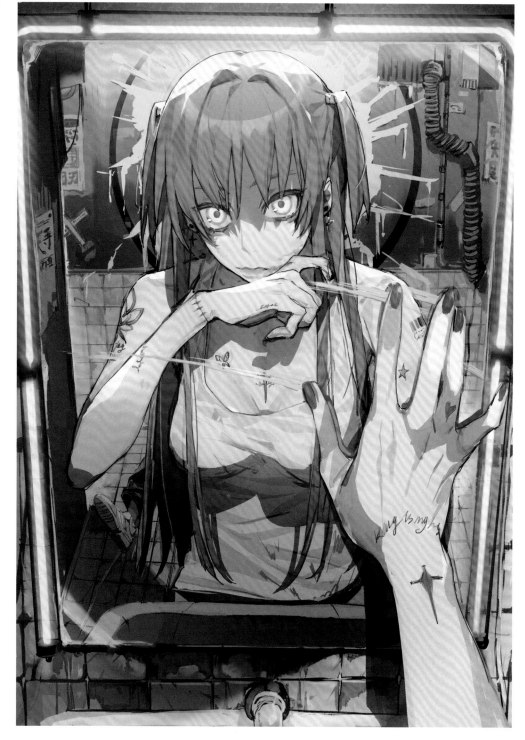

| 1 | 2 | 3 |
| | 4 | 5 |

TITLE **1** a Girl / 2021 **2** I saw a devil / 2022 **3** Youkai Character design (*note: youkai* are supernatural creatures and spirits from Japanese folklore) / 2021 **4** Oriental Character design / 2021 **5** Dragon Samurai / 2022 all original works

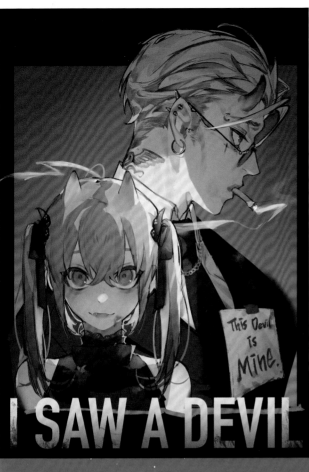

I SAW A DEVIL

This Devil Is Mine.

SEA MONSTER
On our planet

SOREYU それーゆ

TWITTER　ywyw_MNTL　E-MAIL　hn2.hrmk@gmail.com
TOOLS　Procreate / iPad Pro (12.9 inch)
PROFILE　Born March 17, 1999. (I'm usually uploading original illustrations and fanart to social media, going to exhibits in the city, or participating in events. I like rodents and racing girls, so I draw them a lot.

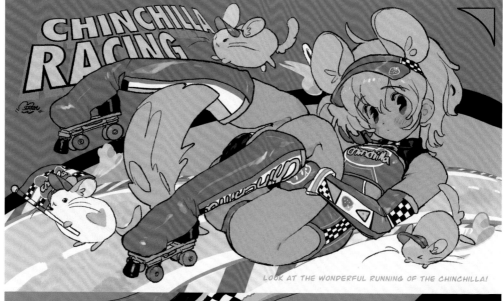

LOOK AT THE WONDERFUL RUNNING OF THE CHINCHILLA!

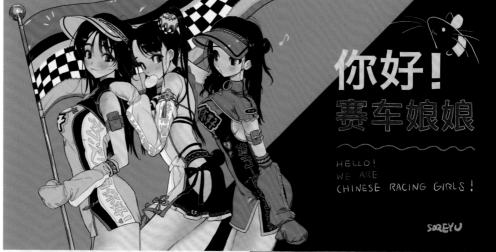

你好！
赛车娘娘

HELLO!
WE ARE
CHINESE RACING GIRLS!

SOREYU

1		5	6
2		7	8
3	4		

TITLE　1 Chinchilla Racing／original／2020　**2** Chinese Racing Girls／original／2021　**3** mouse／original／2021　**4** Sweet or Spicy?／original／2021　**5** Kumakko Cookie-chan／original／2022　**6** Ashton♥Marten／VTuber fanart design work (*bubble:* Ohashu! *bottom note:* I did the character design and 2D live model illustration!!)／2022　**7** China Racing-chan／original／2021　**8** Sweet & Spicy／original／2021

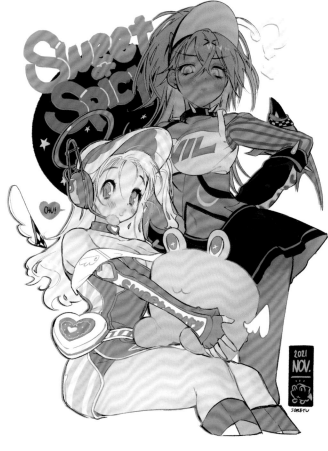

Squiddy

TWITTER big_squid_man

TOOLS Procreate / iPad Pro 11

PROFILE Illustrator from the UK who specializes in drawing chaotic environments and dogs with dead-looking eyes. Likes finding beauty in common things. Would like to stir up oppressive sensations while creating an atmosphere and story that will make people stop to look. Please have a seat and take your time viewing my works.

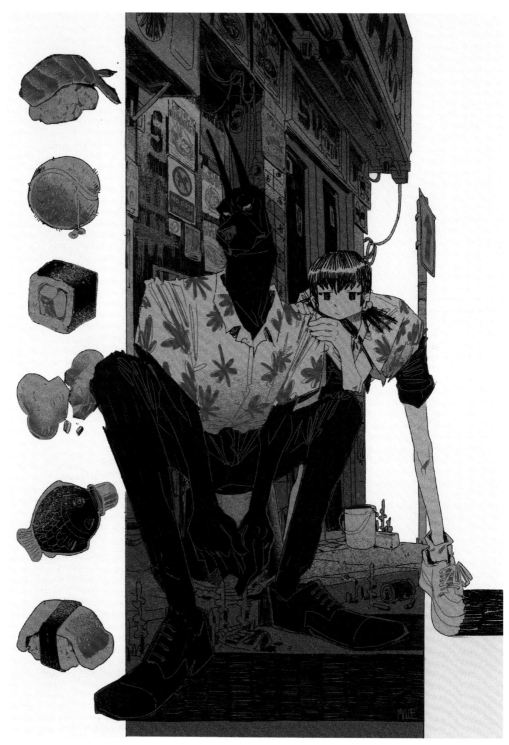

| 1 | 2 |

TITLE 1 No dogs allowed **2** Strike a pose all original works created in 2022

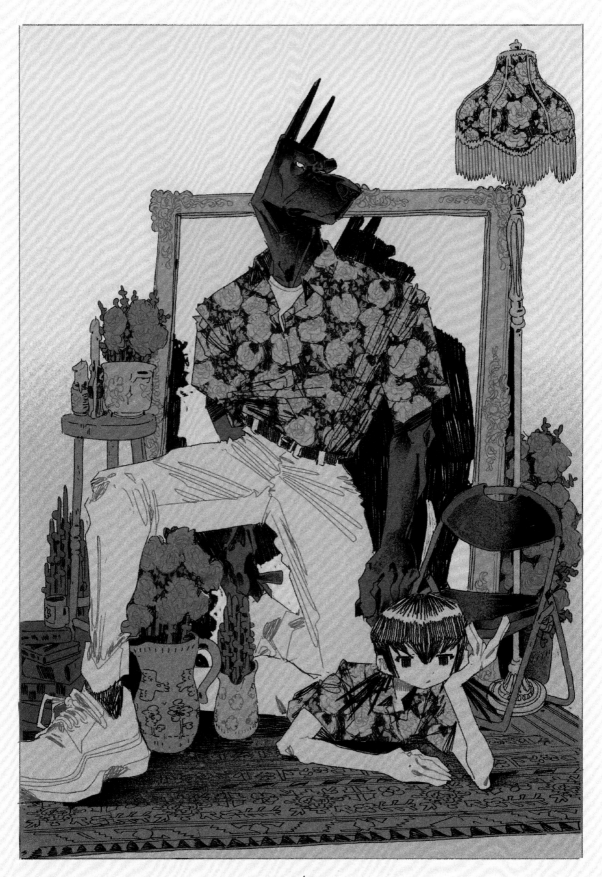

— ENOLA / GREY —

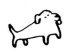

syokumura しょくむら

TWITTER syokumura E-MAIL syokumura01@gmail.com
PROFILE Hello!

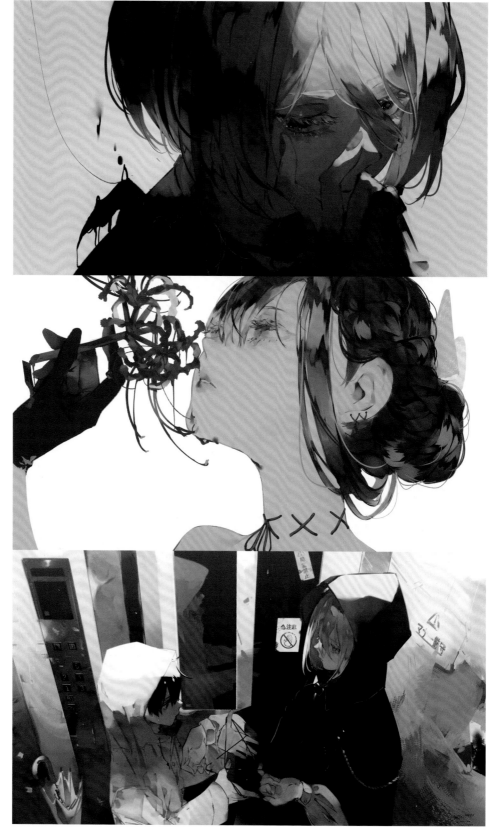

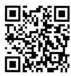

1	4
2	
3	5

TITLE **1** Child of the Night / 2020 **2** Flower / 2020 **3** Boundary (*signs*: no exorcisms / caution / no exorcisms) / 2022
4 Despite It, I Still Wanted To See the Morning Sun / 2020 **5** Flower Offering Day / 2021 all original works

tabi

TWITTER tabisumika URL https://tabisumika.wixsite.com/tabi

TOOLS Procreate / iPad Pro

PROFILE Illustrator living in Osaka. Began working in earnest in 2020. Works mainly on visuals for advertisements and videos. Main subjects of creations are animals and wistful scenery.

1		4	5
2		6	7
3			

TITLE 1 Luminescence / 2021 2 Undersea Café / 2021 3 Moonlight / 2022 4 Beyond / 2022 5 Blue sky / 2022
6 Mimosa / 2022 7 Until dark / 2021 all original works

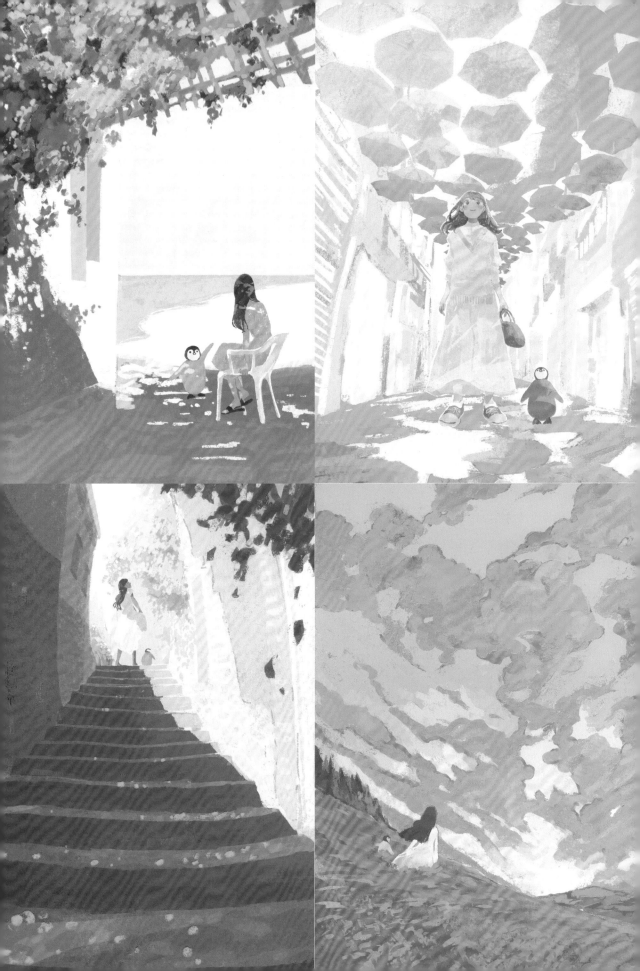

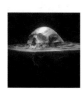

TAJIMA KOUJI 田島光二

TWITTER Kouji_Tajima

TOOLS Zbrush / Wacom Intuos4

PROFILE From Tokyo. Currently working as a concept artist in Vancouver. Works on concept designs and illustrations for a variety of media, but mainly films. Won the grand prize at the 3DCG AWARDS 2010 while still in school, and received the WIRED Audi Innovation Award in 2017. Appeared in Forbes 30 Under 30 Asia in 2018.

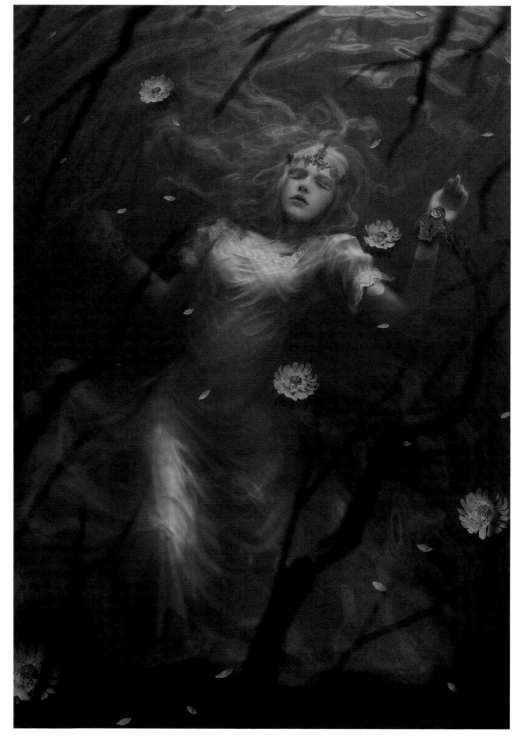

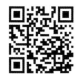

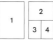

TITLE **1** Sacrifice / 2016 **2** Dragon / 2016 **3** Aberration / 2020 **4** Worry / 2016 all original works

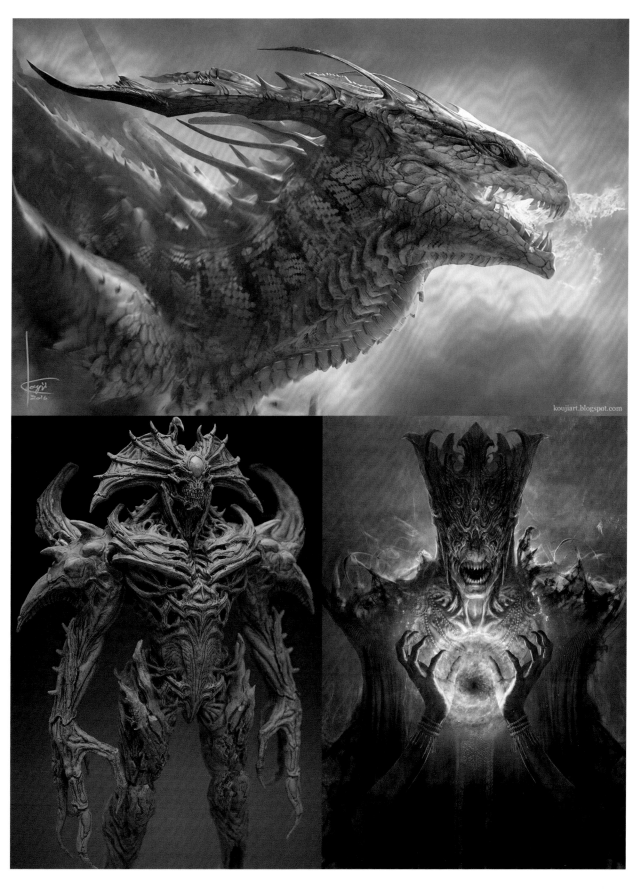
koujiart.blogspot.com

takashi タカ氏

TWITTER C_hkt URL https://takaciao.myportfolio.com/work

TOOLS CLIP STUDIO PAINT / Wacom Cintiq 22HD / iPad

PROFILE From Tokyo. Specializes in artistic, elegant illustrations, makeup techniques, and expressing the colors of a wide variety of things from nature. Work focuses on character designs and music video illustrations.

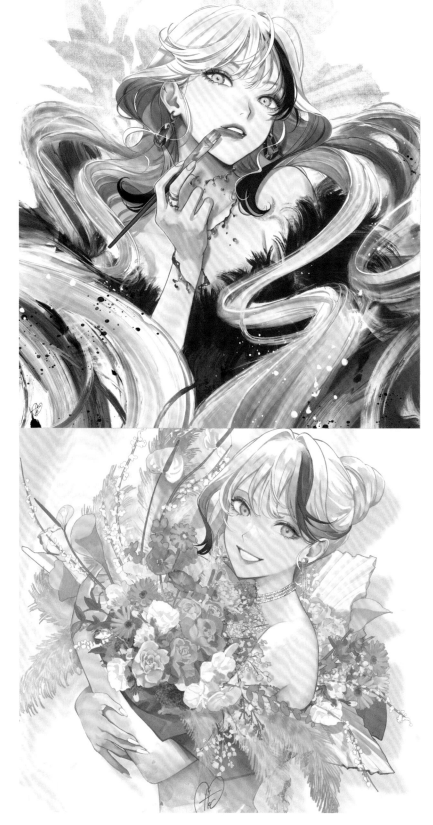

1		3	4
2		5	6

TITLE **1** Art make／2022 **2** Bouquet／2022 **3** May／2020 **4** Flamingo／2022 **5** Aggressive／2022 **6** Ennui／2022 all original works

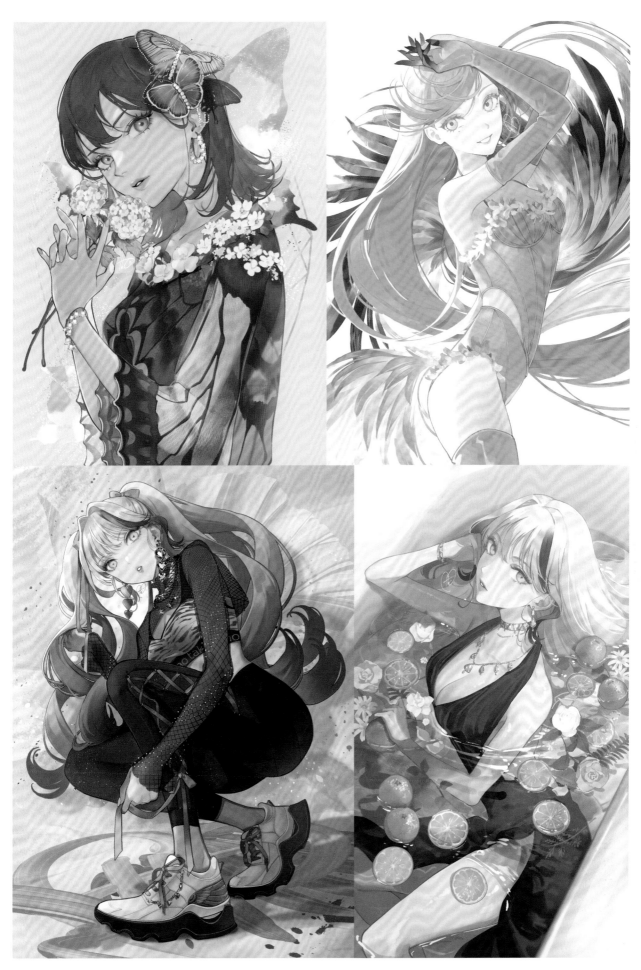

Tanaka Hirotaka 田中寛崇

TWITTER tanakahirotaka **E-MAIL** gonnaga1021@gmail.com

TOOLS CLIP STUDIO PAINT EX / Wacom Cintiq 27QHD

PROFILE From Niigata City, now living in Tokyo. Mainly produces illustrations for books and advertisements. Recently created the jacket for Aoi Fuji's album *Yuukiteki Palette Syndrome* (UNIVERSAL J), along with various works for Nijisanji and textbooks.

TITLE **1** I Was Told To Go West / 2021 **2** Spinning Compass / 2022 **3** To Whoever's On the Spaceship / 2022
4 KNOCKDOWN / 2021 **5** Invitation to the Dance Hall / 2022 all original works

TAO

TWITTER tao15102　**E-MAIL** tao15102@gmail.com

TOOLS CLIP STUDIO PAINT / iPad / Wacom Intuos Pro Medium

PROFILE Illustrator living in Hokkaido. Works are unique for their depictions of everyday life with high information density. Studied illustration independently and began working as a freelance illustrator in 2020. Professional works span many areas, including main visuals for corporate events and product advertisements.

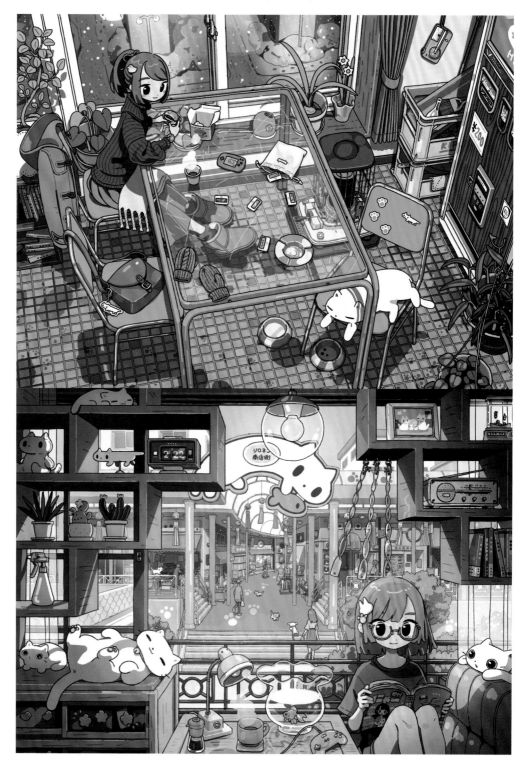

1	3
2	

TITLE 1 So Nice and Warm / original / 2020　**2** Routine / Flop Design "Penguin Town Font" image (*sign:* White Cat Shopping District) / 2021　**3** Ichou-machi 1-chome (*signs: (top green)* Purple Dog Dining Hall / *(orange)* Ichou Supermarket Rooftop Park / *(white)* The Silver Apricot Ice Cream Parlor / *(yellow)* Ichou-machi Shopping District *(blue)* 1-chome Butcher) / 2020

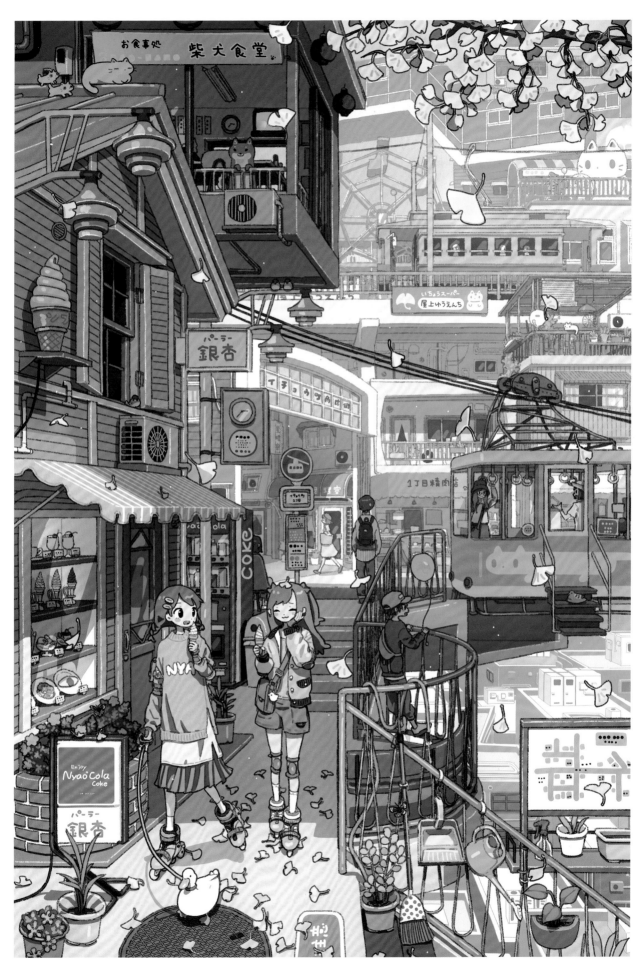

tekitou midori 適当緑

TWITTER tekito_midori **E-MAIL** tekito.midori1@gmail.com

TOOLS CLIP STUDIO PAINT / Artisul D16 Pro

PROFILE High school illustrator. Specializes in cool illustrations using a lot of black. Came up with a nickname that felt like a perfect fit (*note*: "tekitou" means "suitable"). Does character design and provides original illustrations for merchandise.

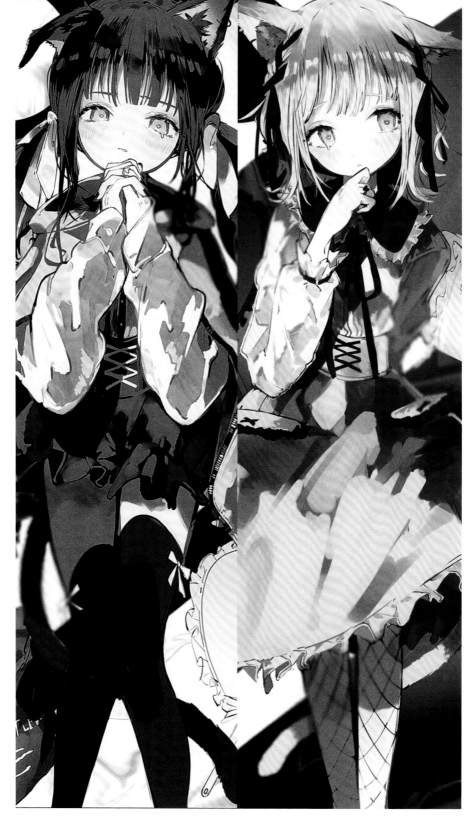

TITLE **1** Mass Production-type Cat-eared Girls / original / 2020 **2** x / Village Vanguard collaboration merchandise illustration / 2022 **3** Tiger Ghost / original / 2022 **4** ??Ring?? / original / 2021

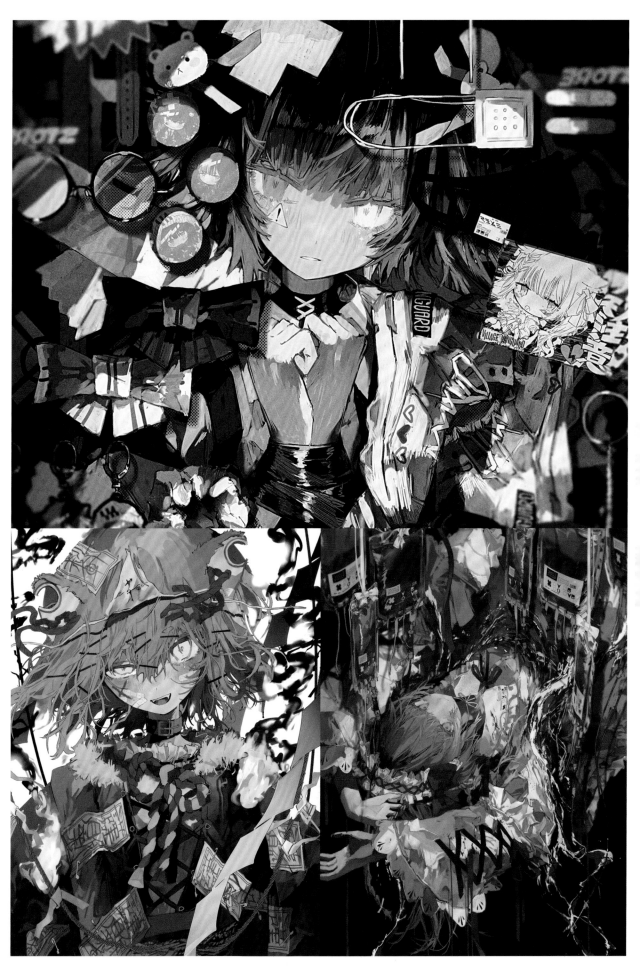

Terada Tera 寺田てら

TWITTER trcoot **E-MAIL** teroot8@gmail.com

TOOLS Photoshop / Wacom Cintiq Pro 24

PROFILE Illustrates for a wide variety of jobs, including collaboration goods and apparel lines for many companies and the music video artwork for songs such as "Turing Love" by Nanawo Akari feat. Sou and "Ashura-chan" by Ado.

TITLE **1** Ground Y x ILLUSTRATORS "CENTRAL" COLLECTION / Ground Y / 2021 **2** Heaven / original / 2022 **3** Liberation / original / 2021 **4** Fusion / original / 2021 **5** Ashura-chan ©UNIVERSAL MUSIC / UNIVERSAL MUSIC / 2021 **6** 26:00 / original / 2021 **7** I'll Be Waiting In Your Dreams / original / 2021

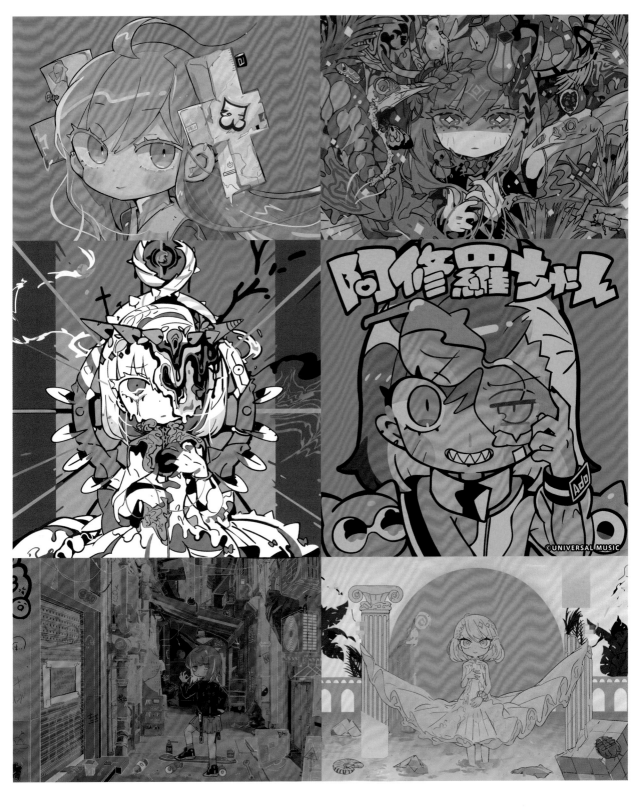

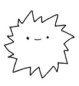

Tokiwata ときわた

TWITTER tokiwata_soul **E-MAIL** tokiwatariharuka@gmail.com

TOOLS Photoshop CC / CLIP STUDIO PAINT / Wacom MobileStudio Pro 16 / iPad Pro

PROFILE Illustrator. From Himeji, Hyogo Prefecture. Mainly uploads works to social media. Works on music videos as well as collaboration goods for things like Thankyoumart × Creator and Favorite Apparel. Energetically participates in *doujin* events like Comiket and Comitia (*note: doujin refers to self-published works*). Loves fashionable imagery and fantasy themes.

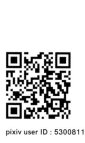

1	3
2	4

TITLE 1 Meat Bun / original / 2022 **2** Fashion / first appearance: music video illustration for maoneko's "Fashion" / 2021 **3** Hey, Are You Listening? / original / 2021 **4** Lack of Freedom / original / 2022

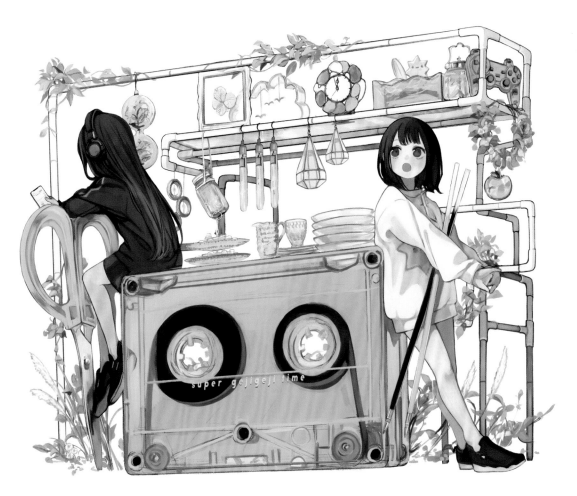

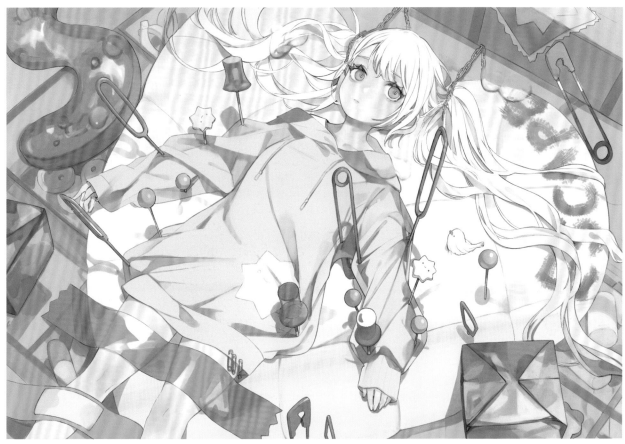

toma-to トマト

TWITTER idoukunn
E-MAIL tomato.s.illustration@gmail.com
TOOLS CLIP STUDIO PAINT / Wacom Intuos
PROFILE Has recently been drinking tomato juice every day.

1		4
2	3	

TITLE 1 A Maid's Cleaning / 2022 2 Maiko-san / 2022 3 happy birthday to me (*TV: report: suicide rates lowest In history*) / 2022 4 School / 2022 all original works

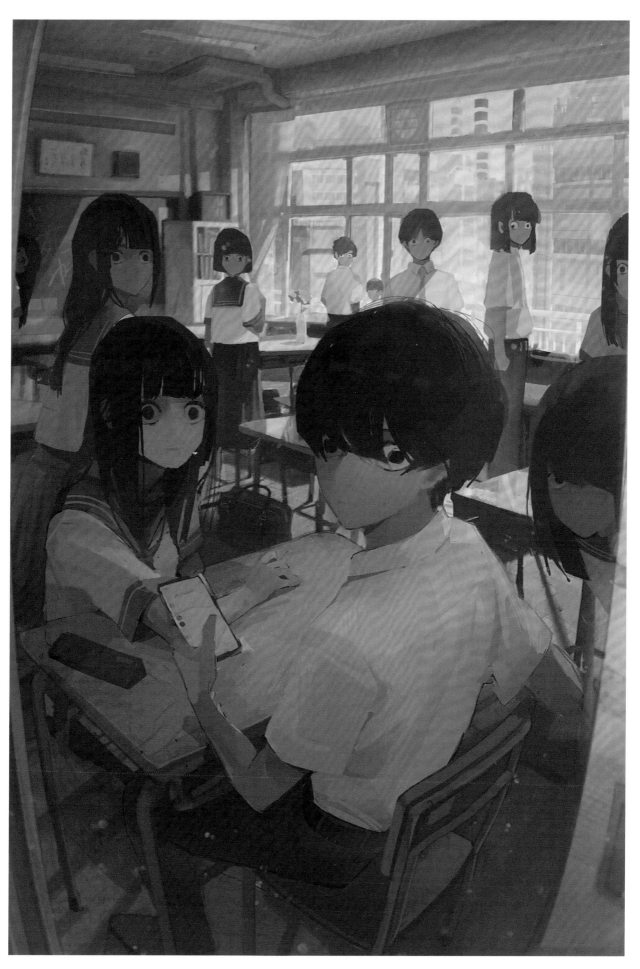

Tomono Rui 友野るい

TWITTER kyame **E-MAIL** pulupulu_gene@yahoo.co.jp

TOOLS Photoshop / Wacom Intuos

PROFILE Does character designs and storyboards for anime and games.

1	3
2	

TITLE **1** Puu-chan / 2021 **2** Ascended Shopping District (*note:* the title of this piece sounds like both "shopping district" and "ascension (to heaven)" / *center gate:* Heaven Ginza Shopping District / *signs:* Heaven, Narcissism Snacks, Café Elizabeth, Momotaro's Fable) / 2020 **3** How to Build a Safe, Secure City (*body:* For Official Shinjuku Ward Business, burnable garbage, 45L / *sash:* Congrats on your first kill! / *yellow tape:* Do Not Enter, Spirit-seeing Department) / 2022 all original works

tororotororo とろろとろろ

TWITTER t_oo_r_oo **E-MAIL** tororotororo0603@gmail.com

TOOLS Photoshop / Wacom Intuos

PROFILE Began using social media in 2019. Enjoys art that shows a person's life.

1	4
2	
3	5

TITLE **1** Tadaima (I'm Home) (*lanterns:* Nikko ⁄ Kyoto ⁄ Hakodate, *banner:* Hakone) ⁄ 2022 **2** Night Ends (*carton: milk*) ⁄ 2022 **3** Texting (*canister:* tea) ⁄ 2022 **4** Sleepy (*papers:* thread ⁄ winter ⁄ sleepy) ⁄ 2021 **5** Boiling Pasta (*book: While the Pasta Boils* ⁄ 2021 all original works

Toy(e)

TWITTER Toy__e **E-MAIL** toye0621@gmail.com

TOOLS Photoshop / Wacom Intuos

PROFILE Creates illustrations of various creatures, monsters, and youkai, including the ones in the *Yuugai Choujuu* series (KADOKAWA). A manga adaptation of *Yuugai Choujuu* began in 2022.

| 1 | 2 | 3 |
| | 4 | 5 |

TITLE 1 Near a Port Facility (*road:* bus route entrance / bus stop) **2** Near an Offshore Location **3** Near a Bathing Beach **4** Near Adjacent Waters **5** Near Tidal Flats all original works created in 2022

TSUCHIYA ツチヤ

TWITTER abisswalker8　**E-MAIL** waremenn@yahoo.co.jp

TOOLS Photoshop 2021 / CLIP STUDIO PAINT / Huion

PROFILE Works at an anime background art company while drawing in their free time. Lives in Nagano Prefecture.

pixiv user ID : 15919563

TITLE **1** Sakura Herbarium　**2** City of Stars　**3** Wisteria and a Flower Clock　**4** Stars and a Compass
all original works created in 2022

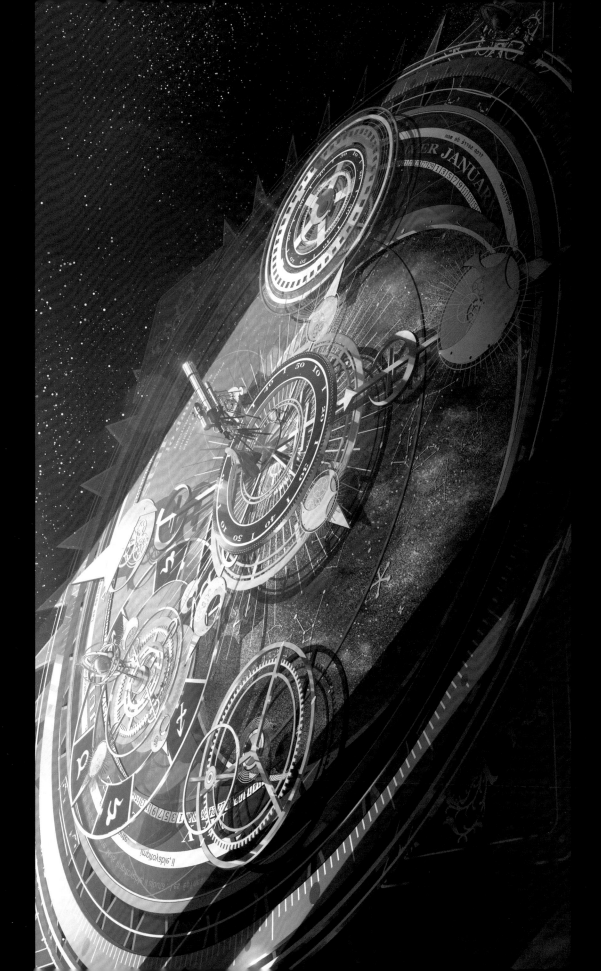

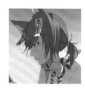

Tsukku つっく

TWITTER tsukku727 **E-MAIL** tsukku0727@gmail.com

TOOLS CLIP STUDIO PAINT / iPad / Wacom Cintiq Pro 24

PROFILE Born in 1998. Illustrator from Hokkaido. Creates many original works that convey the existence of the gods that exist in nature and inside people's hearts. Draws beasts and gods in nostalgic settings, all based around a theme of local faiths.

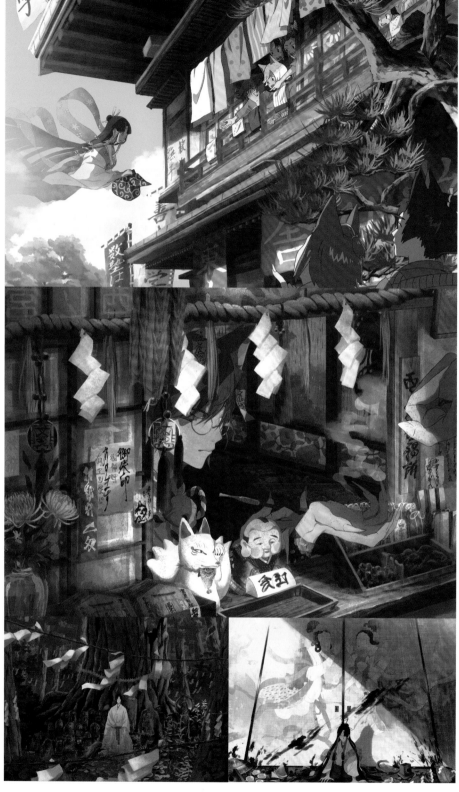

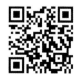

TITLE 1 The Bento Is Flying!!!! (*note:* a bento is a boxed lunch / *sign:* school) / 2022 **2** I'd Like One Protective Charm… (*placard:* payment) / 2021 **3** Holy Precincts / 2021 **4** A Goddess? Like Hell / 2020 **5** Invocation Ceremony / 2021 **6** Maidservants' Morning / 2021 **7** Lost a Tooth… (*sign:* Save Water!!) / 2021 all original works

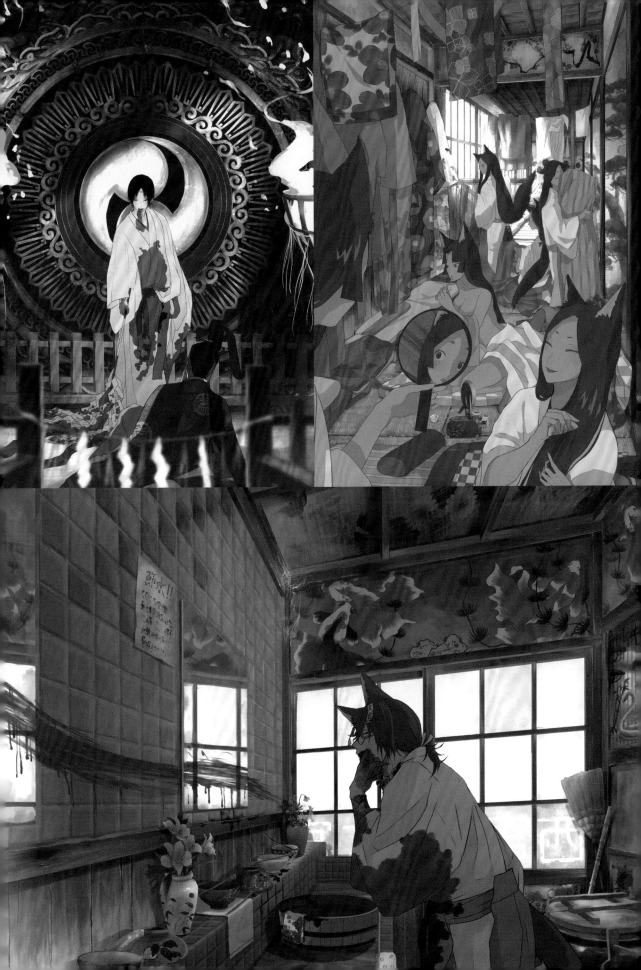

tsunotsuno
つのつの

TWITTER ve9etable0831
TOOLS Blender / iPad
PROFILE From Kyoto. Other than CG art, also creates illustrations and three-dimensional works.

1	2	
	3	4

TITLE **1** Under the Overpass **2** desire **3** untitled **4** Cer, Ber, Us all original works created in 2022

Uekura Eku 上倉エク

TWITTER ekureea
TOOLS E-MAIL uekuraeku@yahoo.co.jp
SAI / Photoshop / CLIP STUDIO PAINT / Wacom Cintiq 13HD
PROFILE

Works mainly on character designs and chibi characters. The shared theme among original illustrations is "girls who seem like they're made of sugar." Enjoys cute motifs like sweets and apron-dresses.

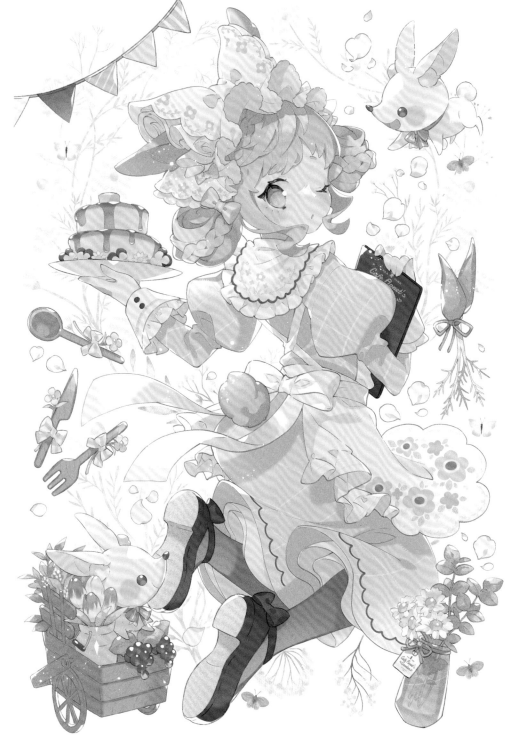

TITLE **1** BotanicalCafe／2022 **2** Lemon／2022 **3** Morning-picked Orange／2022 **4** Letter from Spring／2022 **5** Holiday／2021 all original works

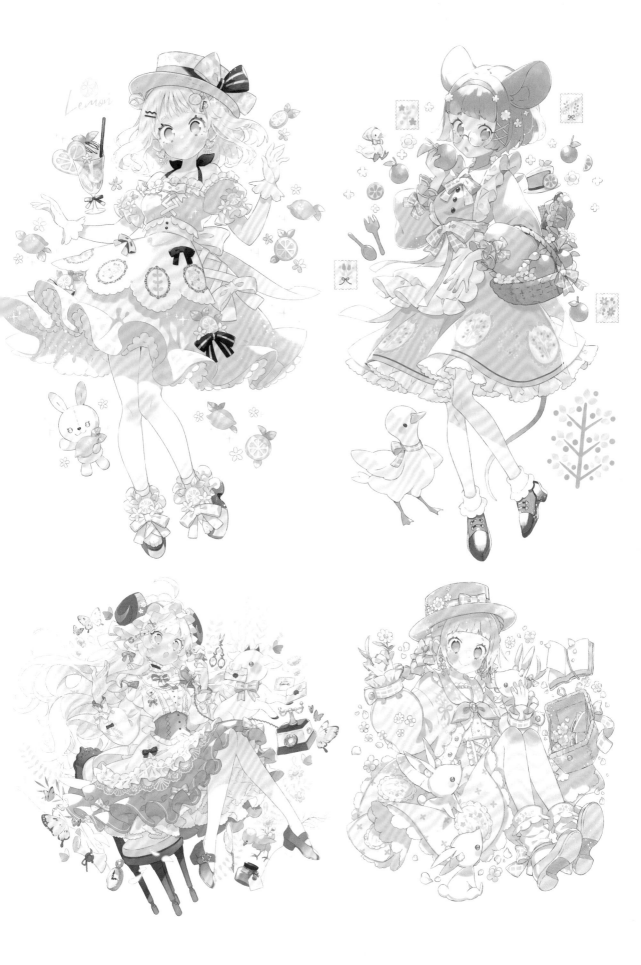

ugonba うごんば

TWITTER ug0nba E-MAIL howatoro@gmail.com

TOOLS AzDrawing2 / MediBang Paint / One by Wacom

PROFILE

Major works include the comic adaptation of GETUP! GETLIVE! #Gerogero (Ichijinsha) and an illustration for Sakura Bloom Goods & Voice 2022 for Luxiem from Nijisanji EN.

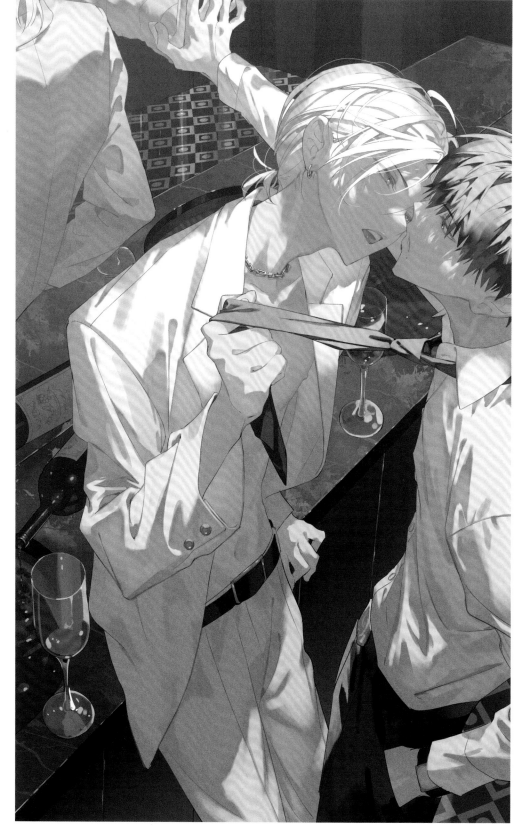

| 1 | 2 |
| | 3 | 4 |

TITLE 1 Drunk **2** Glare **3** MelonSodaFloat **4** Mask all original works created in 2022

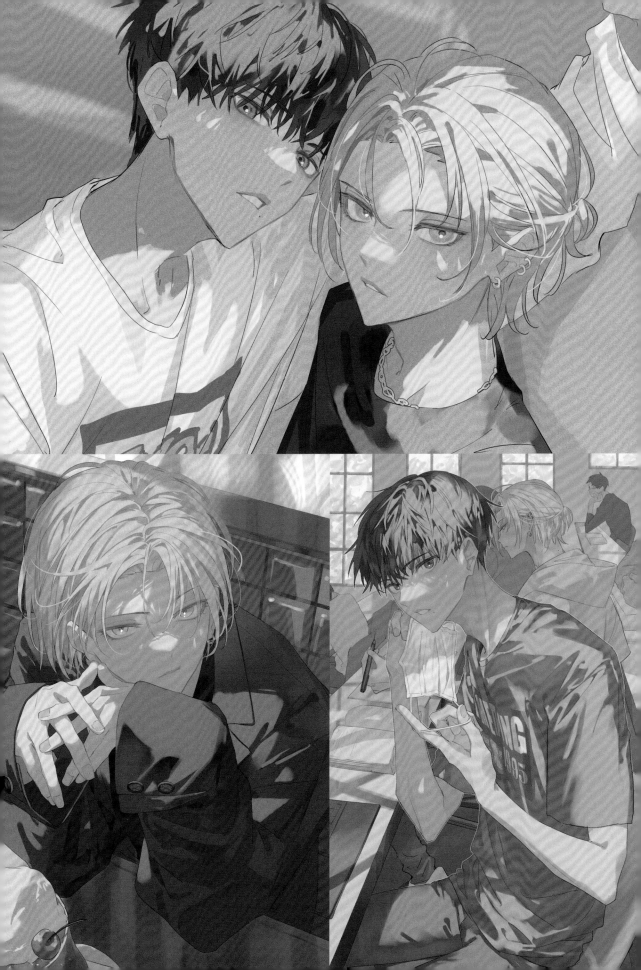

Umemaro 梅まろ

TWITTER umeboshimaro **E-MAIL** umemaro0908@yahoo.co.jp
TOOLS CLIP STUDIO PAINT / Wacom / iPad
PROFILE

Eats, sleeps, listens to music, and draws what they want. Likes pickled plums and girls who have an odd darkness to them.

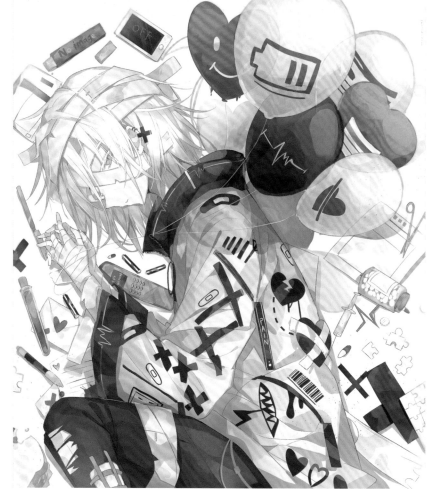

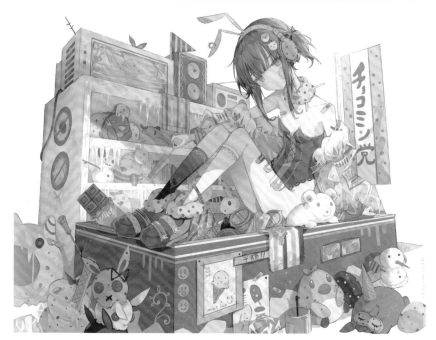

1	3	4
2	5	6

TITLE 1 untitled / 2020 **2** untitled (*banner:* chocolate mint chip lovers) / 2022 **3** untitled / 2022 **4** untitled / 2021
5 untitled / 2020 **6** untitled / 2021 all original works

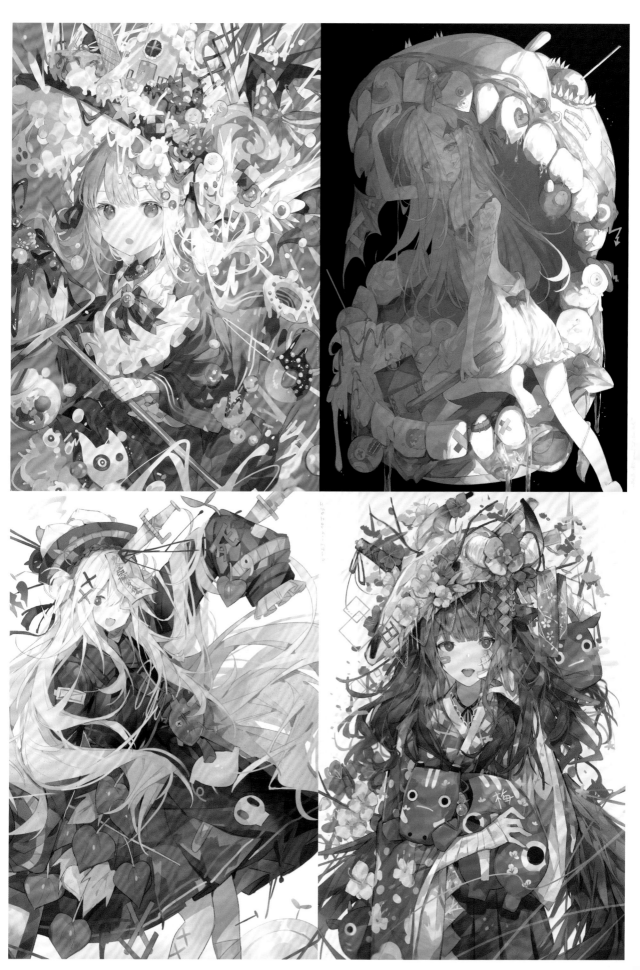

umiko U35

TWITTER umiko35
E-MAIL umiko35@ymail.ne.jp
TOOLS SAI / CLIP STUDIO PAINT / Wacom 16HD
PROFILE Born in Shimane Prefecture, now lives in Kanagawa Prefecture. Likes summer and kids. Activities include character design and insert illustrations.

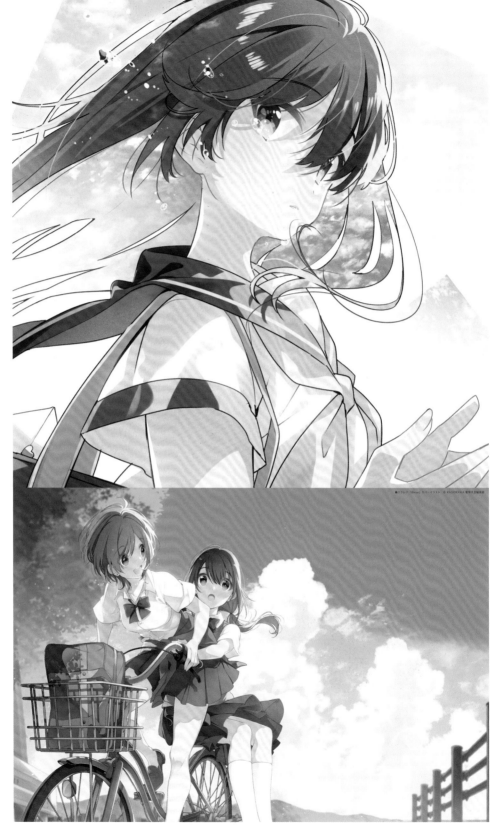

1		3	4
2		5	6

TITLE **1** Blue Summer / original / 2021 **2** cover illustration of *Eclaire Bleue* / KADOKAWA / 2022 **3** Pool Cleaning / illustration for *Learn Pro Techniques from Scratch: Drawing Beautiful Girls* (*Kamiwaza Sakuga* Series) (KADOKAWA) / 2017 **4** Hansel and Gretel / original / 2021 **5** Fresh Green / original / 2021 **6** Beach and Dress / original / 2021

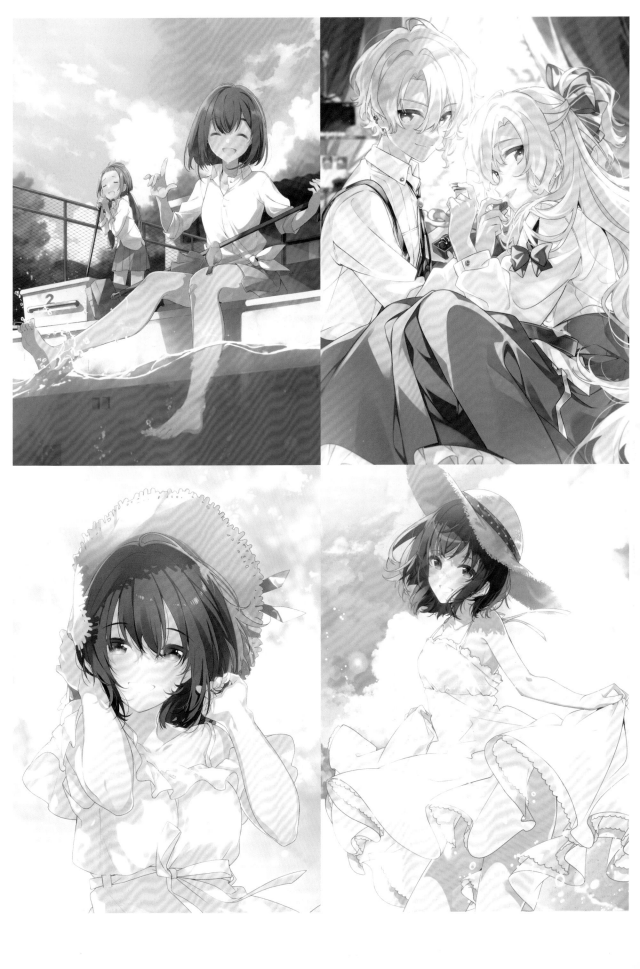

Unoyama Muji 宇野山むじ

TWITTER uimss E-MAIL uimss.imagelabo@gmail.com

TOOLS CLIP STUDIO PAINT / Wacom Cintiq Pro

PROFILE Creates works for a variety of projects, including video games, manga, and illustrations, all based mainly around themes of everyday life and mental imagery. Works include the key visual for Indie Games Connect 2022 (Konami) and the cover for Harta, Vol. 84 (KADOKAWA).

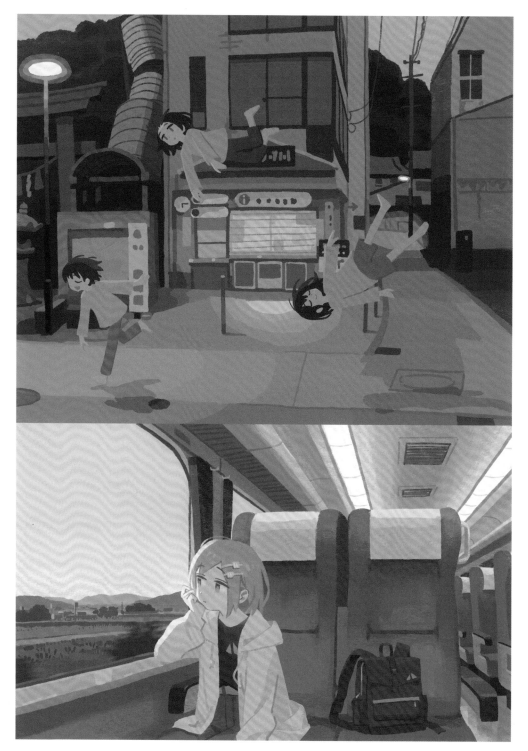

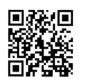

1	3
2	4

TITLE **1** I Still Want To Play At Night / original / 2022 **2** Highball Signal / music video illustration for "Highball Signal" (ADVANCE Musics) / 2022 **3** Grain of Sand / original / 2021 **4** yokaze / 2021 key visual for the indie game *Yokaze* (room6) / 2021

Vab.png

TWITTER Vab0118　**E-MAIL** taniryu1192@gmail.com

TOOLS CLIP STUDIO PAINT PRO / Huion Kamvas 13

PROFILE Draws mechanical portraits of characters. Raised in Akita. True home is Oga. Currently active with the VTuber group Room 201, supervising character design and Live2D images. Everyone there is enthusiastic.

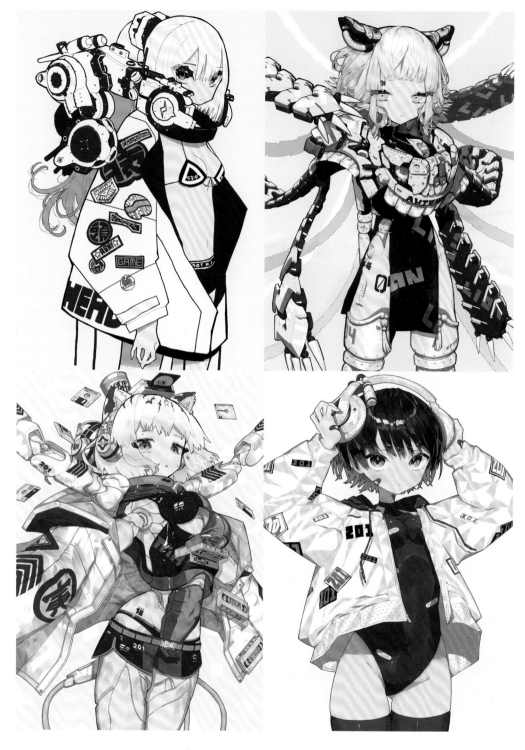

1	2	
3	4	5

TITLE 1 Headphones / 2020　2 Lion / 2022　3 Tiger / 2022　4 Wolf Cut / 2021　5 Space Suit / 2021
all original works

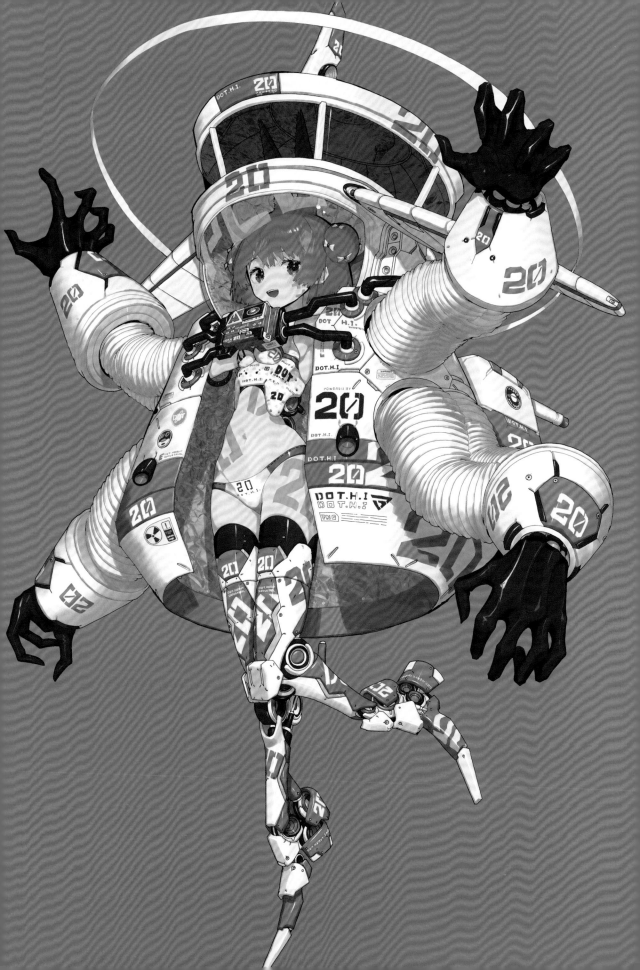

void/RE:era

TWITTER void_ling **E-MAIL** 826805867@qq.com

TOOLS Photoshop / Wacom Intuos

PROFILE Major works include the *Event Book: Reincarnation Era* series and promotional illustrations for *Genshin Impact*.

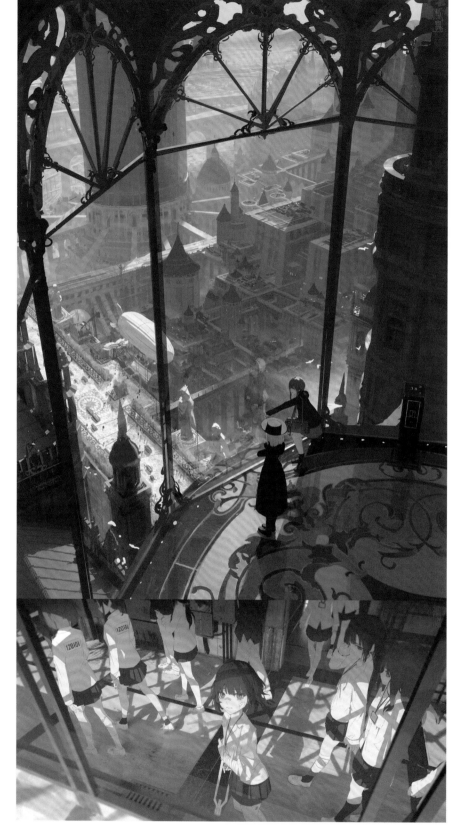

1		3	
		4	
2		5	6

TITLE **1** *Reincarnation Era* Chapter I Ⅳ / 2021 **2** *Reincarnation Era* Prologue / 2022 **3** *Reincarnation Era* Chapter I Ⅱ / 2021 **4** *Reincarnation Era* Chapter I Ⅴ / 2021 **5** *Reincarnation Era* Prologue Ⅱ / 2022 **6** *Reincarnation Era:* Kaede Sugane / 2020 all original works

wataboku

TWITTER wataboku_ **E-MAIL** watabokuinfo@gmail.com

TOOLS Photoshop / Wacom Cintiq

PROFILE Published first artbook, KANZERO, in 2016 through Pony Canyon and held their first private exhibit that year. Since then, they've had several exhibits around Japan and throughout Asia. Has been expanding fanbase internationally over social media.

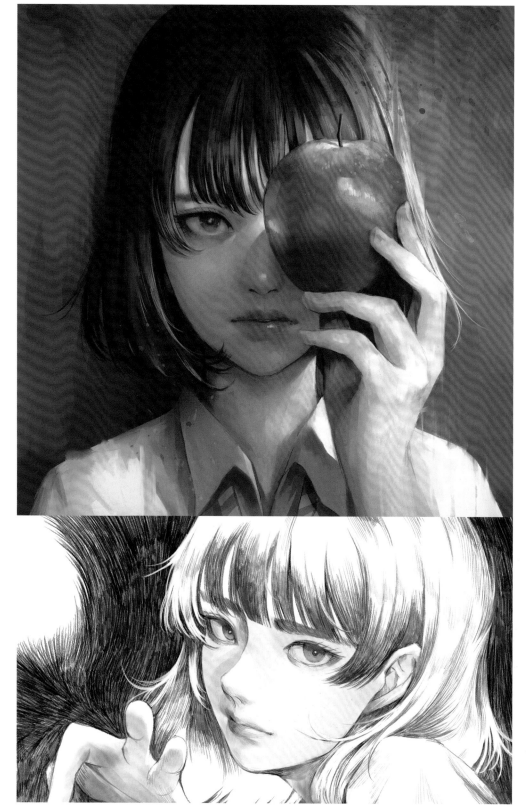

1	3	4
2	5	6

TITLE **1** Forbidden / 2022 **2** Foolishness / 2022 **3** Clean Freak / 2022 **4** hid / 2022 **5** STEM / 2021 **6** WHO / 2021 all original works

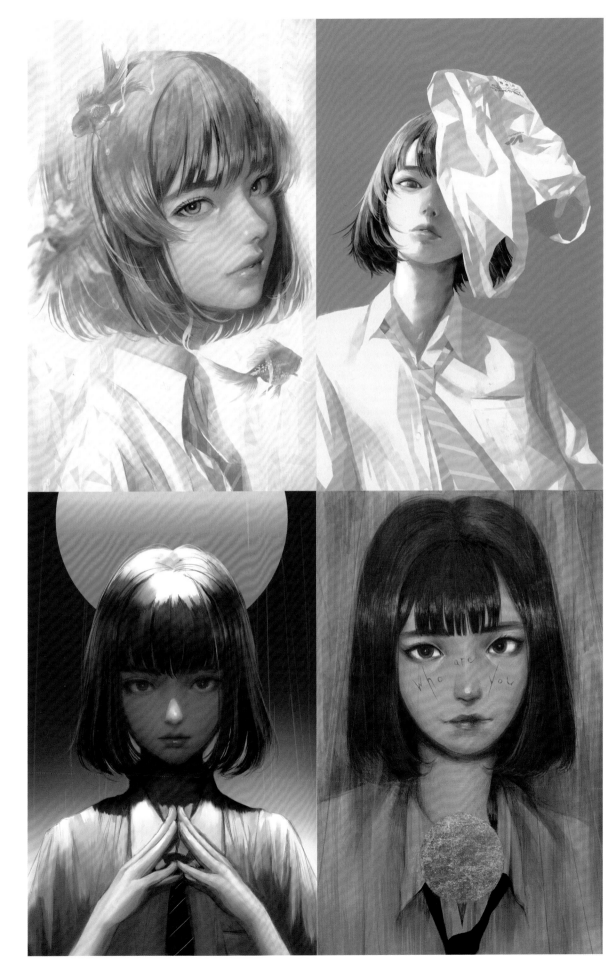

Whispwill

TWITTER　whispwill　E-MAIL　whispywashere@gmail.com

TOOLS　CLIP STUDIO PAINT / Wacom Cintiq Pro 16

PROFILE　Webcomic artist born in California and living in Seattle. Focused on learning rendering, value, and lighting for several years, but threw it all away and now creates art with a heavier emphasis on line art.

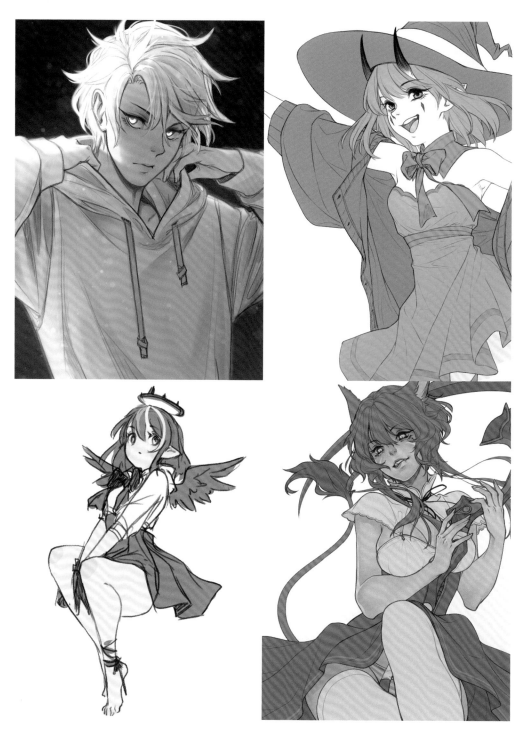

1	2	
3	4	5

TITLE　**1** Elliot / 2021　**2** Witchy / 2021　**3** Angle / 2020　**4** Valentine / 2021　**5** Late Summer / 2022
all original works

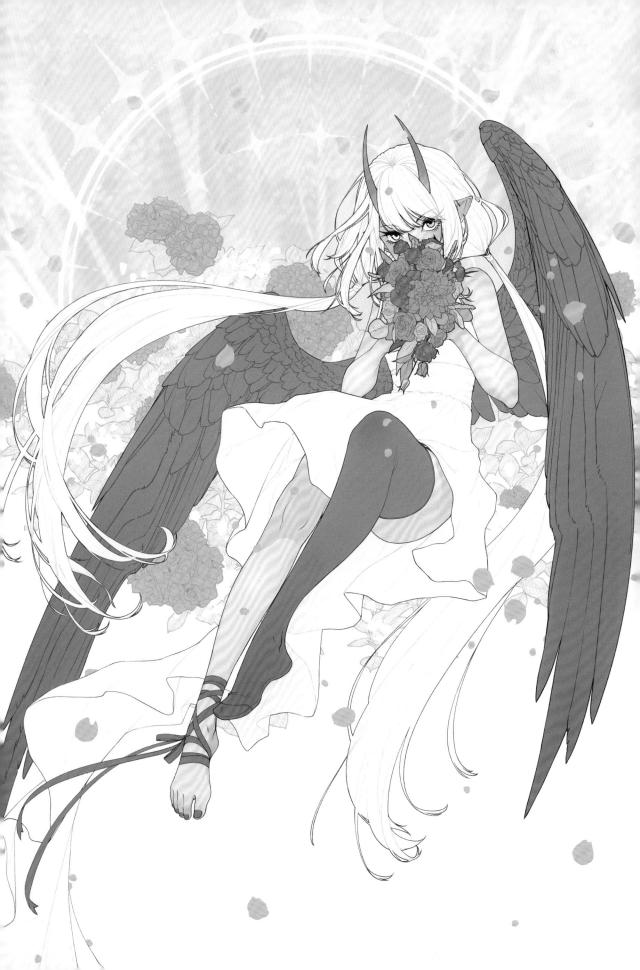

WOOMA

TWITTER tomapocpo
E-MAIL rainwonder17@gmail.com
TOOLS CLIP STUDIO PAINT / Wacom Intuos / iPad / Wacom Cintiq Pro 24
PROFILE Likes drawing men and blood.

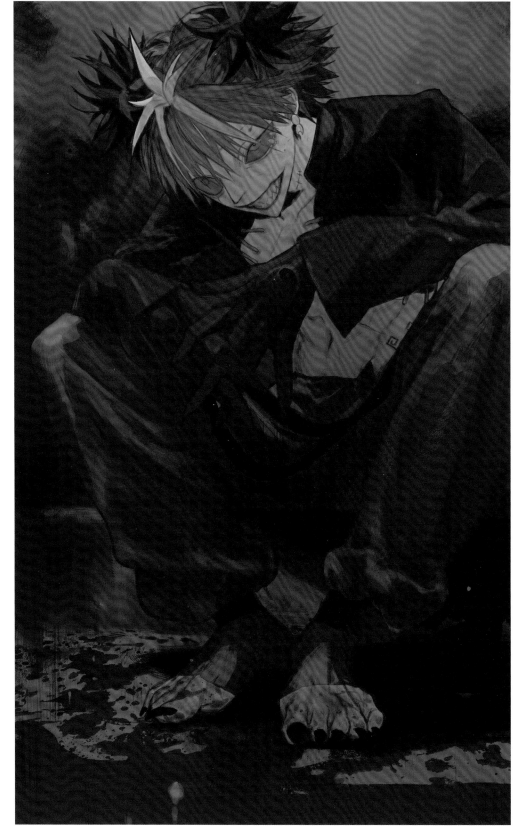

TITLE 1 Liu / original / 2022 **2** Milk / music video illustration for "Dance in the milk (2022 ver.)" by Flower / 2022 / Assistance: Sony Music Labels Inc. **3** Sia / original / 2022 **4** artist / original / 2019

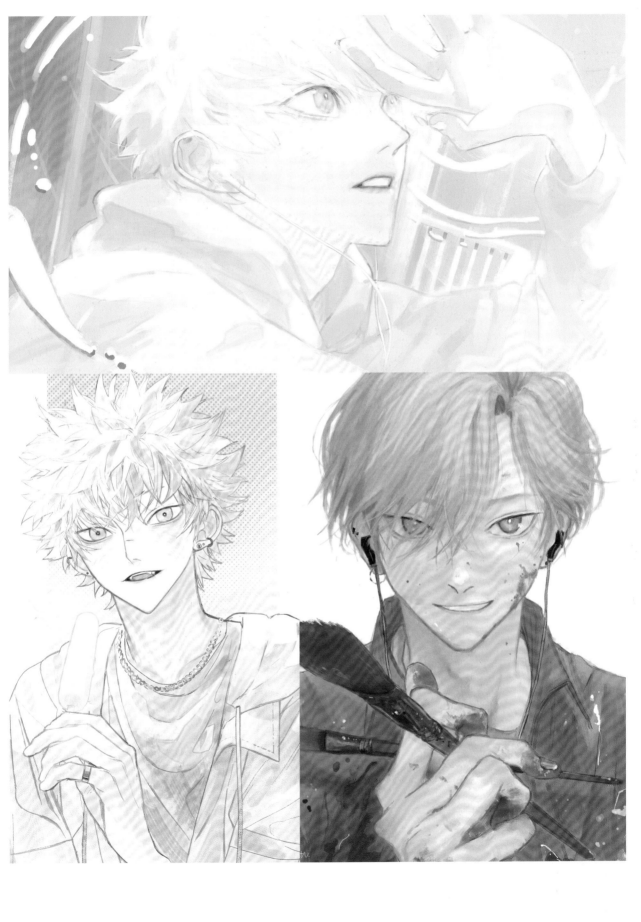

Yanagi Sue 柳すえ

TWITTER YANAGISUE E-MAIL yanagisue@gmail.com

TOOLS CLIP STUDIO PAINT / iPad Pro

PROFILE Currently enrolled at Tokyo University of the Arts. Activities include participating in events and special exhibitions and creating music video illustrations, jackets, and cover art for books. Puts particular effort into making color distributions feel good and expressing people. Likes girls with an air of charm and mystery about them.

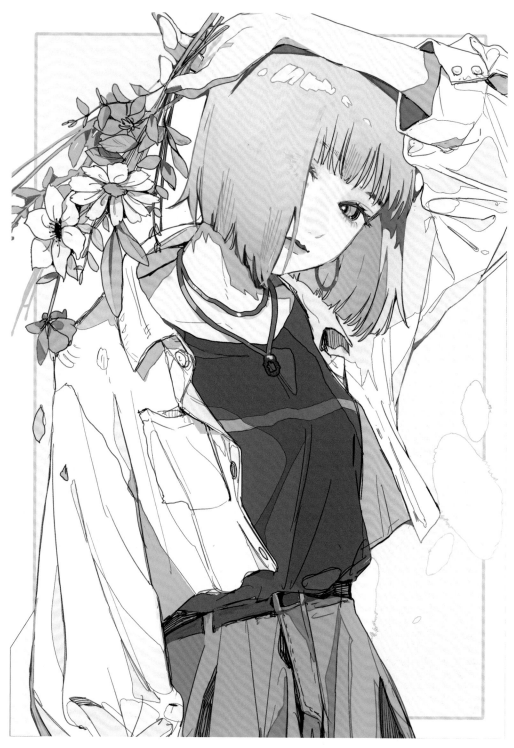

1	2	
	3	4

TITLE **1** Young Leaves／2022 **2** I Let You Get Away Again／2022 **3** PHASE／2021 **4** Commanding the Talons／2021 all original works

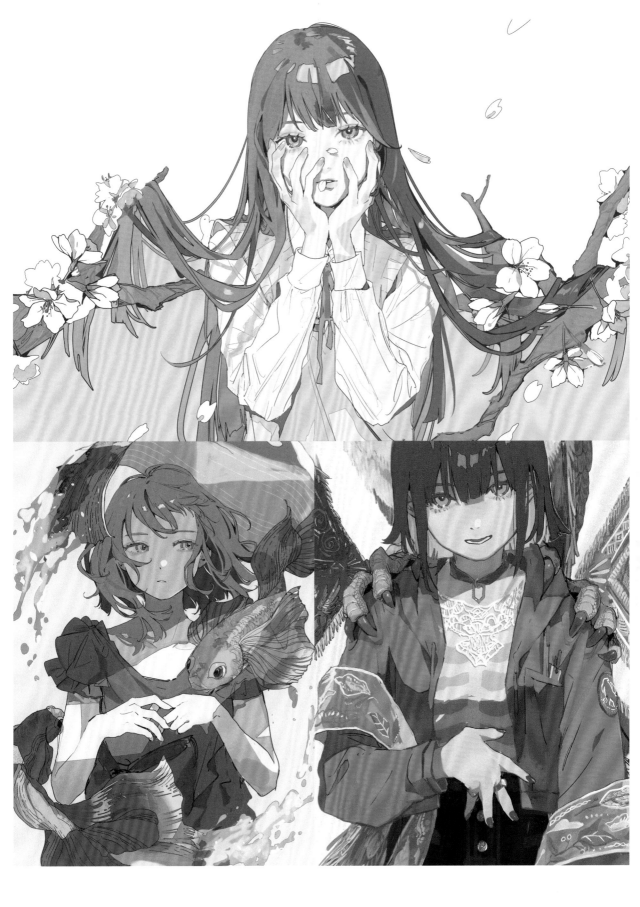

yonemuro 米室

TWITTER yosk6000

TOOLS CLIP STUDIO PAINT / Wacom Intuos

PROFILE Activities mainly include illustrations and character designs. An illustrator who creates lots of illustrations centered around girls and the color white.

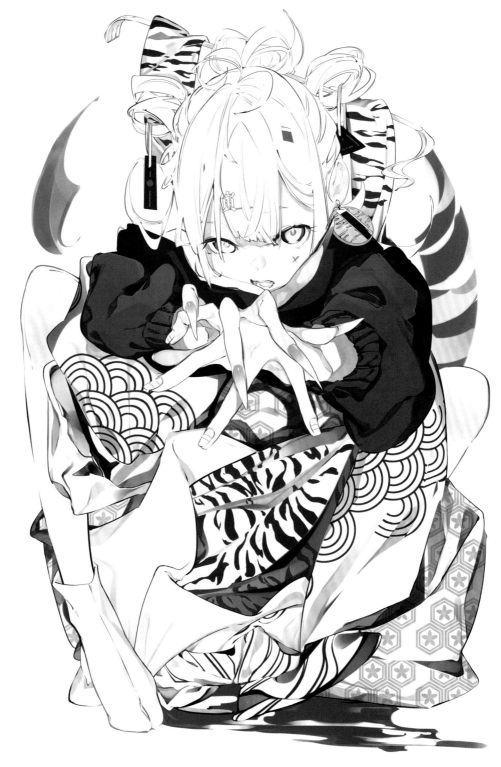

TITLE 1 untitled / 2021 **2** untitled / 2022 **3** untitled / 2022 all original works

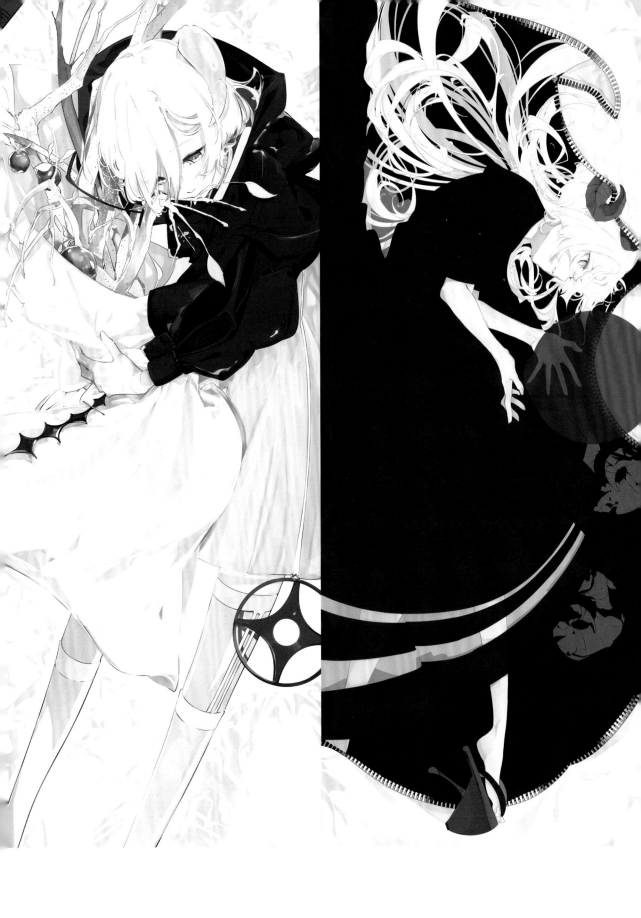

YONEYAMA MAI 米山舞

TWITTER yoneyamai **E-MAIL** yoneyamai@hotmail.co.jp

TOOLS CLIP STUDIO PAINT / Wacom Cintiq Pro 24

PROFILE From Nagano Prefecture. Illustrator and animator. Uses experience working at an animation studio to create illustrations, prints, and films. Activities include a private exhibit in 2021 called EGO as well as music video direction and illustration for Eve's "YOKU," the inspiration song for the KATE YOKU Collection (2022).

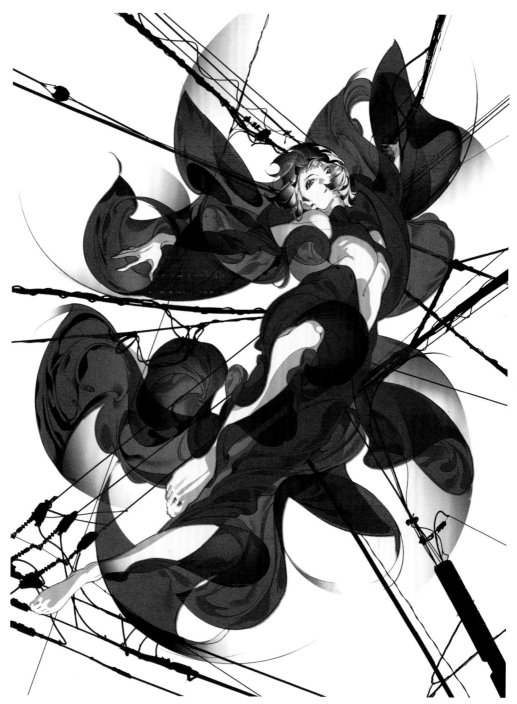

TITLE 1 Ground Y × ILLUSTRATORS "CENTRAL" COLLECTION／2022 **2** LAYER／original／2022 **3** illume／cover of *Illustration* Issue 233 (Genkosha)／2021

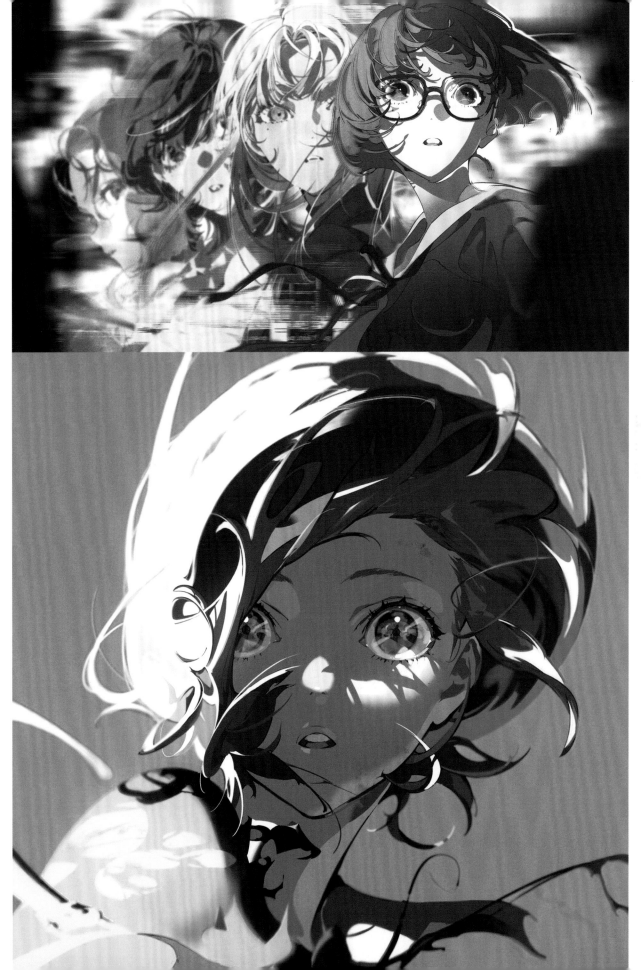

Yooncook 윤요리

TWITTER yoon_cook **E-MAIL** yooncook217@gmail.com

TOOLS CLIP STUDIO PAINT / Wacom Intuos Pro Medium (PTH-660)

PROFILE Born in 2000. From South Korea, currently living in Gyeonggi. Likes girls in uniforms and maid outfits. Currently observing and learning many things.

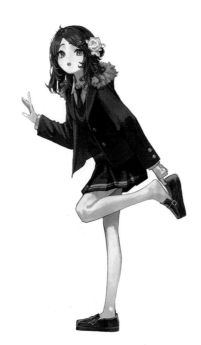

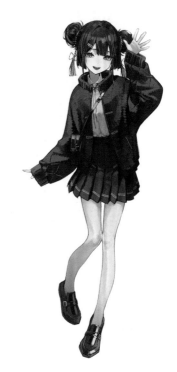

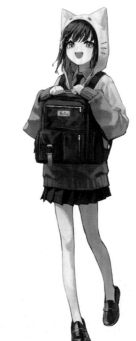

| 1 | 2 | | 5 | 6 |
| 3 | 4 | | 7 | 8 |

TITLE **1** Dana **2** Mara **3** Huije **4** Soso **5** Dana's maid form **6** Mara's maid form **7** Huije's maid form **8** Soso's maid form all original works created in 2022

Yoshida Noel よしだのえる

TWITTER noellemonade E-MAIL noellemonade@gmail.com

TOOLS FireAlpaca

PROFILE Born in 1995, blood type O. Favorite color is yellow. Works mainly on song illustrations and album jackets, but also does work for music videos.

TITLE **1** APOLLO 09／Doujin Music Exhibition APOLLO 09 advertisement illustration／2018 **2** Bears Searching For Treasure／original／2019 **3** Cherry Blossom Road／original／2019

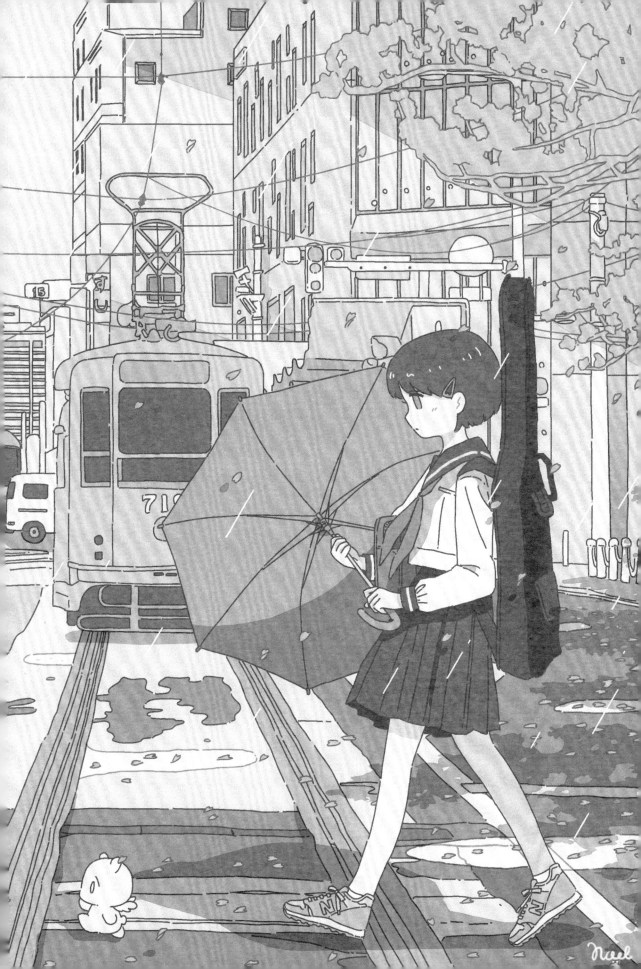

Yoshioka よしおか

TWITTER o10fu **URL** https://haco11.tumblr.com/

TOOLS CLIP STUDIO PAINT / Wacom Intuos

PROFILE Draws illustrations for books, video games, and music. Published their first artbook, embroidery: The Art of Yoshioka, through PIE International.

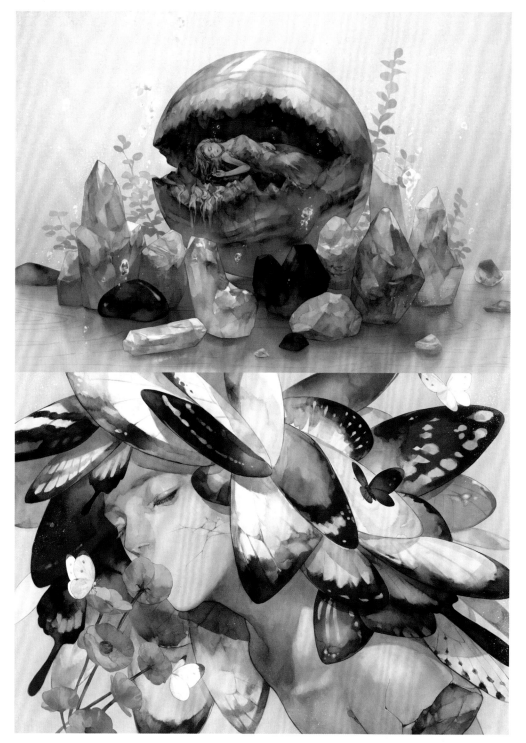

1		3	4
2		5	6

TITLE **1** Nap / 2018 **2** Signs of Spring / 2020 **3** Bride / 2021 **4** Envy / 2020 **5** Mushroom Witch / 2021 **6** Flower and Horn / 2021

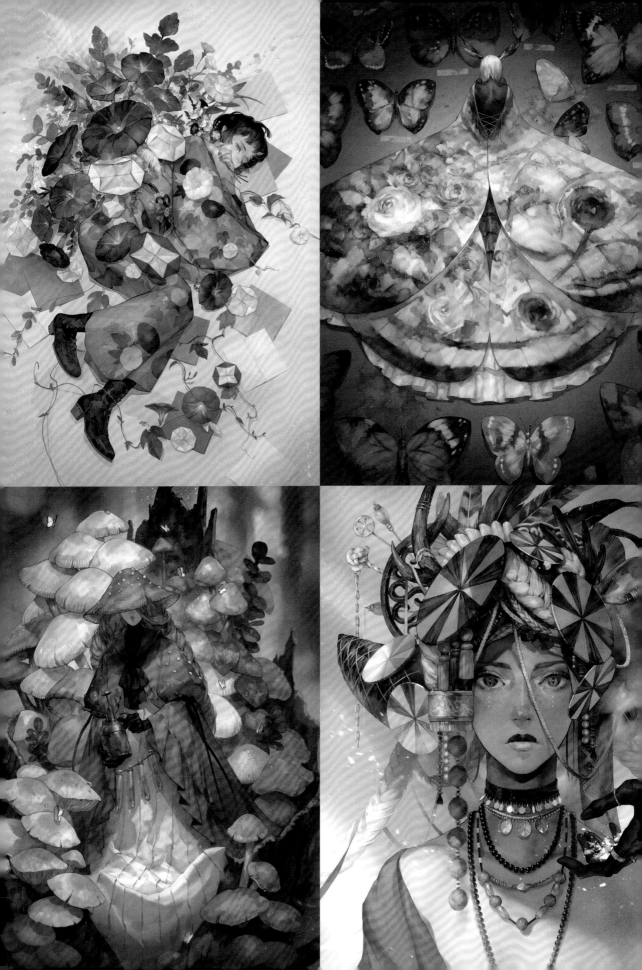

yuko

TWITTER XxxYono **URL** https://foretnoire.mystrikingly.com

TOOLS Fresco / CLIP STUDIO PAINT / iPad / Wacom Intuos

PROFILE Specializes in recreating delicate analog touches using digital methods. Sometimes exhibits acrylic paintings and sells at events. Prior works include book cover images, song art, promo pieces, and situational illustrations.

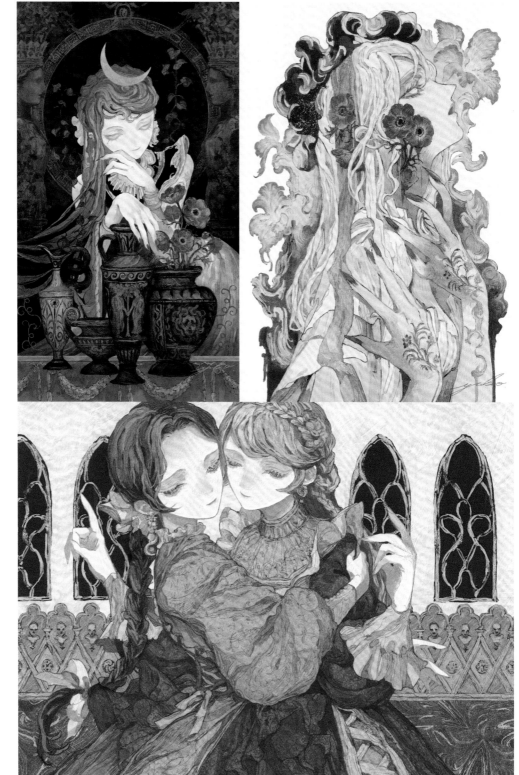

TITLE **1** Queen of the night **2** I'll Always Be Waiting **3** Beautiful People **4** Exotic room all original works created in 2022

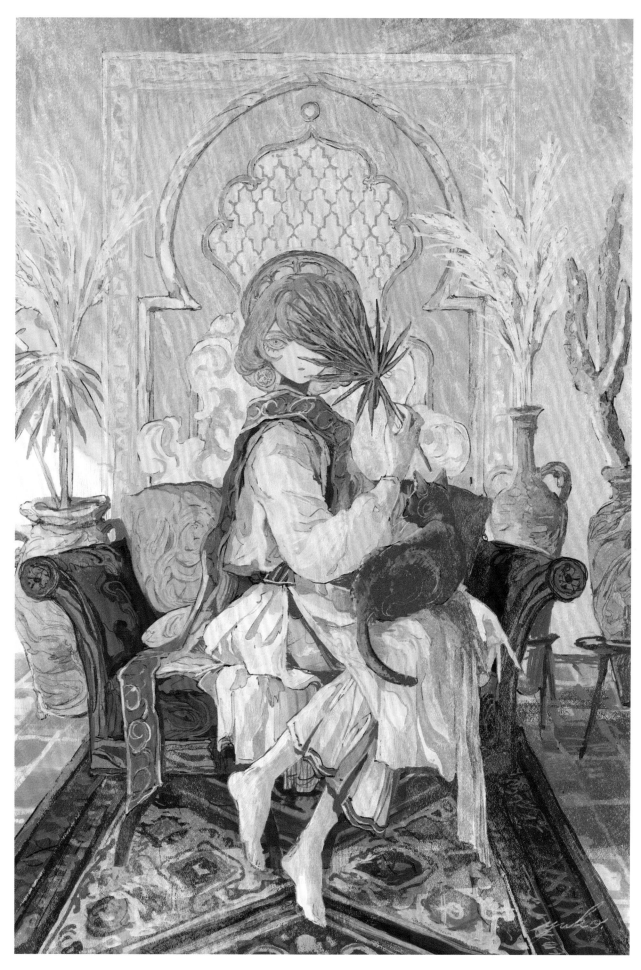

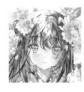

Yukoring 優子鈴 (ゆこりん)

TWITTER _yukoring　**E-MAIL** oekaki.yukoring@gmail.com

TOOLS watercolors

PROFILE Creates analog illustrations using watercolors. Currently active as a freelance illustrator. Likes pictures with light and elements of transparency.

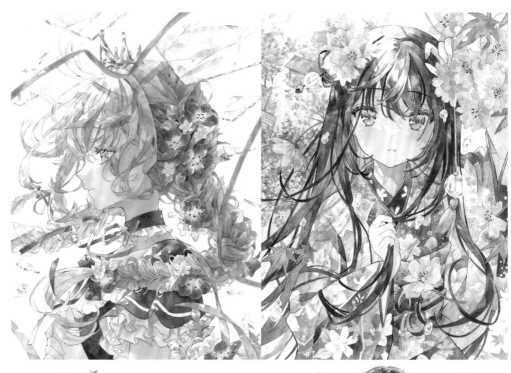

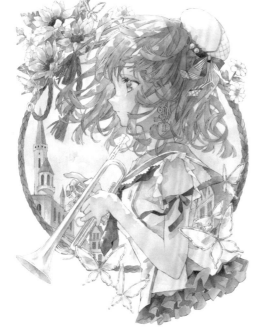

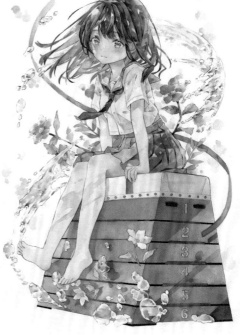

1	2	5	6
3	4	7	8

TITLE **1** Nemophilia - The Defeated Heroine／2022 **2** Iroha Chiru／2021 **3** Trumpet／2022 **4** Watercolor／2022 **5** Bearing Happiness／2022 **6** Snow Falls On the City／2021 **7** Mechanical Feathers and Girl／2022 **8** New Color／2022　all original works

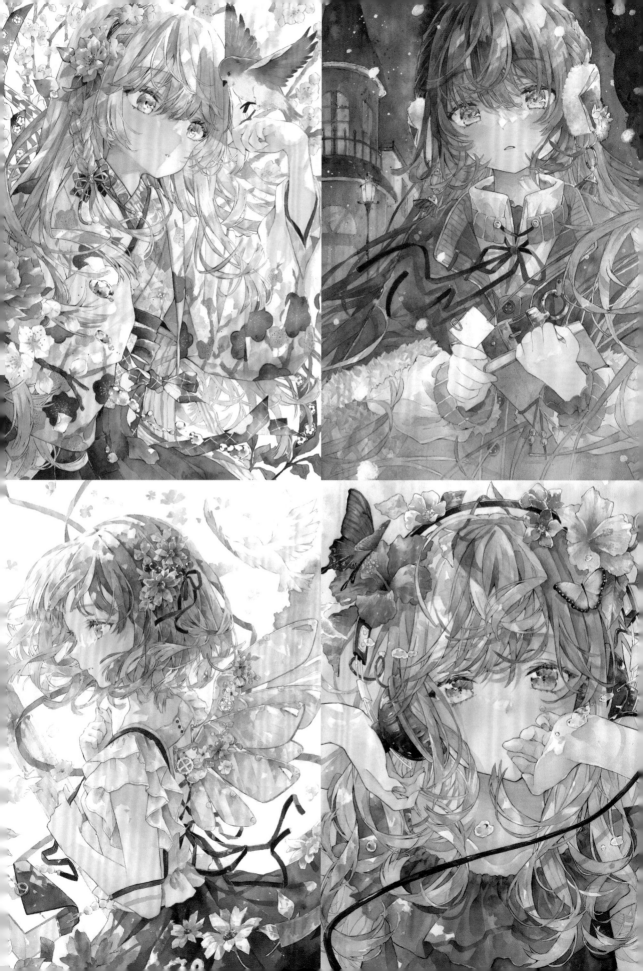

yutsumoe ゆつちえ

TUMBLR https://yutsumoe.tumblr.com/ **E-MAIL** yutsumoe@gmail.com

TOOLS CLIP STUDIO PAINT / Wacom Intuos

PROFILE

Working independently on projects such as character illustrations for the smartphone game *Reversal Othellonia*, virtual YouTuber character and clothing design, and contributions to how-to illustration books.

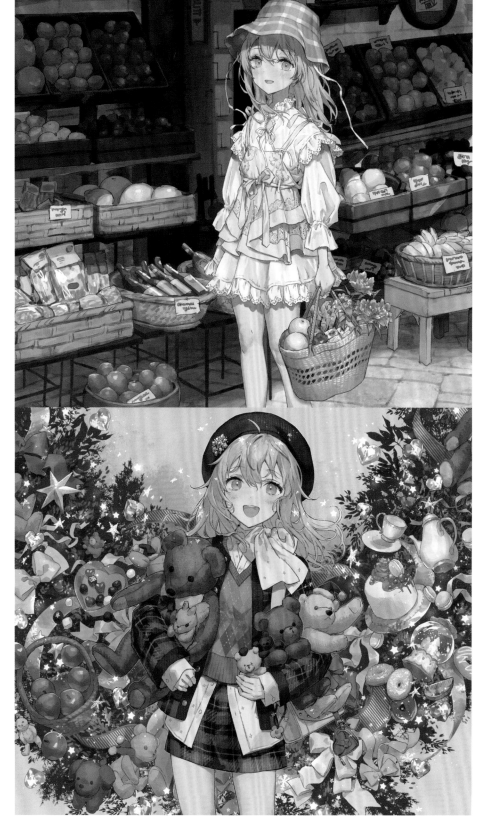

1	3
2	

TITLE 1 fruits / 2021 **2** sparkle / 2022 **3** room / 2021 all original works

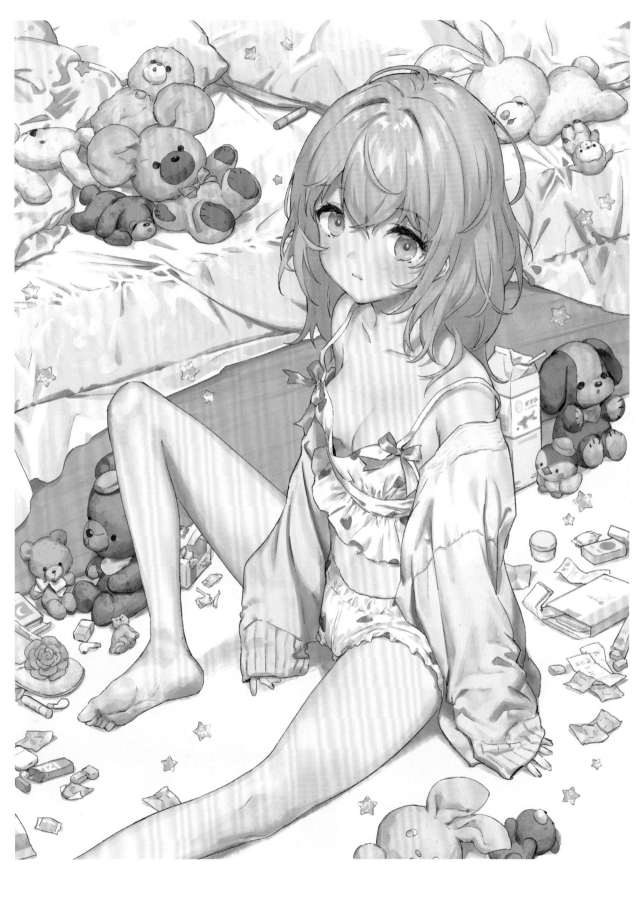

Yuuri 有里

TWITTER tenkichi1212 **E-MAIL** yuuri.pot12@gmail.com

TOOLS Photoshop / Wacom Cintiq 22HD

PROFILE Freelance concept artist and designer. Formerly worked at a video game company. Mainly works on background settings for video games and anime. Published Sekaikan no Tsukurikata (How to Create Worlds) through Shoeisha.

1	3	4
2	5	

TITLE **1** Atelier / 2019 **2** Astronomy Cafe / 2020 **3** Interior of a Kitchen Car / 2021 **4** Exterior of a Kitchen Car / 2021 **5** Festival Day / 2020 all original works

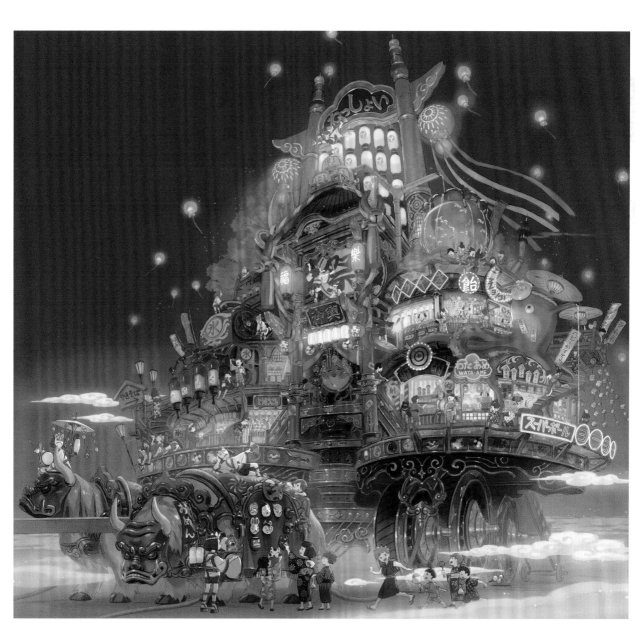

Yvecz

TWITTER yvecz_ **E-MAIL** yvecz@outlook.com

TOOLS Photoshop / Wacom Intuos PTH-450

PROFILE Yvette Chua is an illustrator born in Singapore. Their pen name is yvecz. They enjoy telling stories and searching for artistic media of all kinds. Their interests in film and music are reflected in their illustrations. They're currently working on their first graphic novel, *Field of Sunflowers*.

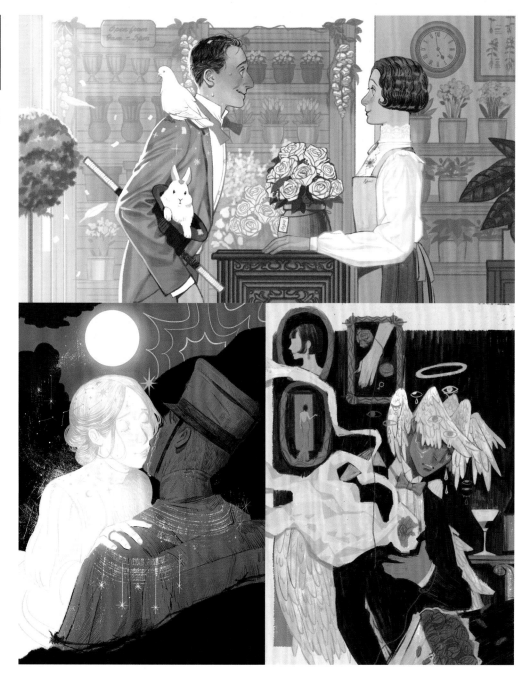

1		4	
2	3	5	6

TITLE **1** Where they first met / 2020 **2** Saints Valentine / 2021 **3** Midnight at the lounge / 2021 **4** Sandman / 2021 **5** Dream / 2022 **6** Forgotten / 2021 all original works

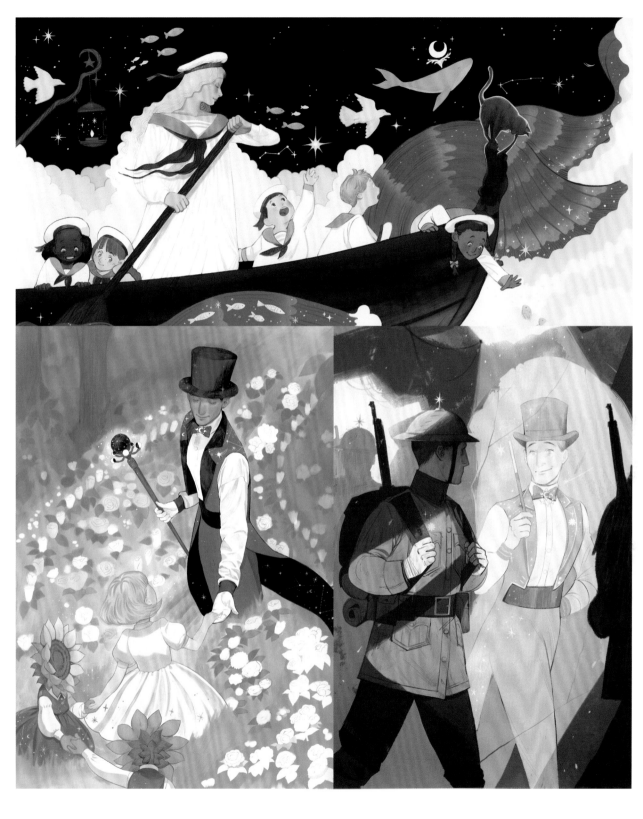

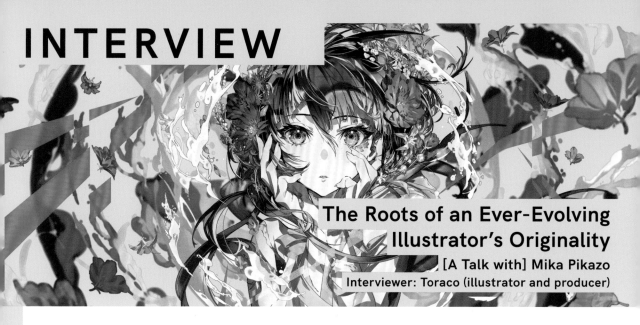

INTERVIEW

The Roots of an Ever-Evolving Illustrator's Originality

[A Talk with] Mika Pikazo
Interviewer: Toraco (illustrator and producer)

This book's cover illustration was created by illustrator Mika Pikazo, who is always eager to take on the challenge of exploring new forms of expression. With her popularity on the rise in Japan and overseas, we spoke with this creator about the shift in her subjects and style, the possibilities of expression, and the feelings she tries to instill in her art.

I WANT TO MAKE THINGS
MY TEN-YEAR-OLD SELF
WOULD LOVE

——Thank you so much for accepting the offer to work on *VISIONS 2023 ILLUSTRATORS BOOK*. What are some of the reasons you decided to take on the project?

MIKA PIKAZO I've been aware of artbooks that collect works from a wide range of illustrators for a long while, but for the last few years, I've sort of refrained from contributing to any. Part of it is because I was questioning my own position as

Kimono Girl ✿ (2016)

an illustrator and as a creator. But I wanted my work to reach more people, and since *VISIONS* is published not just in Japan but overseas as well, it seemed like a good chance to get my name out there, so I participated in this one. I'm terribly honored to have been in charge of the cover illustration for this year's edition.

——When I interviewed you in 2016, you were an up-and-coming illustrator in her early twenties. It's been six years since then, and you're still at the forefront of the illustration scene. But over the last few years, I feel the detail of your compositions and clothing have become even more intricate, and your approach to design has grown a lot. Do you find you adopt a different mindset when you create a single illustration versus when you design a full character, like a VTuber?

MIKA PIKAZO Single illustrations are meant to be studied to some extent, so I consciously try to create something that will appeal to a viewer's emotions and feelings. But with character design, I think it's more important to make sure that character is loved for a long time, even by those with no interest in illustration. When people like that say, "Oh, such-and-such part of the character is really cute," I feel incredibly happy, so I'm always thinking about ways to

give the characters as much depth as an actual person when I draw them.

Also, a lot of my character designs are done as parts of group efforts and they continue to develop even after they leave my hands. For example, they might be given a voice, or music, or a 3D model—they grow beyond the limitations of illustrations, and that's what makes it so fascinating. I can have faith that this character I drew on a screen, on a flat surface, will spring to life. I think seeing that is why I take on character design challenges. And I hope to do it more in the future as well.

——Since your artbook *MikaPikaZo* (BNN) was published in 2019, I feel there's been a major shift in your style when I look at more recent works. I would say it's more more cute and stylish, and also more cool. Was this change intentional?

MIKA PIKAZO I've always wanted to branch out and draw many different things. While part of me is happy that someone might think to themselves, "Oh, Mika Pikazo draws *this* sort of thing," I also don't want to let that trap me. No matter what I'm creating, I'm always trying to find methods of expression I personally find interesting. I have a huge drawer of ideas in my head full of challenges I'd like to tackle and specific things I'd like to express.

In terms of my art style, I think I've been using heavier deformations at times, while other things have become more realistic. Looking back, maybe my style really has changed a lot. But I also believe that there's something in my art other than my style that will tell people that I was the one who made it.

——Lately it seems to be more normal to see people wearing the kinds of clothes you might see in illustrations, like reality is adopting some of the more realistic parts of those designs. Do you do fashion research as well?

MIKA PIKAZO For a long time, whenever I did the clothing for character design, I'd pick out pretty easy to understand pieces like sailor uniforms. Lately, though, I've been thinking more about what actual teens wear, what kind of fashion they have, wondering what would happen if I really went for it and depicted the latest fashion in my art.

——Why that specific age range?

MIKA PIKAZO In my teens, creative works like art and music affected me a lot. Whenever I faced setbacks or just had a hard time, the things

Cover illustration of the artbook *MikaPikaZo* (2019)

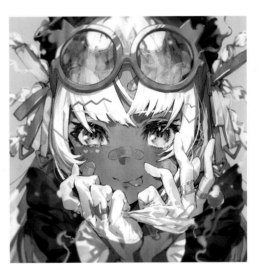

"LAUGH" (2021)

that supported me most were what I saw and heard. I have a lot of respect for the works and artists that saved me in those fragile, sensitive moments. What helped me was how upfront those creatives were about wanting to save others' emotions. I think that was why I wanted to be an illustrator in the first place—so I could do that, too. So I want to make things that other people, especially teens these days, can look at and enjoy. As you get older, your likes change— like you'll only come to appreciate certain things in your thirties, and then you'll come to

INTERVIEW

[A Talk with] Mika Pikazo

like other things in your forties, and then your fifties, right? And when I look at the creators currently active in the industry, I can tell that they've developed their own unique approaches because of their ages and how long they've been working. But for now, I'd like to keep my focus on what I would have thought about my own art when I was young.

THE ACCUMULATION OF NICHE SUBCULTURES BECOME POPULAR CULTURE

——Have you noticed anything in particular by looking at the recent works of young creators?

MIKA PIKAZO I feel like young creators have an amazing ability to absorb things. It's so interesting to see the development of culture, how sensitivities and techniques keep on changing. And I feel like that's something people will think about younger generations no matter

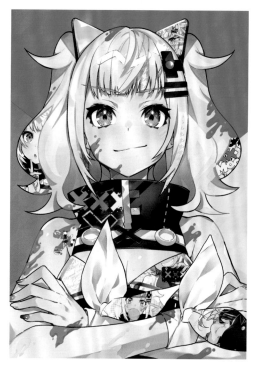

Kaguya Luna's 1st Album: ××× (SACRA MUSIC)
Jacket Illustration (2019)
Assistance: Sony Music Labels Inc.

what era you live in. It's not only drawings and illustrations and paintings, either. I think there are more and more approaches to things like music and design, too.

In particular, there have been a lot more creators specializing in social media content. Social media sites let you see all the numbers, which can make you too concerned with what others think. But I believe having this outlet creates more people who take an interest in things, try them out for themselves, and show them off. You can find a lot of people among these growing young creators that you can just tell will become outstanding one day.

——Are there any illustrators in particular that catch your eye?

MIKA PIKAZO One is the Mimicry Meta unit, a team made up of the illustrator Nike Shimaguchi and the filmmaker Bivi. They've made music videos with outstanding camera work and stylized illustrations. It really feels like they're the next generation. Their works are made to shake up the viewer's feelings, and those heavy single cuts are just incredible. I don't think they could have accomplished what they have if they'd approached their productions solely from an illustration angle.

——I think people like them are amazing—they have this balance of being on the cutting edge while still creating things that fit into pop culture. Do you keep pop culture in mind while working?

MIKA PIKAZO Pop culture, the genre of it, is basically the royal road. People have the impression that going that route would be easy for anyone to tackle. I feel the opposite. I think it's very difficult to do something that will fit into pop culture. The "royal road" may be wide, but there's only one king, after all. And I get told a lot that my art is very pop culture-y, but in my mind I'm actually always doing super obscure stuff. I don't think many people can do it "properly." After all, it's really hard and scary to trust yourself and to be bold.

Making something simple that everyone will like is extremely difficult, and even when you may think you have something with that kind of appeal, it's never that easy. If you go in believing that everyone is going to like what you make, you'll never make something truly beloved. And

I think pop culture (the common) itself contains so many subcultures (the uncommon). The "royal road," so to speak, is actually an affirmation of subculture and a form of respect for it.

I love music, so I check up on musical artists a lot. And I see many very niche creators who aren't well-known, yet they still have people attracted to their works and making whole music videos for them. Young creators will rally together and do their best to show how much they think this person should shine, and it's like a chemical reaction. There are just so many creative possibilities in that realm alone. Pop culture wouldn't exist without underground culture—and pop culture is the reason such beautiful subcultures can be born.

THE POSSIBILITIES OF EXPRESSION EXPANDING WITH ANIMATION

——Depending on the project, it can be difficult for an illustrator to remain attached to a single piece of content for a long time. But one of the VTubers you designed, Kaguya Luna, was an active content creator while you continued to provide her illustrations. Both of your contributions come together to give that project its true value. What approaches would you say there are when you're an ongoing part of content creation like this?

MIKA PIKAZO How much do I have to do with the original, you mean, like adding to her story? It's different from usual illustration work, but sometimes there are certain elements of a character that can be best evoked through a drawing.

——You've participated in projects like these in the past as well. Are you considering moving forward with your own original works and drafts?

MIKA PIKAZO I'd like to. I don't know enough about directing to say I'm aiming to supervise a larger project, but I'd like to learn a lot more about what it takes to create things with a team of other people. It's not just one of those things that I think would be cool to try—I actually feel restless, like I need to take on the challenge and give it a shot. It takes a lot of people to make a team, all of whom are putting a lot of time toward these projects, which is exactly why I'd like to take on the challenge of accomplishing something as part of a larger group.

Collaboration with Hanabushi at the online event Drawfest held by pixiv and Wacom. ©CFM

——Is that the reason behind your recent animation work?

MIKA PIKAZO I got my start doing animation after a conversation I had with an animator named Hanabushi. I told them animation always seemed so difficult, and they were like, "No, not at all!" and, "For example, when an eye moves, these processes are involved..." and very kindly taught me all sorts of things, like how eyes blink or how hair flutters in the wind. If they hadn't taught me that way, I might never have tried to tackle the challenge of animation.

I've always enjoyed music as much as illustration—maybe even more—but I love music as an art form. With music videos, for example, I like the combination of videography, live performances on stage, and stage props. But I'd given up on doing any work in that vein, telling myself there was no place for someone who draws static images in that world. Ever since starting to animate, though, I've awoken to the possibility: Maybe I really can take part in the music or films or stage performances I love so much.

To tell the truth, I actually received an animation-related project recently, and my new challenge this year and next will be to fill the role of director and work alongside other creators and cinematographers. I'm a fan of foreign films, so I'd like to try an approach that's at least a little different from a Japanese one.

——Have you made any new discoveries that you've brought over to your illustration work since you started animating?

MIKA PIKAZO Doing animation has improved my art skills. When I made illustrations before, I only sought out what would make it feel good as an image. But animation is all about motion. Static illustrations can start looking a little odd if you draw hair in motion and reveal too much of the forehead, for example, or windswept

INTERVIEW

[A Talk with] Mika Pikazo

hair that hides too much of the face. With illustrations, you can avoid all that and make the hairstyle perfect. But I was told I could really go all-out with animation, so I started drawing motion in a very bold way. That experience was when I began wondering if I could go more all-out with my illustrations as well. Until then, I'd thought it was best to draw a character without much hair movement so the design was easy to see. Now I've started to feel like, yeah, maybe I could move things this much and it would still work as a piece of art. Static images feel good, but things in motion feel good too, so I'm trying to express that in my art as well.

TRYING HER HAND
AT CUBISM WITH THE
COVER ILLUSTRATION

——Moving to our cover illustration, I was wondering why you chose the pose you did for the *VISIONS* theme.

MIKA PIKAZO I did this with my artbook too, but my favorite motif is people who look like they're actually living on the page. So I went with a composition featuring a girl right smack in the middle. My idea was to draw her in such a way that if you look at the book straight on, you'll lock eyes with her.

——The focus being placed on the face is just outstanding, but the clear, strong front lighting draws the eyes as well. And the complexity of the hair color is something I'm not sure I've seen from your works much in the past.

MIKA PIKAZO I'm a fan of cubist expression. I really love the very clear, flat planes that feature in Picasso and Georges Braque's cubism and the works of Andy Warhol. The starting point for me is works that show a level of perfection as a single two-dimensional image rather than reaching to create a three-dimensional feel. I like works that aren't restricted by the literal dimensions of the subject or its components—pieces that take both design and art into consideration rather than allowing the drawing to impose a limitation.

Forms of expression using straight lines, like cubism, have been something I've wanted to try out for a long time. The depiction of hair in

this cover illustration has plenty of curves and circular shapes, but I've always admired the idea of drawing an illustration with geometric lines like in cubism. I'm still searching for ways to implement that into my own art, but my style isn't very compatible with cubist techniques, so... This cover was a challenge to myself to see if I could capture even a little bit of that feel. My aim wasn't for the hair to exist as hair, but to create a stage upon which the hair was part of a unified design.

THE HEAT FELT AT
LOS ANGELES'S ANIME EXPO

——You frequently attend Comiket and other events in Japan, but not long ago you went to Anime Expo in Los Angeles. I imagine that felt quite different from Japan.

MIKA PIKAZO While I was at the autograph session, it struck me that a lot of people in Los Angeles seemed eager to just give you their own impressions. Plenty of people give their impressions and opinions in Japan as well, but Americans felt more enthusiastic and happy about it, like, "Hey, listen to these feelings I have!" I was really glad about it.

——Then you heard feedback there that made you happy?

MIKA PIKAZO I had thought most of my illustration work and the content I'm involved in wouldn't be widely-known overseas, but a lot of people had their antennas up to keep track of it all. I was moved. There was even a lot of interest over there for DEN-ON-BU, which I did the character designs for—and which had just been announced. That was really cool to see.

When in Japan, I tend to unconsciously gear the content I create toward making a Japanese audience happy. But seeing all the attention it's getting even in the US made me want to make those people happier as well.

——I was actually honored to be along with you on the trip. And before that, I had also figured overseas fans would only have an interest in the really famous stuff rather than individual illustrations. But there were so many there who said, "I'm a Mika Pikazo fan!" and really knew

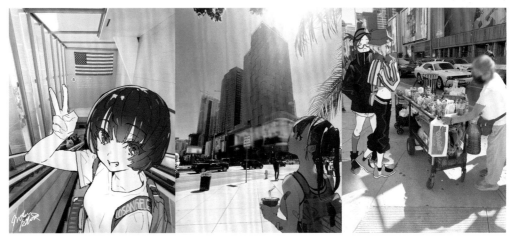
The Look of Los Angeles (Photography and Artwork: Mika Pikazo)

your works very deeply. It was a happy thing to see indeed.

MIKA PIKAZO There were so many people even just at Anime Expo who love and enjoy the characters from anime and video games. As a creator, that simple expression of enjoyment made me very happy. Knowing that so many around the world enjoy Japanese content and illustrations gives me energy.

——**You got to meet several Japanese creators working overseas there too, like Shigeto Koyama, huke, and Kouji Tajima.**

MIKA PIKAZO I was seriously appreciative of them all taking time out of their busy schedules on their huge projects that they're doing even in the US. To be perfectly frank, after getting to meet them like that, I felt so frustrated that I didn't know what to do with myself! (laugh) All three of them are doing really big things on the world stage, and it just made me want to prove myself even more. I feel so much more aspiration and ambition after my visit. I didn't think I'd get such a strong sense of "I need to try even harder" from it.

——**What are some of your goals going forward?**

MIKA PIKAZO From my early- to mid-twenties, I was creating things I like and getting to know the industry better. And just plain working like mad. But from now on, I'd like to create things I'd never be able to make alone, and to do that, I need to put in the effort to confront myself and develop ways of expressing what I want to express.

I'll backslide if I slack off even a little, so I have

this strong sense of obsession where every day, from sunup to sundown, I'm always thinking, "I have to do something!" So I have to draw and draw, learn everything I can no matter what it is, tackle new challenges, and bring new techniques of expression into my work. I'm full of anxiety and restlessness, which is exactly why I have to keep what's enjoyable and fun in mind as I create. And I need to be serious about that. In order to create things that go beyond what I like, I'd like to start from the beginning again as Mika Pikazo.

——**I look forward to your future challenges. Thank you for this interview.**

PROFILE : MIKA PIKAZO
Illustrator.
Born in Tokyo. After graduating high school, she developed an interest in the film techniques, advertising design, and the music of South America and moved to Brazil for two and a half years. Upon her return to Japan, she began working as an illustrator.
With her trademark vivid color sense and charming character design, she has worked on designs and key visuals in a wide variety of genres, such as the character design, live art direction, and apparel design for VTubers Hakos Baelz and Kaguya Luna; the main visual for Hatsune Miku's Magical Mirai 2018; the costume designs for Project Sekai; and character designs for DEN-ON-BU and *Fate/Grand Order*.

PROFILE : TORACO
Born in 1986. Illustrator and producer with Pixiv Inc. Associate professor at Kyoto University of the Arts. General manager for the *VISIONS* artbook series. Author of *Net Art: How Has the internet Changed Illustration?* (BNN, Inc.) and *Even First-Timers Will Understand! The Secrets to Getting Money from Illustrating: Kamiwaza Sakuga Series* (KADOKAWA).

COVER ILLUSTRATION:

1

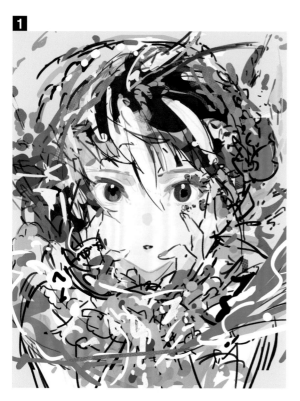

2

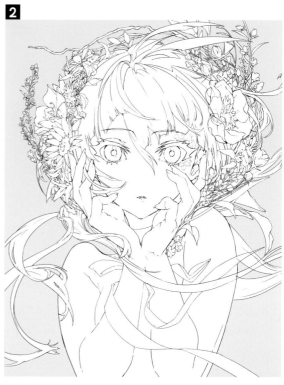

3

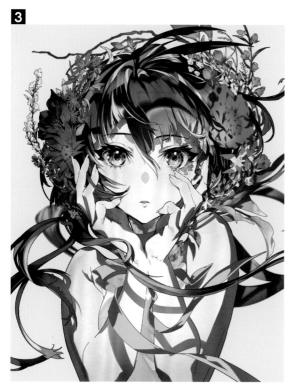

4

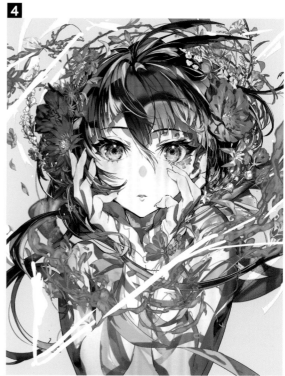

MAKING OF

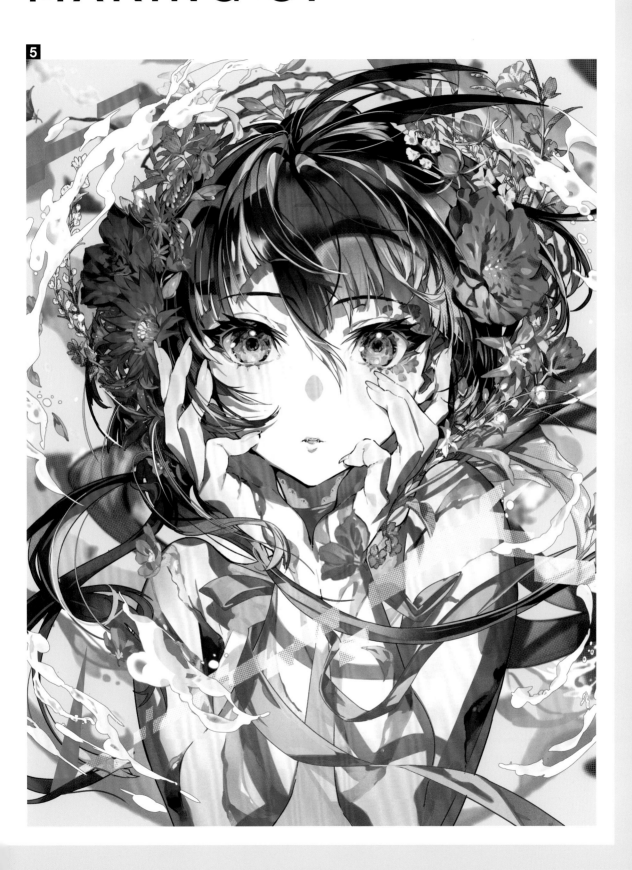

JAPANESE STAFF

Supervisors (pixiv)	Toraco (planning supervision)	**Book Design**	Yuji Nojo (BALCOL0NY.)
	Tetsuaki Higashine	**DTP**	Ayami Iizawa (ATOM STUDIO)
	Yu Otsuka	**Proofreader**	Kaori Nakajima
	Kotaro Hamano	**Sales**	Kenichi Tani
	Takayuki Kitamura	**Progression**	Yui Takeda
	Kazumi Ono	**Editor**	Takashi Wakatsuki
	Yuki Umezawa		Aoi Takahashi
		Editing Assistance	Mai Hinenoya (FIG INC)
			Yuki Nakagawa (FIG INC)
			Susumu Takaseki
		Assistant Editors	Xue Ma
			Sawa Nishimura
			Kana Saitou

TRANSLATION Alice Prowse
LAYOUT Abigail Blackman

VISIONS 2023_ILLUSTRATORS BOOK
© pixiv Inc., KADOKAWA CORPORATION 2022
First published in Japan in 2022 by KADOKAWA CORPORATION, Tokyo. English translation rights arranged with KADOKAWA CORPORATION, Tokyo and Yen Press, LLC through Tuttle-Mori Agency, Inc.

English translation © 2024 by Yen Press, LLC

Yen Press
150 West 30th Street, 19th Floor
New York, NY 10001

Visit us at yenpress.com
facebook.com/yenpress
twitter.com/yenpress
yenpress.tumblr.com
instagram.com/yenpress

First Yen Press Edition: June 2024

Yen Press is an imprint of Yen Press, LLC.
The Yen Press name and logo are trademarks of Yen Press, LLC.

The publisher is not responsible for webstes (or their content) that are not owned by the publisher.

Library of Congress Control Number: 2021939590

ISBNs: 978-1-9753-8909-3 (paperback)
 978-1-9753-8910-9 (ebook)

10 9 8 7 6 5 4 3 2 1

TPA

Printed in South Korea